TOTAL
CHAOS

TOTAL
CHAOS

The Art and Aesthetics of
HIP-HOP

Edited by

JEFF CHANG

BASIC
CIVITAS
BOOKS

A Member of the
Perseus Books Group
New York

This project was made possible in part by the La Peña Cultural Center with the support of the Ford Foundation.

Books published by Basic Civitas are available at special discounts for bulk purchases in the United States by corporations, institutions, and other organizations. For more information, please contact the Special Markets Department at the Perseus Books Group, 11 Cambridge Center, Cambridge MA 02142, or call (617) 252-5298 or (800) 255-1514, or e-mail special.markets@perseusbooks.com.

Text design by Jeff Williams
Cover design by Mike Stern

Total chaos : the art and aesthetics of hip-hop / Jeff Chang.
 p. cm.
Includes bibliographical references and index.
ISBN-13: 978-0-465-00909-1 (alk. paper)
ISBN-10: 0-465-00909-3 (alk. paper)
1. Hip-hop. I. Title.

NX456.5.H57C43 2006
700.9'05—dc22

2006024180

06 07 08 09 / 10 9 8 7 6 5 4 3 2 1

Contents

PART THREE

THE REAL: IDENTITY IN FLUX 161

PART FOUR

WORLDWIDE: HIP-HOP ARTS BEYOND BORDERS 247

Introduction

Hip-Hop Arts: Our Expanding Universe

Jeff Chang

What you hold in your hands is *not* another book about rap music. This is about hip-hop.

To most people, hip-hop signifies rap. And perhaps well it should, for since the art of party-rocking was transferred in the form of 1979's "Rapper's Delight" to a twelve-inch piece of black polyvinyl chloride, born literally of salt and oil, then distilled further from fifteen minutes of rhymes to a three-minute pop song—in other words, a portable commodity that could leverage hundreds more valuable commodities, the salt and oil of the new global entertainment—hip-hop has been an inescapable fact.

But rap's pop dominance has eclipsed hip-hop's true importance. In particular, it has hidden the way that hip-hop has become one of the most far-reaching and transformative arts movements of the past two decades. From condemned farmland barns in South Carolina to flashy postmodern boutiques in Shibuya, from brick-and-stone alleyways to the bright lights of Broadway, in airy suburban bedrooms crowded with the stuff of urban detritus and overheated inner-city schoolrooms abuzz with the noise of personal journals, in front of white laptops, in black-box theatres and red-light districts, hip-hop has set the imagination of a generation afire. I don't say this to make a "look how we've grown up" bid for acceptance, an "it's more respectable than you think" apology, or even a "you better recognize" boast puffed full of triumphalism. Again, it's just a simple fact.

The hip-hop arts movement has left its mark on theatre, poetry, literature, journalism, criticism, performance art, dance, visual arts, photography, graphic design, film, video, name your genre, not to mention the recombinant and emerging versions of any and all of the above. I've said this elsewhere, but

it's worth repeating: hip-hop is one of the big ideas of this generation, a grand expression of our collective creative powers. But when recognized at all, the hip-hop arts have often been divided into subcategorical themes—"spoken word poetry," "street literature," "postmulticultural theatre," "post–Black art," "urban outsider art"—by critics trained to classify trees while lost in the forest. Perhaps this is simply because the hip-hop arts movement did not undertake to formally announce itself in such circles, as in Antonin Artaud's 1938 manifesto *The Theater and Its Double* or the 1971 Black Arts Movement anthology, *The Black Aesthetic*. Perhaps it is simply because, despite all the interest in the talking, the hip-hop arts movement has been chiefly concerned with the *doing*, which is just what it has done, organically, for more than three decades.

Harry Allen, the pioneering hip-hop critic and the first self-proclaimed hip-hop activist, likens the movement's development to the Big Bang. Its vanishing point is in the Bronx, somewhere around '68. Its "epoch of inflation" is the six-year period before the breakthrough of commercial rap in 1979. Sometime between the middle and the end of that epoch, Afrika Bambaataa famously articulated the outlines of the hip-hop aesthetic by defining four primary elements, its founding genres: graffiti writing, b-boying/b-girling, DJing, and MCing. In Allen's formulation, before 1979, together these elements constituted "one, never-to-reappear 'superforce.'" After that, anything could happen.

Sure enough, upon its Athena-like downtown appearance at the turn of the '80s, hip-hop seemed to have already outrun the avant-garde. Graffiti art was celebrated as a reaction to minimalism and conceptualism, an "outsider" art that correlated to postindustrial dislocation, confronted "drop-dead" government with kid's-eye creativity, and encapsulated all that was transgressive and progressive in the moment. B-boying's radically democratic reclamation of public space and its aggressive athleticism reinvigorated modern dance. DJing brought the noise for the postmodernists' interest in rupture, repetition, and bricolage, and MCing seemed perfectly tailored for the poststructuralists' obsession with textuality. And we had just begun to account for hip-hop's effect on the popular.

Still, hip-hop's internal creative force does not rest. In the time that it takes for a group of kids in the neighborhood to go from wide-eyed young'ns to confident teen arbiters of style, slang, swing, and swagger to grown-folk moving on and out (and then declaring the next set of kids to be the murderers of *their* natural-born hip-hop, which, of course, is completely true), the culture has turned over again, leaving the universe with a whole lot of new matter to

deal with. So from kids battling in roller rinks, shopping malls, and city centers to teens showcasing in cultural centers and nightclubs, we have adults taking over the performance space, the theatre stage, and the soundstage. From kids painting graffiti on trains to teens customizing canvases, we have adults re-thinking painting, sculpture, graphic design, installation art, and architecture.

Why not? The alternative to an outsourcing, McJob world is to get busy. Maybe the new hip-hop universe must expand to fill the vacuum left by the old. If the hip-hop generation was the first to enjoy the freedoms of a post–civil rights world, they were also the first to recognize the hollowness of those promises and to bear witness to the effects of the repeal of many of those same freedoms. In the word of the Cuban rappers, we adopt the spirit of *inventos*, not merely building on the advantages afforded by the ever shrinking revolution but also learning the value and necessity of starting fresh.

Enter artists like Sarah Jones, Saul Williams, Jerry Quickley, Jonzi D, Beau Sia, iona rozeal brown, Kehinde Wiley, Rebecca Meek, Carlos "MARE 139" Rodriguez, Barry "TWIST" McGee, Sofía Quintero, Asia One, Kwikstep and Rokafella, Universes, Matt Black, David LaChappelle, Hype Williams, Jamel Shabazz, Joe Conzo, Jonathan Mannion, Jessica Care Moore, Touré, Carl Hancock Rux, Dream Hampton, and Mos Def, artists like those writing in this book, and it don't stop. They share a desire to continue to break down boundaries between so-called high and low, to bring the street into the art space and the art space into the street, to make urgent, truth-telling work that reflects the lives, loves, histories, hopes, and fears of their generation, the hip-hop generation. Heir to the Black Arts and the postmodernist and multiculturalist movements, head high amid all of the terms batted about to try to frame the imperatives and urgencies of Now—such as post-Blackness, polyculturalism, globalism, and transnationalism[1]—hip-hop is where flux, identity, revolution, and the masses mix, and keep on expanding.

Yet after more than three decades, hip-hop is also encountering a sense of exhaustion, even among its most ardent followers. By the beginning of 2005, hip-hop music, in particular, had become a weapon of mass distraction—abused by corporate media monopolies with their deployments of block-buster-minded execs, reactionary programmers, and vernacular shock jocks, incurring a grassroots clapback from hip-hop activists dismayed at the pimping of their culture. In an angry disquisition on rap's accommodation to global hypercapitalism, Greg Tate wrote: "Consider, if you will, this 'as above, so below' doomsday scenario: twenty years from now we'll be able to tell our grandchildren and great-grandchildren how we witnessed cultural genocide: the systematic destruction of a people's folkways. We'll tell them how fools

thought they were celebrating the 30th anniversary of hip-hop the year Bush came back with a gangbang, when they were really presiding over a funeral." At the landmark Hip-Hop and Feminism Conference at the University of Chicago in April 2005, there were contradictory impulses. Thirty- and fortysomething scholars and writers, impatient with the culture's backsliding on heterosexism and misogyny, made calls to "let hip-hop go," to abandon it and welcome the *next* thing. But a vocal contingent of twentysomethings also expressed a strong desire to advance both the aesthetics of the culture and the activism against its more reactionary elements. Fuck being hard, the women had unmasked the complications of the culture in the new postmillennial moment.

The paradox was this: even as hip-hop was at the peak of its function as a multiplier for entertainment and luxury lifestyle capital, a service that seemed to empower only the crassest tendencies of mass culture, hip-hop continued to give voice and grant vision, one-to-one, to millions around the world. Indeed, it continued to split, mutate, evolve, and neologize: krumping, parkour, pichação. Hypercapitalism hadn't yet killed the folkways. In fact, many signs pointed to the culture's continuing expansion, à la Allen's Unified Theory. The concussive effects of the Big Bang were still being felt in boutique galleries on pregentrified streets, on hundreds of poorly lit stages, in cramped and crammed after-school spaces all around the world, let alone the few downriver venues that had not yet been fully transformed by it: Broadway, mainstream museums, yes, the academy, and City Hall.

And so here we are.

If this book is not overly concerned with rap music, well, there's so much more to speak about. From Tricia Rose's classic 1994 text, *Black Noise*, through the recent deluge of published scholarship and the cyberspace chatter right now, most of the intellectual energy expended on hip-hop is taken up by rap, all out of proportion to the actual creative energy of the hip-hop arts movement. We tend to focus on the objects on offer from the vast North American–centric entertainment conglomerates—CDs, videos, DVDs, movies, and all of the "lifestyle" commodities that they sell in turn: energy drinks, alcoholic drinks, shoes, clothing, automobiles, jewelry. Hip-hop arts deliverable via remote control and instant download represent an always visible, supremely capitalized, but very narrow sliver of the range of hip-hop cultural production. Although this part reaches millions around the world via monopoly distribution, the number of producers with access to this system is necessarily small and getting smaller. Most hip-hop cultural production operates outside of this limited field, and so outside of the scope of the intellectual gaze.

For instance, nearly everyone dances, but very little work, apart from what is being done by the dancers themselves, has been done on hip-hop dance—whether social dance, "traditional" dance (b-boying, popping, and locking), or performance dance—let alone the genres that spring from it, like hip-hop theatre or performance art. The less likely a genre is able to be converted into a durable product, the less likely it is to have been documented properly. Yet hip-hop began as a lived culture—you had to *be there*, you had to be *in it*—and it continues to grow as such all around the world every single day. In this way the hip-hop arts movement continues to build audiences and open possibilities. Imagine the infrastructure of the Harlem Renaissance—poets, artists, photographers, publishers, patrons, and fans—raised to global proportions, and you have (very alive and well, thank you) the hip-hop arts movement. Once we've decentered the media monopolies—and, just admit it, doesn't that feel a whole lot better?—a new set of narratives, questions, themes, and art arises.

That is exactly where we want to situate you for *Total Chaos*, pun intended. Of course, this project proceeds regardless of whether hip-hop "needs" it. The movement has done fine without attempts to totalize it—even if it does end up looking expansive and unruly without the organization brought to it by the containing logic of hypercapitalism. And there is absolutely no attempt to be definitive here. Rather, *Total Chaos* intends to document some of the movement's historical vectors, capture a snapshot of some of its most pressing issues, illuminate marginalized and emergent aspects of the movement, and, above all, suggest the breadth and the beauty of hip-hop arts. Consider it a trail book to our universe, and go explore.

Your guides are the artists driving the movement, along with just a smattering of practicing "experts." This was deliberate. Displacing the voices of the culture's producers not only leads to shoddy scholarship but also sucks off the art's vitality. Interpretation should never be the place where art goes to die. So *Total Chaos* centers the cacophony and cross talk of the practitioners over the boilerplate stuff of the "experts." In this mix of essays, pieces, rants, interviews, and roundtable discussions, they spin you their stories, disagree with each other and themselves, and give it to you raw and real.

Their concerns are paramount here. How do hip-hop-generation artists conceptualize their aesthetics? What continuities with the past and visions of the future guide them? What is their relationship to the communities they come from? How does hip-hop both delimit and reframe questions of racial, gender, and sexual identity? How do artists grapple with issues of patronage and sponsorship, especially in relation to a global entertainment industry that

promises greater success and more exploitation than ever before? How does working in a connected world affect their artistic process and their vision of local culture and democracy? And, of course, the ever present stinger: isn't hip-hop dead yet?

These questions were of central importance in an artists' gathering sponsored by Roberta Uno, Program Officer for Arts and Culture of the Ford Foundation, and organized by La Peña Cultural Center in the Bay Area in September 2003. Roberta was interested in looking deeply at two issues: how demographic change should affect cultural funding and how aesthetic change was manifesting in the arts. Under the rubric "Future Aesthetics," forty-five artists—most of color, all of post-Boomer age, ranging from the twenties to the early forties—gathered to discuss, as Roberta put it, questions of "artistic innovation, changing aesthetics, the changes between the market place and communities, new networks of arts organizing and models of organization, the influence of the media and generational shifts, and also cultural production in a local and international arena." Many, but not all, either called themselves hip-hop artists or felt comfortable with working in hip-hop arts. Others were ambivalent about hip-hop arts, and some were antagonistic to hip-hop arts entirely. Those views are included here as well, because what is hip-hop without an argument? If there's one thing this generation embraces, it's getting messy in all the contradictions—you know, "keeping it real" and all that.

Above all, this anthology was born as a way of extending the conversations begun among the artists on questions of aesthetics at the beginning of the twenty-first century. In the first part, "Roots: Perspectives on History, we examine, revise, reframe, and uncover the roots of the hip-hop arts movement. "Flipping the Script: Beyond the Four Elements" then reveals some of the vectors along which the hip-hop arts movement has traveled. "The Real: Identity in Flux" explores the dimensions of identity, how the hip-hop generation begins to imagine itself, and some of the perils and limits of that process. "Worldwide: Hip-Hop Arts beyond Borders" looks at the relationship between hip-hop arts and place, while moving beyond the borders of its North American metropole. "Next Elements: Hip-Hop Arts and Future Aesthetics" presents different visions of the future of hip-hop arts and aesthetics. All in all, this collection is loose, ungainly, contradictory, volatile, unstable. But there are patterns to be discerned, fractals to find. The metaphors we reached for earlier were a primeval explosion and the turbulent, irregular systems emerging from it. So welcome to our universe. It's time to expand.

NOTES

1. Here's a primer on our use of these terms.

Polyculturalism is a term coined by Robin D. G. Kelley and advanced also by Vijay Prashad to describe the process of cultural exchange. Polyculturalism, unlike more recent forms of multiculturalism, is not merely about "diversity," which tends in practice to fix and essentialize cultures. Instead, polyculturalism describes the way cultures influence each other. It functions like a jazz quartet (blending, inspiring, and changing together) or a DJ mixing records (matching rhythms and keeping it moving).

The oft-misunderstood term *post-Blackness* was coined by Thelma Golden, the influential curator of the Studio Museum of Harlem, to describe African American visual arts at the turn of the millennium. She wanted to emphasize that postmulticulturalist African American artists had both benefited from and wanted to move on from the narrow focus on racial content over formal quality. She certainly didn't mean to suggest that racism had gone the way of the dodo bird or that race was no longer a concern of these artists—in fact, quite the opposite. Multiculturalism had freed "post-Black" artists to be received on many levels of interpretation.

The ideas of globalism and transnationalism came into vogue by the mid-1990s to describe how the changes in late or postmodern capitalism had affected culture. *Globalism* related to the interconnectivity and interdependence of cultures around the world and focused largely on economic flows. In this way, it was related to what has come to be known as globalization, although the roots of the idea go back to cold war foreign policy. *Transnationalism* is a somewhat similar term, more popular in the academy than in government, that refers to the movement of culture, capital, and people around the world. It is often invoked to discuss ideas that seem to have become larger than nation-states, such as religion or marketing. Scholars who work in transnationalism are interested in identity formation, especially as it relates to immigration, diaspora, or the emergence of floating classes of workers.

PART ONE

ROOTS: PERSPECTIVES ON HIP-HOP HISTORY

Roots

Perspectives on Hip-Hop History

Hip-hop began as an early '70s youth street culture in New York City, with all of the peculiarities of place embedded in it—the slang, the cadence of talk, the way people moved. If one had grown up in the Black community of Oakland or Detroit or Philadelphia instead, the local dance might be The Boogaloo or Stepping rather than B-Boying or Rocking. Just as James Smethurst reminds us that the Black Arts Movement looked different whether you stood in Watts, Newark, Chicago, or Atlanta, what became hip-hop would take on the characteristics of each community's quirks and idiosyncrasies. Everything has a context, a beginning point.

It may have been only in the Bronx in the late '70s that Afrika Bambaataa's "four elements" converged the way that they did. Yet by now the concept holds much more than ideological weight, even feels like gravity itself. The Big Bang has swept up everything with it, and even the forces behind hip-hop's origins sometimes obscure as much as they illuminate. So this section attempts to spark new or reopen dormant lines of inquiry into the history of hip-hop arts.

In "Dreams of a Final Theory," the nostalgia and extreme mathematics rather than the futurism and virtuosity embodied in a turntablist exhibition draw Harry Allen to examine what has happened to hip-hop culture since its mythic days. His conclusion that hip-hop has, in his words, "destabilized" opens up the possibility that the culture is destined to continue to scatter into entropy, if not experience a fate much worse.

Father Anthony "Amde" Hamilton is a living bridge to the Black Arts Movement. He ran the Watts Writers Workshop and the Mafundi Institute on 103rd Street, then cut two records, *Black Voices on the Streets of Watts* and *Rapping Black in a White World*, with his group, the Watts Prophets, that became the foundation for Los Angeles's "gangsta rap" and its less heralded but

3

influential early '90s freestyle underground. Hamilton's work refocuses hip-hop arts from the idea of word-as-sound or word-as-commodity to word-as-word, a lineage that ties back centuries to the African concept of Nommo.

Here is where Marc Bamuthi Joseph, the actor, playwright, and teacher, enters. The national revival of interest in poetry owes much to hip-hop. Joseph's "(Yet Another) Letter to a Young Poet" pointedly notes that the interest is more at odds than in convergence with institutionalized Eurocentric standards of beauty. His notion of a hip-hop poetic draws on the Harlem Renaissance and the Beats who were influenced by it, the Black Arts Movement and the multiculturalism movement that extended it. Last, Joseph outlines one of the deep, abiding interests of hip-hop arts: to stir possibilities as pedagogy.

If Joseph is interested in hip-hop's liberatory potential, Jorge "POPMASTER FABEL" Pabon, a Rock Steady Crew and Universal Zulu Nation elder and a dancer and hip-hop historian of more than twenty-five years, maintains a folkloric interest in passing on traditions. Despite the fact that hip-hop dance elders maintain a rigorous system of knowledge, dance is the least formally documented of hip-hop's forms, and the most likely to be decontextualized. FABEL's indispensable piece, "Physical Graffiti," is one of the most succinct and influential pieces to date on the topic, a hip-hop nod to Marshall Stearns and Jean Stearns's indispensable book, *Jazz Dance*. FABEL's history of hip-hop dance points to its roots in African American and Afro-Latino social dance, names the dances and their innovators, and discusses the aesthetic problems of bringing the dances to film or the theatre stage.

African American social dance—whether krumping/clowning in Los Angeles, footwork/juking/japping in Chicago, jitting in Detroit, or hyphy/turf dance in Oakland, all twenty-first-century successors to the indigenous social dances described above—has always incorporated competition. At the heart of hip-hop's regeneration and evolution is the ritual of the style war and the art of battling. In an interview with Joe Schloss, b-boy Zulu King Alien Ness describes his process of preparation and execution when he competes in the global circuit of b-boy battles. In the cipher, hip-hop's vitality is reaffirmed, its participants recommit to its primacy, and the culture transforms itself.

The concluding piece of this section is an extensive roundtable discussion featuring cultural critics Greg Tate, Mark Anthony Neal, and Vijay Prashad and filmmaker and photographer Brian "B+" Cross taking up hip-hop in a postmulticulturalist moment. Hip-hop's breakout years in the early '80s coincided with the rise of the multiculturalism movement, a radical political and aesthetic agenda to broaden the representations of marginalized people in

mainstream institutions and the popular culture. By the '90s, hip-hop had helped foster a dramatic increase of representations of people of color. Our panelists discuss the implications of hip-hop's successes and failures in advancing a radical multiculturalist platform. At the heart of their discussion is the desire to understand hip-hop's journey, the possible endpoints of that journey, and its still unfulfilled possibilities.

1

Dreams of a Final Theory

Harry Allen

Physicist Nathan Myhrvold, Microsoft's chief technology officer, once summarized his primary research focus as an inconceivably tiny sliver of time after the Big Bang, when the cosmos was but a mere trillionth of a trillionth of a trillionth of a second old, and the universe swiftly grew from about 10–33 of a centimeter in diameter—roughly a hundred billion billion times smaller than a proton—to "about the size of a grapefruit." Casually dismissing everything that would follow this "epoch of inflation"—the formation of most matter and galaxies, and the entirety of the human record—he notes, "After that, it's all sort of history as far as I'm concerned."

Though bundled with less intellect by several orders of magnitude, I share Dr. Myhrvold's search for the rudimentary, even if my gaze is neither so far-reaching nor quite so reductive. If this writer could study, with infinite resolution, any early time period, it would be the one dominated by hip-hop culture in New York City before September 1979 and "Rapper's Delight." Much the way scientists theorize that, prior to Myhrvold's tiny epoch, nature's four fundamental forces—gravity, electromagnetism, the strong force, and the weak force—were united in one never-to-reappear "superforce," pre–1979 hip-hop's four fundamental forces—MCing, DJing, b-boying, and writing—were, they say, united in a way that, after that time, they would never be again.

Roughly a quarter century after hip-hop's Big Bang, I'm watching Invisibl Skratch Piklz's awesomely skilled DJ QBert deftly mesmerize a characteristically white crowd at Symphony Space for the Fourth Annual Battle Sounds Turntablist Festival. The event has been convened as a screening of, and fundraiser for, Brooklyn video maker John Carluccio's as-yet-uncompleted *Battle Sounds Hip-Hop DJ Documentary*. The producers also distribute copies of

Turntablist Transcription Methodology, Version 1.0, their proposal for a DJing notation system. Scattered throughout the gathering are such notables as DJs Barry B, Steve D, and Grandmixer DXT, whose turns on Herbie Hancock's "Rockit" were like Plymouth Rock for many of the DJs who will line the stage. (As far as one can see, there's not a major rapper on the premises.) When suddenly, I'm struck by an odd insight. I realize that I am not seeing a manifestation of "true" or "original" hip-hop—as many are wont to proclaim these days, particularly in the gamma-ray glare of that rare, very heavy, silvery white metal, element 78 on the periodic table: platinum.

I realize, instead, that such demonstrations are just a slightly less false remapping of hip-hop's original intent than that which the almost completely DJ-less rhyming art form has become—due to the covalent greed of its practitioners and distributors, coupled with the lack of internal cohesion that, after art forms grow, makes them destabilize. "Turntablism" isn't "real hip-hop" any more than, as it's often said, "rap"—the commercialization of MCing into 4:30 arrangements of rhymes in pop-song structure for radio play—is "hip-hop." *Turntablism* is a word that renames, for the objectives of its practitioners and distributors, what hip-hop has been doing since Kool Herc: using the turntable as an instrument. In truth, however, what Flash 'n 'em had to do was some degree more ambitious: (a) be showy and devastating, (b) rock a partying, uninterested, or even partially drunk or violent crowd, and (c) set up the rhythmic bed with which skilled MCs would interact so that they could also (a) and (b). When was the last time that you saw a "turntablism" demo with MCs? In some ways, "turntablism" reminds one of technical diving, where the goal is not to ogle clown fish in a warm coral reef but to descend more than 1,000 feet below the ocean's surface in less than twelve minutes—not the twenty-four hours such a plunge usually takes—aided by ten to fifteen dollars' worth of clusters of "diving computers, heads-up displays, rebreathers, and portable recompression chambers" scrounged through the Internet, to quote a *Wired* article: swimming as pure math. As well, "turntablism" has begun to develop its own branched time line (oriented around the historical dates of widely heralded DJ battles), geography (in turntablism terms, *West Coast* means the Bay Area, not Los Angeles), and mythology (in the sense of an indigenous narrative tradition)—for example, the myth that Grand Wizzard Theodore invented scratching in his bedroom, ably retold and demonstrated by the Wizzard himself in the *Battle Sounds* doc. In the history of "turntablism," this precious fact is almost a phylactery—knowledge that differentiates specialists from dilettantes. Yet like much of hip-hop culture, it has yet to bear the brunt of rigorous historical review, or

even a few basic questions. For instance, does "inventing" a practice in one's bedroom count, or do you have to do it in public to get the credit? Or the one with which this writer has been grappling: why do we count writing ("graffiti") as part of hip-hop culture, when its origins predate Kool Herc's public performances of the music?

One of the holy grails of modern physics is a unifying, mathematical description of the universe's four forces that, says theoretician Paul Davies, "you could wear on your T-shirt"—a formula ideally as compact, memorable, and all-encompassing as $E = mc^2$. Hip-hop could also use such a binding formula or philosophy. In the time since its creation, its subtending parts have each gone off along their own vectors, some more or less prosperously, but all at great deficit to the potency of the others. The question, then, remains, much as it does in the study of the heavens, whether hip-hop is, in fact, a closed universe—bound to recollapse, ultimately, in a fireball akin to its birth—or an open one, destined to expand forever, until it is cold, dark, and dead.

Harry Allen began writing in Brooklyn's *City Sun* and the *Village Voice* in the mid-1980s. He coined the term "hip-hop activist" and was the "media assassin" for the fabled Long Island crew Public Enemy.

2

Nommo

Anthony "Amde" Hamilton

The flesh
Of the word spoken
Is the breath of the one who spoke it
Each word spoken
Is a tangible piece
Of someone

Words can make the bitter sound sweet
Make a heart skip a beat
Words describe to us
What we taste feel smell and see
Words are like communication
In most of life's situations

Oh
What an artistic flair
Happiness or despair
Can come
From a precious breath of air

Anthony "Amde" Hamilton has been performing and teaching the spoken word as a member of the Watts Prophets. His works are collected in the book *Me Today You Tomorrow: Journey of a Street Poet* and the album *Things Gonna Get Greater: The Watts Prophets, 1969–1971*.

3

(Yet Another) Letter to a Young Poet

Marc Bamuthi Joseph

Let me tell you a story:

I'm in Senegal, twenty-two years old, and just finished with my first year teaching high school. The thing they don't tell you about your summer reading list is that your teachers don't want to read that bullshit either, but we must. And so instead of trailing the Fulani near the Mali border or kickin' it on the beach in the Casamance, I'm spending the day reading Rilke. He's this early-twentieth-century European philosopher-king who writes of creating poetry from the depths of the soul out of an irrepressible, intrinsic need. I've never read his work, but these letters he wrote to his young charge are supposed to be THE standard for inspiring "pure" poetry. I'm supposed to TEACH these joints next year to my juniors, but I KNOW they won't give a fuck, because they've never enjoyed the kind of privilege Rilke did. He could merrily merrily merrily down streams and leaves and skies and be "pure" all the fuck he wanted, because there was no whir or hiss or BANG of the machine placating his thoughts or framing his means. And I'm thinking, right then and there, that I'm gonna quit my job, because I can't believe that I'm in Africa but my eyes are in the book of yet another dead white guy. And yeah, Young World, you should probably read his shit at some point, you know just 'cuz, but ultimately it exists in his dead-white-guy vacuum that was never meant to include you. I'm sure whoever the hell he was writing to turned out to be a great poet, but as we both know, Young World, there was no way that dude could EVER bust like you.

Which makes sense, 'cuz if poetry hasn't evolved in the past two hundred years, than we're ALL fucked.

Somehow this logic hasn't seeped into the marrow of the canonical mind, and most teachers end up feeding you dead scrolls instead of living word, but never mind them for now, and let's turn instead to you, young poet. Know this: if you are a child of hip-hop, the simple truth is that in the beginning was the word, and the **word** was **spoken** in body language.

As if abiding by some prescribed low-end theory, your aesthetic progenitor was born of the bass, with reinventors of the wheel like Herc and Bam spinning wax, and Black and Puerto Rican kids twisting their bodies in heretofore unimaginable ways. This dance and its unintended corresponding "movement" arose from organic response to the beat, broken into funk drums, Latin percussion, and disco horns. In the U.S. of A. This American language of the body, of the people, is the first truth in hip-hop's creation myth.

As communities gathered at an odd intersection of competitive zeal and nonviolent response to gang warfare, freestyle scribes showed up to chronicle the times. These first MCs were city-block John Maddens, latter-day hosts-with-the-most calling out insightful play-by-play. The mobile stage was set by Krylon color, after which the beat called, the bodies responded, and THEN came the voiced commentary . . . which in strict Darwinian logic would lead one to believe that the word in hip-hop, being the last to arrive, is still in its most observable evolutionary state. And this is where you come in.

After Bambaataa's cornerstone media expressions, hip-hop's children continue to annex the original temple, growing with the culture into areas of knowledge, politics, parenting, journalism, fashion, economics, and philosophy. Young World, you manifest the belief that a poetic thread runs through all of these elements, and that if any cultural mode has the capacity to save hip-hop from itself, it is indeed the spoken word. Your work is an emergent pedagogical foundation, political arbiter, and the aesthetic pathway toward finding culturally viable, noncorporate success.

Hip-hop culture changed young people's relationship to language and put their literary referents in a stream of authors whose modern era probably begins with the publication of Ginsburg's "Howl." *Howl* gives us the Beats, and from the Beat Era comes Amiri Baraka, who sits on the edge of the Black Arts Movement with Sonia Sanchez, Etheridge Knight, and Nikki Giovanni. These authors open the public consciousness unto the nationalism of the Watts Prophets, the Last Poets, and Gil Scott Heron. These poets release their poems in LP form, speaking poetry over spare drums, and later fuller musical arrangements. Gil Scott's music and poetry gives way to Ntozake Shange's choreopoem *for colored girls who have considered suicide when the rainbow is*

enuf. . . . Shange joins Miguel Piñero at Joseph Papp's Public Theater, thrilling New Yorkers with raw, autobiographical plays in politically keen verse.

All these writers exemplify an urban, musical poetic that has prevailed since at least the Harlem Renaissance, but never has been more globally impactful than inside hip-hop culture. As this particular literary chronology continues, The Furious Five's "The Message" is the first visible signpost in a litany of work that preserves both political and poetical traditions, from KRS-ONE to Rakim to Nas. In this lineage, Saul Williams is the crossroads figure who officially hybridizes hip-hop and spoken word, unequivocally representing both, with or without a beat. His work in the seminal film *Slam* popularized this new DNA strand of verse and voice, availing it to countless writers, among whom stand Dennis Kim, Ishle Park, Sarah Jones, Staceyann Chin, Chinaka Hodge, and Dahlak Brathwaite.

Young World, you are an embodied testament to this aesthetic continuum. You've been published in *Newsweek*, been featured on HBO, and graduated from Harvard. You've also struggled with homelessness and abuse, and you've dropped out of high school. Everyone is in your cipher. Hip-hop has given you a model to present yourself verbally in the public domain. What the culture hasn't modeled, at least on the commercial level, is how to be accountable for language once you've found your spotlight. This is the essential quality of spoken-word poetry that is clearly rooted in hip-hop yet demonstrates aesthetic maturity where hip-hop has strayed from its political promise. Spoken word inherently adheres to the intellectual and social upliftment of the collective.

———————

Hey Young World, let me tell you a story:

Somewhere around 1992, I got bored (two hours before my deadline) with a Shakespeare assignment, and I decided to turn in a "hip-hop" rendering of Julius Caesar's third act instead of the essay I was supposed to write. So my teacher, this young kid in his first year out of New England, FLIPS his SHIT, gives me like an "A quadruple-plus" or something and tells the whole class how I'm on some "postmodern shit" blah blah skippy. He demanded that we read it out loud, which didn't work for all the Paul Beattyian reasons you'd expect of a private school on the Upper East Side. I signified on Shakespeare, spun rhymes eleventh-grade urban, and unwittingly made my first poems without a clue that what I was doing was called "spoken word."

———————

Less than one high school generation later, I was replicating this process of linguistic discovery as a contracted teacher with Youth Speaks in San Francisco. I am currently part of a team that addresses one hundred thousand teens annually across the United States and Europe through spoken word.

There is one major conceptual bridge between the high school Junior I was, and the high school Juniors I teach. For that matter, the same bridge spans the performer I was at fifteen and the artist I am at thirty. The agent at work is encapsulated in the populist ethic espoused by Brazilian educator Paolo Freire. The seminal *Pedagogy of the Oppressed* ultimately makes the case for the *creation* of literacy in our communities as a means of confronting the status quo, becoming an avenue to liberation. Our public education system supports the opposite vision. It is a machine to promote hierarchical class structure, and teachers are shackled by dysfunctional federal mandates in their attempts to incite the full capacity of their students.

To counter this movement of complacent literacy, Youth Speaks' system reintroduces into the learning environment the concept of Nommo—the generative power of the word. The traditional methodology in a classroom is to have students read a canonical text and then create responses to the author's writing in the form of an expository essay. This sequence presents texts as separate and more relevant (worthy of study) than the realities of the students. It perpetuates complacent literacy where literature is taught not to inspire original thought and action on the student's part but to confirm that which is already legitimated as Culture. **Fuck that.** There is an entire generation of educators who come to the classroom with a radically different relationship to oral language (hip-hop), access to information (the Internet), and velocity of thought (wireless communication) than their predecessors. As such, we've sought to change the way literature and literacy are taught, invoking a different approach to language to empower young people to dismantle the narrow self-images that hip-hop reflects back to them. Instead of essays that deconstruct on the page, we ask students to create spoken word that creates, in sound and fury, a new discourse for a new time. First they write their own stuff, THEN they read the "classic" work, and our subsequent classroom discussions are a dialogue between authors—Antonio from Hunter's Point and August Wilson from Pittsburgh all choppin' it up on the same writer's block.

Does that make sense to you? Young World, your words are JUST as valid, though not necessarily as sculpted, practiced, or crafted as the writers in any library. Besides maturity, a major difference is that those writers are necessarily accountable for their published thoughts. Are you accountable for your spoken dreams? Should you be?

Young World, let me tell you a story:

"... so ... then ... what happened?" she asked me. "How come I never hear anything positive about Haiti?"

February 2004. I am driving down to Palo Alto to teach class at Stanford when she begins to wonder out loud. The questions catch me complicit in my own unraveling. As with most cycles of abuse I am so accustomed to the denigration that I don't flinch anymore when my antagonist moves to strike. Rather than fists, the assault has been waged with abstract iconography of Haiti's waking dead. Raft-wrecked refugees. Rampant AIDS. Until now, I haven't thought to examine the historicity of these social constructs. I've accepted Haiti's place at the bottom of the Caribbean economic and social hierarchy as either transparent manifestation of self-hate or matter of fact. Without immediate access to fact, I reach for poem to allegorically answer my colleague's questions, to reconcile personal pain, to use the realm of myth as the narrative device through which we present social theory. I commence to make art in order to make sense. In response to my girl's questions, I use performance to make history. This is my pathway to resistance.

A broad force of hip-hop resistance was activated by movements against apartheid, police brutality, and the systemic abandonment of social services spurred on by Reaganomics. Similarly, a new generation of activists is engaged with the Iraqi War, immigrant rights, and the hijacking of civil liberties by the Bush administration. This twenty-year sweep has also brought changes in the mainstream's handling of hip-hop as a cultural form separating the music from the movement in startling ways. Hip-hop music used to be "the Black CNN." Now it is only the Black MTV, and probably more accurately, the country's audio UPN (and UPN is dead). Commercial hip-hop and the monopoly of caricatured imagery on mainstream radio have depoliticized hip-hop music in the public consciousness.

To even speak of "commercial hip-hop" is also to mark a generational difference. In the mid-1980s hip-hop was a marginal form that scared the mainstream. It is now a mainstream form that corporations use to entice and solicit the margin—and everybody else for that matter. A music innocuous enough to sell burgers to old people is not going to rile anyone up to revolt or resist.

In this vacuum, spoken word has emerged as youth culture's most active and accessible response to verbally engage political consciousness. As a distinct element of hip-hop culture, it is the aesthetic bridge to a reaffirmed free speech. The form and its adherents engender conversation of resistance, spoken in the vernacular of young urban people. Where commercial radio undermines the value of political verse, the poetry of Suheir Hammad, asha bandele, and Ise Lyfe evolves the scale of free speech, changing it to fit the body politic, just like jazz became rock became soul became rap. Spoken word will be spoken untrue only if for some reason, after all this work, the next generation fails to speak for itself.

———————

Last story, Young World, I promise:

It's the summer of 2000, Dumb and Dumber are running for president, and Saul's movie is turning out kids all over America. An ad agency in San Francisco is looking for the newest, latest thing and puts out a call for "spoken-word-sounding" cats to record some dialogue for a radio commercial. Somehow I hear about the audition, I nail it, and me and two other folks from the poetry slam scene do the gig. Man, I'm thinking I just got OVER on these dumb asses! They paid me five hundred dollars (!) to bust some poetry for their dumb-ass product that I've never even heard of, and who the hell pays attention to the commercials on the radio ANY WAY, . . . so about two weeks later, I start getting called out. All the community-radio backpackers are apparently listening to Clear Channel on the low. They want to know why I'm selling this whatever-it-is, and did I actually WRITE that shit, 'cuz the poem was hella weak and did they pay me and how much and man did you know that commercial is on like five times an hour and with mumia and gentrification and the lack of real hip-hop on the radio couldn't I have actually SAID some shit with my twelve seconds and what kind of example was I setting for the kids and daaaaammn five hunnit dolla's that's IT you got PLAYED dude and

———————

So I can't front like Rilke wasn't on to something. His gorgeous ideal of pulling words out from the soul and committing them to the page out of an urgent need to express is phenomenally inspirational. However, I don't think dude could ever have envisioned a climate like this for performed verse. Why draw motivation from within when so much external incentive abounds? It isn't far-fetched for a mediocre poet to make a six-figure salary peddling non-

confrontational verbal charisma to conferences and colleges, showcasing on cable TV, or writing radio spots for McCulture.

I'll tell you what, Young World, I can't tell you what to write or why, but I can suggest what's at stake and leave it up to you. What if the American populace were better prepared to distinguish passion from zealotry? What if we demanded style to go with the infantile drivel that somehow manages to pass for contemporary political speech? What if these ideals were presented and confirmed in the classroom, the theatre, and in our headphones? What if we operated on the belief that it was critical that young people have opportunities to find, develop, publicly present, and intentionally apply their voices? Like hip-hop, spoken word reflects American diversity and engenders a community of young artists who reach across demographic boundaries toward self-exploration and growth, providing a platform where conflicts are resolved on the page or the stage, rather than on the street. Young World, your work has the power to provoke movement from silence to empowerment based in liberatory pedagogy and youth development. It democratizes a civic population of youth by giving them a platform to speak. Your elders in rhyme challenge you to find your own voice, to work hard to apply it, and to do so responsibly. If you're not afraid of your own potential, we promise you that we won't be. *Hey Young World, the **word** is yours . . .*

Marc Bamuthi Joseph has been a National Poetry Slam champion, Broadway veteran, featured artist on Russell Simmons's *Def Poetry* on HBO, and recipient of 2002 and 2004 National Performance Network Creation commissions. His acclaimed evening-length solo work *Word Becomes Flesh* has toured internationally. He is currently working on *Scourge*, a reflection on the plight of Haiti in the postcolonial New World, and *The Breaks*, a meditation on hip-hop. His proudest work has been with the organization Youth Speaks where he mentors thirteen- to nineteen-year-old writers and curates the Living Word Festival for Literary Arts.

4

Physical Graffiti

The History of Hip-Hop Dance

Jorge "POPMASTER FABEL" Pabon

PREFACE

As we complete the third decade of what has been termed *hip-hop culture,* much has yet to be explored regarding its roots, history, terminology, and essence. Deciphering theories from facts is a gradual, seeming endless process since many resources are scattered, leaving missing links in the chains of history. Nevertheless, it is safe to say that there are authentic facts, proven by sound testimony and evidence, regarding hip-hop history. These truths, unanimously agreed upon by the pioneers of the culture, should constitute the "hip-hop gospel," whereas the questionable theories should remain as footnotes until proven to be fact.

In order to properly report the history of hip-hop dance forms, one must journey both inside and outside of New York City. Although dance forms associated with hip-hop did develop in New York City, half of them (that is, popping and locking) originated and developed on the West Coast as part of a different cultural movement. Much of the media coverage in the 1980s grouped these dance forms together with New York's native dance forms (b-boying/b-girling and uprocking), labeling them all "breakdancing." As a result, the West Coast "funk" culture and movement were overlooked and

"Physical Graffiti" is dedicated to the legendary Skeeter Rabbit of the Electric Boogaloos. Rest In Peace.

underrated as the public ignorantly credited hip-hop as the father of the funk dance forms. This is just one example of misinformation that undermines the intricacies of each dance form, as well as their origins and structure. The intent behind the following piece is to explore the past, present, and future of these dance forms and their contributions to the performing arts worldwide.

Note: The facts in this piece were obtained through conversations with and/or public appearances by Boogaloo Sam, Poppin' Pete, Skeeter Rabbit, Sugar Pop, Don Campbellock, Trac 2, Joe-Joe, King Uprock, DJ Kool Herc, Afrika Bambaataa, and other pioneers. Information was also obtained from various interviews in magazines.

In the early 1970s, the unnamed culture known today as hip-hop was forming in New York City's ghettos. Each element in this culture had its own history and terminology contributing to the development of a cultural movement. The common pulse that gave life to all these elements is rhythm, clearly demonstrated by the beats the DJ selected, the dancers' movements, the MCs' rhyme patterns, and the writer's name or message painted in a flowing, stylized fashion. The culture was identified in the early 1980s when DJ Afrika Bambaataa named the dynamic urban movement "hip-hop." The words *hip-hop* were originally used by MCs as part of a scat style of rhyming; for example: "Hip Hop y'all, and ya don't stop, rock on, till the break of dawn."

At about the same time, certain slang words also became titles of the dance forms, such as *rockin'* and *breakin'* used generally to describe actions with great intensity. Just as one could rock the mic and rock the dance floor, one could rock a basketball game or rock some fly gear. The term *break* also had more than one use in the '70s. It was often used as a response to an insult or reprimand; for example, "Why are you breakin' on me?" Break was also the section on a musical recording where the percussive rhythms were most aggressive and hard driving. The dancers anticipated and reacted to these breaks with their most impressive steps and moves.

DJ Kool Herc, originally from Jamaica, is credited with extending these breaks by using two turntables, a mixer, and two of the same records. As DJs could recue these beats from one turntable to the other, finally, the dancers were able to enjoy more than just a few seconds of a break! Kool Herc also coined the terms *b-boy* and *b-girl*, which stood for "break boys" and "break girls." At one of Kool Herc's jams, he might have addressed the dancers just before playing the break beats by saying, "B-boys, are you ready? B-girls, are

you ready?" The tension started to mount, and the air was thick with anticipation. The b-boys and b-girls knew this was their time to "go off!"

Some of the earliest dancing by b-boy pioneers was done upright, a form that became known as "top rockin'." Toprockin's structure and form fuse dance forms and influences from uprocking, tap, lindy hop, James Brown's "good foot," salsa, Afro-Cuban, and various African and Native American dances. There's even a top-rock Charleston step called the "Charlie Rock"! Early influences on b-boying and b-girling also included martial arts films from the 1970s. Certain moves and styles developed from this inspiration.

African slaves introduced *Capoeira,* a form of self-defense disguised as a dance, to Brazil. This form has some movements that are very similar to certain b-boy and b-girl steps and moves. Unlike the popularity of the martial arts films, *Capoeira* was not seen in the Bronx jams until the 1990s. Top rockin' seems to have developed gradually and unintentionally, leaving space for growth and new additions, until it evolved into a codified form.

Although top rockin' has developed an identifiable structure, there is always space for individual creativity, often expressed through the competitive nature of the dance. The same is true of all dance forms associated with hip-hop and West Coast funk: as long as dancers represent the root forms of the dances, the rest can be colored in with his or her own flavors.

As a result of the highly competitive nature of these dances, it wasn't long before top rockers extended their repertoire to the ground with "footwork" and "freezes." For instance, one dancer might start top rocking, then drop to the ground suddenly, going into leg shuffles, then a freeze, before coming to his feet. His opponent might have to do twice as much floorwork or a better freeze to win the battle. The fancy leg movements done on the ground, supported by the arms, were eventually defined as "footwork" or "floor rocking." In time, an impressive vocabulary of footwork, ground moves, and freezes developed, including the dancers' most dynamic steps and moves.

Top rockin' was not replaced with floor rocking; it was added to the dance, and both were key points in the dance's execution. Many times one could tell who had flavor and finesse just by their top rockin' before the drop and floor rock. The transition between top and floor rockin' was also important and became known as the "drop." Some of these drops were called front swipes, back swipes, dips, and corkscrews. The smoother the drop, the better.

Equally significant was the way dancers moved in and out of a freeze, demonstrating control, power, precision, and, at times, humor. Freezes were usually used to end a series of combinations or to mock and humiliate the opponent. Certain freezes were also named, the two most popular being the

"chair freeze" and the "baby freeze." The chair freeze became the foundation for various moves because of the potential range of motion a dancer had in this position. The dancer's hand, forearm, and elbow support the body while allowing free range of movement with the legs and hips. From the chair freeze came the floor trac, back spin with the use of arms, continuous back spin (also known as the windmill), and other moves. These moves pushed the dance in a new direction in the early 1980s, the era of so-called power moves.

The first spins done in b-boying were one-shot head spins originally known as pencils, hand spins originally known as floats, knee spins, and butt spins. The first back spin came from a butt spin. Once a dancer gained momentum on his butt he could lie back and spin into a freeze. The next phase of back spin came from a squatted position, tucking the arm and shoulder under the body onto the floor, then rolling onto the back and spinning. This spin developed from the neck move (a move in which the dancer rolls from one shoulder to the other). Finally, the backspin, from the foundation of a chair freeze, was developed.

Power moves is a debatable term since it is questionable which movement requires more power: footwork and freezes or spins and gymnastics. One notable point introduced by B-Boy Ken Swift is that spins are fueled by momentum and balance, which require less muscular strength than footwork and freezes. The laws of physics prove this to be true: spins require speed, and speed creates momentum. The advent of power moves brought about a series of spins that became the main focus of the media and the younger generations of dancers. The true essence of the dance was slowly overshadowed by an overabundance of spins and acrobatics that didn't necessarily follow a beat or rhythm. The pioneers didn't separate the "power moves" from the rest of the dance form. They were b-boys who simply accented their performance with incredible moves to the beat of the music.

In the late 1960s and early '70s, dancers from Brooklyn played a major role in the creation and development of another dance form in hip-hop culture known as rocking. Eventually, this dance became known as uprocking. Inspired by similar or the same break beats used by b-boys and b-girls, this dance was more confrontational. Typically, two opponents faced each other and engaged in a "war dance" consisting of a series of steps, jerks, and the miming of weapons drawn against each other. There were also the "Apache Lines" where one crew stood in a line facing an opposing crew and challenged each other simultaneously. This structure was different from b-boying/b-girling since dancers in b-boy/b-girl battles took turns dancing, while uprocking was done with partners. Uprocking was also done to records played from

beginning to end. In Brooklyn, DJs played the whole song and not cut break beats. This allowed the uprockers to react to the song in its entirety, responding to the lyrics, musical changes, and breaks.

Just as power moves became the focus of b-boying/b-girling, one particular movement known as "jerking" became the highlight of uprocking. Jerking is a movement that is used in direct battles, typically repeated throughout the break of the record. Today, uprocking consists almost entirely of jerking; the original form has been all but forgotten by the younger generation.

Uprocking also depended on quick wit, humor, and finesse as opponents attempted to humiliate each other. Winning meant displaying the swiftest steps, being receptive to the rhythms and counterrhythms of the music and the opponent, and catching the opponent off guard with mimed assaults, humor, and endurance. Uprocking consisted of quick arm and leg movements, turns, jumps, drops, and freezes. This dance was similar in spirit to b-boying/b-girling, yet different in form. Some practitioners believe top rockin's first inspiration came from uprocking. The two forms developed simultaneously from similar inspirations yet kept their own identities.

The West Coast was also engaged in a cultural movement throughout the 1970s. This scene was nourished by soul, R&B, and funk music at outdoor functions and discotheques.

In Los Angeles, California, Don Campbell, also known as Don Campbellock, originated the dance form "locking." Trying to imitate a local dance called the "funky chicken," Campbell added an effect of locking of the joints of his arms and body that became known as his signature dance. He then formed a group named "The Lockers," who all eventually shared in the development of this dance. The steps and moves created by these pioneers were named and cataloged. Some of them include the lock, points, skeeters, scooby doos, stop 'n go, which-away, and the fancies. Certain members of The Lockers incorporated flips, tucks, dives, and other aerial moves reminiscent of the legendary Nicholas Brothers. The main structure of the dance combined sharp, linear limb extensions and elastic-like movement.

The "lock" is a specific movement that glues together combinations of steps and moves similar to a freeze or a sudden pause. Combinations can consist of a series of points done by extending the arms and pointing in different directions. Dancers combined fancy step patterns with the legs and moves done in various sequences. The Lockers also jumped into half splits, knee drops, and butt drops and used patterns that would take them down to the ground and back up to their feet. This dance gained much of its popularity through The Lockers' various televised performances, which included *The*

Tonight Show, The Dick Van Dyke Show, The Carol Burnett Show, and *Saturday Night Live.*

In 1976, the Electronic Boogaloo Lockers was formed in Fresno, California, by Sam "Boogaloo Sam" Solomon, Nate "Slide" Johnson, and Joe "Slim" Thomas. Since the group's inception, Sam has continued to recruit and help each member master his individual form. Some of Sam's early inspirations were Chubby Checker's "Twist," a James Brown dance called "The Popcorn," "The Jerk," cartoon animation, and the idiosyncrasies of everyday people. From these many influences, Sam combined incredible steps and moves, conceiving a dance form that he named "Boogaloo." This form includes isolated sharp angles, hip rotations, and the use of every part of the body. Sam's brother, Timothy "Poppin' Pete" Solomon, described Boogaloo as a dance that was done by moving the body continuously in different directions.

He also compared the body to a musical instrument in which the movement was as varied as the notes. Originally, "popping" was a term used to describe a sudden muscle contraction executed with the triceps, forearms, neck, chest, and legs. These contractions accented the dancer's movements, causing a quick, jolting effect. Sam's creation, popping, also became known as the unauthorized umbrella title to various forms within the dance, past and present. Some of these forms include Boogaloo, strut, dime stop, wave, tick, twisto-flex, and slides. The transitions between steps, forms, and moves were fluid, unpredictable, and precise, and delivered with character and finesse. Various forms were clearly showcased throughout the dancer's solos and group routines. Eventually, popping was also misrepresented and lost its purity, as younger generations strayed from its original forms.

The titles "Electric Boogie" and "Boogie" were given, in ignorance, to the dance, in New York, after the Lockers and Electric Boogaloos performed on the television program *Soul Train.* Unaware of the dance's history, New Yorkers attempted to name the dance after The Electric Boogaloos (derived from The Electronic Boogaloo Lockers).

Dancers in Los Angeles also distorted the name by calling it "pop-locking," while in France it was called "The Smurf." Elements of pantomime were merged with the dance, diluting its original essence. Miming creates illusions of the body without a rhythmic structure, whereas popping and Boogaloo create movement synchronized to rhythmic patterns. Most of the time, this fusion was done unsuccessfully since one would stray from the beat of the music.

Other townships in central California are credited with creating original forms of dance as well. Each region was identified by its style: San Jose was

known for "flying tuts" and "dime stopping;" San Francisco had the "Chinese strut;" "Fillmore strutting" originated, obviously, in the Fillmore neighborhood. Oakland became known for "Frankenstein hitting" and "snake hitting." East Palo Alto was also known for "snake hitting." "Roboting" and "bopping" were popularized in Richmond. Sacramento had its own dances called "oak parking," "bustin'," and "sac"-ing (pronounced "sacking"). Dime stopping, strutting, and hitting all predate popping and have their own histories within the West Coast funk movement. In summary, all of these dance styles have contributed to the evolution of phenomenal forms of expression.

A connection between the East and West Coast movements is certain records that are danced to by b-boys/b-girls, uprockers, and lockers. One example is "Scorpio" by Dennis Coffey and the Detroit Guitar Band. For the most part, each dance form had a different musical influence, dress code, and terminology (all of which were mismatched and misrepresented during the 1980s media coverage of these dance forms).

As relatively new dance forms, b-boying/b-girling, uprocking, locking, and popping are rarely seen in a theatrical setting. They are usually performed in music videos, commercials, or films for just a few seconds, revealing very little of their full potential. In many cases, the filming of these dances has been poor, capturing only part of the body, taking away from the full impact of the steps, moves, and illusions. The film editing of these dances also deprives the audience of transitions and composition, since the editors are usually unfamiliar with the structures of the dance forms. Proper consultation with the dancers concerning filming and editing can remedy this recurring problem.

Another challenge related to the commercialization of the dance forms is the loss of spontaneous performance. In a cipher, the circular dance space that forms naturally once the dancing begins, the dancers can direct their performance in various directions, uninhibited and free from all counts and cues. This freedom is the key to creativity since the dancer is constantly challenged with variations in music, an undefined dance space, and potential opponents among the audience. The transition from cipher to stage has had its effects on the dancers and their craft.

What were once improvisational forms of expression with spontaneous vocabulary became choreography in a staged setting. A stage performance creates boundaries and can restrict the free-flowing process of improvisation. The dancers are challenged in a different way. Nailing cues and choreography become the objectives.

Another major difference between the original dance forms and staged versions is the positioning of the audience, since most traditional theatres have

the audience facing the stage in one direction. Having to entertain an audience in one general location requires the dancer or choreographer to consciously space the performance, allowing the best viewing of the dance. In order to preserve the true essence and dynamics of these dance forms, they should exist as a social and cultural reality celebrated in their natural environments, that is, at jams, events, clubs, and so on. Theatrical film and video productions can be used as vehicles for their preservation as long as the essence of the form isn't compromised and diluted in the process.

The same concern applies to the story lines and scripts pertaining to the dances' forms and history. The mixing and blending of popping, locking, b-boying/b-girling, and uprocking into one form destroy their individual structures. Unfortunately, the younger generations of dancers either haven't made enough effort to learn each dance form properly or lack the resources to do so. However, the outcome is the same: hybrid dances with unclear form and structure.

In addition, each of the dance forms is performed best with its appropriate musical influences. Intermixing dance forms and their musical forms dissolves their structures and ultimately destroys their identities. Dancing on beat is most important. Riding the rhythm makes the difference between dance and unstructured movement. The formula is simple: submission to the music, allowing it to guide and direct, equals dancing.

Finally, the best way to preserve the dances is by learning from the earliest available sources or a devoted practitioner of the forms. The pioneers of these dance forms hold the key to the history and intentions of the movement. They remain the highest authorities, regardless of other opinions or assumptions.

Unraveling the history of locking, popping, b-boying/b-girling, and uprocking takes us toward a true understanding of their essence and significance in the world today. Many other genres of dance have borrowed without giving credit to their rightful owners. We hope we will see the day when these dances are clearly distinguished and given their due respect. Every so often, the dance world is introduced to innovations that revolutionize the arts. The hip-hop and West Coast funk movements have succeeded in replenishing the world with new, exciting dance forms that entertain and change the lives of many people worldwide.

Jorge "POPMASTER FABEL" Pabon was born and raised in Spanish Harlem, NYC, where, at an early age, he developed his dance and choreography career at

hip-hop jams and clubs throughout the city. His pioneering individuality has been showcased internationally since 1982. Fabel is senior vice president of the Rock Steady Crew and also cofounder of GhettOriginal Productions, Inc. With GhettOriginal, Fabel coauthored, codirected, and cochoreographed the first two hip-hop musicals ever, *So! What Happens Now?* and *Jam on the Groove.* He was a featured dancer in the movie *Beat Street.* Fabel gives lectures, demonstrations, and master classes and participates in outreach programs and conferences internationally. He is a historian of and activist within hip-hop culture. Contact Fabel at FabelRSC@aol.com.

5

The Art of Battling

An Interview with Zulu King Alien Ness

Joe Schloss

Without battling, b-boying itself would not exist. Every aspect of the dance was created for competition, and every move is judged according to its effectiveness as a weapon. Through battle, b-boys and b-girls learn to use humble discipline as a foundation for arrogant creativity. They transform precision and finesse into symbols of raw aggression. They attack without mercy yet still see their opponents as distinct and valuable human beings. Ultimately, battling teaches its disciples how to use style to reconcile opposing forces, a skill that may well be at the heart of hip-hop itself. It is certainly the reason Luis "Alien Ness" Martinez can simultaneously be one of b-boying's most vicious warriors and also one of its most respected diplomats.

A former member of both the New York City Breakers and the Rock Steady Crew, Alien Ness has studied the theory and practice of b-boying with its finest teachers, including Buck 4, Mr. Freeze, Trac 2, Action, Icey Ice, POPMASTER FABEL, Crazy Legs, and Mr. Wiggles, as well as—"mentality-wise"—Flex 4, Ken Swift, Zip, and Papo Love. Now, after a quarter century of commitment to the art form, he is the president of the Zulu Kings, the b-boy division of the Universal Zulu Nation. It is a role he takes seriously, spending his time traveling the world developing Zulu Kings chapters from Australia to Japan to France, mentoring younger b-boys and b-girls, researching and teaching b-boy history and—always—battling. For Ness, the battle is everything: a method of conflict resolution, a work of art, a teaching tool, even a personal catharsis. "The day that I can't battle anymore," he says, "I'm gonna be a miserable person."

Sitting in his apartment overlooking Marcus Garvey Park in Harlem on a cold February afternoon, Alien Ness discussed his battle philosophy, punctuating each of his opinions with a brief demonstration, a hearty laugh, or both. He began by talking about the Octagon, a series of battles he has organized in which b-boys are disqualified for stepping outside the perimeter of a seven-foot octagon.

NESS: The Octagon came across originally when one night I was hanging out with Lil Lep [of the New York City Breakers]. And I was like, "When you gonna train me?"

And he's like, "I'll start training you right now!" And he pointed at the box in the sidewalk. He's like "Get in that box and do a set from beginning to end." He was like "Give me about thirty seconds worth of footwork." Thirty seconds doesn't sound like nothin', but if you break, going down for thirty seconds, you'll know what I mean. I drill my students thirty seconds.

And I did it, and I would hear him go, "Uh-uh. You messed up!"

And I be like, "What you mean?"

"You stepped out the box."

. . . Then he went on and telling me stories on how back in his days, you had venues that might've had a capacity of a hundred people? They'd fit in *two hundred* people. So when the break came in, you was fighting for space, and *God forbid* you stepped on somebody's shoes, or kicked somebody. So you needed control.

And that was one thing that I used to always look at when I used to judge battles. I'd be like—you know these people are going crazy for this one person—and I'm like "he lost." And everybody look at me like I'm crazy. I'm like "he can't even control his own moves." Part of mastering is controlling. If you can't control your own moves at any given point, you're worthless. You're just doing moves. . . . To me, control was a big thing

But, between us, it goes way beyond the Octagon. . . . Sometimes it's hard for me to express certain things, so I like to use things that's already commonly known. And apply 'em. Like now I have my five elements, which I got from the *I Ching*, but I use it in b-boying. And I apply b-boy philosophies.

JOE: You mean like earth, air

NESS: You got fire, earth, air, water, and ether. Ether's what holds everything together in existence. If there's no ether, our molecules would be breaking apart.

But fire's your intensity. Your heat. How you come into the dance. Then you got earth, which is all your ground moves. Back rocks, body rolls, footwork. All that stuff, that's earth. Air is all your air moves, including swipes. Swipes, flips, air flares, windmills—those are all your air moves—that's Air. Water is your flow. Trying to keep everything in one consistent motion. 'Cause too many people are stuck with, "step one, step two, step three, step four," and there's no flow in it. And of course ether's what holds everything together: that's the rhythm.

So now I judge battles like that. I'm like, "OK, he's got water, he's got air, he's got a little bit of fire, but he's got no ether." . . . I break it down like that—it's real easy. I think different. Between the *I Ching* and Bruce Lee's *Tao of Jeet Kun Do*, basically I base all my b-boying on all that.

JOE: Really?

NESS: Yeah. If you read the *Tao of Jeet Kun Do,* it applies to b-boying. Easy. *Easy.* He talks about rhythm, broken rhythm, the importance of footwork, the importance of foundation. You know? In competition or in combat, the need—or *not* the need—of all this flashy stuff that all these other martial arts are made of.

JOE: Right, 'cause he was very straightforward with all of his stuff. . . .

NESS: Right, so I do the same thing. You've seen my battle style? I don't do no moves! Everything is more straightforward. It's more about me bringing you into my run than me doing a run showing off moves. I don't show off moves in a battle. I do that onstage. You want me to show off moves? Pay me! You want me to battle? I'm gonna battle you the way a battle should be. And a battle should be personal.

Fire, to me, is important. I think it's wack that people are winning battles and don't even look at their opponent. They're coming out like this: toprocking looking down. And breaking looking down. And doing freezes, and the crowd's going "Oh! Oh! Oh!" and meanwhile you got a guy who might not be good as him, but he's coming in like *this*, looking at homeboy dead in the grill. And, man, I talk so much crap in a battle. See, that's all part of the game, though. That's all part of the game: the mental aspect. The trash talking. All that is part of the game. Whoever says it ain't don't know what this game is about. It's all part of the game. I would rather see someone going *at* somebody than doing a million dope moves. . . .

JOE: Somebody was telling me that, too, just as a strategy, it's better if you can take somebody out with basic moves. Because then it's like, if they can't do that, not only did you win but it makes them look really stupid too.

NESS: Right. You know what else I like to do, man? And I tell people this, and they think I'm crazy, and they don't believe me. But, in a big competition, you have the prelims—first round, second round, finals, right? A lot of b-boys like to hold back—like, you'll see b-boys lose competitions and not advance, and then see them in the ciphers later and they going off. Me? I'm hittin' you my *best*, first round of the prelims. I'm comin' at you with everything I got.

JOE: How can you afford to do that? 'Cause you have so many moves? Or you change everything up?

NESS: It's not that—it's a mind game. You see, if I attack you that hard right now, the crowd is feeling me. They're all like, "Whoa—the match just started, and this kid's blowin' up!" The judges already got an impression on 'em. They're like, "OK, I'm feeling this guy. He came here to win." Forget the guy you're battling; everybody else you're gonna battle later, that's their first impression.

So now, we come to the next round, they call up you and Alien Ness. You got Alien Ness in front of you; you don't even see me. You seein' the first Alien Ness you saw. You saw that guy that came and blew up. And to make things even harder, I'm changing clothes every round!

You know, it's like you're battling the first impression. So now you saw me going off, *you're* gonna try to go off. And that's when Alien Ness takes it easy. You're trying so hard to beat him, you're messing up. You don't even got control. And at that point, I don't gotta do nothin' impressive—all I gotta do is look neat. Eighty percent of the battles I've won, I've won because I looked neat. Not because I'm the best man in the room, not because I'm better than my opponent, not because I'm the best battler on the planet. Just because I can stay neat.

JOE: I noticed some of the times when I've seen you at places, you also, you don't get down immediately. You watch for like fifteen, twenty minutes to see what other people are doing.

NESS: I like to see who's who. To me everything is a war, alright? And you never run out on a battlefield blind. You don't go out on the battlefield shooting your gun like, "pow pow pow," not knowing who's there, who's around

you, what they got, you know. I'm walkin' in there, OK, I'm looking for the low-level thugs, I'm looking for snipers, I'm looking for the weapons of mass destruction. OK, I know where everything's at, now I know how to approach it.

JOE: I was just thinking about what you told me before, "I hate b-boys . . . "

NESS: Oh, I *hate* b-boys—that's why I break. You cannot get into that whole love thing. 'Cause when you're into that whole love thing . . . You know when I like b-boys? When I'm home and I'm watching somebody's video, you know what I mean? Or when I go to an event and I'm judging. You know what I mean? That's when I like b-boys. But when I walk into a cipher, man? Everybody there is my enemy. I'm the merciless God of everybody that enters my universe, and that cipher's my universe and I ain't got no time to like you. If you're not backing me up, you're my enemy.

JOE: You're known as a b-boy that has a lot of attitude . . .

NESS: You know what? I *am* cocky! I *do* have a ego problem! I *do* got a big mouth! But it's part of the game. That's what keeps me grounded. That's what b-boying is about! Do you enter a battle to be diplomatic? Do you enter a battle to share energy and to express yourself? No! You enter a battle to win! I don't care what anybody says. Everybody's trying to water down and put panties on the game lately, you know what I'm saying? I'll keep it real: I enter battles to win. I live off my dancing. I battle for meat. If I don't win, I don't eat. It's that simple. And I talk a lotta crap. I'm gonna try to talk you out your game. I'm gonna try to talk the judges out your game. And don't *let* it be a crew battle. Don't let it be a crew battle. 'Cause if I got a tight unit? People will never even remember what our opponents are doing! You know, we doing routines on the sideline while *you're* breaking. I'm doing crazy stuff the whole battle.

JOE: You seem to put a lot of thought into coming up with crazy stuff.

NESS: One time I came up with a run where I pull out my gun, cock it, spin around and blast you, and end up in dead man's freeze. Everybody in the room was like, "Whoa! That's dope!"
And Lil Lep was like, "That shit is wack!"
And I'm like, "What?"

He's like, "What happened to the gun? He said, "I saw you pull it out. I saw you blast me. But when you went into the freeze, you didn't put your gun away." That's how technical Lil Lep is. If you pull a weapon, put it away. Or throw it away. He's like, "I wanna see you throw it away, or put it back away— do something. But that, it looks wack, it's not believable." And that's what the problem with most b-boys is. They're not believable. They doing things that don't make no sense whatsoever. Some of them look like they're imitating somebody washing a floor. Like, they'll do things that don't make no sense. And I'm like, "What is he saying?"

This is a vocabulary. With commas and periods and capitalization and exclamation points and question marks and all type of stuff. And you look at people's sets, and it just looks like mumbo-jumbo words together. They're not saying nothing, you know what I'm saying?

JOE: So you really think about that when you're doing a set. Like the punctuation of it, the phrasing . . .

NESS: Oh, yeah. Every time I'm on the dance floor I'm saying *something*. There's this one run that I do at every event, every jam, every party. It's the first set that I do when I walk in the door. My first set of the night, it's always the exact same set. And that's my way of letting people know I'm there. I'm walking in the door, I'm letting people know "This is Alien Ness. This is what Alien Ness brought to the game." And I'm getting up with an attitude and *backing* up out of the cipher. I never walk out of a cipher. I back up out of ciphers, like, "I *dare* you to step in there." And if anybody comes back into that cipher too quick? I'm *still* there.

You know what's beautiful? When you got a heated cipher and you break in that cipher. And you get up and you got that moment of dead silence and nobody goes out? That's when you know your job is done. That's when you pick up your bag and leave.

Joe Schloss is the author of *Making Beats: The Art of Sample-Based Hip-Hop* (Wesleyan University Press, 2004), which won the International Association for the Study of Popular Music Book Prize for 2005. His writing has appeared in *The Flavor, Seattle Weekly, URB, Vibe,* and the anthology *Classic Material.* He holds a Ph.D. in ethnomusicology and teaches at Tufts University. A practicing b-boy, he is currently writing an ethnography of the New York City b-boying scene, titled *Foundation: B-Boys, B-Girls, and Communities of Style.*

6

Got Next

A Roundtable on Identity and Aesthetics after Multiculturalism

Greg Tate, Vijay Prashad,
Mark Anthony Neal, and Brian Cross

While introducing this rigorous, sometimes heated, always fascinating panel discussion held at the Ford Foundation on May 18, 2005, vice president for education, media, arts, and culture Alison Bernstein quipped, "Any time someone like Nathan Glazer writes that 'We are all multiculturalists now,' that gives rise to the thought that, boy, do we need to reexamine what being a multiculturalist is." For many of us, hip-hop has been that reexamination.

Multiculturalism's moment probably lasted from the 1979 united-front boycott of "Fort Apache: The Bronx" through the publication of Glazer's 1997 book and thoroughly changed the face of business, academe, the media, the culture writ large—not just in North American life but around the world. In between, the battle for representations of communities of color in the arts led to dozens more boycotts of movies, films, and music; launched the careers of hundreds of artists such as Spike Lee and Chuck D; and at least temporarily accommodated alternative visions from the margins in the theatre, gallery, museum, and popular culture. At the opening of the '80s, people of color were mainly relegated to consuming images in which they rarely appeared. A decade later, they were moving to the center of the new global media economy, as

Thanks to the Ford Foundation and Dave Tompkins.

producers, icons, pitch men and pitch women, and elite, trend-setting consumers. Does that mean multiculturalism was successful? That's just one question our panel takes up in this revealing discussion.

Ideas such as polyculturalism, post-Blackness, globalism, and transnationalism have emerged to explain the aesthetics and cultural politics of the late twentieth century and the early twenty-first. Oddly enough, hip-hop has rarely been considered seriously in this light, although it has easily been the most popular global articulation of new aesthetics. The following discussion attempts to situate and interrogate the rise of a hip-hop arts movement in this postmulticultural moment, within the context of twentieth-century Black and urban-youth arts movements and under the auspices of triumphant neoliberalism. The participants also discuss hip-hop arts within sweeping changes in race, class, and state and debate its possibilities as an avant-garde and as a social movement.

THE PANELISTS

One of the most celebrated Black cultural critics from the 1980s onward, **Greg Tate** is a staff writer at the *Village Voice* and a pioneering hip-hop journalist. Tate authored the classic *Flyboy in the Buttermilk* and edited *Everything but the Burden*. He's also the musical director for the fifteen-member conducted improvisational ensemble Burnt Sugar. Tate moderated this discussion.

Mark Anthony Neal is associate professor of Black popular culture in the program of African and African American Studies at Duke University and a commentator for *News and Notes* on National Public Radio. An acclaimed, prolific author, Neal's books include *What the Music Said, Soul Babies*, and *New Black Man*. He coedited *That's the Joint: The Hip-Hop Studies Reader*.

Vijay Prashad is the director of international studies at Trinity College, a leading thinker around questions of polyculturalism, and the award-winning author of *Everybody Was Kung Fu Fighting: Afro-Asian Connections and the Myth of Cultural Purity, The Karma of Brown Folk*, and *Fat Cats and Running Dogs*.

Brian "B+" Cross is a hip-hop photographer, filmmaker, and author. He wrote *It's Not about a Salary: Rap Race + Resistance in Los Angeles*, and he produced and directed the acclaimed hip-hop movies *Keepintime* and *Brasilintime*. He's also directed many hip-hop videos for artists such as DJ Shadow and photographed more than one hundred hip-hop album covers.

We greatly missed the presence of Tricia Rose, author of *Black Noise*, who was scheduled to be a part of the panel, and who contributed greatly to shaping the discussion that follows, but who was unable to attend.

GREG: I like the fact that the title of this particular panel is just ambiguous enough, allows for a certain kind of specificity and also a certain amount of vagueness that will allow us to branch out into some tangential but important related areas. In some ways what we're here to talk about is not just this question of whether hip-hop is the new multiculturalism but also think about how you begin to theorize around hip-hop as a progressive political tool. The notion of an oppositional Left of progressive politics has become very diffused, very scattered in this particular moment in time, and it's because the forces we see as the opposition have since learned from the ingenuity and the cunning and the fluidity of the progressive politics that preceded them, which really when we do a tally—say, from the early parts of this century through the civil rights, women's rights, and the gay rights movement—achieved tremendous victories, and I think that could never be undersold.

I think there's a tendency for a certain amount of despair or melancholia to set in because it never seems like we've won everything. Or at the moment which you feel like you've made these tremendous breakthroughs that the forces of reaction then took their game up to another level. Then when I think to that moment in the late '80s, early '90s, when dialogues around multiculturalism and diversity became very prominent, this is also the moment when people are in reaction, in resistance to Reagan, and in New York, to Giuliani. And people are also organizing around South African liberation and around the denial of access to the institutions and opportunities that exist in academia, people talking about canon reformation in terms of the pedagogy, in terms of the literature. And it's also a moment of emergent, very vocal, very community-connected but very lofty public intellectuals via Cornel West, bell hooks, and also our friends in the UK, Stuart Hall, and so forth.

For me, in New York, a lot of that activity and energy, in terms of a theoretical piece, really culminated in something called the Black Popular Culture Conference (Dia Center for the Arts and the Studio Museum of Harlem, 1991). But I think very few people actually were thinking about hip-hop as a force to be reckoned with in the future, in terms of oppositional politics, in terms of organization. Because of where hip-hop came from in the social base, it already suggested a political opposition and a political possibility for

the creativity for the people at the margins of society, socially, economically—people at the margins in terms of power. And it's very interesting to look at how the political landscape has changed. It's really been overhauled in the intervening years.

If you're intimate with the culture, you think about hip-hop as operating in a multiplicity of spaces, but at the same time you think about it as being a very powerful metonym. You say "hip-hop," you really locate a space that as diverse as it is, it still operates in a singular kind of relationship to other spheres of culture and power of authority. I mean people are still very much afraid of this culture and who it represents, no matter how commodified and blinged-out it seems to have become. It still represents the people who my friend A. B. Spellman once referred to as "the most despised and feared group of people on the face of this earth, the African-American working class."

But what I think that still remains promising about hip-hop, as much as it's become a subset of this very virtually integrated selling of what's called "the lifestyle economy," "the leisure economy," is that it still has this potentiality, born of it very much being the product of a fugitive slave culture and a fugitive slave aesthetic—which has always been about, for as long as African American people have certainly been here, improvisation and improvised identities and improvised politics. And when you think about the progressive politics and progressive political movements that preceded us, from the 1940s onward, if you really think about the ingenuity the people brought to dramatize their movements and the way that they used media to dramatize those movements—in our time, we certainly see that hip-hop has the ability to continually regenerate itself through drama, to continually bring drama to the table.

Having said all that—that's my preamble, just to show you I'm a moderator with attitude—I wanna bring my friends here into the discussion and actually, to really, directly address this issue of what the debates around multiculturalism and diversity meant around the time we all first became aware of them and certainly to speak of the history of how those debates came to emerge so prominently and see what relevance they may have to our current situation.

MARK: As an African American who was still on college campuses in the mid-'80s, and just looking at it from a standpoint of a nineteen or twenty year old, what multiculturalism meant for us initially was resources. It was the hammer we could bring into the room, the student associations, the college presidents,

and say that we demand that we have a budget of forty thousand dollars and we have a dedicated budget to Black History Month programs and that we actually do some real work on the ground about recruiting Black faculty and staff. Ironically, in the Reagan era you could make a credible demand upon resources based on the reality that everybody knew that they had to do something around this. The same thing happened to corporate America. It also became an act of faith for folks who knew that they would make hoards of money off of it—whether it was textbook publishers or speaker-bureau organizations—there was money to be made in this context.

I think, for me, the multicultural conversation became much more complicated and very conservative in that regard because it's this debate about what gets identified and what gets embraced as a representative multicultural model. What's the model African American culture that's there? What's the model Puerto Rican culture that's represented? Again, this becomes very conservative because then some things are deemed to not be recognized as representative of a multicultural project.

VIJAY: Mark referred to two institutions, the academy and business. The third major institution in American society is the military. In fact, this comes together in the University of Michigan case regarding affirmative action, where the three main institutions in American society coalesce to defend affirmative action. The military was interested in affirmative action to have officers of color, as it were, to increase morale in the battlefield. Fortune 500 companies understood the need for managers of color, in order to both attack the domestic markets of color and to send people overseas for sales in the world of color. And the third, of course, is the academy, where Mark was right: it's a resource question, but it was also a way to start peeling away discussions of what is the curriculum and what is white supremacy, which brings me to the second point.

Multiculturalism was an ideology from above. It was about the institutional management of diversity, and it decided not to engage with the principal feature of the antisubordination movements, the antiracist movements which fought white supremacy and power. Multiculturalism became about celebration; it became about dealing with your history and your past. But white power and white supremacy was off the table and out of the room. So you could have an engagement with African American history in African American History month, but you couldn't talk about the slave master because the slave master was out of the building. In that sense, multiculturalism

from the onset was a deeply conservative—in fact, reactionary—ideology which we have now unfortunately come to hold on to, believing it's actually liberal when indeed it's actually power telling you not to engage it.

GREG: But then speaking personally, as a youth, my first exposure to any idea of multiculturalism really came about from exposure to the kinds of organizing that people were doing as artists and as political workers really in the Bay Area in the early '70s, and the journal that exposed me to that was Ishmael Reed's journal, *The Yardbird Reader*. At a time when the leading position to take as a Black person towards white supremacy was very exclusive and parochial, Ishmael Reed was bringing to light the fact there was a history of Blacks, Asians, Latinos bonding together and forming different alliances around issues of social justice. That's the first definition of multiculturalism that I became aware of.

VIJAY: I think partly where we have any conversation we're always stuck by words or labels or categories. Any category like multiculturalism could have multiple renditions, multiple readings. We could say that there's a good multiculturalism which talks about the multiplicity of human cultural interaction, which engages power such as, say, any number of multiracial community-organizing projects. There are lots of good multiculturalist political engagements. In a way we have to separate those, because those are the subjugated forms of multiculturalism. The dominant form of multiculturalism becomes this bureaucratic management.

GREG: The crafty appointments of Colin Powell and Condoleezza Rice do in a sense affirm some of what you're saying about a kind of hijacked multiculturalism run amuck—the one that's controlled from above.

To engage the issue of hip-hop, there are a number of people here who are certainly a part of an emergent community of hip-hop activists, and in one sense that speaks to hip-hop's power as a formative influence and particularly the moment when I'm sure many of them became politicized through hip-hop, which would be that crucial moment of the emergence of the Public Enemies, KRS ONEs, and other figures. When you look at the possibility of organizing around, or Black political organizing in this particular moment, what kind of potentiality or possibility do you see that a hip-hop generation has to work with, given where hip-hop is in terms of this vertically integrated lifestyle economy, given where it is in terms of its collusion or relationship

with various corporate-media entities—what are the possibilities on the ground that you guys see?

BRIAN (B+): We're at an extremely interesting moment. If the subject of the panel is about "Is Hip-hop the New Multiculturalism?" then I think the question we have to decide is: are we looking at a situation where we have a dominant and subjugated hip-hop? Are we in a moment where progressive forces are being subjugated? Obviously I'd say that we are. For me it's more a question of thinking about the ability of certain kinds of work to fabricate and create certain kinds of communities of resistance—whether it's around issues of police brutality, which I would say over the past ten to fifteen years in Los Angeles especially is continuing. It's been incredibly significant. However, it doesn't map easily onto, say, mainstream electoral work, and this is part of the problem and also part of what makes it interesting to me.

I think the key issue is there are other non-Western ways of garnering people together that have those powers, that are there, that are available to poor people, that are available to people of color. We have to figure out ways to not fall into the same kinds of administrative traps that multiculturalism fell into. I'm an immigrant; I came here in the early '90s. I stepped into a situation where multiculturalism, institutionally at the academy, already had a foothold. And it was certainly very much part of the educational process for me. Hip-hop, for me, was the great disengagement with the academy. Ice Cube told me much more of what was going on in Los Angeles than any academic I met, including progressively interesting people like Mike Davis. And subsequently I've spent the last ten years working way outside of that environment.

MARK: I think we have for a long time—and when I say "we," I talk about those of us who aren't actually on the ground, college professors, journalists, artists, etc.—romanticized this notion that whatever we need to get out of the experience of the lumpen proletariat, that hip-hop was going deliver that to us. And even if we didn't have to deal with the actual proletariat, we could deal with hip-hop, and it's the same thing. In 2005 that becomes a much more complicated and complex question. In what ways is 50 Cent part of the lumpen proletariat? In what ways is Jay-Z part of the lumpen proletariat?

Tricia Rose has this great conversation about the underground of hip-hop and the underground of actual people. The underground of actual people don't listen to underground hip-hop. They listen to 50 Cent. So no matter

how much folks castigate mainstream hip-hop and discuss the value of the underground, the underground's not reaching the folks that need to be reached anyway. So how do we complicate this conversation and go forward in a kind of way that understands the possibility of a hip-hop multiculture? How do we take that and resist what is already a top-down control of what was once this open space? Those spaces have been closed off. And the underground space is going to be closed down also, very shortly. So how do we go forward in this? The question becomes: how do we start thinking beyond hip-hop? How do we take the constituency that's been brought together by hip-hop and go *beyond* hip-hop?

And this becomes a very complicated conversation because one of the things I'm struck by—and this is really an aesthetic critique—is that we're in this kind of process now of *saving* hip-hop, conserving it for something. Conservation is a good way to describe what is happening with hip-hop. And aesthetically and artistically, the history of African American artistic production has always been when it comes to the point that you need to say something, something else emerges from elsewhere within those spaces that makes the conversations about conservation irrelevant. So the conversation about conserving swing became irrelevant once bebop emerged. Conversations about conserving bebop, given what's happening on 52nd Street in the late 1940s, become irrelevant once we start talking about rhythm and blues. Conservation of soul becomes irrelevant when we start talking about funk.

And it doesn't mean that these forms or genres are no longer relevant and no longer powerful. Hip-hop is unique in this regard because we've been talking about the conservation of hip-hop since the very first time Puffy picked up a mic. We were talking about the death of hip-hop. We're talking about eleven, twelve years—for some of us, this should have been dead already. Of course, the reason that we know that there's a lifeline is because corporate America is imperialist, and when they realized they had done all they can do in terms of the West Coast and the East Coast they went on this imperial trip around North America to find other little localized spots that they could blow up and become part of the corporate process, which is why we deal with southern rap now.

B+: Which was underground. These were the underfunded forgotten spaces until this sort of critical moment that's like, "Oh, word, we can sell it?" And suddenly—that's the moment of co-optation for underground.

MARK: And corporate America provides a context in which they can do that.

B+: But as long as I remember, hip-hop has had this sort of ability to do both things. To some degree, hip-hop is the project of saving soul music or saving funk music. So it's operated both ways at the same time. But the difference is, and the reason it isn't a Buena Vista Social Club kind of operation, is that—this is when we get into the aesthetic issue—it's about the rupture at the same time. You can conjure a past, you can imagine a future, but somehow in the process of doing it, in the process of chopping—if you take the music as an analogy, which I think we'll be doing a lot—it's in that moment. That's what's interesting to me, and it's why the underground isn't going to go away I don't think. I hope.

GREG: The thing about hip-hop that does complicate the whole conversation is that it doesn't just function as exploited culture inside the corporate frame. It is very much still a viral presence there. The thing is, if you extract hip-hop from the virtual economy of representation, in a lot of ways, Black people cease to exist there as anything other than consumers. In terms of hypercapitalist purposes, a lot of the innovation comes from the thing that creates the greatest hungry demand among the consumers. But I think when you talk about theorizing beyond hip-hop, on a certain level you don't transcend how you're gonna engage capitalism in this moment. There's no countervailing political opposition.

MARK: Hip-hop is a default.

GREG: The question is really: how can you use it to kind of explode things from within?

VIJAY: My feeling is I have a different understanding of what you call the lumpen proletariat and the observer's relationship to the producer. There's a point that you just made which is that the first generation out of Jim Crow produces hip-hop, which is then able to hold on to its cultural property to a sense greater perhaps than people and their culture production prior to the mid-'60s. By the '80s, when this production begins, that's the first generation with enfranchised rights—that's something to sit with for a second.

The civil rights movement and civil rights ideology was, in a way, compromised by the Voting Rights and Civil Rights Act, which gave people legal equality, formal equality, and at that moment, the civil rights agenda largely dissipated. At the same time, the American state changes. It ceases to be a state *responsive* to citizens and becomes a *repressive* state. This is the Nixon period

where there's the war on drugs, this is the expansion between 1970 and 1973, the law enforcement money is tripled in three years, and you then see the escalation of law enforcement.

And what's interesting about hip-hop is that it emerges, in a way, as an ideology that the state has shifted. It recognizes that the state is repressive and not responsive. And it has a different understanding of the state than civil rights organizations that continue to operate under the assumption that we have a responsive state to whom we can make a plea. Like, "Please give us housing." See, the state has said, "We don't give anybody housing anymore. We just give you police." And in a sense, the hip-hop ideology understands the shift in the state, so I actually think that's the important piece of it. It's not necessarily that there's a generation out of the civil rights vision that has constructed a different relationship with the state.

At the same time, in the mid-'60s, you also have the Immigration Act. So you have a large number of immigrants flooding into areas that had been segregated, pretty much entirely African American. This same aesthetic also engages the question of immigrants who don't ever apologize for being immigrants. There's not only a different understanding of the state but a different understanding of society. In that sense I think there is a potential to mine hip-hop for a different political vision of the future. I don't see it necessarily that hip-hop is a cheap window into the lumpen, but this complicated new class. The Black working class, and now the multiracial working class, has provided for us a different understanding of the state and a different understanding of how the movement must go forward. That's what I understand our work has got to be. It has to understand that people have figured out there's a shift, and we have to theorize from what we're hearing how to make the agenda go forward.

GREG: The civil rights movement really collapsed with the death of Martin Luther King, not just because he was this messianic figure but also because the last great political action he was trying to organize was a poor people's movement. And so he was, in a sense, making his next avant-garde move even within his own movement. He was planning on taking a million poor people to Washington to create shelters and tents and make a statement. I think what happened after his death is that the focus became more on moving *into* American institutions, moving *into* these educational institutions, moving *into* business and *into* government, and that piece was forgotten.

But then, in one sense, hip-hop certainly has a voice. It reemerges when, as you said, people who don't have a connection to kind of this bourgeois defini-

tion of the civil rights movement have to do what a friend of mine calls "aesthetically embracing one's disenfranchisement." One of the things I find most fascinating about hip-hop is that it almost was designed to participate in this digital virtual economy—just in the way it miniaturized all the previous Black cultures through this thing called the breakbeat, and then embraces the sampling technology, where it's not just about people like Flash and Bambaataa who literally have the hands to freeze a breakbeat, but now you can do it with a chip. What's interesting in terms of the hip-hop generation is the way it's about ten years ahead of the culture in terms of embracing technology. The first Black people I saw using computers were producers in studios in the early '80s. Those were the first Macs I saw Black people have their hands on, bending it to their own ends and desires. So there's a way in which hip-hop represents in terms of oppositional possibility the embrace of technology. And also entrepreneurship, something that we also had not seen before certainly in previous African American movements with maybe exception of Garvey, the Nation of Islam, but certainly not on this widespread anybody-can-jump-in kind of level. It's not just this community but this community's relationship to technology, entrepreneurship, to means of production of communication as well.

So at this point we're ready to open it up to all these brilliant minds. We're gonna open up the floor, and they're asking everyone to go up to the mic and ask their question so it can be recorded.

Q: I have three sisters. Two of them are teenagers, and they watch MTV for most of the day. They watch a 50 Cent video, and then they watch a Blink 182 video, and then they watch a Britney Spears video back to a Fabolous video. It's all pop. It's very diluted. They don't claim hip-hop the same way I claim hip-hop. For me part of the answer is working on a film about hip-hop in four Latin American countries. Here we talk about hip-hop activism. In Brazil, Chile, Mexico, and Cuba, hip-hop *is* activism. They've been looking to us for all this time, and I feel like we need to look to them and create that kind of exchange and dialogue.

GREG: People we consider the founding figures of hip-hop were really born in the '50s and '60s. Then there's a generation of people who emerged in the late '60s and early '70s who were born at that period in time, who really come to develop and refine hip-hop as a popular language and as a popular medium. And now we're in the kind of third generation of consumers of hip-hop, which would be a lot of people who were born in the '80s and afterwards.

The thing that's interesting about the people born in the '50s and '60s, they really lived through their communities and their home environment and also had access to a lot of information of a lot of generations that came before them. And that's also true for people who were born in the '70s, in terms of that access. A lot of them had parents who were influenced by or were participants of movements of the late '60s and the '70s. So that's part of their consciousness and environment as well. By the time you start moving into the '80s and '90s, there's clearly a break in terms of the kinds of information that people are exposed to just in their communal home environment about histories of struggle and legacies of consciousness, and that's gonna make for some of that diffusion that you speak of. This is a very mediated, media-centric, media-struck reality. Anybody who's a teenager now, a lot of their reference for reality is virtual, and that's why what goes on in these kinds of forums is really important in terms of theorizing around media and politics and the integration of what's supposed to be street culture and global corporate culture.

MARK: My whole thing about the end of hip-hop and post-hip-hop is trying to be provocative. One of the reasons why I'm trying to be provocative, one of the things that I think is unique about the "hip-hop audience" now, at least the one that Viacom recognizes on a regular basis, is that this is a generation of folks for which the only thing they've known is hip-hop. How do you get them to actually imagine beyond hip-hop? How do you get them to imagine "*post*-hip-hop"?

Q: I feel like hip-hop was more multicultural in 1975 that it is in 2005, in that its diasporic roots were more acknowledged and celebrated, and in that the immigrant communities that contributed to its genesis were also acknowledged and celebrated. But when the larger corporate culture industrialized hip-hop, it became centralized not only into African American culture but the face of all African America. Just as the civil rights agenda was lost with the Civil Rights Act, I feel the broad hip-hop culture agenda was lost at that point.

Even in this room in this conversation we've essentialized hip-hop to music. And the conversation keeps going back to music because music is the main hip-hop product in this country. But few of us in this room would characterize African American culture as jazz culture or Mexican culture as mariachi culture, so why do we even on the Left continue to do it with hip-hop? And I feel like avoiding the deeper discussion of going deeper into what the aesthetics are has us lose again and again and again. So I guess my question to

you is—what should the conversation that we're having be? Not that I don't like it so far—you've been blowing up my spot, I've been taking notes—but what is the urgent conversation in order for us to *win*?

VIJAY: My urgency, my interest, in this kind of conversation is this: is there a possibility to craft a new agenda, an agenda which provides a new way to understand our imaginations?

You hear the understanding that the state has shifted to be a regressive state in the art. You hear, for instance, about an attack of the police. What you *don't* hear is: why isn't the first responder a social worker? If somebody's in trouble in public, why do the police show up? Can we think of the state producing social workers to go and help people first? Why isn't the artistic imagination able to expand itself beyond simply the police? Even the artistic production is hampered by the lack of an agenda.

My interest is to expand the political imagination, and to have the artistic imagination also be expanded. That's why I think it's an urgent conversation. Otherwise, all we'll be discussing will be valorizing populist understandings of the state repression and saying that's where the people are at. Maybe that is where certain consciousness is at, but that consciousness is not grappling with a broader question. Just battling the police is insufficient. Do you understand the state you would like to build? And that's what an artist needs to understand as much as anybody.

MARK: My question, Vijay—which is something that is kind of underlying the conversation here—is what does that have to do with hip-hop? Why do we need hip-hop to work through this urgency? And what is about hip-hop—obviously it brings us here, literally, physically, here today—but what is it about hip-hop that validates us having this conversation? Why do we need it to have this conversation? Why doesn't the urgency exist outside having to recognize and engage hip-hop?

GREG: If you're talking about African American culture, sound and music is the glue. Hip-hop, as we understand it as an idiom, it already is hip-hop theatre. It already is visual art. It already is cinema. It is so in its definitive, ontological birth essence. It is a visual medium, it is a performance medium, it is the medium through which people who don't really exist within the institutions of power as self-authorizing forces. I'm not just talking about hip-hop; I'm talking about Black music in general. There's always been that kind of alternative space. That's the space where you're able to make it hot and define

yourself against all these other forms of representation in media and institutions that basically are about excluding you, basically until they get to the point where they cannot exclude you. It's not just music. If you say "hip-hop," you're already saying something that incorporates vast dimensions of our lives and being. It's become a vernacular, a whole continuum of vernaculars through which African American people in particular have been able to speak to the world most authoritatively. Hip-hop is the translation of Malcolm X and the name Harriet Tubman and the name Chesimard, Assata Shakur. Music becomes a platform, or the popular music industry becomes a platform, through which all this other information about identity, politics, and aesthetics can be sprung.

When you were asking about the term *hip-hop activist,* what does it mean? I see that as being very generationally specific. It is really specific to your generation. There may not be a generation after yours that even wants to identify itself in that way, but it has something to do with a recognition of how powerful a culture that sprung out of this thing we call hip-hop is in its ability to address the world and its ability to become an issue on the floor of Congress and the Supreme Court. That's why there's a way it forces the world to deal with its existence: because of the social base that it represents and stands on. In some ways it's the buffer between power and the masses that it represents. But then there's also the kind of terror of those same people kind of breaking through to real power, agency, and autonomy in our lives.

Q: I have a question for Vijay. What you brought up is the most profound issue: white supremacy. And I think that what hip-hop hasn't done, especially in the last five to ten years, is have a deep conversation about race, imperialism, and white supremacy in America and how that white-supremacy imperialism is being exported abroad. So whether we have the hottest cats in Brazil and Cuba and Panama or these other places where hip-hop is speaking truth to power, it's still America's imperialism that maybe in twenty years, Brazilian hip-hop is gonna be bling-blinging. The reason 50 Cent is mass consumed is because the media allows him to be mass consumed, unlike a Dead Prez or a Danny Hoch or a Toni Blackman, who will never be a part of the mainstream media the way the media's going now. So if you could talk about the issue of media conglomeration that's happening and this issue of white supremacy.

GREG: Hold that thought, and let's run through these questions.

Q: Hip-hop was actually born out of a Third Worldist vision, which was again rooted in the work of Assata and Malcolm but also Che and Mao. I wanted to cite that to get to the next question, which is what is really the future of this cultural manifestation, or does it have a future as a political tool, given that I would ask the question again if hip-hop is the new imperialism? I think we have this very romantic idyllic portrait. I work with hip-hop globally. I work with artists around the world who are hip-hop artists—but one of the reasons I do that work, and a lot of us in this room do that work, is because we understand while it's manifested and developed very organically in a lot of parts of the so-called Third World, it also becomes the target for predatory media and predatory industries that want to blow up—MTV Africa, MTV Asia, MTV Latin America—and so we have to create alternative mediums and forums for artists to express themselves when they don't fit within the paradigms that MTV and the broader media conglomerates are defining for hip-hop. Vijay said that a good multiculturalism could be the multiplicity of cultures that engages power, and I think hip-hop in its present manifestation is more like a multiplicity of cultures that bows to the powers-that-be. According to the media, we're this fast-food eating, reality-TV watching, bling-loving rainbow tribe— which actually serves to really distract us from the fact we have a host of social political issues and challenges related to economics, related to imperialism, globalization, prison industrial complex, military industrial complex, etc., and we don't touch those issues because we're so busy being a happy rainbow tribe in hip-hop. So my question is how do we address those issues, the very issues that brought us together as a hip-hop generation, the very issues that inspired a culture of rebellion and resistance and at the same time embraced the reality that hip-hop is somewhat out of our hands?

Q: Vijay, I'm wondering if you'd agree that what we see with hip-hop that we haven't seen with other Afro-diasporic or Black cultural genres is a specific and strategic class analysis? The other question is this: Definitely in the popular culture imaginary, we consider hip-hop a trope for Blackness. However, what I've been finding increasingly is African American–identified communities feeling that hip-hop might increasingly be a trope for whiteness. I wonder whether you consider the possibility of hip-hop as a shifting trope in regard to race and identification and how much have we, as academics, journalists, and cultural critics, contributed to that?

B+: I'll try to speak on the issues I can that I'm qualified to speak on. In the early '90s, in Cal-Arts when I was there, there was this idea of post-social-reformist photography. The idea was that photography had this social-reformist role: by shining light somehow into areas where light wasn't being shined, that this would encourage a culture of social reform. Mike Davis, who was teaching there at the time, was making an argument which seemed really far out: that we'd entered into a realm, which is precisely what Vijay is talking about, of post-social-reformist photography. In other words, the whole project of making a photograph of a situation that could be *fixed* had collapsed. At that moment—we're talking about circa '92—the argument was running weirdly in the face of where hip-hop was at. But it's funny now to sit here where we may be facing that prospect. I think I do agree more where the state isn't the place for change, where real change might be initiated.

The second thing is that one of the problems we're encountering here is that our ways of understanding history in terms of whether it's hip-hop or anything else, the tendency is to kind of center the kind of classic western European tradition of the subject. As if it is this singularity. And I think we need to complicate that idea of history. That idea of history is very problematic. But what hip-hop maybe does describe, and this is back to the idea of the trope, is this sort of syncretic, collective way of looking at the social reality we live in.

The final thing is, one of the most frightening things for me—I spent some time in Ethiopia recently, and have spent a lot of time in Brazil—is to see kids in countries that don't have enough access or education to be able to speak English, listening to all the jiggy-bling shit that we have to deal with here on the daily. The only way in my environment that I have to hear it is if I'm unfortunate enough to have to listen to the radio, and then we hear it with all the cuss words bleeped out—whereas there, they don't. In Brazil, hip-hop, by virtue of the fact that it is this sort of elite product, does define a place of access. If I got the new 50 Cent album, and it's legit and it ain't a boot and I got it before anybody else, it gives me a kind of consumerist status. Whereas the circa '92 model of hip-hop, obviously you didn't need to own something to be part of it.

VIJAY: There were so many questions, I assembled three categories: media, class, and state. The media piece is important. In 1990–91, when the United States first started to bomb Iraq, I went to the first demonstration the first night, where essentially we were beaten by the police and we got no media

coverage. We went the second night; we were beaten by the police again. There was no media coverage. So the third night we marched down 63rd Street and turned right on College Row, and, instead of getting media coverage, we had enormous numbers of people come out of their houses and collectively joined the march. In other words, the media is entirely co-opted. So what I am trying to say is that you have to create your own media, that there is no way we're going to go into corporate media without being incorporated formally, where the content is toothless, where you follow Britney Spears. There is no need to feel empowered by their media. We need to make our own media. That's the first thing.

The second thing, on class: The one way I don't believe that hip-hop culture in general has really embraced the class analysis is that the American working class lives in China and increasingly lives in Bangladesh, and that hasn't really been taken to heart. Once that is taken to heart, we may understand the industrialization, the degradation, of work. It has been demeaned and has been exported. So deindustrialization is being represented, but without this context. So that's class.

And the state question. I don't personally think the state, because it's repressive and nonresponsive, should be ignored. The state is an important vehicle that we have to challenge. The state essentially now is parasitical to corporations. In much of the Third World, the elites were parasitical to the states. Now our state is a parasite on corporations. We have to destroy that. But to destroy that, we have to first recognize it for what it is. The state is also our state. We pay taxes to it, we live under its rules, we are governed by it, we are disciplined by it, so it's us as much as it is something else. So we have to fight for it. I don't believe we are like in Argentina where you can say get rid of them all and say we are creating an autonomous reality outside the state. We're not at that stage of social consciousness. We cannot create our own autonomous zone and say to the state, "Go away." You have to challenge the state, even though there's so much stacked against us.

MARK: The end of the civil rights movement brought about a moment where it was very clear that the state co-opted the kids of the civil rights generation in different kinds of certain ways. Mass media was one of the most prominent ways in which that occurred. There is a sitcom-ization of our view of the world in that we start watching at 8 o'clock, and everything will be resolved by 8:27. I think the problem with that, and we're all co-opted in that context, is that we bring that kind of concept to our view, to our political struggle. One

of the things I've been left with with the November election was talking my students off the ledge the next morning. Because this is the first election they got involved with, and their candidate lost. And for many of them, it was the end of the world.

When we hear the questions, various things have been bandied about today about what are we going to do to counter what's happening with mass media; we're in fact doing those things already. The significance of blog culture in terms of countering what's happening in mainstream media is just one example of that. We're doing those things already. We're losing, right? Because we're reacting to a conservative Right that has been fine-tuning this for thirty years. So we need to be more proficient and understanding that we're in for a long-term struggle that's not going to be resolved by the next election.

GREG: One of the things that's come up again and again is how you reconcile your love of hip-hop with your participation in activism, with your own need to somehow survive and advance your position, the position of your art and aesthetics, and all I could think about is just my own life at this moment in time and this notion of multiple practices. By that I mean I consider myself a pimp and a whore of the hip-hop industry. I'm a music journalist—it comes with the territory. But I also live in Harlem, and the central issue in terms of politics and political organizing right now is what could be called land rights in Harlem. There are realtors who are openly telling people that in five to seven years Harlem won't even be Black. I'm from Washington, D.C., once known as Chocolate City. I go down there and ask myself, "Where are the Black people?"

My father still works in D.C.; he's a retired businessman, but he's definitely one of those stay-busy kind of seniors, so when he retired he was going to spend five years developing a charter school, and the agenda for the charter school was to take high school students from the worst schools and what's considered the worst neighborhoods in the city and prepare them to able to pass SATs and also to become leaders in their own community. That was his agenda; my dad's an old-school race man. But the funny thing that happened this year was I wrote this piece for the *Village Voice* ("Hip-Hop at 30," January 4, 2005), which everyone called "Hip-Hop Is Dead." My father read that piece, and hip-hop became alive for him. It was like he finally got it. He called me up, and he said, "Look, we gotta change the whole pedagogy of the entire school. It's got to become a hip-hop pedagogy—like overnight." It was just ironic given the way everybody I knew who was part of hip-hop was like I'm trying to plant the tombstone. For him, it made him see the students he was

working with—they don't read, but they know lyrics back and forth of about twenty albums off the top of their head. They have the ingenuity and creativity and relationship to themselves and their own understanding of culture and life that we need to replicate in the educational process.

So I say all that again to say that the dialectical reconciliation of all the oppositions we feel inside of ourselves because of where our politics are in relationship to this industry and this culture—you're not gonna reconcile them necessarily in one particular activity or practice. It's going to be how you function on multiple sites. That's my finale.

PART TWO

FLIPPING THE SCRIPT:
BEYOND THE FOUR ELEMENTS

Flipping the Script

Beyond the Four Elements

From the start, hip-hop spilled out of its own categories. If graffiti was hip-hop's visual art form, what happened when the aesthetic hit the mimeographed party flyer? Wasn't it then graphic design as well? When it spilled onto gallery walls, whether contained by a framed canvas or not, had it then become painting or installation art? What if it was captured by a lens? Had graffiti now spawned hip-hop photography and film? This is the way that hip-hop arts naturally infected and spawned genres and expanded outward.

Rennie Harris, the dancer and choreographer, illustrates this progression in his own life story. Moving through his teens from the Philadelphia stepping scene into the hip-hop scene, Harris was "commissioned to create a work" in his late twenties, a dance presenter's term of art that he didn't understand at first. The result, the autobiographical "Endangered Species," transformed his trademark popping routines into a harrowing piece for the modern dance stage. In this interview, Harris talks in-depth about a career that has revolutionized hip-hop dance, modern dance, and hip-hop theatre.

In recent years, hip-hop theatre has become a key site to interrogate hip-hop aesthetics. *American Theatre* magazine devoted three issues in 2004 to a package of articles defining the genre and its importance for serious students of the stage. Playwright and actress Eisa Davis's essay "Found in Translation" was one of the features (Roberta Uno's and Danny Hoch's pieces in Part 5 were also part of the package), and it is a wonderful, personalized encapsulation of the hip-hop generation's contribution to theatre. She notes that a key development was the institution of the Hip-Hop Theater Festival, a touring multicity production company that hosted the roundtable discussion included here featuring Kamilah Forbes, Traci Bartlow, Javier Reyes, and Marc Bamuthi Joseph.

Another of the *American Theatre* essays, written by gay Latino playwright Jorge Ignacio Cortiñas, argued that hip-hop theatre was a poor substitute for multiculturalist theatre. "The very term 'hip-hop theatre' seems to white producers to have an almost totemic power to draw in young and nonwhite audiences," he wrote. "But hip-hop theatre's strength is also its limitation because the genre always brings us back to a reactive, North American–centric, Black-white bifurcation that is ill-suited to deal with the complexity of our transnational, multilingual 21st century." The rise of hip-hop theatre threatened to, he wrote, "subsume complexity under [its] banner," to become "the latest orthodoxy that artists of color are expected to conform to." Cortiñas's essay set the context for this highly charged panel discussion.

If hip-hop theatre advocates bristled at Cortiñas's reading of their culture, novelist Adam Mansbach's essay "On Lit Hop" defends hip-hop literature from a literary critical establishment apparently unequipped to even begin interpretation. Mansbach seems to do a closer reading of the critics than they do of him and other hip-hop novelists. At issue, he argues, are the unexamined racial and class privileges that not only do reviewers bring to bear on the works but also uphold the entire illusory quest for the Great American Novel. Hip-hop aesthetics reveals the lie of today's literary aesthetics.

Photography, with its legacy of social realism, was the perfect mirror to hip-hop culture. From Henry Chalfant's and Martha Cooper's photographs of graffitied trains to Jonathan Mannion and Chi Modu's icon-making shots of rappers like Jay-Z and Tupac, the images defined the culture's virtues of daring, authenticity, and cool. Legendary hip-hop publicist turned gallery curator Bill Adler's documentary paean to hip-hop photography, "Who Shot Ya," introduces readers to a canon of camera-bug characters who, he modestly avers, never ushered in formal breakthroughs in their genre but certainly took a whole bunch of really great photos. Here the history of hip-hop appears just as larger than life behind the camera as in front of it.

The hip-hop generation's contributions to graphic design have been sorely overlooked. Yet just as rap music's rise coincided with the rise of inexpensive sampling technology, hip-hop design exploded not just with the growth of the hip-hop industry and the development of the high-end luxury "urban" market but also with the emergence of digital software. In "Words and Images," Cey Adams, Brent Rollins, and Sacha Jenkins talk about the legacy of

The Cortiñas essay is available online at http://www.tcg.org/publications/at/MayJune04/beat.cfm.

graffiti and desktop publishing, how hip-hop designers created an indigenous visual vocabulary, and the creative tensions of working within the industry.

Hip-hop has transformed not only the commercial arts but the fine arts as well. In 2005, curator Lydia Yee convened an intriguing panel of acclaimed young artists for a roundtable discussion at the Bronx Museum of the Arts, including Nadine Robinson, Sanford Biggers, Luis Gispert, and Jackie Salloum. Their work ranges from mixed-media installations to conceptual pieces and easily traverses performance art, film, painting, and other genres. Yee makes the point that all of these artists began their careers in the mid-1990s, after multiculturalism and "identity politics" had been roundly rejected by the art world. This shift mirrors hip-hop culture's arrival at a time when civil rights reforms began to be overturned. In indirect ways, the artists discuss the legacies of the multiculturalism and Pop movements—interestingly, the early '80s dalliance between graffiti and the art world doesn't figure much in the conversation—even as they push forward a diverse body of works that articulate a new hip-hop aesthetic.

In a career ranging across music, video, film, performance art, teaching, and writing, Paul D. Miller, also known as "DJ Spooky," has always relished the ways that technological advances create new modes of manipulation and interpretation. His good friend Matt Black, a DJ/VJ/producer with the British hip-hop act Coldcut, describes samples as "moments of human perception frozen in time." So hip-hop's remix aesthetic continually affords new forms of perception, and this theme is constant in Miller's work. In his essay, "The City in Public versus Private: Through a Scanner Darkly," he remixes German experimental filmmaker and Futurist Walter Ruttmann's 1927 work "Opus: Berlin—Symphony of a Great City" with not only "Style Wars" and "Wild Style," Saul Williams and Notorious B.I.G., but Walt Whitman, Sun Ra, and the rise of the surveillance state. He concludes, provocatively, "Could this be hip-hop?"

7

The Pure Movement
and the Crooked Line

An Interview with Rennie Harris

Jeff Chang

Called "the Basquiat of the U.S. contemporary dance scene," Lorenzo "Rennie" Harris has literally embodied the history of hip-hop dance. Born and raised in North Philadelphia, Rennie began performing as a preteen with church groups and with crews involved with stepping (also called Iking or GQ)—the neighborhood's unique social dance, and, for the record, a style quite unlike Chicago stepping or collegiate Black Greek stepping. When stepping went out of style in the late '70s, young Rennie became absorbed in popping, a California style that had been developing for decades and would soon join with New York–style b-boying to become the foundation of traditional hip-hop dance. During the late '80s, he became a celebrity in Philadelphia as the popular host of a succession of local TV dance shows that catered to the hip-hop, house, and dance undergrounds. But by the early '90s, hip-hop had moved away from dance crazes. Broke and at his wit's end, he was offered the chance to choreograph a group for a contemporary dance performance. That 1992 gig became the turning point that led to his unique reimagining of hip-hop dance as a wholly expressive form, and the creation of his Puremovement dance company.

This interview was originally commissioned as part of the Democratic Vistas Profiles (http//:artspolicy.colum.edu/DVprofiles.html). Thanks to Mike Wakeford and the Center for Arts Policy at Columbia College, and to Anna Alves for the transcription.

Since then, Rennie's pieces such as "Endangered Species" and his full-length productions such as "Rome and Jewels" and "Facing Mekka" have toured the globe to massive acclaim. He has been compared to Alvin Ailey and Bob Fosse, won countless awards, and was named one of the most influential Philadelphians of the twentieth century. Just as important, Rennie began convening an annual conference and festival in Philadelphia called "The Legends of Hip-Hop" in order to shine a light on the pioneers of local dance forms like b-boying, Boogalooing, strutting, roboting, and locking that became the foundation of hip-hop dance. "The Legends" event featured both public performances of many of the dance masters and private sessions in which the same masters could discuss the historical development, preservation, and growth of their craft. Rennie's unique mission has been to both maintain the traditions of Black social dance cultures and extend them into the realm of fine arts.

In this interview, he talks about social dance in Philadelphia, taking hip-hop dance from its familiar haunts to high-end venues, crafting a piece, and expanding hip-hop dance's breadth of expression.

JEFF: You were born in 1964. You say you're part of the last generation to come along before hip-hop.

RENNIE: I was around when there was no name for it. I don't even remember people referring to it as "rap'" or "rhyming.'" When "Rapper's Delight" came out, we were in shock. I remember that day, I remember where we was at—on Eighteenth and Thompson—and we were standing on the corner. My man had his radio on his steps. We were sitting there going, "How the hell they let rap get on the radio?" We couldn't believe it. It was just like this sense of accomplishment.

JEFF: So the dancing thing . . .

RENNIE: It just came out of living. You know, I went to a party. I was dancing. I guess I was just good at it. Like it started when I met other guys who danced. I was like preteen—eleven, ten. We did little steps in my backyard, but it wasn't anything serious. Some girls across the street, we would go to their backyard, make some stuff up, have a little contest, in their house or whatever. But when I was in middle school, it became clear that I can dance.

You just went to the dance, and everybody was lookin' at you. "Rens can dance! You go ahead and dance!"

JEFF: So when did the stepping thing come in?

RENNIE: The stepping thing was happening in the early '70s. I came in at the tail end of it. The dude I was stepping with was, his brother was one of the original steppers, used to step for a crew called GQ. I was getting some stuff from this cat, but this cat got it from his older brother. Everybody was like, "That's the old shit. Why you doin' that?" Yeah, but there was still a lotta young groups that was takin' it on with their brothers. But it was like that weird time from '76 to '79, '80 and to the end of the era, which was '81. By '81, I was popping with the Scanner Boys. We did a challenge on a television show called *Dancing On Air*. We challenged a group called the Philadelphia Floor Takers, an old stepping group. And we challenged them. And the public called in their votes. So we won.

JEFF: So you were actually part of the ending of stepping in Philadelphia and the beginning of hip-hop dance.

RENNIE: The young boys had come to me to ask me to captain their group, to be the leader of their new group, the Scanner Boys. They thought of me as an old hand, 'cause I had a stepping history. Everybody knew back then, if you dressed a certain way, if you dressed in a suit or a hat, or slacks and a tie—or anything that looks really dressed up, people knew you were a stepper. Especially if there was nothing going on on a Saturday, and you walked around in a goddamned suit. So these young cats knew that about me, and came to my door, "Alright, cool, let's go, what's up?" and that was the beginning of the Scanner Boys, really. Stepping was pretty old already, and the Disco Kings and Queens was an older group, the Mighty Boom-Shakers—they was an older group. They tried to make the transition to popping, but failed. 'Cause even in this battle we was doing with the Floor Takers, they bringing in ringers to try to pop. It was becoming so popular, they was trying to be on the same level in some way. But popping and stepping were so totally different. It was like, "Nice try. It's not gonna happen. You guys getting beat now."

Yeah, stepping is—you don't do upper body. Basically, you're miming the tapper. You're doin' the tap-dancin'. The closest thing to stepping that I can

explain what that would look like is the shit that Nicholas Brothers did for singing groups like the Temptations. But we were also doin' hard, flatfooted movements. And when we turn, we would turn like the Temptations. And there's some similarity in the fraternity stepping, the fact that sometimes we do hand rhythms. It's all accents of dance. And you might see him do a cane. But it's not like that kind of stepping exactly. It's rare to have gotten any of it on tape.

JEFF: In this battle, were both sides mixing up the styles, or were you straight popping?

RENNIE: No, we was straight popping. When I stopped stepping, it was like '81, '82. And I don't remember making a conscious decision, but that's the way that it happened. I transferred high schools, so I wasn't around my stepping buddies no more, you know what I mean? And in the summer, I wasn't hanging as much as I did with the stepping buddies as I did with the Scanner Boys, 'cause that was in my neighborhood. And my stepping buddies lived a little out of reach up in the projects, on the other side of Broad Street. So things just kinda changed organically.

JEFF: The music at the time is getting to be more electro. It's moving out of the disco and funk phase.

RENNIE: Yeah, and that also determines the shifts of style of popping here. We never popped to funk. Funk for us was just something we danced to. You stepped to funk too. I remember this roller tried to step to "Planet Rock," and we were like: it was not hip.

JEFF: So what were the big stepping songs?

RENNIE: Blackbyrds' "Rock Creek Park." "Love the Life You Live," Kool and the Gang! That was like our theme song. When the break come, steppers lose their mind. Then the drummer come—man, that shit was the shit. When you were a stepper, people was just jumping on top of each other, pulling the canes out, the suits out!

JEFF: After coming up in hip-hop dance, you went on to become a local celebrity, doing your own TV dance shows, and then that faded. How did you start doing dance performances for theatres?

RENNIE: In 1992, I was commissioned to create a work. I didn't know what the word *commission* meant. I didn't know what people meant when they said, "create a work." So I asked, "You want me to create a routine?' Because that was my vocabulary at that time. And I remember 'cause it took about ten minutes for them to explain what they meant by "work." I was like, "I don't understand—what do you mean? You wanna pay me to create something?" And he said, "Why don't you do forty-five minutes?" And I remember my heart dropped. I had never danced past ten minutes. Even when I performed in front of all those people, you do three minutes long.

JEFF: Tell me about one of your first pieces, "Endangered Species." It was an autobiographical solo piece about teenage violence.

RENNIE: Really, honestly, this is the piece that in everything that I do, I use as my template. Because it's the one piece that marries hip-hop and theatre in a very simple way. I call it the "ED Factor"—the "Endangered Species" Factor: when people watch this, are they thinking about the choreography, or are they engulfed in the story? How can you get people not to think about the movement? 'Cause if you got them thinking about the movement, then they're not paying attention to the whole piece.

JEFF: You want to have people experience the story and the choreography together.

RENNIE: And hip-hop. It's just about the dynamic. And in contemporary dance, to me it seems that the hope, the goal, is to have people be pulled in by the movement. For me, my goal is not to pull people in by the movement. The goal is to pull people in aesthetically with the spirit of the work, the sincerity of what it is, and everything else has to complement it. I mean, it has to be just enough cream, and just enough milk, and you're still able to taste the coffee, the bitterness at the same time. That's the key.

It's only after the work is up that I can look at it and then decide whether I have an ED Factor or not. Because while I'm doing it, I can't judge myself too much, because I'll stop myself. Unfortunately, the first people who see the first work are the guinea pigs. Especially with hip-hop. Because everyone is expecting it. They're expecting it, you know?

JEFF: You mean they're expecting it to be abrasive, confrontational? But do you think that that's watering down the original vibe of hip-hop, to have to adapt it to a contemporary dance piece?

RENNIE: It is adaptive, but I don't think that my work is *not* being confrontational.

JEFF: You think that your work *is* being confrontational.

RENNIE: Yeah, because you can still taste a bit of coffee. There's a way to be able to be confrontational, and also make sense. You know what I mean? I mean, sometimes people are just yelling, and they're not making no goddamn sense. I don't want to just yell without making no goddamned sense. And that's what I'm saying. I want to be in the angst of the argument and in the angst of whatever you are in, but who started the argument? Or what happened? I want it to be emotional, I want there to be angst, but I want there to be serenity, and I want there to be, you know, reflectiveness, and I want there to be questioning. In all of us. My goal is: "How do I make the marriage?"

On a hip-hop level, those things are not talked about and/or focused, but it's understood. In hip-hop, the idea of relativity exists, always. I can be too far up in my brain and the next minute tell them to shoot you, like, "Nigga, what?" Because it's the idea-of-relativity thing that positive begets negative and negative begets positive. Those things in hip-hop are unspoken and understood. And what happens is we get caught trying to explain it, and most of the time, we can't explain it. It's like learning a language that doesn't have a goddamned meaning—I mean, "How do you explain 'so-and-so' in this language?" And so, in hip-hop, I think we all understand that, and so when we're challenged, we're feeling inadequate in how we're gonna convey that. For me, I don't want to be in a place of feeling inadequate; I want to be very clear about what's unspoken.

JEFF: That's a really interesting thing. You're exploring how to present hip-hop in what one could consider a non-hip-hop space. It seems like what that did was force you to think about the assumptions that you had.

RENNIE: You know what the interesting thing is? For me, everything that I do, to me it's hip-hop. And going into this space, it's not me going into someone's space, it's me going in, making hip-hop. Because hip-hop does that. We jump up on walls, we spin around over here, and in this case, it was a stage, so let me use it. That's what we've always done. And in thinking about it when I create the work, I can't think about it.

JEFF: You can't think about the venue or the audience.

RENNIE: I can't think about anything that I'm doing or my goal or the marriage or bullshit or anything like that. Because like I said, that stops the whole process of inspiration for me. You know what I mean? I just gotta go in and do what inspires—let me do it. Alright—boom! And then I look back, and now I'm thinking, "What did I mean by this?" and "Where's the relativity?" and then I'm challenging myself, "Is this hip-hop?" When I'm creating it, I'm just coming from the idea of a pure movement—the philosophy of that, because I am hip-hop.

When I drink this coffee, it becomes hip-hop. So if I take some movement that's maybe looked at as maybe "contemporary movement," to me it's hip-hop because I changed it. Now the issue is your vessel; it shifts the shape again. So the dancer, depending on the dancer's makeup—whether they were trained or not—they're gonna understand it for what it is. So if I put in something that I think is contemporary for me, and I give it to a dancer who is contemporary, it's gonna be contemporary.

'Cause when I do this [shows a hand wave], that's a popping movement for me, and when I slowed it down and we do this [shows slowed version], then it became, "Oh, it's like that African dance you've been doing." So I like to start the movement here. The foundation is "hip-hop"—associations with hip-hop—but when I begin to change the aesthetic of it, the quality, how the movement is presented, via the music or whatever, then it takes a new form. And then it takes *another* form depending on what dancer I'm using.

I like using only the hip-hop dancers. That's the best. Modern-dance contemporary dancers are good; they give you great lines that I envision in my

head, and I do like that. But if they were hip-hop dancers doing the same thing, it would be rough, 'cause they couldn't do it. They'd be humped back—and that's what I really like—it's like that original aesthetic of jazz. That crooked line. That fucking offbeat, that twist, that's what's the hepcats did, that lean. That walk. That's all African American.

To me, when you're talking about African American history in this country, we're talking about that crooked line. You wanna see who Black people is? That diagonal right there. We're not gonna get anything straight. Not to say that being straight is being negative. I'm saying, there's no fun in that. There's no lesson in that. Everything that we do is like walking that line of, "Damn! Do we go straight, or do I just make this left over here and figure out where I'm at and get back on path?" In Western construct, they want to glorify the structure, the line, as the guideline, and we like to look at our line as a guide-line, not a god-line.

One time, I had my dancers take their shoes off to do a piece. And we were doing Last Poets' "Die Nigga." I just had the guys come on the stage and just fall every time they heard the word *nigga*. "Niggas love dying." Boom. And I would try to get them to really fall for real. And that's all they did in the piece. So anyway, this was one of those pieces I said you could take your shoes off, and they were like, "Rennie, my feet hurt!" And that's when I realized, "Okay, you have hip-hop feet. Get the sneakers back on." So we realized our tender hip-hop feet could not touch the floor no more. And that actually was really simple, but it made me think, "You know what? Keep this shit hip-hop. Don't go off the path of what you know."

JEFF: Have you taken formal dance classes?

RENNIE: I took one dance class in my entire life as training. I just recently went back to take a hip-hop dance class, the old-school stuff, some of the pioneers who were teaching Boogaloo. I wanted to refresh my memory of certain dances that I remember in my body but I don't know the names of them. But other than that, the only class I took was a ballet class when I was thirteen 'cause some priest thought I could dance, and I never went back.

JEFF: You took it once and never went back.

RENNIE: Yeah. You had to wear them tights. I was done! As I got older, I took some African dance here, there. But naw, that's it. I can count the actual

dances that I've taken on my hands. I'm not interested in taking class from other stuff, just to see, you know.

JEFF: Is this a process about you assimilating dances for the movements?

RENNIE: Well, not so much for the movement. [Long pause] I'm not interested in other people's movement. What I'm interested in is the connection. I mean, I'm not interested in "Oh, I like that movement, let me take that, extract it." I'm interested in the movement I already do but approaching it in a different way. And me recognizing that in something else and going, "That's so-and-so."

And then that's when the light goes off in movement, 'cause now I got these two different aesthetics to play with. How do I fuse them? For instance, I might take African dance and some Japanese Butoh. There's a connection with Butoh and popping, internally and spiritually, that I see. I'm interested in those kinds of connections, and then challenging them, and then playing with the through-line. The through-line is what confuses everybody.

I have an African cat who saw me dance and told me, "Oh, that's Manjani." I was watching Ethiopian traditional dance the other day and saw some social dances of hip-hop. I mean, like, "That's The Whop!" So I'm interested in the connections that we all have—and the thing is, the public doesn't realize that there's major connection in movement. And that's what I'm interested in.

JEFF: Talk a little bit more about the connection between Butoh and popping. How did you come upon that?

RENNIE: I define popping as a dance style that creates illusion. Its objective is to create the illusion that makes you think that you're doing something that you're not. And in order to create that illusion, there's a way you have to think, you know what I mean? Movement is just the last manifestation of sound. So if that's the case, then you know, a lot of times jazz musicians, they make noises when they playing their thing, they make noises when they're dancing, because it helps manifest the actual reality of what it is. And so the popping, you have this connection of this internal energy with Butoh, where you believe you just go inside of yourself and you change and you morph into this water, you morph into this monster, you morph into this pain or anguish, you morph into this clown or whatever. The mind has to believe it, and the body is gonna believe it. It's the process of internal thinking that to me is that connection to

Butoh, you now what I mean? Especially on the pain or anguish part. 'Cause I dance aggressively when I pop, you know? My a.k.a. is Prince Scarecrow. And so it lends its hand to that pain and anguish, you know what I mean?

JEFF: But until I saw you do "Endangered Species," I had never actually connected that sound or that emotion to popping action. That was the breakthrough for me—your taking this idea of the mental chaos you're experiencing and also the feeling of being trapped and putting it into popping. Or the idea that you're trying to run but you can only move in slow motion, a little bit at a time.

RENNIE: "Endangered Species" was that breakthrough for me. When at that moment when I was being chased, it was like being in a dream and I couldn't move, I couldn't run fast enough, and my body was in slow motion. And I heard my breath, so I heard my heartbeat, and I was like, "Oh shit! What's goin' on?" My life is flashing in front of me, that kind of thing. And so that was the breakthrough, movement-wise.

You get down to the crux of it, and get down to the bottom of what that anguish is in your body. Or when I want to move softly, and it's kind of like floating in space. I want to apply the same concept from modern dance, postmodern dance, contact improv, whatever, that's always existed in hip-hop movement. The thing is, we have all seen it, we've taken it for granted, and all that's just relative to us. 'Cause our structure is just built on improvisation.

But here, now, what I feel like is: let's take what's unspoken, and let's make it spoken. Let's say your woman just left you. How do you express that in your popping? The way I look at it, when you break them all down, popping is a way to be expressive in another way. B-boying/b-girling is a way that you can be expressive. There's a flowy quality like in that modern dance, a ballet kind of quality when you do it that's just pretty when you break it down and deconstruct it. House is like early jazz dance. Right?

JEFF: A lot of lightness in footwork.

RENNIE: Right, right. And so they all break up, and they fall right in parallel with what people call "trained dance," but it totally exists in our world too. I'm interested in bringing that out, in showing people you can do this too. And it's not about *affirmation*. I'm saying, "We could do this, and it's expression for *us*." I'm telling our practitioners, "Don't buy into the idea of 'Oh, it's just the way I feel, and when I'm upset, I do this and that.'"

I'm beginning to touch some people. I'm beginning to see the effects of it. One guy told me, he said, "Hey, Mr. Harris, I saw you when you came to D.C., and I thought you guys were amazing, and I just wanted to thank you 'cause you changed my life. You know, after seeing you and I heard you talk, I went back to school, and now I'm graduating from college." And I had another woman who was teaching in Philadelphia, she just walked up to me and said, "Can I hug you?" And I'm like, "Sure! Hey, how ya doin'?" And she said, "I just want to thank you, and I just wanted you to know I got my kids back." And I said, "What're you talking about? What do you mean?" And she said, "Well, I saw you perform. I was on crack, and they took my kids away from me." And she was like, "After seein' y'all, and y'alls were doin' your thing, and I knew you from so-and-so, from when you was on TV, and you were still doing your thing and you come to this level, it just inspired me to go get my kids." And I was like, [whispers], "Damn." You know? So that, and another person come up and tell me, "I was about to commit suicide last night. I saw you guys perform." This older guy, and he went through this whole thing, and we wound up praying. That made me think, "This is a lot different from just me surviving." Even though I fight it. I mean, I don't want to do this shit. There's got to be an easier way. But this is what I'm supposed to do.

8

Found in Translation

The Emergence of Hip-Hop Theatre

Eisa Davis

I said it before, and I'm-a say it again: I belong to the church of hip-hop. Cain't help it. If your after-school program is dancing to a boombox made out of two speakers, a suitcase, and a skateboard spray-painted gold, if you remember when *The Source* magazine was just a double-sided Xerox copy, if you've got Queen Latifah's autograph from back when she used to be a dope MC, you are a hip-hop head, without a doubt. And that I am.

I also belong to the cult of theatre. My other after-school program was playing Bilbo Baggins in *The Hobbit,* Teeta in Alice Childress's *Wedding Band,* crying through the monologues from Ntozake Shange's *for colored girls who committed suicide / when the rainbow is enuf* over and over to the bunks on my bunk bed. When I saw Anna Deavere Smith's *Fires in the Mirror* at the Public Theater in New York City and then Tony Kushner's *Angels in America* at the Mark Taper Forum just a few months later in Los Angeles, I knew that theatre was a place I could make my home.

One MFA and several jobs later, I heard about something called hip-hop theatre and lost my natural-born mind. I was already doing this—writing plays with hip-hop in them—but had no idea that this sort of work was being created by artists all over the country, all over the world. In New York, London, San Fran, and L.A., a new movement was being born, a syncretic

A previous version of this essay appeared in *American Theatre* magazine, published by Theatre Communications Group.

art form that, in combining two genres, was actually revitalizing the aesthetics of each.

Having a name for what we did suddenly meant we had a community. We were not alone; we had crew, comrades, an umbrella 501(c)(3). Having a name meant we were consciously developing artistic voices unique to what had come before us. The name *hip-hop theatre* still brings people together, recognizing that the separation of hip-hop from theatre to begin with was an unnecessary, artificial split. Hip-hop theatre is a family reunion, says Javier Reyes, artistic director of Colored Ink of Oakland, California. It's a clarion call to artists who want to resurrect American hip-hop by siphoning the formaldehyde out of its commodified veins, and to infuse theatre with our bright, fresh blood. It's the child of hip-hop *and* theatre. Perhaps there is another name that it has yet to find. For now, it carries the name of its parents—and is more than the sum of its parts.

What is hip-hop theatre? When did it start? Lot of heat around this, not enough light. Some take it all the way back to Amiri Baraka's *Dutchman*, the Last Poets, and Ntozake Shange—works from the '60s and '70s that exemplify what Paul Carter Harrison calls the African continuum. Then came the Santa Claus skit by The Treacherous Three in the movie *Beat Street* and the interludes on De La Soul's debut album, *Three Feet High and Rising*. All of the b-boying and breakdance from *Flashdance* and *Breakin'* to GhettOriginal and *Noise/Funk*. The graffiti writing in *Wild Style*. Might have been recorded on film or on tape but was theatre just the same.

Four years ago, I wrote an article in the grown-up, glossy version of *The Source* magazine about "hip-hop theatre." I didn't coin the term: it had actually appeared some months before in an *American Theatre* article by Holly Bass, who would go on to curate for the Hip-Hop Theater Festival. But she didn't coin the term either. I think that just like calculus being invented simultaneously by Leibniz and Newton, hip-hop theatre simply *arrived* because of evolutionary necessity. Because my article was in the March 2000 issue of *The Source*, a hip-hop magazine, the term *hip-hop theatre* was able to galvanize a community of artists already developing the form, some of whom had never met before. Danny Hoch and Kamilah Forbes and Clyde Valentin founded the New York Hip-Hop Theater Festival that year.

In *The Source* article, *Noise/Funk* cocreator Reg E. Gaines said that "hip-hop theatre becomes valid if Puffy or Russell or Master P reads this, invests and puts hip-hop theatre on Broadway. . . . [U]ntil they invest, nothing matters." Since then, Russell Simmons has won a Tony for producing *Def Poetry Jam*, and MC-actor Mos Def has starred in Suzan-Lori Parks's Pulitzer-winning

Topdog/Underdog. And regardless of your opinion of Sean "Diddy" Combs in *Raisin in the Sun*, by simply being on stage, he created an excitement around live theatre that many young people had never felt before.

Some pioneers of the recent wave working explicitly in traditional theatre venues include Hip-Hop Theatre Junction, Sarah Jones, Jonzi D, and Full Circle. Will Power, Universes, and Danny Hoch work at the New York Theatre Workshop and the Mark Taper Forum. We've had a "Future Aesthetics" retreat for artists spearheaded by Roberta Uno at the Ford Foundation, and plays by Ben Snyder, Indio Melendez, Gamal Chasten, myself, and others are being developed by theatres nationwide. Through such grassroots initiatives like the International Hip-Hop Exchange, the roots of hip-hop are being nurtured by MCs in Colombia, Brazil, Mexico, and Cuba.

There's no way to essentialize all these artists' work. Each re-creates the genre as s/he creates individual pieces. Some are more interested in innovative theatrical form, utilizing one or more of the four elements for storytelling and form, and others are more interested in innovative narrative, making use of the sensibility, language, and stories of the hip-hop generation for content.

You could break down the difference between these creative styles like this: whether it's Jay-Z rhyming (hip-hop form) or Latrell Sprewell playing basketball (hip-hop content), both are hip-hop through and through. What do I mean by that? *Scarface, Boiler Room, Ghost Dog*: these are all hip-hop films even though there is nary a graf artist, MC, DJ, or b-boy in sight. Instead, the protagonists are dealers, schemers, and samurai stylists—and through them, the narrative, and the soundtracks, comes a stance that reveals hip-hop vision. Just like your subway conductor can be as hip-hop as Spoonie Gee.

And just what is a hip-hop stance? Besides what Run and D showed you twenty years ago—cross your arms and put your hands in your pits, twist up your lip, and look hard—there is a post–Black power: know your past, bring the block with you wherever you go, I'm a get mine, go for yours, I'm original, I'm dope, I don't have time for you, some days I care about making the world better, some days I don't, don't make me mad, I've got a long memory, I feel silly and I'm gonna make jokes that make no sense, I'm still in love with my fifth-grade teacher and my junior high girlfriend, I buy Utz potato chips and do the *New York Times* crossword in pen listening to the Pharcyde. The hip-hop stance is not a lifestyle, it's a thinking style, and if you try to define it, those brain waves will run away from you and set up shop on another corner.

Just as Anna Deavere Smith and Tony Kushner did in the '90s, hip-hop theatre artists are pushing the envelope and *creating* culture instead of just riding it. With hip-hop theatre, we have what rapper KRS-ONE calls "edutainment."

There is ritual, call *and* response, and an amped, young audience of many colors that actually wants to be in their seats.

But hip-hop theatre is a name, and names hold water, weight, sway. Names can be outgrown. Names can be used to pigeonhole, denigrate, exclude. "You mean you're 'doing' poetry instead of writing it? Slam poems instead of page poems?" "How can you be a hip-hop theatre artist *and* write a traditional play set in 1955 in the California redwoods! That's not street; write something uglier." "If you don't use the four elements, you are not hip-hop." "You're Asian, you're white, you're Pacific Islander, so you are not hip-hop." "You're Black, so why are you so smart and articulate?" These attempts to limit expression don't just come from outside the community; they also come from inside. Even when comments don't intend to be exclusionary, there is no agreement on what hip-hop theatre *is*, whatsoever. It's like that, and that's the way it is. It's the internal dialogue that keeps the form vital and relevant and enhances the ability to be participants and observers simultaneously. Which is what artists must always be.

I like the name "hip-hop theatre" because when it's ascriptive, voluntary, and utilized by a self-described hip-hop generation that speaks through theatre, we are *found* in translation. Here it is, finally: a form that describes and comprises our "multiness." When U.K.-based artist Benji Reid dances his monologues, it's new, and it's the best kind of new—the kind that plays with conventions and serves up their permutations. And we've got all kinds of historical precedents. Art forms progress when they mimic other art forms, whether it's Langston Hughes writing the blues on the page or Aaron Copland building symphonies from folk tunes or Lee Strasberg bringing the therapist's couch into acting. The purists shriek, the open-minded are jazzed, and the culture follows.

There's an intergenerational dialogue that's going on with hip-hop theatre, too. Sometimes it's a screaming match, sometimes it's a passing of the torch, sometimes it's an active collaboration. But it's a dialogue that is entirely welcome, and it has to do with the conscious relationship that hip-hop has always had to the past. When you sample old records and quote lyrics, you're not just stealing; you're showing respect. A DJ is doing her job when she generates nostalgia for music itself. And tradition is strengthened—our parents may not know their parents' songs, but we know our parents' songs like they're ours. When we convened a presentation and discussion of hip-hop theatre at New Dramatists in February 2004, I was heartened to hear from Baraka Sele, curator of the New Jersey Performing Arts Center's World Festival, and Gwendolen Hardwick of New York University's Creative Arts Team

that we are doing exactly what they were doing in the Black Arts Movement of the '70s: trying to make theatre that is for us, by us, about us; being ignored by the mainstream; funneling the same raw energy into work that takes a stance in the endless struggle for socioeconomic, racial, gender, and sexual equality.

Hip-hop theatre is already happening to older, primarily white subscription audiences in mainstream theatres, even on Broadway. A recent example is Regina Taylor's *Drowning Crow*. An adaptation of Chekhov's *The Seagull*, the play dramatizes the conflict between mother and son as an aesthetic war between traditional and hip-hop theatre, between Arkadina's fading glory as a Negro Ensemble Company actress and Constantine's youthful search for "new forms." Of course, Chekhov wrote himself in as Constantine—with *The Seagull*, he was attempting to create a new form himself. In Marion McClinton's Manhattan Theatre Club production, Constantine, or C-Trip, as Taylor renames him, was played by Anthony Mackie. As an actor, his hip-hop cred is high after playing Tupac in Michael Wynn's *Up against the Wind* at the New York Theatre Workshop, and for penning his own rhymes as Papa Doc, Eminem's arch rival in the film *8 Mile*. So when Mackie as C-Trip presents his play within a play on the lake in the first act, guess what it is? Hip-hop theatre. He recites blank verse and rhyme to a beat, dancing expressively as he speaks. Before presenting the play, C-Trip even speaks to other characters with rhyme and rhythm, revealing that his artistic experimentation with new forms is taking place in every facet of his life. And because the play unfurls from his perspective, the entire production employs the projections and dance and sampling that hip-hop theatre is known for.

But back to C-Trip's play. What does Arkadina (played by Alfre Woodard) think of it? She thinks it stinks. Why couldn't he do an excerpt from August Wilson's *Seven Guitars*? she asks. Eventually, C-Trip kills himself because he can't get any love, can't get any understanding. And even if Regina Taylor had changed the ending to spare his life, Ben Brantley slayed the whole show in the *New York Times*, and no one could be caught dead appreciating the bold stylistic leap that Taylor had taken.

I appreciated it. Playwright and poet Cornelius Eady, author of *Running Man* and *Brutal Imagination*, always insists that the instructions for hearing the play must be written into the play. We must always be sure that every audience member has a way into our work. In *Drowning Crow*, the instructions were there. But in our world of de facto cultural segregation, some audience members may not know the language in which those instructions are written. So we keep trying to be found in translation.

When I was in grad school, the director-actor Stuart Vaughan once came and spoke in our Shakespeare class. He talked about two major epochs in drama: the theatre of the articulate and the theatre of the inarticulate. Vaughan used Shakespeare as a prime example of the articulate, where each character eventually says exactly what s/he feels. Sam Shepard was his example of the inarticulate, where much of the play's meaning takes place in the subtext, in what is not being said or is unable to be said. Articulate theatre recognizes a one-to-one correlation between thought and word, whereas inarticulate theatre does not trust words to say it all, recognizes that expression, let alone communication, is often impossible. Hip-hop joins the articulate with the inarticulate. The lyrics provide the articulation of intellect, the need to speak plainly or with complexity, with irony, local and personal specificity, satire, longing—and the beat brings the inarticulate release of pure music, of the drum, of our primal rhythm. And we can flip it. The lyrics can be inarticulate, the pure feeling evoked by a curse word, a nonsense rhyme—and the beat can be intellectual, not danceable, just something to contemplate, to analyze. When hip-hop moves from the corner and into a theatre, you get the one-two punch. Articulate inarticulateness. Restoring theatre to its full power.

In just twenty-five years, we've already got a classical hip-hop aesthetic. Just as ballet technique became codified over the years—first through fifth position for legs and arms, arabesque, tendu—so have hip-hop music, lyrics, dance, and visual art developed a stable vocabulary—battle rhymes, freestyle, uprock, poplock—that can be taught and used to tell anybody's story. Philly collective Olive Dance demonstrated this loud and clear in its recent piece *tOy/bOx*, which imagined a set of mechanized children's toys dressed in green and yellow coming to life through breakdancing moves. Harlem Renaissance writer James Weldon Johnson once said that history judges a race by the quality of its literature and art. If jazz and modernism are the formal legacies of his generation, hip-hop and postmodernism may well be the formal legacies of ours. Content may never change, stories always stay the same, but new forms alter consciousness, actually change the way we imagine ourselves.

What does theatre do to hip-hop? You change the venue, you change the expectations for listening. Bringing a live hip-hop show into a theatre with seats suddenly means you are in church and the word is sacred. You are not wandering and stepping on plastic cups with blue and red liquid sticking to your shoes; you actually have to pay attention to the lyrics. This means that the MC has to be on point! Has to carry a show moment to moment. That requires sick craft. And if you bring a theatre show into a hip-hop/concert

venue, you allow people to get out of their seats and move. Although you still need narrative shape (any evening-length work does), the burden of telling a story is removed, and theatre has the opportunity to engage the audience physically. So the ideal hip-hop theatre venue might look a lot like Shakespeare's Old Globe: a circular house with boxes and raised orchestra seats for the patrons, and a mosh pit for the groundlings right in front of the stage.

The theatre space may challenge the hip-hop artist to come correct, but it also means you can let your guard down. When the battles reach "Pac versus Biggie" or "Dr. Dre versus Dee Barnes" proportions, the lyrical performance of domination can get conflated with the need to flex actual domination. Once you're in a theatre, not all lyrics and visuals have to be adversarial to be heard. The dialogue can open beyond battles and be vulnerable, exhibit a feminine principle as opposed to a booty shake. And that's what hip-hop and theatre audiences want right now, something to break the monotony. Which is why we've been clinging to OutKast like an oxygen mask. And if they aren't hip-hop theatre, no one is.

But the transformation eclipses venue. The late critic James Snead once wrote about how Black experience was simply untranslatable to the Hollywood film formula. The linear, rational narrative couldn't articulate us and what we'd been through, still go through. And it is an uncommon Black film that is able to break the bonds of the slave/pre–civil rights drama or the asinine comedy. For colored folks, music has been the most direct form of expression because it isn't necessarily about the passing of time and all that prickly cause and effect. It can be about holding a single moment and its emotion up to the light, and in the rhythm, the trance of that, the plight and joy of a people can be felt. Fully. In all its contradictions. What hip-hop theatre is up to is bringing the bittersweet complexity of music out and into narratives that never expected us to visit.

And we don't stop. Who knows what impact hip-hop theatre will have twenty years from now? Thespis didn't know he'd be spawning Tennessee Williams when he first broke out of the Greek chorus with some dialogue, and Kool Herc had no idea that he'd be giving birth to Lauryn Hill. If, as Eleanor Roosevelt said, the future belongs to those who believe in the beauty of their dreams, then hip-hop theatre is a diversified, sound investment.

Eisa Davis began as an associate editor of *Rap Sheet;* has written for *Urb, The Source,* and *American Theatre;* and has been featured in the anthologies *To Be Real, Letters of Intent, Step into a World, Role Call,* and *Everything but the Bur-*

den. Her plays include *Bulrusher, Hip Hop Anansi, Paper Armor, The History of Light, Umkovu, Angela's Mixtape,* and *Six Minutes.* As an actor, Eisa has worked extensively in theatre, film, and television, and as a singer-songwriter she has performed at Joe's Pub, the Whitney Museum, and BAMCafé. She has received awards and fellowships from Cave Canem as well as the Mellon, Van Lier, and Helen Merrill Foundations. She is a member playwright of New Dramatists, a graduate of Harvard, and a native of Berkeley, California.

9

From the Dope Spot to Broadway

*A Roundtable on Hip-Hop Theatre,
Dance, and Performance*

Marc Bamuthi Joseph, Kamilah Forbes,
Traci Bartlow, and Javier Reyes

The emergence of hip-hop theatre could be dated to GhettOriginal Production Dance Company's staging of "So What Happens Now?" a piece presented in 1992 at New York's famous PS 122 that was written by and featured members of Magnificent Force, Rock Steady Crew, and Rhythm Techniques, including Richie "Crazy Legs" Colon, Ken "Swift" Gabbert, Steve "Mr. Wiggles" Clemente, and Jorge "POPMASTER FABEL" Pabon. A bittersweet musical about the early '80s rise and fall of b-boying and its most famous proponents, it fired the imagination of Hip-Hop Theater Festival founder Danny Hoch. Eight years later, Hoch, Clyde Valentin, Kamilah Forbes, and others launched the first festival, featuring the likes of future Broadway star Sarah Jones, acclaimed playwright Will Powers, and the Bronx's highly accomplished crew, Universes.

The success of the festival has led to the expansion and serious consideration of new forms of performance art, dance, and theatre. (And not only in the United States. Jonzi-D's Breakin' Convention festival in London has become a hub for European activity.) In May 2005, at a Hip-Hop Theater Festival event at Berkeley's La Peña Cultural Center, we gathered together four of the most important artists and presenters for a discussion about the past, future, and present of hip-hop in theatre and performance.

Thanks to Anna Alves for the edit and Dave Tompkins for the transcription.

THE PANELISTS

Marc Bamuthi Joseph is originally from Queens and now resides in the Bay Area. A National Poetry Slam champion and Broadway veteran, he was a featured artist on the last two seasons of Russell Simmons's *Def Poetry Jam* and a recipient of the 2002 and 2004 National Performance Network Creation Commission. He has written and starred in his acclaimed plays, *Word Becomes Flesh* and *Scourge*.

Kamilah Forbes is the artistic director of the New York Hip-Hop Theater Festival. Founder of D.C.-based Hip-Hop Theatre Junction, she has been a coproducer for HBO's *Def Poetry Jam* and assistant director to the Tony Award–winning Broadway tour of *Def Poetry*. She has directed many plays, including *Scourge*. Nominated for the Helen Hayes Award as best lead actress, Kamilah also received the District of Columbia's Mayor's Arts Award.

Traci Bartlow is a dancer, choreographer, photographer, and poet from East Oakland who has worked internationally in theatre, film, and television. Her passion is documenting and preserving Black dance and culture while forging new ground to create a unique expression. Star Child! Entertainment produces dance and theatrical events and is the base for her company, Traci Bartlow and Dancers.

Javier Reyes is a Black Puerto Rican actor, writer, activist, and entrepreneur from San Francisco. Cofounder and artistic director of Colored Ink, he is also the project coordinator of Two Generations, One Heartbeat.

JEFF: Kamilah, could you start by giving us a little bit of historical context for the Hip-Hop Theater Festival?

KAMILAH: The Hip-Hop Theater Festival started in 2000. We realized that Danny Hoch, the founder of the festival, and a collection of a few other artists had also realized that this work was happening all over the place. Jonzi D in England had been touring his piece "Aeroplane Man" since 1995. I actually saw it in London, England, and that was the first time that I had ever heard of hip-hop theatre. And then you had Sarah Jones and Danny Hoch on the East Coast, Will Power on the West, folks really all over the country making it happen. In 2001, we expanded the reach for more national work, which was really great because then it became an institution of sorts.

JEFF: What puts the hip-hop into hip-hop theatre?

KAMILAH: First and foremost, I think its voice, its energy beyond the aesthetics. There's the "four elements," but what's even more important are the relevant issues to the hip-hop culture and hip-hop generation.

TRACI: The energy in the raw element of hip-hop dance is something that is important for me to capture and preserve in my work. Bringing that raw element to the theatrical stage helps keep the hip-hop "truth" in my work. I started out as a dancer on the block, going to all of the town shows, and I eventually studied dance, and now I find myself coming full circle back to the street with a lot more experience to bring to the table. I like the organic nature of the dance that I first did on the block. So it's important to me to keep that organic energy of hip-hop dance in my work.

JEFF: Does it matter what the form is in order to call it hip-hop?

TRACI: Yes, in terms of the dance in hip-hop theatre, the form has to be the styles that define hip-hop dance, whether it be the foundation movement; breakin'; Boogaloo; poppin'; lockin'; the party dances of the '70s, '80s, and '90s; or the new school styles like Hyphy or Krump.

JEFF: Javier, talk about what you define to be your vision of hip-hop theatre.

JAVIER: At first, Colored Ink was just a bunch of young people doing theatre that happened to have hip-hop as a backdrop. But as our craft evolved, so did the way we went about approaching our work. Many of the crew loved hip-hop as much as they loved theatre. We began mixing and matching the two, creating a hybrid. So the way I correlate hip-hop theatre is like a family reunion. When the family gets together, it can be explosive. Aunty comes in with rhythm, poetry. The young ones are doing the latest dance that is reminiscent to ancient African dance. You have the uncles being theatrical in their storytelling. The elders are singing songs of yesterday. The teens are repping the hip-hop of today. Folks turn on the music, and everyone starts vibing off each other and contributing bits and pieces of each other to make something new. Finally, you have those in the family who are mixed and conscious, who embody all the crafts that bring "edutainment"—educating and entertaining all at the same time. That's my vision of hip-hop theatre: constant creating and reinventing of the arts. Even if you just talk about theatre, when people like Sidney Poitier and Ossie Davis were coming up, you had to be able to sing, dance, and act. And if you couldn't, you wouldn't be onstage. Once the

bar's been set that you have to be multitalented, then that's when the real creative stuff comes out.

JEFF: Where's the hip-hop in your theatre, and where's the theatre in your hip-hop?

JAVIER: I think that hip-hop is about consciousness and chorus, as in the unison of the cause, like "the hook" of a song. Theatre is the responsibility in what you say and the work you have to put in to best convey the message.

BAMUTHI: There's a reason why I think more and more scholars are approaching hip-hop from the perspective of prescribed consciousness. There's always a kind of cyclical relationship between what we think and what we do and who we are and what our social, political, and spiritual environments dictate that we do. I was born in 1975, and I don't really know life without hip-hop. It's a part of who I am. It certainly gave me vocabulary. I wouldn't have known who Farrakhan was if Chuck D hadn't said, "Farrakhan's a prophet, and I think you oughta listen." I was eleven. I wouldn't have understood that my generation and my folks were empowered artistically if it wasn't for Spike Lee cinematically scrolling to "Tawana Told the Truth" on a brick wall in *Do the Right Thing*. These were seminal moments for me artistically, and intellectually and ideologically are a part of who I am and how it is that I create.

The number-one thing that makes what we do hip-hop theatre is the ritual and community interaction. We understand that the audience is socially, spiritually, and intellectually implicated in what goes on. So when I bust "Word Becomes Flesh" in Seattle in front of a bunch of managerial old white ladies that are on the board of directors, they don't understand what is going on and they don't give me anything back, then that affects the collective energy in the room. So the same three hundred silver-haired ladies in Seattle, if by the end of "Word Becomes Flesh," they have moved to a place where they feel empowered to vocalize how they're doing, then the ritual has worked. Javier talked about "edutainment," and that speaks to performance as having educational impact and import, and this, too, is who we are. There is a constant flow, and the idea of reciprocation is essential to all of our work. And that's what makes it hip-hop—because the cipher continues to move.

KAMILAH: In this country, there are societal perceptions of what theatre is and what theatre is supposed to be, simply because of the classism that has been ever so present in theatre. There is a huge barrier between the stage and who I

am and between the audience. Particularly as a young theatre artist, I felt very excluded from the theatre community. Hip-hop theatre breaks down many of those barriers simply because of who is invited, or rather who is not invited, which I think also opens a lot of doors for audiences and for that sort of exchange to happen.

JAVIER: When you first learn about theatre, you are taught about the "fourth wall," the imaginary wall that divides you from the audience or, as they used to say, "the peasants." That wall still exists metaphorically, especially when it comes to the outreach to Black and Brown communities. It is almost a vibing-out process because most of the material has no relations to the reality of my people.

And I don't even want to talk about pricing of some of these shows, even though some of our people will pay forty dollars to go to the next hip-hop show versus going to see a good hip-hop theatre show. It got so drastic for me that I had to go out to the most grimiest spots—like dope spots where people sell dope—and give 'em a sample like, "Brother, if you trust this, if you like this, it's going to be even bigger and better when you come to the theatre." Then when you get them into the theatre, they're just like, "Damn, I didn't expect that!" But once they get hip to it, they never leave it because it touches people; you can be from whatever economic class—it just hits you and sticks with you.

With Colored Ink, we try to get an equal percentage of races up in our shows. I want to represent the Blacks, Latinos, Asians, whites, and whoever else is interested. People see optimism when they see a multirainbow of performers on a CI stage, and subconsciously they feel like this is how it should be. We each go out and do our own individual thing about our cultures and stuff, but there has to be a certain point where we get together, and in my opinion, hip-hop—next to jazz—has been the only thing that has united folks and brought people together.

TRACI: Hip-hop has a lot of theatrics in it. You look at the new Hyphy style that has a lot of pantomime and skits in the movement. That is street theatre that stays connected with the roots and spirit of hip-hop by raw creativity, coming up with something original and unique. It's a way of living through your art and culture. And very much like African culture, hip-hop is a way of living. Hip-hop is my art, and art is my life. You create it to have people experience it. I really digged what Javier was saying about going to the grimy spots, you know? That's such a dope element of audience and cultural development:

bringing in people who normally don't go to theatre but are very much a part of hip-hop culture.

JEFF: You all are raising this idea of "theatre for the folks," "theatre for the people," and representing the experiences of folks that are marginalized, people of color. These are the kind of questions that have gone through previous movements like the Black Arts and multiculturalism movements: a push to develop community theatre, toward including different kinds of stories and breaking traditions. It seems as if hip-hop is building on some of those legacies. How do you see what folks have done before influencing what you're doing?

BAMUTHI: There's Phyllis Wheatley, David Walker, Nat Turner, W. E. B. Du Bois, Langston Hughes, Richard Wright, Amiri Baraka, Gil Scott-Heron, The Last Poets, Grandmaster Flash and The Furious Five, and on and on and on. So we have this mode of principle, in our way of being, called "Nommo" which originates with the Dogon in Mali, which essentially is the idea that we *speak* things into existence. To me, the idea of the oral tradition and the oral culture begins with this concept. "In the beginning, there was the word." That's the first lineage—that we are all a part of a spiritual tradition. We heal with our art. We uplift and enlighten with our art. We are repositories for our culture with our art.

Then on the political spectrum, I think also what we're doing, and what we've been confronted with, is moving an existence and a lifestyle and a perspective that the mainstream marginalizes, and being responsible for moving that to the center of our collective consciousness. For me, the first Black art in this hemisphere was slaves being forced to dance on ships. That's the first Black performance in the Americas, and we kind of continued from there.

TRACI: I liked that you included the Black Arts Movement as part of this discussion because with me it was very important for your art to serve your community. I grew up in Oakland watching Boogaloo dance groups like the Black Resurgents and the Black Messengers. These were dancers that were inspired by the Black Panthers and the Black Power movement and that were on the cutting edge of hip-hop dance culture. My first dance class was an Afro-Haitian class in the cafeteria of my elementary school. It was taught by an artist that saw the importance of cultural education and making art accessible to community. Other artists and educators in the Bay that laid the foundation for what I do are Dr. Halifu Osumare, Leon Jackson, Linda Johnson, Naomi

Diouf. All of these people not only taught dance but taught important life lessons on history, culture, family, community, arts administration, and expanding your horizons globally. It's not like, "I want to create this great art." It's like, "No, I want people to feel this, and I want to share this passion and vision that's inside of me." I want to heal and transform, and that's what I try to pass on to my students.

JAVIER: I wanna name three people. First, Miguel Piñeiro. Augusto Boal's *Theatre of the Oppressed.* And I was just thinking about this—he can arguably be one of the first hip-hop theatre writers—and that's August Wilson, because everything he wrote was based on music he grew up in, and that was like '70s, late '60s. So when I do my thing, I hear Augusto, see Miguel, and listen to August. So that's my inspiration every day when I wake up. I mean, Augusto Boal got hung upside down from his toes for teaching poor people in Brazil how to use theatre to solve community issues. And dude's like seventy years old, still coming out and saying, "You gotta keep this going." He can't even stand up—they tortured him that bad—but he got his whole theatre company elected into political office. He got laws passed from his theatre company! So if that ain't inspiration, man, then you gotta be numb.

KAMILAH: When you bring up the Black Arts Movement—here was a group of theatre folks during a very high political time in this country, and their whole thing was really creating a brand-new set of rules. I remember reading one of Amiri Baraka's earliest plays, and he would not capitalize or use stage directions in any sort of traditional or conventional sense. That's what I think hip-hop theatre is: it's a crop of innovators and not necessarily folks who are prescribing to the conventions of how you're supposed to create art.

JEFF: On the flip side, hip-hop's all about the break. Hip-hop's about that thing in the middle of the song that breaks up the song, and hip-hop, when it first comes in, is experienced as a break, and out of breaks—there's always a lot of tension involved. What kinds of arguments and tensions have you had with the elder generation?

KAMILAH: On the flip side of the Black Arts Movement, it's difficult for me to name more than five Black theatres that are functioning, that are financially and fiscally responsible right now. That's something I think we need to take note of as theatre innovators, as artists: being able to handle our business so that we are around for years and years to come. Because the art is great, but

when you're not able to support yourself, it's very difficult. Woody King says it all the time: "I want you all to learn from the mistakes that we have made as your forefathers and foremothers in the theatre movement." That's real talk.

JAVIER: Any youth program you associate with hip-hop, nine out of ten times, it's going to be the first thing that they cut. It's always the thing that's innovative and reaching people that's going to get cut first. When you say "hip-hop," some see it differently. There's no legitimacy in it. No, we're disgracing the art. They don't really delve into it and find the beautiful stuff. They just attach a label to it, and that's it. Wrap and send it to FedEx, and that's it.

TRACI: Somewhere along the way the torch was dropped, and my elders feel that we don't take advantage of the way they paved. They would like to see us stake a claim in who and what we are, collectively. We are more individualistic, whereas they were more about community and interdependency. They also challenge us with the idea of selling out for cash and fame versus staying true to cultural arts and building community.

BAMUTHI: What a lot of folks are talking about in terms of the financial struggle of being an artist and what we need to do in terms of the Hip-Hop Theater Festival is to push an aesthetic across the country. What this is doing is enabling a national audience to recognize what is emerging in the theatre and, therefore, cultivating an alternative media and audience for this type of work, and that is really important. I think folks are afraid. We've all alluded to it in different ways. Folks are afraid to cross the aisle, to break through a barrier or a threshold. And no one wants to go to places where they are alone. That's part of our humanity: am I going to be the only person there?

The idea of a festival is that you are part of a community. You are part of a collective. You talk about the break. Colored folk have difficulty working together, and press folk (the media) have difficulty working together and consolidating our efforts to push forward and to push through. And one of the things that I think the festival is so good at is developing a cache of artists from all over the world and, correspondingly, audiences from all over the world that enable us to work together to build confidence in the fact that you're not going to be alone and be by yourself in the theatre.

This gives us an alternative to 50 Cent on the radio and makes this a viable form for, hopefully, my son and his son to make theatre if they so choose in the verse of their times, knowing that their community will support it. I don't think that you have to be Tyler Perry and do *Diary of a Mad Black*

Woman to have folks come out and see your show. I think that anybody that goes out to see "Madea" can come see my shit. That, to me, is what Black theatre has become. It's like Suzan-Lori Parks, August Wilson, and church plays. And there's so much more that's available on the spectrum. Creating this festival, creating a collective community of artists, is what I think is going to help us move forward.

KAMILAH: I'm all about not only creating new models on the stage and being creative with the art but also being innovative with organization, being innovative with fund-raising and how things are structured. And the church plays—"the Chitlin Circuit"—is quite a phenomenon to me in just the way that they're able to sustain these productions and make a lot of money. That's really understanding an audience and tapping into an audience, which many times theatres don't do enough of. Regional theatres will be handing out flyers to *The Cherry Orchard* in the 'hood and thinking that that's audience development.

JEFF: There's been a real intense debate within the pages of *American Theatre* about whether or not hip-hop theatre is actually becoming "the New Orthodoxy." We often look at ourselves as the underdogs, but some people look at it differently—that we've already won. Are there limitations that are being put on artists, especially artists of color, because they have to fit into a "hip-hop box"?

KAMILAH: I think that whole concept of hip-hop ultimately becoming a box comes from a very Western view of thinking about art. For instance, the whole multiculturalism movement in theatre was, "OK, we're going to do Chekhov's *The Seagull,* and we're just going to make it Black and white and Latino and Asian, and there it is." That's great, but once again, where is the content? Who are we speaking to? Just because you put Black and Latino and Asian people on the stage does not mean that the content has changed. The colors used to color in the structure may have, but not the structure in itself. Hip-hop, I think, breaks that down.

JEFF: Specifically, Jorge Ignacio Cortiñas has argued that the category of hip-hop is limiting, particularly if you want to look at new ways of understanding gender, sexuality, queerness, and identity.

BAMUTHI: Language is limiting. The real problem is how artists—particularly of color or artists on the margin—are called "hip-hop" to satisfy "the

Center's" needs. When I say "the Center," I could talk about Yerba Buena Center calling my shit "Outsider Art." So the Center needs to create some kind of language for their traditional audiences to be okay with not presenting Shakespeare, Arthur Miller, etc. Instead of saying, "I'm going to tell you about the Filipino gay experience," it's easier for the Center to be like, "A hip-hop generation artist talks about . . . ," because it's closer to the center—it's sexier, it's more accessible. I think that's what's at the crux of Jorge's argument: not what we're doing, but the way that the Center is using this term to define all of us, which I think is bogus and, I think, is insulting, actually, to our collective intelligence.

But hip-hop is not "orthodoxy." And what we're doing is not "orthodoxy." When I was at the University of Maryland a couple weeks ago, I looked at their season, and they had the five joints that every theatre department in the country is doing right now because those are "the works." None of them were made after 1980. When folks start doing "Word Becomes Flesh," then that's when we'll become "orthodoxy." But that shit ain't happened yet.

JAVIER: In terms of a box, unless you don't have a creative mind, it will stay in a box. But if you are listening to these kids, and this generation coming up below us—yo, we got folks in prison now, male and female, who are some of the most talented people. They just don't have access to the right resources to be able to do it. Do you know how many different kinds of people are doing hip-hop right now? Once again it's something that's unifying people.

KAMILAH: Unfortunately, theatre is about selling tickets. That's the attractiveness of putting that hip-hop title in front of something completely unrelated.

TRACI: There's no way it could stay in a box. It's constantly evolving and changing and being redefined.

BAMUTHI: You talked about hip-hop being on Broadway. Hip-hop ain't on Broadway. You open up the *New York Times* and probably 75 percent, if not 80 percent, of the plays and musicals that are on Broadway right now are revivals. Of the 20 percent of the rest, *Russell Simmons' Def Poetry* was on Broadway for five months, and that was that. Sean "Puffy" Combs doing a Lorraine Hansbury play may or may not be hip-hop on Broadway, but it's a Lorraine Hansbury play.

JEFF: There was *Top Dog/Underdog*.

BAMUTHI: There we go, "the one." You have Suzan-Lori Parks, "the one." You have *Anna in the Tropics*, "the one." You can't even say *Miss Saigon* is "the one," really. But that's what folks will try to argue. I understand Jorge's argument, and I think he's a brilliant writer, but we have a long way to go to be the New Orthodoxy.

AUDIENCE MEMBER 2: I was wondering if you guys could give some of your definition of hip-hop.

KAMILAH: What's your definition of hip-hop?

AUDIENCE MEMBER 2: My definition stems more towards culture and community and more so African American community because that's just what I saw growing up. It was powerful for us, in a way that maybe the civil rights movement was . . . or the jazz movement. That's what I associate it with.

KAMILAH: Well I would definitely be right along lines with you with the definition of hip-hop. That's the culture I grew up in as well. I don't know life without hip-hop, so it's definitely, identifiably, my culture. It's definitely, identifiably, a movement of resistance. An arts movement is definitely a part of it, going beyond the four elements. I think it becomes confusing because there's so many debates at hip-hop conferences about "what's hip-hop" and "what's not hip-hop." And it's because we're trying to force ourselves to put it into a box that will lead to the death of it. I think it's important that we don't always try to pin down what it is and what it's not.

BAMUTHI: For purposes of scholarship and documentation, we continue to have these arguments and continue to debate these definitions. But ultimately, you can't define a movement. Hip-hop is folklore is gospel is order is *ocha* in orbit, no bullshit, no doubt. That's what I think it is. I think it's spirituality. I think it's truth. But mostly, it's a folkloric medium enjoyed by billions of people all over the planet that is rooted in the idea of movement.

TRACI: For me, the first definition that comes to mind is the raw expression of urban Black youth. It's totally not that anymore. Now it's like the popular culture around the world that's based on these four foundational elements. We'll see what it's going to be in the next ten years.

JAVIER: The new underground railroad going under a rainbow revolution.

AUDIENCE MEMBER 2: I just wanted to say I disagree with Traci's comment— your first definition—because that's how I look at it, and I still see it that way. Even though it's evolved, I see that raw expression of Black.

TRACI: That imprint is on there, but there are many things that I look at, and I say, "What is that? That's not hip-hop." It's a very different voice, although some people may define it as hip-hop. It's undoubtedly the voice of youth around world. Hip-hop is now "pop," as in popular culture. So how someone in Japan, Australia, London, Brazil describes hip-hop may be very different from my own. But what's important to understand is that is an extension of the African diaspora, and that is where the definition begins across the board.

BAMUTHI: What do you think of when you think of democracy? I think that's the whole. When I think of democracy in the United States, it certainly wasn't meant to include us. I see or I understand it to be a movement or a dictate that has radically shifted from its original intent. Because to me, hip-hop wouldn't have jumped if it weren't for Black folk, but Latino folk who in the Bronx were at the center of b-boying. I think that's the struggle that we all have: how do you deal with a form that is constantly evolving, that different people have their hands in?

What is real? What is true, and how far away from the original voice does something have to get before it's no longer that voice? Because when I meet kids in Bosnia and I meet kids in Tokyo or when I meet kids in Cuba, they're all doing this thing they call hip-hop. But the Bosnian kid don't look like me and doesn't have my experience, and I watch him trying to emulate in language and in posture what he thinks I'm bringing to the table. And Jeff talked about the break, and that really is where hip-hop happens . . . that's not really with him trying to be like me, but in me meeting him, and there's the break.

AUDIENCE MEMBER 1: What people see on television and how they see misogyny and violence and what people see when they see hip-hop theatre, it's a whole different experience. I saw Rubberbandance Group yesterday, and I was just amazed seeing classical music with an old-school b-boy with Capoiera and modern dance and contact improv. But I don't know if hip-hop heads see that as hip-hop. Like they might see that as, "He's doing some modern stuff. That's wack." But the evolution of hip-hop theatre, I hope, would challenge that status quo of the multibillion-dollar industry that's created what hip-hop is to folks in the country that don't see hip-hop on the daily.

AUDIENCE MEMBER 3: Commercialism in the corporate world has really affected hip-hop music, in particular, because it's out in the media, but it's also created a lot of rules and negative aspects. How do you see that affecting hip-hop theatre?

KAMILAH: Broadway affects many different forms of theatre in that respect, in which the dollars now control how and what is presented on the stage, particularly how it's presented. *Def Poetry Slam* ran on Broadway for about five months. Ticket sales did not do so well, particularly because Broadway audiences didn't know what it was. Let me clarify "Broadway audiences." We're talking about older white American tourists who come to New York to see Broadway plays. They're used to seeing the *Sweeney Todd*s, the *Oklahoma*s, the big musicals that they're familiar with. And *Def Poetry Jam*—what is that? The audience—there were certain nights where there was just an amazing amount of young people of color coming in to see the show where I was just like, "Wow, this is great!" But again, when you're talking about numbers and dollars and cents, there was a disconnect with the traditional audiences.

Then, on the flip side of it—I was also able to see Puffy in *A Raisin in the Sun*. And regardless of what people think as far as his acting ability or his validity as an actor, what he was able to do, the audiences were just absolutely amazing, absolutely unlike any other that I had seen. And there was the ritual between the stage and the audience, and it was a whole new experience.

JAVIER: I'm a very optimistic person, man, and it's through life. I'm third generation from the projects. I shouldn't be here. When I see stuff like this, I'm like, "It's gonna happen that way, and we're gonna flip the game." Because you gotta know the rules before you break them, and once you know 'em, you break 'em and you make it work. And I think it's going to happen, and I think that we have to be very careful on who we let in, because not all money is good money. It ain't. So what we lack in dollars, the hip-hop theatre genre needs to be wealthy in community.

TRACI: You know, that was something that I was also going to comment on—the wealth of community. I was just speaking with James Kass last night after the show and was just saying how dope it is that all of these different elements came together to make the festival happen. Where La Peña, Youth Speaks, Hip-Hop Theater Festival, Yerba Buena all put in resources to make this thing happen, that's a big part of hip-hop—that element of community coming together and supporting each other.

BAMUTHI: I think at some point, corporate America got hip-hop to sell its wares. And I'm thinking about two moments—1986 and the Beastie Boys and Run-DMC and Aerosmith—and then all of a sudden, hip-hop was on MTV. And I don't know if ya'll remember this, but before there was TRL and 106 and Park there was Yo! MTV Raps at 4:30. That was the *American Bandstand* for a whole generation of folks. And somewhere in that time, Luke Skywalker and 2 Live Crew started doing these videos where . . . there was a lot of naked girls at the beach. Somewhere in there, all hip-hop videos followed that format. I don't know what happened . . . but that became the face of hip-hop. Prior to that, I remember my mom and dad wouldn't let me go to hip-hop shows because a riot was going to break out at any moment—"No hip-hop. No rap because you're gonna get shot." Reg E. Gaines has this poem about his Air Jordans, and that is the kind of iconography that I came up with. First, there was gonna be violence, and second, hip-hop is still associated with everything negative in American commerce and culture. At some point, I don't know if it was the Fresh Prince, but hip-hop became safe enough to sell our shit.

Commercial culture, I think, in a way informs what we do but won't infiltrate it until somebody figures out how we can help them sell stuff. In other words, this is a vehicle for creative expression. It is a vehicle for commerce. And at the point where you take the art and you co-opt it and make it a vehicle to sell something, it changes the face of the art, and you won't be able to call it hip-hop theatre anymore.

10

On Lit Hop

Adam Mansbach

What I do, mostly, is write fiction.[1] And as a hip-hopper—somebody who has participated in, observed, criticized, and championed the culture for twenty years—the aesthetic techniques and political assumptions of my work derive from and dialogue with the foundational tenets of hip-hop as I understand them. Other writers of my generation have been similarly affected, in ways more complex, profound, and subtle than have generally been recognized by readers, critics, or the market. I want to do two things in this essay: discuss my lit-hop aesthetic and to explore some of the ways lit hop has been misunderstood thus far, in hopes of preventing future works from being dissed with the ease, ignorance, and prejudice that currently pervade the public discourse. I still maintain the increasingly antiquated belief that literature can be transformative, socially and spiritually, and thus I don't want to see the work of the hip-hop generation marginalized—not even for some probationary, wait-outside-until-they-finally-get-it period. We don't have time for that. The literary establishment grows ever more elitist and alienating and threatens to exclude not just a generation of writers, but a generation of readers.

Any discussion of hip-hop's original impulses tends to veer toward rhapsody, dogma, or both. As a well-intentioned but problematic strand of hip-hop originalism emerges, it becomes common to hear hip-hop talked about as if it is a cosmic revelation, bestowed upon Herc, Flash, and Bam atop some Bronx-rooftop equivalent of Mount Sinai.[2] Hip-hop becomes a single narrative in the retelling, a child sprung full-grown from the womb, five-elements-indivisible-for-which-we-stand. I don't think it's possible to overstate the ingenuity, beauty, or political significance of hip-hop practices at their purest, but I'm wary of pretending hip-hop aesthetics represent a radical departure

from everything that came before them. The *practices* of b-boying, MCing, graffiti writing, and deejaying had never been seen before, but the aesthetic concepts that underwrite them were updated, not invented. As with everything in hip-hop, the key is how everything is put together, and the energy with which it is suffused.

For instance, one of the foundation elements I hold most dear, and try hardest to translate on the page, is the notion of *intellectual democracy through collage*: the idea that whatever's hot is worthy of adoption regardless of its location or context: a dope Monkees drum break is not penalized for the corniness of its origins, any more than a lackluster James Brown jam gets any run on reputation alone. Hip-hop—as dramatized by the crate-digging of DJs, by breakers' assimilation of everything from Capoiera to cinema kung fu, by graf writers' blend-happy attitudes toward color and style—values a free-ranging, studious, and critical-minded approach to source material and, by extension, life.

In and of itself, there is nothing about this concept that is unique to hip-hop.[3] It is the way the influences are made to cohere, the way the collage is put together sonically or visually, kinetically or verbally, that is original. Hip-hop introduces a specific sense of interplay in revealing and obscuring the layers of the collage, takes a specific kind of pleasure in the mash-up refreaking of technologies and texts, understands history as something to backspin and cut up and cover with fingerprints in a particular kind of way.

It is this energy that makes hip-hop's aesthetic principles its own: what's unique is not just the reclamation of public space on behalf of marginalized peoples and purposes but the audacious brilliance of jimmying open lamp-posts to steal electricity to run sound systems, thus literally reclaiming power from a city that had denied it. Not just the notion of public expression through guerrilla art but the specific genius of taking over the New York Transit System and engaging the same city that had cut school funding for arts programs in a $250 million subterranean war over art, ownership, and access. Not just the impulse to think interdisciplinarily but the *instinct* to do so, hardwired in hip-hoppers in a way no previous generation can claim and made manifest in every hip-hop art form. Not just innovation-as-mandate, a feature of many artistic movements, but the specific critical skills and frenetic learning curve that hip-hoppers taught themselves—the way train pieces and rhymes and musical productions became fodder for what was to come next at the exact moment of their completion, going from innovative to passé in the blink of an eye because of the sheer intellectual force of every kid clocking and biting and scheming on how to take it one step further,

chop those wild-style letter segments or that rhyme scheme or that drum loop just a little bit flyer.

I like to think of a novel in terms of a mix board. Harry Allen once claimed that Public Enemy's seminal 1988 album, *It Takes a Nation of Millions to Hold Us Back,* was the first rap record to make use of all forty-eight channels: on any given song, layers of musical and vocal samples overlap and abut each other, swirling in and out of the mix at the glide of a fader. The listener's degree of appreciation for the collage is related (probably directly, possibly inversely,[4] and maybe in some other way) to his or her degree of familiarity with the elements of the collage. Resonances, echoes, homages, and subversions bubble up: a Wattstax vocal sample evokes a historical moment of Black unity in the aftermath of chaos; a James Brown break summons up not just the godfather of soul but the long history of the song's hip-hop usage; an old-school rap snippet throws a head nod to a forgotten predecessor; a Funkadelic loop reminds us that funkin' on the one has always been a political statement.[5] On top, Chuck D builds a vocal collage of his own, paraphrasing his contemporary Ced Gee before embarking on a bob-and-weave narrative that touches on racial profiling, the teachings of Farrakhan, and Public Enemy's mission, as well as laying down a double entendre that he himself will mine as a sample later on this very album . . . and this is all in the first verse of "Bring the Noise."

My goal is to write fiction that works the same way: that builds layers of reference and meaning and plot and dialogue and character, tweaks the levels of the mix for smooth reading but still allows you to dissect the individual elements and analyze them. If you read the three-page prologue of my novel *Angry Black White Boy* and you're familiar with Kool Keith, Malcolm X, Michael Jackson, Winston Churchill, old GI Joe commercials, Martin Luther King Jr., Amiri Baraka, the Doors, *Brown vs. The Board of Education,* Nation of Gods and Earth's numerology, *Native Son, Eyes on the Prize,* Eldridge Cleaver, Red Rodney, and Bernhard Goetz—some of them mentioned, some referenced, others sampled—you'll appreciate the text (and the character speaking) on one level. If not, it should still work. But differently. If you were so inclined, you could drop out everything but the samples and graph their meanings and connections the same way you might drop everything on the PE mix board but the drums, and just peep those. Some samples might be deliberately forefronted; others, in the tradition of DJs steaming off record labels to protect their secret weapons and producers making artful chops to avoid illegal-use litigation, are obscured.

Sampling is more than an authorial technique in my work. It is also a way to reveal character and map a novel's worldview: because *ABWB* is populated by hip-hoppers, conversations and actions are studded with a range of references and echoes, flips and homages. Conversant with race literature and real-life struggle, the characters are able to position themselves in relation to these traditions, both playfully and seriously. The events of their lives are bound together by the same internal logic, and with the same sense of tension, that binds a bunch of disparate sounds into a coherent musical composition. They make decisions to reenact historical moments (like commandeering the corner of 125th and Lenox Avenue, à la Malcolm X and the title of Gil Scott-Heron's first album); adopt and adapt and reject roles like abolitionist John Brown, *Native Son*'s Bigger Thomas, and *Crime and Punishment*'s Raskolnikov; debate each other in shorthand because a shared culture has given them a common language. They act with the freewheeling, undisciplined vigor and all-embracing attitude of hip-hop: natural historians, but only for eight bars at a time. Not the entire breadth and context: just the party-rocking shit. Lest I sound too celebratory about it, I should also say that this mind-state underwrites both their success and their failure. They face the same void in leadership that hip-hoppers did as we came of age in the eighties, step into that void as best they can, and do just as brilliant and terrible a job of it.

Ultimately, the notion of literary hip-hop aesthetics begs the question of form versus content. Can a novel whose plot has nothing to do with hip-hop culture—one that takes place a hundred years before Herc was born or is populated by people with no relationship to hip-hop whatsoever—take up the aesthetic and political concerns of the culture and thus be lit hop? My answer would be yes; the jazz literature of Langston Hughes, Amiri Baraka, or Yusef Komunyaakaa does not have to take jazz as its subject, any more than the jazz painting of Romare Bearden or Jacob Lawrence.[6] Rather, they share techniques with the music. They may have produced iconic images that, in turn, enhanced the popular understanding of jazz; they may even have lionized their musical muses. But such things are only an incidental part of their total work; their genius was not in writing *about* jazz but in *writing jazz.*

In some ways, the mark of success for lit hop will be when a book that isn't about hip-hop is understood as beholden to the aesthetics of the culture. That will mean we've surgeoned lit hop from the crass market concerns that now define it and enforced a fuller understanding of the expansive ways in which a literature of hip-hop can exist, and flourish.

As it now stands, a "hip-hop novel" denotes any book in which words usually ending in "-er" instead terminate in "-a"; any book containing characters who are young, urban, and Black or at least two out of the three; any book aimed at a demographic group more notorious for purchasing CDs. As soon as the notion of using hip-hop to market literature dawned, belatedly, on the publishing industry, the phrase started getting tossed around without much rigor—and thus, many writers I know cringe at the prospect of being termed "hip-hop novelists."

The literary world isn't just late to the party in co-opting hip-hop to move product; it is equally tardy in throwing off the institutional influence of old-guard critics (some of them quite young) determined to act as cultural gatekeepers. To them, literature is the last bastion of high culture, and hip-hop a corrupting force.[7]

I should say *what they think of as hip-hop*. Snobbery, racism, and the sheer desire to maintain a position of cultural centrality are all factors in the critical resistance to lit hop, but benign ignorance is in play too. If I understood hip-hop not as a culture rooted in poetic, dexterous, inventive, courageous resistance to oppression, but rather only through its most visible, consumable, misogynistic manifestations, I wouldn't want that shit infesting literature either.[8]

Hip-hop novelists don't need a free pass, merely a critical infrastructure that approaches lit hop as it would any other genre: on its own terms, with an eye toward understanding what is being attempted. Some of the most pointed and common critical complaints about lit hop stem from resistance to hip-hop paradigms. Ecstatic genre-crossing and cultural multiliteracy have been fundamental since the first time Herc blended a reggae record with a funk break, then threw a TV jingle over that, but literary mash-ups are still a surefire way to get dissed—to say nothing of characters capable of both teaching the seminar and rocking the boulevard. The number of times I've been told some variation of "a drug dealer would never be as articulate as the one in your book" by writing teachers and reviewers alike is surpassed only by the number of young writing students who have contacted me to complain about being on the receiving end of the same kinds of comments. What is behind this incredulity at the multiple literacies of the hip-hop generation? And why are book reviewers hanging out with such inarticulate drug dealers?

For a compact seminar on pervasive anti-lit-hop prejudices, peep this 1999 *New York Times Book Review* of Victor LaValle's debut collection of stories, *Slapboxing with Jesus*.[9] Reviewer Ray Sawhill begins by speculating that LaValle's ambition seems to be "to make the book approximate an hour or

two of rap videos" (huh?), then describes the book as "full of peculiarities of punctuation and phrasing, creat[ing] effects impressively close to the scratch-and-sample effects of rap. . . . A case could be made that LaValle has found a way to give linguistic form to the brain patterns of media-soaked, post-PC street youth. But readers less taken by the idea that literature should come out of a boombox are likely find the book tediously juvenile."

Note, first, the laziness of Sawhill's take on hip-hop: his unexplicated video reference employs an obtuse critical shorthand, leaving the reader to speculate on just what goes on in an hour or two of rap videos, and how LaValle might translate the sensibility of a three-minute clip into a collection of stories. The only thing clear about the sentence is that Sawhill thinks rap videos are all the same and approximating them is a bad idea. The reader is expected to agree; at work here is a tacit disdain that necessitates no further explanation. Any evidence in support of the ridiculous assertion that video verisimilitude is LaValle's goal to begin with goes similarly uncited.

Sawhill then belittles scratches and samples as "effects," when they are, rather, the musical bedrock of contemporary hip-hop production. And note the phrase "peculiarities of punctuation and phrasing": LaValle's prose is being dissed for its departures from standard English. Although "a case could be made" that the author's language is evocative of the brain patterns of "street youth" (whatever *that* means—none of LaValle's characters are homeless), Sawhill certainly can't be bothered to make that case himself, or pretend he thinks LaValle's goal in presenting such characters is valuable. Sawhill's problem is not with LaValle's execution (his scratch-and-sample effects, after all, come "impressively close" to the real thing) but with the unworthiness of speaking for, like, or about the hip-hop generation.

The parting-shot image of literature spewing from a boombox makes this clear. Putting aside for a moment the utter inaccuracy of this description of LaValle's quiet, understated storytelling, what is the image intended to connote? Literature from a boombox—abrasive, confrontational, noise pollution . . . rap. One can almost feel the wind as Sawhill shuts the gate in LaValle's face. *This is literature—there's no place for boomboxes, street youth, or nonstandard phrasing. Go wait outside with your hoodlum friends, LaValle.*

Behind such gatekeeping is a deep discomfort not only with the amplification of marginalized voices (and what they might say if allowed to speak) but also with the way hip-hop drags American race—hypocrisy and class—complacency out of the catacombs, kicking and screaming, and throws them on the examination table. It's true that the mainstream press rewards books that address race and class, but only if they do so within certain parameters.

Those parameters, to quote my editor, Chris Jackson, are "Give us our lesson and go."[10] Tell us racism is tragic, or slavery was an inhumane institution, and then get the fuck outta here. Give it to us clean, simple, unambiguous, so we know how to feel: empathetic, indignant, disturbed. Don't start mucking around with satire; don't abandon gravitas or cross genres or switch tones on us. You start blurring right and wrong, buddy, and it's all over.

The *New York Times Book Review* of *Angry Black White Boy* delineates the location of these parameters quite well. *ABWB* is a satire about an Afrocentric white hip-hopper who starts robbing white people, becomes famous, and ends up orchestrating a disastrous National Day of Apology on which whites are supposed to follow Malcolm X's rhetorical advice and apologize to Blacks. The reviewer, Nathaniel Rich (Frank's kid), really liked the most straightforward parts of the book—a series of chapters set in 1889 that detail the near-lynching of the last Black player in about-to-be-segregated major league baseball. Those scenes, according to Rich, "capture vividly the inhuman sadism inherent in racial violence," just the kind of unambiguous "lesson" Race Novels are celebrated for imparting (it's also a tiny part of what those chapters were intended to do, but lemme not get into all that).

ABWB's modern-day story line, meanwhile, Rich faults because "despite the complexity of his subject, Mansbach's tone is distractingly breezy and frivolous" and because it "unfolds in jarring bursts of fantasy. . . . Mansbach's shrewd observations of race in America are too often obscured by . . . bizarrely whimsical excursions that are ultimately too fanciful to unnerve."

I'm far from impartial on this one, and it's certainly possible that Rich is right. He seems unwilling, though, to accept the notion that a novel purporting to grapple with race can depart from the kind of earnestness he found so compelling in the 1889 sections. The breeziness Rich found so distracting is a narrative voice calibrated to reflect the young, intelligent hip-hoppers who are *ABWB*'s main characters—and who, as members of a generation whose race politics were forged equally in the flames of the Rodney King riots and the fiery funk of Chuck D's voice, possess an instinctive, interdisciplinary comfort with both the absurdity and the horror of race in America. Satire, surrealism, absurdity, dream sequences in which Ol' Dirty Bastard takes over *Seinfeld, The Cosby Show,* and *Beverly Hills 90210*—such tactics comprise an attempt to make race approachable, to reflect its complexity, and to draw on the raucous, subversive legacy of race novels like George Schuyler's *Black No More*, Ishmael Reed's *Flight to Canada*, and Ralph Ellison's *Invisible Man*. If *Angry Black White Boy* doesn't manage to pull that off, so be it. But Rich seems antagonistic to the very approach. *This is race literature—there's no place for*

breeziness or satire. Take your jarring bursts of fantasy and wait outside with your homies until you learn to limit yourself to being unnerving, Mansbach.

I could run down a further litany of critical hostilities, misreads, and belittlements—from the *NYTBR*'s characterization of Danyel Smith's novel *More Like Wrestling* as "save-the-drama-for-mama fiction" (would they take that tone if a sixty-year-old white writer from Connecticut had penned the tale?) to *Kirkus Review*'s standard practice of adopting faux Ebonics when reviewing so-called urban novels. As I write this, the *NYTBR* has just published a review of T Cooper's novel *Lipshitz Six*, which contains the following line, seemingly written just for this essay: "Would a published novelist, even one who has taken to impersonating a rap star, really write lines like 'I know I can spit an ill rhyme'?"

But you get the point. And anyway, there is more at stake than simply offering critics a road map or enfranchising hip-hop writers. If lit hop bum-rushes the show, it threatens to break apart one of the most psychotically hegemonic conversations in the literary world: the State of the Novel.

Right now, that conversation looks like this: every few years, a writer hungry for success and frustrated with his lack of popular acclaim publishes an essay (typically in the pages of *Harper's*) lambasting whatever dominant set of aesthetics—in stark contrast to his own—seems to be capturing the hearts and minds of readers. In so doing, said writer (most recently Ben Marcus, and before that Jonathan Franzen) knocks down a figurehead or two, gets people buzzing for a couple of weeks, and sets high expectations for his own next work: with a framework in place, readers can now anticipate and later understand just how the writer will flip the paradigm upside down. Ten years later, this writer, and this paradigm, will again be flipped.

This perpetual king-killing accounts for only two paradigm positions: right side up and upside down. It enforces the notion of literary binaries—experimental versus mainstream, accessible versus alienating—and excludes from the conversation any writer or reader bored by the narrowness of such strictures. It also tends to privilege a set of concerns and aesthetics that dovetails neatly with a white, male, (over)educated writership.[11] In the tradition of the *New York Times Magazine* praising the new literary journal *N+1* for being bold enough to editorialize that "It's time to say what we mean," the writers who pen these essays are having a discussion about aesthetics and literary mores that excludes the people doing some of the bravest and boldest work.

Perhaps "saying what we mean" is a revolutionary idea for a generation that, if you believe the *New York Times*, has grown up in the throes of cynicism, irony, and disaffection. But these are tremendous luxuries, and, in truth,

the dominant art forms of my generation have never embraced them. Hip-hop is a lot of things, but it has never been ironic. Nihilistic, yes, but not cynical. It has always said what it means. The people who pioneered hip-hop and chaperoned it to global prominence have been too *affected*—by poverty, by discrimination, by incarceration, by Reaganomics, by crack, by the struggle to survive and create—to cultivate the disaffect for which our generation is unfairly known.

Self-awareness—the oft-lamented paralyzing postmodern condition of *knowing* that one is producing art, *knowing* that it's all been said and done before, *fearing* that in forging ahead you risk redundancy, irrelevance, pretension—has not produced paralysis in hip-hoppers. Perhaps our immunity from this generational malaise stems from hip-hop's love of collaging, sampling, dislocating, and reconfiguring: the more that's been said and done already, the more we have to play with. Where others see defeat, we find liberation, empowerment.

This is the high culture/low culture dichotomy in full effect: despite inventing one of the most brazen, earnest, and political art forms on the books, my generation is defined by the tortured self-aware pomo aesthetic of a few writers, filmmakers, and musicians. Then, when the camps that cultivated and embraced disaffection begin to reconsider it, they get props for doing so. This is the twenty-first-century equivalent of coronating Paul Whiteman the King of Jazz while Armstrong and Ellington and Basie wait outside: you only find the Voice of a Generation where you look for it.

Adam Mansbach is the author of the novels *The End of the Jews* (Spiegel & Grau/Doubleday), *Angry Black White Boy* (Crown), and *Shackling Water* (Doubleday); the poetry collection *genius b-boy cynics getting weeded in the garden of delights* (Subway & Elevated); and the coeditor of *A Fictional History of the United States with Huge Chunks Missing* (Akashic). He was nominated for the 2006 Young Lions Award and the *Granta* Best American Writers Under 35 list.

NOTES

1. The jury's still out on whether the contraction of "hip-hop literature" in the title is corny, but we'll go with it for now, because it's mad short.

2. The hip-hop version of Justice Scalia's notorious judicial philosophy, hip-hop originalism deifies the founding fathers, insists on strict fidelity to their supposed intentions, and treats dissenters as heretics.

3. The notion of hip-hop as a structural metaphor for democracy, for instance, has also been applied to jazz and baseball, two other quintessentially American inventions.

4. For instance, if you'd never heard Diana Ross, you might hear "Mo Money, Mo Problems" and think Diddy was the greatest musical mind of his generation.

5. My favorite example of sample-as-subversion is the Notorious B.I.G.'s first song, "Party and Bullshit," in which a line from the Last Poets' "When The Revolution Comes" is truncated in such a way that Jalal's critique of folks too caught up in hedonism to fight for change becomes a celebration of that hedonism.

6. If jazz were hip-hop (and it's a common-enough metaphor), it would be roughly 1935, and we'd be in the middle of the swing era. Charlie Parker would be a teenager in Kansas City, Miles Davis a nine year old in East St. Louis. John Coltrane wouldn't be jamming with Thelonious Monk at the Five Spot for another twenty years. Bebop, modal, free, and fusion would all be things of the future. All this should be reassuring to those of us who worry that hip-hop peaked in 1988 and has increasingly been on some bullshit ever since—as should the fact that critics were pronouncing jazz dead as early as the 1930s. None of this is reassuring in the least, of course. But it should be.

7. Do we need their approval, or would it be a death knell? That's an eternal conversation, and I don't want to spend too much time on it. My investment isn't in winning over critics, per se, but on the mainstream audiences their support—or even respect—would help us access. Those audiences need to hear what we have to say and through us understand hip-hop as something deeper than what they flip past on MTV.

8. This seems like a good time to mention so-called street lit, the usually self-published books available on your finer 125th Street card tables, because so much of it seems intent on embodying this exact paradigm. Although I'm down with anything that encourages kids to read, or allows folks to get paid for writing, it seems to me that the bulk of these books are—from a literary perspective—garbage. If we indulge the increasingly tired "hip-hop versus rap" polarity, these books would be rap: chocked with brand names, populated by blinged-out thugs and video-vixen-style women, and plagued by shallow characters and bad storytelling.

9. There are two reasons I'm drawing so heavily on the *NTYBR*: first because as our national "newspaper of record" it wields more influence on a book's fate than any other review source, and second because it publishes a lot of egregiously bigoted reviews.

10. In the interest of full disclosure, Jackson is also Victor Lavalle's editor and Danyel Smith's. He also holds the distinction of being the only hip-hop-generation Black male senior editor in big publishing. Yes—the only one.

11. On paper, I'm totally one of those guys—a white Jewish novelist with an MFA from Columbia. I've never activated my membership in that club, though. Nor have I ever made a conscious decision not to; I've just always been a hip-hopper, and the sensibilities, artistically and politically, that followed from that have dictated my path since I was eleven, memorizing *Criminal Minded* and beginning to understand the subjectivity of whiteness, as hip-hop was wont to make a white boy do back then. I'm relegating all this to a footnote because I think us white folks tend to centralize ourselves and our issues way too much when we do deign to talk about race or privilege or access. Is it the role of yet another overeducated white guy to point out the elitism of the State of the Novel convo? I think it can be, for the same reason I wrote *Angry Black White Boy*: because I can't be labeled as just another complainer speaking from bitterness and self-interest, which is the way people of color are often tagged, and dismissed. To me, this is the proper use of privilege: to say things for which people with less privilege might face knee-jerk recrimination.

11

Who Shot Ya

A History of Hip-Hop Photography

Bill Adler

Before getting down to cases, it might be useful—or at least amusing—to ask ourselves a basic question: is hip-hop photography as radical as hip-hop music (a.k.a. rap and DJing), hip-hop dance (a.k.a. b-boying), or hip-hop painting (a.k.a. graffiti)?

The short answer is no. The best-known hip-hop photographers have not, so to speak, made their reputations spinning on their necks, using subway cars as canvases, playing turntables like drums, or speaking rather than singing their songs. For all of their varied approaches to the subject, these photographers are all essentially documentarians.

That said, hip-hop photography is very satisfying. Indeed, its most notable practitioners have collectively created an almost complete visual record of the culture from its birth in the early seventies through the present moment.

I say "almost" because no professional photographer was present at the creation of the culture. The first wave of b-boying had come and gone before Martha "Marty" Cooper began to shoot Crazy Legs and the Rock Steady Crew in 1980. Herc, Bambaataa, Hollywood, and Flash had been deejaying parties for five years and more before capable photographers began capturing those legendary figures on film in the late seventies.

When does hip-hop photography start? With Cooper and Henry Chalfant, who are, respectively, the form's mother and father. (Although most of the pioneers of hip-hop were young—not to say teenaged—and of color, that description fits very few of the culture's pioneering documentary photographers.) Marty and Henry take the prize not only because they were shooting

so early but also because they collected and published a book of those photos so early.

Indeed, there is no way to overstate the importance of *Subway Art,* the Cooper-Chalfant collaboration that first saw the light of day in 1984. Given that subway graffiti was illegal at the time and that individual pieces were subject to effacement within hours of their creation—sometimes even before the train left the train yard—Cooper's and Chalfant's photos are all that remain of an entire era of art history. It is a testament both to the beauty of the original graffiti and to the photos preserving them that *Subway Art* continues to remain in print, racking up twenty-one printings through 2005. The book was also crucial in legitimating graffiti as art; the paintings were not only illegal, they were produced for the most part by an unlettered, ragtag posse of underaged youth of color.

It is very much to the credit of all concerned that Cooper (born 1943) and Chalfant (born 1940)—white folks old enough to be the parents of the young aerosol artists—managed to gain the trust of their subjects. Photographer Ernie Paniccioli once saw a crew of young graffiti kids running toward Henry—a mild-mannered gent who put Ernie in mind of "a little Jesuit priest"—and figured "they were gonna have him [Henry] for dinner." Instead, they hugged him. Marty's interest in graffiti grew out of her interest in documenting "what [the kids of the Lower East Side] were doing when their parents weren't watching." After taking a few photos of Dondi at work, she was in. "Marty turned out to be just like one of the guys to us," recalled Duro. "Even though she was white and a girl, too, she had this personality that somehow we trusted her."

Henry starting documenting graffiti circa 1975, when he saw a train by Blade and understood that the art form was evolving. "It was more than just calligraphy," he said. "It had become mural painting."

Marty, who began documenting graffiti in 1979, says she "began to spend whole days standing in vacant lots just waiting for graffiti cars to pass by." Indeed, the work was so time consuming—and her commitment to it so deep—that Marty quit her job as a staff photographer at the *New York Post* in order to concentrate on graffiti.

Competitors at first, Marty and Henry decided to collaborate when it became clear that it would be hard enough to convince the publishing industry to underwrite one book about graffiti, let alone two. The partnership turned out very well; their disparate methods produced nicely complementary bodies of work. Time after time Henry delivers a clear, dead-on, superdetailed shot of one or another of those amazing, long-gone sixty-foot canvases, while Marty's shots of the trains "in the context of the urban environment" demonstrate

exactly how much verve these candy-colored trains bestowed on a cityscape otherwise painted in tones of brown and gray. The trains and her photos of them are electrifying.

Although they went their separate ways, Henry and Marty continued to travel along parallel tracks through the world of hip-hop. Henry teamed up with filmmaker Tony Silver to make *Style Wars,* a thrilling and essential documentary film that saw the light of day in 1983, a year before *Subway Art,* and which did as much to legitimate b-boys and b-boying as aerosol art.

Marty had to wait twenty years before *Hip Hop Files: Photographs, 1979–1984* was published in 2004. The book is her magnum opus, a sumptuous coffee-table tour of all of New York's hip-hop arts in their first flowering. In addition, Marty was on the set, snapping away, during the production of three early mass-media landmarks of hip-hop: Henry and Tony's *Style Wars,* Charlie Ahearn's *Wild Style,* and Michael Holman's *Graffiti Rock* television show. *Hip Hop Files* is unlikely ever to be surpassed as the definitive photographic history of hip-hop in that period.

The photos of **Charlie Ahearn** (born 1951) are a nice complement to the work of Henry and Marty. A filmmaker who says, "My ear was onto hip-hop by 1978," Charlie was introduced to the Bronx scene by Fab 5 Freddy and Lee Quinones in 1980, when the three of them teamed up to produce *Wild Style,* the first and best of the early hip-hop movies. In effect, the photos Charlie took during the next couple of years—of the likes of Kool Herc, Bambaataa, Grandmaster Flash, Grandwizzard Theodore, and Busy Bee rocking the house, and of such seminal party spots as the Black Door and the T-Connection— were research for the movie. They have since grown in stature as a crucial trove of images from a time when the world of hip-hop hardly extended beyond the borders of the Bronx. Most were shot in darkened nightclubs, with Charlie's flash penetrating just far enough to reveal the artists at work. His most iconic shot, however, appears to have been made with available light. It is of DJ AJ on the wheels of steel at the Ecstasy Garage in 1980. AJ's headphones, face, hands, and mixer are virtually the only things that are visible. The illumination comes from a bare bulb set in front of the turntables, which is all the light that AJ himself had to help him see what the hell he needed to do. It is this photo that adorns the cover of *Yes Yes Y'all: An Oral History of Hip-Hop's First Decade,* the publication of which in 2002 provided the first comprehensive presentation of Charlie's photography.

Janette Beckman may have been the first photographer to produce a whole book of photos devoted to those hip-hoppers discounted by Marty Cooper because she thought they lacked visual appeal, namely, rappers and deejays.

Rap: Portraits and Lyrics of a Generation of Black Rockers was published in 1991. (Full disclosure: the author of this essay wrote the text for Janette's book.) Like Marty, Henry, and Charlie, Janette came to hip-hop from outside the culture. Unlike them, she wasn't even an American. A young art school–trained photographer from London who devoted the period between 1977 and 1983 to the documentation of English punk-rock (work recently collected in a great book entitled *Made in the UK*), Janette first encountered hip-hop in London in November 1982 in the form of the New York City Rap Tour. As shaped by the young Fab 5 Freddy, Afrika Bambaataa, and the English promoter Kool Lady Blue (who was booking the hip-hop nights at The Roxy in New York), the tour was a perfect little microcosm of hip-hop culture. It featured rappers (including Fred), deejays (including Bam), aerosol artists (Phase 2, Futura, Dondi), b-boys (the Rock Steady Crew), and the rope-jumping Double-Dutch girls. Janette loved the show and immediately saw a connection between hip-hop and punk-rock: both were animated by a spirit of rebellion, and both were street cultures.

Janette moved to New York in 1984 and immediately began capturing American rappers on their home turf for English magazines like *The Face*. Pretty shortly, she was hired by America's rap record labels to shoot publicity photos and album covers. In effect, then, *Rap* begins where *Subway Art* and *Hip-Hop Files* end. Janette's individual portraits of the first international stars of rap comprise a sterling group portrait of hip-hop during the years when the culture's energy was still centered squarely in New York. Shooting in black and white or color as the occasion required, and in the studio or on the street—but almost never in concert—Janette memorialized nearly everyone of any importance, starting with Herc, Bam, Flash and the Five, Lovebug Starski, and Kurtis Blow, and ending with De La Soul, the Jungle Brothers, the 2 Live Crew, and N.W.A.

Janette also thought it was important to document the women in the game. Accordingly, she shot sessions with Roxanne Shante, the Real Roxanne, MC Lyte, Salt-N-Pepa, Jazzy Joyce, Antoinette, Queen Latifah, and Monie Love. She also produced a classic group shot of what might be called the Women's Class of '88, which features not only Lyte and Shante, but Sparky Dee, Ms. Melodie, Sweet Tee, Finesse & Synquis, Yvette Money, Peaches . . . and, in the center of the photo, the one and only Millie Jackson, a.k.a. the Mother of Them All.

Glen E. Friedman, justly celebrated for his definitive photos of the great Def Jam artists at the beginning of their careers, likely does not consider himself a hip-hop photographer. Instead, he is devoted to a genre of his own creation—the Fuck You Hero. However much such artists as the Beastie Boys, Run-DMC,

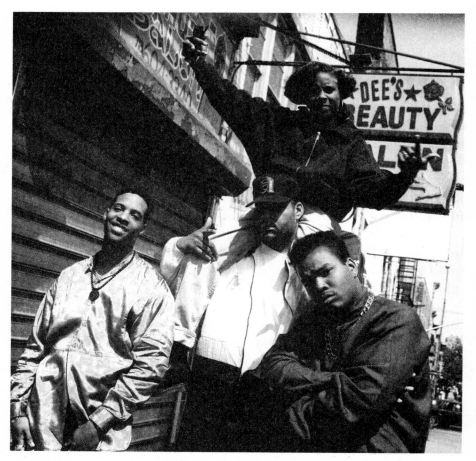

Janette Beckman. MC Lyte with Master T, Big Drew, and K. Rock. Brooklyn, 1990.
© Janette Beckman.

LL Cool J, and Public Enemy mean to lovers of hip-hop, Glen (born in 1963) sees them as the last third of a seamless continuum of rebel figures that begins for him in the mid-seventies with the skateboard kings of southern California and moves on to the American hardcore punk bands of the early eighties. In effect, he has created three separate bodies of work, each one of which is prized by its particular devotees. But in Glen's life and imagination, they all occupy the same pantheon, which is how they're presented in *Fuck You Heroes* (1994) and *Fuck You Too* (1996).

Who is a Fuck You Hero? Glen describes them as "the individuals who say 'fuck you' to those trying to limit the thinking and ideals of others." (Curiously, almost none of these individuals are women.)

Although Glen didn't get involved with rap until the advent of its second generation, circa 1985, it was nonetheless a moment that suited his politics, ripe as it was with rebellion against the status quo then defining the genre. Run-DMC, LL Cool J, and Public Enemy—guided and inspired by Russell Simmons and Rick Rubin—were relatively comfortable suburban renegades looking to make rap records leaner, harder, more "authentic," and more political than the rap records made during the previous five years by the truly hardscrabble artists from the South Bronx. The second generation thought rap might be a vehicle for more serious messages . . . or at least more serious attitudes. And, as for the Beastie Boys, three young white kids who'd started out in hardcore bands, they perfectly embodied Glen's notion that rap was "a natural progression" from punk.

For the most part Glen's rap photos lack the frenzy of his punk photos (a notable exception is a shot of DMC in midrap, bearing down on the mic in his fist with a volcanic ferocity worthy of the comic-book superheroes of his youth), but they nevertheless bestow a seriousness of purpose on these young artists that the artists themselves may have lacked. I'm thinking in particular of two different black-and-white shots of Run-DMC in Hollis, Queens—one a close-up and one in which they're posed on the block under a sign reading "Hollis Ave." The trio, in their trademark Stetson hats, Lee jeans, and Adidas, are almost supernaturally *present* and unified in these pictures. They seem simultaneously down-to-earth and absolutely assured of their own starry destiny, *people's* heroes, if not exactly fuck-you heroes. Glen's photos of Public Enemy—which favor the thoughtful Mr. Chuck D over the ridiculously photogenic Flavor Flav—radiate the charismatic militancy of the Black Panthers in their prime. His approach to the Beastie Boys is similar; he tamps their clownish tendencies in favor of their skate/punk accoutrements, which helped to grant the Beasties the gravitas they needed to overthrow the spandex battalions ruling American rock in the mideighties.

The fact that many of Glen's best images were reproduced numberless times in the form of album covers and publicity shots has helped to cement them as hip-hop icons. Ice-T—the beneficiary of a series of Friedman portraits that establish him, at the least, as the noblest gangsta of them all—has nicely captured not only Glen's achievement but also the *wonder* of his achievement: "Glen's were the very first images of rap to cross America, and he captured them exactly—this white kid from where-in-the-fuck."

It's tempting to think of **Ricky Powell** (born 1961) as Glen E.'s evil twin or, more accurately, as Oscar Madison to Glen's Felix Unger. They're roughly the same age, and they both started enjoying privileged access to the stars of Def

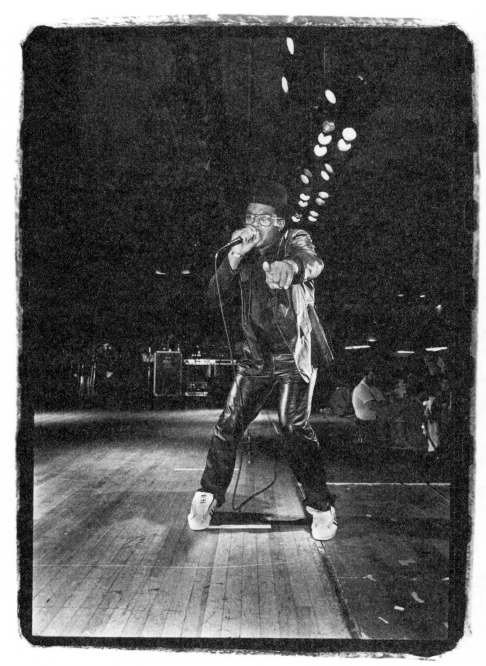

Glen E. Friedman. DMC at the Palladium. Hollywood, fall 1985. © Glen E. Friedman, from the book *Fuck You Heroes,* courtesy of Burning Flags Press (http://www.BurningFlags.com).

Jam in 1985. But Glen is serious, and Ricky is playful. Glen is meticulous, and Rick is careless. Glen is straight edge, and Rick is a weedhead. Not unnaturally, they end up making very different photos even when they're shooting the same artists. Rick's Beastie Boys photos are absolutely the wildest and most unrestrained ever taken of them. His shots of P.E. and Chuck are put in the shade by his shot of Flavor and Biz Markie, the music's supreme clown princes, arm in arm. And his photos of Run-DMC emphasize their light-hearted side—Jason wearing two hats stacked one on top of the other, a thick gold rope, and a huge world-beating smile as he steps onto a plane in Europe; DMC driving an ice-cream truck through Hollis; Run pulling a young fan from New Orleans into the frame with him to make sure that Ricky immortalizes the Adidas logo that the kid has had shaved into the hair on the back of his head.

But Rick is very much like Glen E. in one regard: it's not easy to pigeonhole him as a hip-hop photographer. To begin with, he's usually loath to think of himself as *any* kind of photographer. (He dismisses most of the breed as "cornballs.") More serious is the apparent miscellaneousness of Rick's subject matter. It's undeniable, of course, that he's shot dozens of classic shots of the great rappers, deejays, and graf artists of the eighties and nineties. But what is one to make of his cats? His dogs? His old ladies? His indie film stars? His one-legged bike messengers? (Not to mention the photos of his late-night television screen?)

The solution to this puzzle is contained in one of KRS-ONE's choicest apothegms: "Hip-hop is like my little dog. Wherever I go, it follows." Exactly the same rule applies to Rick's work: if he shoots it, it's hip-hop. Consider the cast of *The Rickford Files* (2000), the second of his three photo books (or the second of four if you count *Frozade Moments*, the book of postcards published by yours truly in 2004). It features, among others, Bobbito Garcia, Walt "Clyde" Frazier, Dondi, Crazy Legs, John Lee Hooker, Zephyr, Seen, Basquiat and Warhol, Cindy Crawford, Marv Albert, Bernard King, Bo Diddley, Ornette Coleman, Fred Gwynne, Gregory Peck, Lauren Bacall, Ahmet Ertegun, Sylvia Miles, Fran Leibowitz, Bonz Malone, Faye Dunaway, Revolt, Chris Rock, Kool Keith . . . and assorted anonymous but intriguing denizens of the night.

A random selection? No more so than the turntable selections of Afrika Bambaataa, who would famously play *The Munsters* theme song followed by James Brown's "I Got the Feeling," followed by a snatch of a speech by Malcolm X. What we're talking about in both cases, then, is taste. Dr. Revolt has

written that Rick "has the ability to pick out the exquisite from an urban sea of the mundane." True, but Rick doesn't stop there. In his books, Rick groups together and reassembles his exquisite images into a seductive world of his own, a world in which one is simultaneously surprised and delighted to find Method Man and a neighborhood character named Stank-Breath Mahoney sharing a stoop—and a joint—in the Village.

In the final analysis, Ricky may be more an entertainer than a photographer. Certainly, he is the only one of the photographers under discussion here who routinely builds photos of himself into his collections. Then again, this is just another way of talking about KRS's little dog.

With the publication in 2001 of *Back in the Days*, a book of photos shot between 1980 and 1989, **Jamel Shabazz** came out of nowhere to establish himself as one of the great chroniclers of hip-hop's "golden age." An African American born in 1960 in Red Hook, Brooklyn, and raised in Flatbush, Jamel's aesthetic has always been informed by racial pride. Although his father was a Navy photographer, Jamel's own fire was lit as he looked through the photo album of a young Brooklyn gangster and his crew. These were, he writes, "powerful photos of the Jolly Stompers standing tall and looking strong, with oiled beaver hats, tailor-made pants, 'Playboy' shoes, mockneck sweaters, and so much more. . . . I left feeling a strong sense of purpose. As soon as I got home, I snatched up my mother's 126 Kodak Instamatic camera and started my photographic journey."

At the dawn of the eighties, with a new generation of crack-obsessed gangsters coming of age, Jamel undertook a "simple" mission:

> to travel throughout the city and capture the beauty and true essence of a people, starting with the teenagers. . . . Guns were now readily available and most of [the young gangsters] had one or two. It was my desire to point them in the right direction. . . . I would sit and vibe with them, give them a few dollars, and try and turn them on to chess, jazz, and orange juice. I felt like Noah, warning of troubling times ahead. . . . Everyone assured me that they'd be all right. As I photographed them, a feeling would come over me that it could be the last time I would ever see them.

But Jamel kept his creative endeavors to himself while he raised a family, working a day gig as a corrections officer, first at Rikers Island, then at the Manhattan Detention Center. It wasn't until he'd completed twenty years of service, with his retirement and pension in sight, that Jamel decided to pub-

lish *Back in the Days*. The book hit with the force of revelation. All of his subjects were anonymous; there wasn't a single celebrity performer in sight. Yet all of them, seemingly, possessed blazing style and originality.

You can call Jamel a street photographer—so many of his pictures are literally shot in the street—but none of his shots are candids. All of his subjects posed for him, delighted to show Jamel who they were and what they had going for themselves. It turns out that their acute sense of fashion, their *freshness* (in hip-hop terms), was the least of it. Fab 5 Freddy has written that Jamel is "a man in love with his people," and one is staggered by the humanity of the kids in his photos, by their self-possession, their toughness, their humor, and their optimism—by their beauty, in a word. Jamel's photos demonstrate, as nothing else has, that hip-hop is a culture that emanates from young people of color, and that that culture's stars are simply its best-known representatives.

Ernie Paniccioli has been a fixture within hip-hop circles since at least 1989, when he became chief photographer for *Word Up!* magazine . . . although the opportunity to see his work whole didn't begin properly until the publication of *Who Shot Ya: Three Decades of Hip-Hop Photography* in 2002. Born in Brooklyn in 1947 of mixed Cree Indian and Italian heritage, Ernie was a first-generation rock 'n roller and jazz head before he began documenting hip-hop. Indeed, he has written of the early hip-hoppers that "seeing these kids and their energy reminded me of Little Richard, who was that metaphorical piano falling off the building or that gunshot that makes you duck." Ernie's midsixties stint in Vietnam was also clearly influential to him, not least because his basic demeanor at hip-hop shows has always been that of the dark-humored combat photographer. "I wasn't a great photographer," he's said of his first forays, "but I did have a camera, lots of film, and the balls to go anywhere and do anything."

But a close look at Ernie's work reveals someone who appreciates—and, indeed, loves—hip-hop in all of its manifestations. Of course he deserves props for having captured dozens and dozens of the world's greatest rappers and deejays at the height of their fame. More impressive, perhaps, is the time and effort Ernie has put into documenting hip-hop's less commercial manifestations: the late-eighties hip-hop fad for customized graffiti blue-jean jackets, or the eternal and ever changing vogues for the hairstyles, tattoos, jewelry, and sneakers sported at any given moment by fashion-conscious youth of color.

One of the very earliest and greatest of hip-hop's photographers has been unknown until very recently. Unlike many of the other photographers described here (with the exception of Jamel Shabazz), **Joe Conzo** is a pure

product of the culture. A Nuyorican born in the Bronx in 1962 and a high school classmate of the Cold Crush Brothers, Joe shot a trove of superb black-and-white photos between 1978 and 1983—then got swallowed up by the crack epidemic. (For a while he sustained a dual career as a photographer and a drug dealer. He was known during that period as Joey Cocaine.) It wasn't until 2005, when a Swiss collector named Johan Kugelberg made Joe's photos the centerpiece of a great London-based exhibit called *Born in the Bronx: A Visual Record of Rap's Early Days* that Joe's achievement was revealed to the world.

His drug days far behind him, Joe Conzo today is an amiable and modest fellow. "I had no formal training, no nothing," he's said of his early development. "I just enjoyed taking pictures." But he was certainly in the right place at the right time, and he had talent. His work is great: here are the Cold Crush at Harlem World (posing in the kind of elegant gangsta wear that would be popularized fifteen years later by Biggie Smalls), Busy Bee rocking the Bronx River Community Center in 1981, the Fantastic Five playing ball on the set of *Wild Style*. All of these photos are well-composed, well-lighted, supercrisp, and vivid.

But that's not to discount Joe's shots of young people at play who weren't celebrities, or of the Bronx itself at the moment when it was the national poster child of urban decay. Consider his photo of a rubble-strewn lot ringed by a quartet of burned-out brick buildings. In the foreground is a car that has not been dismantled so much as picked clean—stripped of its tires, its doors thrown open, both its trunk and hood popped. It is as raw and desolate an image of New York as anything shot a hundred years earlier by Jacob Riis. It also helps us to understand one of hip-hop's central paradoxes—it was an arid landscape indeed that gave birth to this endlessly fertile culture.

The miracle is that any of Joe's pictures survived. Both Easy A.D. (Joe's old high school pal from the Cold Crush) and his grandmother Dr. Evelina Antonetty (a well-known community activist in the Bronx) took care of Joe's negatives when Joe himself was in no condition to do so. Many of Joe's priceless "old-school" photos had never even been printed until recently.

Here are some shorter appreciations of photographers whose work in hip-hop is deserving not only of further study but also of exhibitions, books, pots of gold—the whole *shmear*.

Although neither of them is Black, **Michael Benabib** and **Al Pereira** worked for competing Black teen monthlies—Michael at *Right On!* Abd Al at

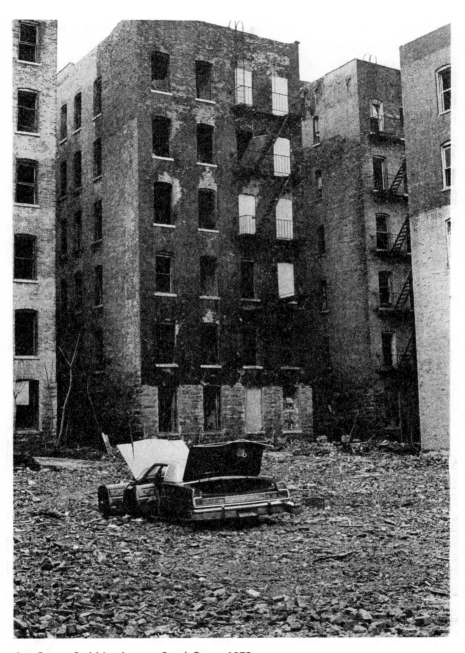

Joe Conzo. Stebbins Avenue, South Bronx, 1978.
© Joe Conzo.

Black Beat—from the mideighties onward. Both are wonderful photographers. Like Ernie Paniccioli, Al shot a thousand live shows. He's great in color, but even better in black and white. Some of his shots—Big Daddy Kane sitting pensively as his hip-top fade is given a careful shape-up in 1989, Grandmaster Flash posed alongside the Chrysler Building in 1991—feel both newsworthy and timeless in the style of the great photojournalism published by *Life* magazine in its glory days. Al also shot one of the only photos ever of Tupac and Biggie Smalls together.

Michael—who's great with black and white, but even better with color—spent most of his time on location and in his studio. As "the unofficial staff photographer" for the Def Jam, Uptown, and Bad Boy labels—as well as for the Flavor Unit management firm—Michael made great shots not only of such artists as LL Cool J, Mary J. Blige, and Queen Latifah but also of such powerful music business executives as Russell Simmons, Lyor Cohen, and Puff Daddy. In a photo shot in Harlem in 1995, Michael also captured Tupac at his most iconically "gangsta"—blunt in one hand, "40" in the other, his shirt pulled up to reveal a large "Thug Life" tattoo etched across his sculptured abs . . . and on his beautiful mug an expression of the purest implacability.

Coreen Simpson, a Harlem-based fashion photographer, was also freelancing for the *Village Voice* when she inaugurated her "b-boy series" in 1982, an astonishing and important project to which she is still adding images more than twenty years later. Reflecting on the series' longevity, Coreen herself says, "It's not an Eighties thing, it's a thug/roughneck thing." In a review of some of this work for the *New York Times* in 1991, a frankly incredulous critic named Vivien Raynor sniffed that "Ms. Simpson gives her subjects the Irving Penn treatment, and the results . . . are impressive." Keith Woods of the Jamaica Arts Center, a cooler head, suggested that Coreen was "one of the earliest fine arts photographers to legitimize the styles of young urban teens by placing them in the more structured museum world." My view? Coreen's black-and-white studio shots of young people of color are as deeply soulful in their own way as the street photography of Jamel Shabazz.

A graduate of Rutgers University and New York's International Center of Photography, **Chi Modu** was the photo editor of *The Source* magazine between 1990 and 1997. In his opinion, these were hip-hop's "defining years." Of the scuffling early nineties, he says, "I remember riding around L.A. in Puffy's VW Rabbit, and it had holes in the roof." By '97 the culture had become quite mainstream, "where you started to see Snoop on the cover of

Newsweek, CNN doing items on hip-hop, and videos on MTV to the extent that you see them today."

Modu enjoyed early access to a number of the nineties' most important rappers: he shot many sessions with Tupac, including one in Atlanta in '93; many sessions with Snoop Dogg, including one in L.A. in '93 in which the rapper is aiming a gun at the camera; Method Man on Staten Island in '93; Mobb Deep on a New York City subway car in '94, etc. Ultimately, his photos would land on the cover of *The Source* more than thirty times.

In '98, after leaving *The Source*, Modu founded his own stock photography company, Diverse Images, which boasts more than two hundred thousand images of subjects of color—"not just African-Americans," he says, "but Asian people, Latin people, and other groups that are underserved photographically."

A kind of West Coast counterpart to Chi Modu, **Brian Cross**—whose *nom du camera* is B+—was the photo editor at *Rappages* magazine in Los Angeles between 1993 and 1997. Born in Ireland, Cross came to America in 1990 to study photography at the California Institute of the Arts. While at CalArts he began work on a graduate thesis entitled "It's Not about a Salary: Rap, Race, and Resistance in Los Angeles," a work of serious political, sociological, and musical scholarship that was published in book form in 1993.

Of his photography, Cross has said, "I prefer to take a still in a room of a few unknowns rather than take photos of people that already are photographed everywhere." He has shot album covers for artists ranging from the Freestyle Fellowship, Mos Def, and RZA to Blackalicious, South Central Cartel, Jurassic Park, and Dilated Peoples.

David Corio, born in London in 1960, has been a professional photographer since he was eighteen years old. He works strictly in black and white, seems to concentrate on portrait photography and concert photography, and is amazingly prolific. Although he is not himself of African descent, David's specialty has been the musicians of the African diaspora. In 1999 he published *The Black Chord*, a volume of hundreds of beautiful photos of the great stars of blues, gospel, jazz, R&B, reggae, rock . . . and rap (with an equally wide-ranging accompanying text by the critic Vivien Goldman). Between 1982 and 1988 David shot a number of important American hip-hoppers in London, including Bambaataa, the Fat Boys, Run-DMC, Jazzy Jeff and the Fresh Prince, Eric B and Rakim, Public Enemy, KRS-ONE, Big Daddy Kane, Biz Markie, and Roxanne Shante. He moved to New York in '92 and, between '93 and '98, captured De La Soul, Ice-T, PM Dawn, the RZA,

the Fugees, Doug E. Fresh, the Wu-Tang Clan, the Notorious B.I.G., and Missy Elliot, among others.

Jonathan Mannion may be the premier big-ticket hip-hop photographer working today. He combines Ernie Paniccioli's work ethic and love of hip-hop with Annie Leibowitz's ability to create truly sumptuous and revealing images of his subjects. A student of Richard Avedon, Mannion launched his career with the cover photos for Jay-Z's *Reasonable Doubt* in 1996. A measure of the respect and affection the photographer generates within the hip-hop community is that he is referred to as "Jigga Mannion" by legendary graphic designer Cey Adams (who frequently collaborated with Mannion).

Given more room, I'd love to sing the praises of a number of other important hip-hop photographers. For now, let's just say the following photographers are deserving of further study: **Ronnie Wright, Johnny Nunez, Ray Tamarra, Toi Sojer, Joe the Cameraman, James Hamilton, Dorothy Low, Raymond Boyd, Carl Posey, Doug Rowell, Julia Beverly, Laura Levine, Josh Cheuse,** and many others.

But let's save the last word for the one and only Ernie P. who recently composed a rant that addresses both the contemporary commercial value of hip-hop photography and the little matter of respect for its practitioners:

> To all the people who begin a conversation with me by saying, "We don't really have a budget, but we will make sure to give you a photo credit." Or "I really love your work, but my label hired another photographer and he fucked up, so can you hook us up?"—plus the hundred other wack-ass things that drip out of the mouths of folks who have never shown me love . . . here is my answer:
>
> FUCK YOU PAY ME!
> FUCK YOU PAY ME!
> FUCK YOU PAY ME!
> FUCK YOU PAY ME!

Now *that* is hip-hop.

Bill Adler has been passionately involved with hip-hop—as a music lover, critic, publicist, biographer, archivist, museum consultant, curator, and documentarian—since the release of "Rapper's Delight" in 1979. He founded the Eyejammie Fine Arts Gallery as a showcase for hip-hop's visual arts in New York in 2003.

12

Words and Images

A Roundtable on Hip-Hop Design

Cey Adams, Brent Rollins, and Sacha Jenkins

When hip-hop encountered the downtown art scene in the late '70s, before it even had a name, aesthetes like Fab 5 Freddy and Afrika Bambaataa were arguing that youth street culture was vibrant, transformational, and radical. Both pointed to graffiti as hip-hop's indigenous visual art form. If it wasn't then, it certainly has become that now. And as Manny Kirchheimer's 1980 film *Stations of the Elevated* made clear, graffiti emerged in the context of an explosion in commercial signifiers. In a billboarded environment, graffiti became advertising for the invisible.

As the hip-hop recording industry grew, and the emergence of hip-hop journalism and the desktop publishing revolution coincided, the culture's visual aesthetics became available in mass form. Magazines like *Vibe, URB*, and *Rap Pages*, then later *Trace, Tokion*, and *The Fader*, not to mention the hundreds of graf zines around the world, found inspiration in a paint-outside-the-boundaries-to-make-a-name aesthetic. During the '90s, an entire revisioning of the marketing environment took place, shifting the look of pop culture from a white suburban ideal to one that was multiracial and urban. Now hip-hop design defines the look of global youth cool, whether in magazines, album covers, or clothing, the rarefied boutique markets of toys and shoes, even high-end goods such as cars, motorcycles, and jewelry.

Thanks to Anna Alves for the supreme hustle and to Bill Adler for the inspiration.

On March 23, 2006, we gathered three icons of hip-hop graphic design at the Eyejammie Gallery in Chelsea to talk about the development of hip-hop's visual vocabulary, tensions between commercial and artistic considerations, what they like in design and what they hate.

THE PANELISTS

Native New Yorker **Cey Adams** was a 1980s subway graffiti artist and a co-founder of The Drawing Board, one of the first and most influential hip-hop design houses during its run from 1986 to 1999. His list of art-directing credits includes large chunks of the Def Jam and Bad Boy catalog, *The Chappelle Show,* Notorious B.I.G.'s *Ready to Die,* Jay-Z's *Reasonable Doubt,* and countless hip-hop campaigns.

Representing Queens, **Sacha Jenkins** is better known for his hip-hop journalism at *Vibe, Spin,* and *The Source,* but he too began as a graffiti writer during the '80s. He started the graf-based hip-hop magazines *Graphic Scenes & Xplicit Language* and *Beatdown,* before helping found acclaimed *ego trip* magazine. He now edits *Mass Appeal* magazine and has returned to his painting roots, mixing graf, characters, found art, and text on large canvases.

Los Angeles–raised **Brent Rollins** has been one of the most celebrated hip-hop designers in recent years. He was art director at *Rap Pages* (1994–1996) and now holds down similar duties for the *ego trip* collective's work in publishing and television. His credits include work for classic '90s flicks *Dead Presidents* and *Boyz N Da Hood,* Mos Def and Talib Kweli, Dilated Peoples, Gang Starr, much of the Quannum Projects catalog, and art installations for the Southern California's Undefeated Store.

JEFF: If we were to write a history of hip-hop design, where would we start?

BRENT: Graffiti is design in that it's advertising—moving billboards and publicity. I mean art is more so like, "I gotta comment about something or express something about some situation." Graffiti seemed to be, "I'm gonna talk all about myself. I'm gonna publicize myself." So if you look at design as like a vehicle using art for some particular purpose, then I would say that graffiti is probably the first hip-hop design. As far as what influenced me, I would say hip-hop flyers—like the Phase 2 flyers. There's definitely an aesthetic that developed that was unique and specific and, in terms of design, started branding the parties by using specific elements over and over again, to become recognizable.

SACHA: I think early on, the graffiti aesthetic was a big part of it. But then I think other artists—sort of wanting to break away from the conventions of hip-hop or what graffiti connotates in terms of, like, being from the ghetto—I think rappers wanted to be more affluent, sort of become more mainstream, and have album covers that spoke to mass recognition.

CEY: I was someone who wrote graffiti. That was where I got my first education about formal design. I honestly didn't even know what design was before that. And for me, I think that was the first time when I really started to think about how words and images worked together in order to communicate an idea.

There's a weird group component to graf. After you've established yourself as being a part of a group or a clique, for the sake of unity, maybe protection—whatever it was, a sense of belonging—then the next step is to immediately disassociate yourself from the group and decide, "Okay, how am I gonna take this to the next level? How am I going to brand myself as an individual? How am I going to figure out how to turn this into a career?" And the next step then immediately becomes marketing. What tools do I have that I can use to sell myself? And it lends itself immediately to graphic design because then you have to all of a sudden find a professional level for this thing that used to, to some degree, didn't have any boundaries or structure.

JEFF: How did you guys see what happened next as people started moving design sense towards doing album covers, advertisements in magazines, doing magazines themselves? Did the images become more professionalized and standardized?

BRENT: It just seems to me, outside of maybe The Drawing Board and Def Jam stuff, like a lot of design for rap album covers were done by non-hip-hop-affiliated people. In some ways, it's an outsider interpreting what "urban" is, or what "street" is. It doesn't mean that just because they weren't involved in hip-hop that it was bad stuff. I mean, Blue Note Records designer Reid Miles didn't listen to jazz.

CEY: A great example of that was the people that did the Kurtis Blow records. They just took a traditional graphic-design approach to dealing with him. They just treated him like an R&B artist. There was no distinction between him as a rapper and maybe what they would do for The Gap Band. But the thing that to me I've always found painful is when those traditional design or creative people try to put a graphic/hip-hop spin on things. Then you can tell.

And that's what happened with all the art direction from all the early break-dance records.

SACHA: In art school now, it seems as though your average art-school kid that goes to Pratt has a sense of what graffiti is like. There are elements that just creep up in regular kids now. And I think that's a part of the impact of people who knew what they were doing, who were a part of the culture. Before that, you would have some random dude who was named Huey in the art department, who was just like, "Okay, rappin'. Okay, cool." And then they would sort of get some bad faux graffiti. Anyone who knows anything knows there's a history. I mean, this "S" has a lineage to Philadelphia and how that lineage went to Harlem and how it sort of morphed into a language that those of us who are in the know—that's how we communicate with each other, from borough to borough, even now from country to country. Regular people didn't notice it. But for those of us who saw a video backdrop and knew that Cey did it, "Okay, cool. One of ours is getting his."

CEY: Yeah, I made it to the promised land. The cats that were working up in CBS when Def Jam first started, they were easily in their mid-fifties. They cared so little about the music that was being made, they didn't want to have anything to do with it. And that was the opportunity of a lifetime for me. To see these guys with their fat paychecks and their big cushy offices, and they don't know the first thing about this music. And they're not pretending to know. They just gave less than a fuck. And so it wasn't even difficult to have the opportunity because nobody wanted to do it. The first time I remember it being of importance was when Public Enemy's *Fear of a Black Planet* sold like a million copies in one week. Then all of a sudden, everybody that didn't care wanted to be a part of what we were doing. Those art directors wanted their names on those packages too.

JEFF: So you all say that there was a visual language getting created out of graffiti. What kinds of things began to constitute for you guys what looked like hip-hop? Because during the '80s, there was the clichéd graphic of a fake brick wall with—

CEY: With airbrush.

JEFF: That is sort of the epitome of what you guys are describing that wasn't us. What begins to constitute the hip-hop visual vocabulary?

121

Logo work by **Cey Adams**, 1995–2005.

BRENT: Are you saying like specific things like spray paint and paint spatters and arrows and stars and Cooper Black?

JEFF: Yeah, that's part of it.

SACHA: Well, it's just that it's crossed so many platforms now. I mean, it's skateboarding, it's fashion, it's rock. You know, it's an attitude. But the fact that skateboarders embrace it, musicians, clothing designers—I think that's become the common language.

CEY: One of the things I immediately thought about when I started to approach the idea of graphic design was that *I am hip-hop*, so I don't need to always have to show it on paper. But one of the biggest obstacles I ran into was when I was designing, people would question, "Where's the graffiti? Where's the dripping paint? This doesn't look street enough." And I said, "It's in me, and it's in the artist. Why does it always have to be on the page? Why does it have to be something that's plain to the naked eye?" And one of the things I aspired to was to be more refined, trying to do things more traditional in a design sense, because all those other things were something I could do blindfolded when I needed to. I didn't always want to have to use stencils.

SACHA: But I think a big part of it is also we learned from each other. We weren't formally trained. He didn't get into this thing because it was like a job. He got into it because, like in New York City, it was like another sport you played. I mean, you play stickball, you play football, and you wrote graffiti. It's not like this was something where like Cey Adams woke up and said, "I wanna write graffiti and become an artist." It was something that he did, that was part of his cultural experience in New York City.

Then when people started recognizing, like wow, this is art created by young people, specifically for young people, they didn't really care about everyone else. When people saw that there was something there, they're like, "Okay, let's put this in a gallery. Okay, well, maybe you can design this." But then I'm sure there was a brick wall where it was like, "Okay, there are limitations." Since there wasn't a real understanding of the culture or the history or where it comes from, there was a wall where in order to survive, in order to stay vital and/or make a living at it, people realized they had to evolve. Now, I feel it's different because the corporations will hire someone who's been doing this for twenty years, because they understand there's a history, and they understand there's an aesthetic quality to it and that there's a language. It's an energy that corporations want to tap into.

JEFF: I wanted to ask about technology, the "before desktop publishing" and the "after desktop publishing" thing. How did design change, and did computers democratize things? Do you think that it damaged or diluted the effects of what folks wanted to do in hip-hop visual art?

CEY: It took the mystery out of what we do. I mean, in the old days, you had to sit there with a sketch pad or a piece of paper, and you had to visualize what you were doing before anything else happened, and it could be a week before you saw it.

BRENT: It was about conceptualizing the idea before you actually do it. So you could argue that your final end product or what you were working towards was a lot more concrete in terms of the idea, in terms of the effect, whereas now people kinda get on the machine: "Just give me a picture." So people just slap on all these visual signifiers on top of a photo—arrows, distressed type, pain spatters—and now, "voilà," all of a sudden it's "designed." They're not doing design. They're doing ornamentation.

CEY: And also one of the things that's happened that still affects the way I work today is that everybody else around you that has no knowledge of what you're doing, they have no conceptual idea of what's involved, *they* start giving art direction . . .

BRENT: Well, they devalue it because they think it's just the machine that's doing the design. They don't understand that the machine is just a tool and, ultimately, it's something that's conceptualized.

CEY: And it's something that you can't explain to people, you know? You can't explain to a young A&R why it can't be done. And they also think it can be done even faster. It killed the whole way in which design was done. They took all that conceptual time away, and now it's all about just, "Screw you, get it done, you've got two days. I've seen you do it."

BRENT: I think it democratized things, but the problem is people haven't even really tried to push the technology because they don't have an understanding of what you're supposed to do with that technology. I mean, you can break the rules, but you still need to know what the rules are.

It's just made more crap. And like I said, it's taken the idea of design to the idea of ornamentation. I mean, like, let's put some stars on it, let's put some Photoshop effects on it, and now it's design. It's not design if you merely put

Work from the **Brent Rollins Design Explosion**, 1994–2006. *From top left:*
Dilated Peoples' *20/20* album cover. Mos Def & Talib Kweli's *Are Black Star*
album cover. Lyrics Born's "I Changed My Mind" twelve-inch single cover.
Rhymefest's *Fever* CD cover. Gang Starr's *The Ownerz* album cover. Ricky
Powell's *Frozade Moments.* Rap Pages' *Big Pun* layout. Rap Pages' *Pharcyde*
cover. Ego Trip's *Big Book of Racism* cover. Installation for Undefeated store,
Los Angeles. Diverse "Jus Biz" twelve-inch-single Blackalicious *Nia* album
cover. Spank Rock's *YoYoYoYoYo* album cover.

some eye distractions on the page. You didn't think about, "What am I trying to do with this?"

A really good example of graphic stuff is if you look at Cuban posters from the '60s and '70s. Those are graphic solutions. They communicate an idea. They distill an idea. That sort of thinking doesn't pervade a lot of stuff that's geared towards the hip-hop audience in terms of rap album covers.

The computer also ruined things in the sense of, like, you know all that Pen and Pixel shit? I remember when I worked at *Rap Pages* how much I hated those ads. It's just funny, because if it wasn't for technology, that aesthetic wouldn't exist, and now that aesthetic is all over the damned place.

JEFF: But it's also considered vintage now.

CEY: It still doesn't make it good. What the technology has done is it's put people that normally wouldn't have an interest in design in the position of a designer. Some of the stuff people do with Photoshop is just absolutely painful. I was gonna reference Pen and Pixel as well. I don't question that their heart was in the right place, but I thought what they were doing set design back, like, a hundred years. What was really bad about it was that they had access to artists, and for whatever reason, that's what people thought hip-hop design should look like. What they were doing and what we were doing at The Drawing Board, they were like polar opposites. I lived to defeat those guys in any way that I could because that was the stereotypical concept of what design is, and it still lives on to this day. You have to acknowledge that Pen and Pixel had a major influence on the way people see what we call hip-hop design.

JEFF: Do you want to defend Pen and Pixel Design at all, Sacha?

SACHA: Uh . . . it's entertaining. But I mean for me, how I got into this whole thing was as a graffiti writer, and I published my own zine. And a big influence on me was *International Graffiti Times*, which was Phase 2's magazine, and I remember being a fifteen-year-old kid, and I wrote to him and I said, "You know, I really want to do my own zine," and he wrote me like a six-page letter encouraging me to do it.

I mean I was also in the punk-rock scene too—but seeing that zine really inspired me, and so my first zine was done by hand just like *IGT*. I wrote everything out, and I did interviews, and I wrote it out with my graffiti hand-style. And at the time, there was also a magazine called *Ghetto Art* out of California. Upski was doing something called *It's Yours* out of Chicago, and then Steve

Powers came maybe a little bit later, right around the same time as me, with *On the Go*, but that was it. That was the only thing going on. And I had no background in magazines. I didn't have a computer in 1988, you know what I mean?

So how things changed was, obviously, there was a demand. There was a demand for these types of magazines, and so there was advertising for it. If you wanna get more advertising, your book has to become more attractive to accommodate that. There were real deadlines, printers, and distributors and people you have to answer to now. So it has to be a little more organized and a little more centralized, and so that's where the computer came in.

JEFF: There are several stock kinds of album covers now. There's sort of the old school of very clean, like, Run-DMC's *King of Rock,* maybe the old Rob Base and DJ E-Z Rock covers, like white background, very stylized, almost like *The Face* magazine—real clean lines and clean typefaces. There's sort of the gritty realism/horror core—DMX album covers, layers of stuff, distressed graphics, gothic fonts. And then there's the Pen and Pixel vibe.

CEY: All that stuff is born out of the idea that that's what the audience wants to see. And my biggest argument has always been, you know, who's the one in charge of making that decision? Like how does anybody know that's what the audience wants to see on the cover? And I remember the thing that just broke my heart, and immediately cleared up any disillusions I had about the direction that graphic design and hip-hop was going in, was the *Doggy Style* cover by Snoop Doggy Dogg. That was the most painful thing I'd ever seen on paper, including Pen and Pixel! It reminded me that for every great piece of design that somebody does, somebody can still do one thing, and it can sell a million copies, and that's what people are gonna remember.

SACHA: So if the album tanked, it would've been all right.

CEY: Yeah, and I wouldn't even have an argument.

BRENT: The problem is the execution—it could've been a little better. I mean, it's not so much the concept of the illustration . . .

JEFF: A woman's ass sticking out of a doghouse?

BRENT: No, it's not even the ass—it's the half-assed-ness of it. It's a poorly executed illustration, and it only exists because it was done by Snoop's cousin.

Nothing wrong with nepotism, but it's not well done. The depressing part is that there's not a standard of quality that people either hold people to or aspire to or even recognize.

CEY: Just by comparison, there's an N.W.A. cover that had an illustration on it—I don't remember the title of the record—but amazing cover!

BRENT: *100 Miles and Running.*

CEY: And that was another example of somebody that they wanted an illustration, and you know what they did? They got an illustrator. When we did the EPMD cover for *Business As Usual*—

JEFF: With comic-book artist Bill Sienkiewicz's painting? Classic cover.

CEY: And he did just such an amazing job. So just because it's hip-hop, it doesn't have to be ghetto. And that was one of the things that bummed me out because everything that we did, we tried to elevate what people thought of Black music from a visual perspective, and then you always had somebody that was reminding us that we hadn't done enough. And to this day, nobody remembers the EPMD cover. Nobody remembers the N.W.A. cover. But everybody remembers that Snoop cover.

SACHA: But then Big Daddy Kane went on the *Arsenio Hall Show,* and they had SLICK who was a pretty prominent West Coast writer. And Kane refused to come on the stage, and he wanted the whole backdrop tore down, and I remember Arsenio interviewing him, "So Kane, why were you so offended by the graffiti backdrop?" And he was like, "Yo, why it gotta be like graffiti, from the ghetto? I'm not about that, you know what I mean? I'm Big Daddy Kane, you know what I mean? I got ladies, you know what I'm sayin'?"

BRENT: He felt it was stereotypical. On the other hand, the other irony is this—SLICK is dope. So it's about being able to discern what's quality and what isn't. And being critical about it. And not standing for wackness. Let's just talk about another element of design, and this is like a pet peeve. You look at graphics for Roc-A-Wear. That's graphic design applied to clothing. And that shit's awful. There's this celebration of stuff that's just not good. I don't understand how people can't see that it's just not a very good design, it's not a very good logo. In music, at least, there's like an understanding in the production like, "That's

sloppy. That's tight." People can discern in music how much effort went into the precision of it.

JEFF: This is a really interesting argument that you guys are making because it would seem that this explosion of visual images about hip-hop would actually leave people a lot more educated about the visual vocabulary, the visual language. Compared to like 1988, there's so much more visual input. I mean, even in a five-second MTV bumper, there's more visual output in those five seconds than in entire issues of *Vibe* from 1992.

BRENT: See, I'm conflicted about how people feel about it. For instance, when *Vibe* came out, the whole idea was it was supposed to be this whole downtown, high-art thing. And you had people who wanted to be in that magazine because of the presentation. But then you don't have a holding of that standard.

A lot of music videos, visually, you see are very sophisticated. But then, in terms of packaging, I feel kinda like Black people are on some like "If it's white, it's wrong"–type shit, where if it looks like it's too produced, then there's a distrust about it. It's almost like it has to be ghetto for it to be Black. Or for it to be authentic. You know, it has to be poorly done almost. So it's like this weird thing I haven't been able to figure out.

SACHA: Well, I think it's because these are products. And you think about the people who are putting them out there: they have no real interest in really connecting with people of color.

BRENT: And they're products, as opposed to like their videos, whereas it makes them look good. Maybe that's what it is.

JEFF: But videos are products too, in a way.

BRENT: Yeah, but they look at it as "I get to put my face all up on the screen and become famous, so I wanna look as good as possible on TV" versus there's no value in having a CD other than selling it. I mean, I don't know if they look at it as this is something you wanna keep and something you wanna value.

CEY: And that certainly goes back to the early days of design, I believe, and collecting records, is that you were proud to own that record. Everything

about it meant something to you as a kid. You would read the liner notes. It was something that you really cherished. And that all went out the window. When we were designing in the early days, we had so many formats. We had the cassette. We had the twelve-inch. And then we had the CD *and* the long box. And you had to conceptualize how you were gonna translate that message across a couple of different platforms, and it was great because it just kept you sharp and you also took what you did very seriously. And I get a sense now that young people are working so quickly, and there's so many people that call themselves art directors and graphic designers and creative directors, that there's just no rules anymore, and it's really painful because there's nobody you can complain to.

SACHA: I just think at the end of the day, these people have no real interest in our communities, and they want the sale. And they know that Black people like grape juice, so just keep it grape. Why deviate from the program? I mean, you look at rock 'n roll: I could be in a punk-rock band and have a diamond on my cover, and no one's gonna say anything. In rock and other genres, you can put a dinosaur on your cover, you can put a hamburger on your cover, you can do anything. You can have some graffiti on your cover or not. But if it's related to people of color, they don't want it to deviate too far. Because they don't understand, nor do they care. Ultimately, they wanna make a sale. That's all they want. And unfortunately, people of color are in situations where they need to make money, and they're not in positions to say, "This is what I really want." So it's all in packaging, and it's all in how to make it as sexy as possible, in a way they feel it won't alienate people of color.

CEY: And theory is always, "I'll change once I'm there, when I'm in a comfortable-enough position—"

BRENT: I'll take the risk when it's not a risk.

CEY: When it's safe. And ultimately, that day never comes. Because the minute you make it, you have too much to lose. I remember having conversations with Russell Simmons having to justify why things *don't* have to look a certain way. And I remember him once saying to me, "I'm paying you too much money to put a photo on a piece of paper and put a name on top of it."

One thing I really dig is the Albert Watson photographs of LL Cool J for *14 Shots to the Dome*. But we didn't use them for that because, you know, he's LL!

We ended up going with one of Glen Friedman's photographs, which is fine, but we ended up using it on LL's greatest-hits package, *All World*. It was one of the first times that I got to do an album cover with no type on it. That's something that you're getting one shot in a lifetime. And I thought, there's nothing that I can do to do justice to his work but to leave it alone. You got to know when to get out of the way sometimes.

BRENT: It's about making a decision what's the best way to present this artist or this product. In that case, you made the decision that this is the best way to do it because LL is a logo in and of himself, so why do you need to put more information?

CEY: Exactly. And the hardest thing is selling that idea to somebody. Minimalism is the most difficult thing to get across, because it's so plain to the naked eye that people just want more, more, more.

BRENT: The problem is that people equate value with more. They don't value the thought process. They want to see physical examples of how much time you spent on this thing. Let me see some labor. Physical labor equals value versus mental labor.

JEFF: A lot of people have branched out from working in the magazine industry or the music industry into applying design to toys or furniture or fashion or clothing. Is there a future for hip-hop designers in those kinds of fields, as opposed to slaving away for a publisher or an A&R person?

BRENT: Yeah, that's what's kinda cool. It's like hip-hop doesn't have to exist only in the music industry. It became a worldview—in the sense that I can have a hip-hop-centric table or piece of furniture. Just the idea of toys, to me, is a pretty radical sort of thing. It's like creating your own world.

CEY: For me personally, maybe that transition came out of necessity. The music industry used to be very lucrative, like, years ago. Then there was a decline in sales. They stopped giving out big contracts to design houses. And also there's a younger generation that is coming up that will undercut you, so you're forced to tighten your game up, but also look in other areas because the money wasn't there anymore. For me, it was a combination of that and I wasn't having the same freedom that I used to have. So it was interesting to look to other areas to be able to find ways to be creative the way I was in the

early days of hip-hop. And that's really all it is for me and applying that to clothing or shoes or skateboards or soft drinks or whatever.

SACHA: The language is here. The culture is here. It's not going anywhere. And as more people understand the vocabulary and the more people communicate amongst one another with that language, you know, these people are coming from all walks of life, it's gonna to show up in their interests. It's gonna show up in what they do as writers, what they do as dancers, what they do as graphic designers. I just think it's a part of the American conversation.

And for me, going back to 1988 when there were maybe two or three zines, they were all black and white. Now, you've got zines around the world, full-color, each representing very distinct styles from those regions. With my eye, I can still see the connection between what people were painting on subway trains here in 1972 graphically to what people are painting in Sydney. So to me, the language is global now.

JEFF: Artists used to spend a whole lifetime creating a particular style. These days, art by folks like Ryan McGinness or Kehinde Wiley might be absorbed into MTV or VH1 and disseminated through the culture in these little five-second bumpers. Then as artists, they literally have to reinvent themselves. So my question is about the impact of globalization and the speed with which all of these images get generated and consumed by the culture. Does that cause you guys any kind of anxiety? You want to get your vision out there, and you want a lot of people to be able to see it, but at a certain point, your art kind of gets devoured by the beast.

BRENT: I think you have to know that your shit's gonna get bitten by people and it's also gonna get exploited by people. You put an idea out there, it's not yours anymore. It's gonna go places. That's the whole point. If you're a creative person, and you have enough confidence in yourself, you just keep doin' what you do, you know what I mean? You're gonna create what you like, and you're gonna love it, and you're gonna wish you that could hold on to it. But you can't hold on to it. So you just gotta keep movin'. You gotta hope that you have ideas that are strong enough that they can: (a) stand the test of time and (b) stand the test of now.

CEY: I think a lot of creative people struggle with that. I'm never really that worried about people copying stuff, because if they can build upon it, then God bless 'em. But it's tough to stay current and yet not follow trends.

BRENT: People who are the consumers need to realize if someone's being lazy with their ideas, you have to question the sincerity of what it is you're looking at and who that creator is. Cuz it's like if you're just doing that, then why am I supporting you? I mean, people shouldn't support that shit. Unfortunately, it's candy to people. It's unfortunate because the United States is basically built on disposable culture. It's even more so upsetting because if you're thinking about hip-hop, and you're thinking of the *core* hip-hop audience, not the larger hip-hop audience, that's the Black culture, and Black culture is very disposable.

JEFF: The last question is, name one or two of the best pieces of hip-hop design over the last thirty-plus years.

SACHA: For me, it's always gonna be the stuff I saw on trains, whether it was good or bad. It was sort of the attitude that sort of inspired a lot of what I do now. One album cover that comes to mind is the Pharcyde's *Bizarre Ride II the Pharcyde* by SLICK. It was classy and classic; it had graffiti elements in a way that was very tasteful, that wasn't exploitative and didn't seem forced. It seemed really organic to the group and where the music was coming from.

CEY: For me, one of the things that I still to this day find absolutely amazing and still so pleasing to the eye is the Public Enemy logo. Chuck D had insight early on of how important it was to have a mark that was stronger than the band. And in some ways, that logo is synonymous with hip-hop itself. Black men are a target, beginning and end, 'nuff said. The idea that he came up with a way of visualizing that—to me, it surpasses everything that's happened since.

BRENT: For album covers, outside of the stuff that Cey did, I'm particularly fond of the second Cypress Hill just because it doesn't look like a hip-hop cover. It did not rely on hip-hop-design stereotypes or clichés. By now a lot of that has been cribbed and they've begat their own clichés, but for me at the time that shit was a big deal.

The thing about hip-hop is it's always reinventing itself, and that's kind of what's exciting. There's always gonna be new shit, and there's always gonna be stuff to look forward to. Some of it's gonna be good, and some of it's gonna be bad.

13

Between the Studio and the Street

Hip-Hop in the Postmillennial Visual Arts

A Roundtable Curated by Lydia Yee, with Nadine Robinson,
Sanford Biggers, Luis Gispert, and Jackie Salloum

At the turn of the millennium, both the Brooklyn Museum and The Bronx Museum of the Arts presented exhibitions meant to capture the impact of hip-hop culture on the arts. Organized by the Rock and Roll Hall of Fame and Museum, the Brooklyn Museum's presentation of *Hip-Hop Nation: Roots, Rhymes, and Rage* (2000) was a nostalgic but curiously static look back at the rise of hip-hop, primarily in New York City. By contrast, the Bronx Museum's lively exhibition, *One Planet under a Groove: Hip Hop and Contemporary Art* (2001), put together by curator Lydia Yee and independent curator Franklin Sirmans, highlighted hip-hop's influence on contemporary art. These visual artists, Yee and Sirmans argued, sought to "reframe the discourse of identity politics in a global era and to expand the art historical discourse."

On May 18, 2005, Yee hosted a panel of four highly acclaimed emerging artists. What follows is an edited transcript of that evening.

THE PANELISTS

London-born, Bronx-raised **Nadine Robinson** creates mixed-media installations that use sound to explore intersections between Black music culture and

Special thanks to The Bronx Museum of the Arts and the Ford Foundation, and to Dave Tompkins for the transcription.

monochrome painting, and she has had numerous exhibitions in the United States and Europe, including a solo show at the Institute of Contemporary Art in Philadelphia. She was a recipient of the 2003 William H. Johnson Prize.

Los Angeles native **Sanford Biggers** makes sculptures and installation that draw from a diverse range of sources, including Eastern religions, Black vernacular expression, process and performance art, street culture, and new technologies to look at everyday experience and the interconnectedness of people and cultures. He's had recent solo exhibitions at the Berkeley Art Museum, the Contemporary Art Center in Cincinnati, and the Contemporary Art Museum in Houston.

Luis Gispert was born in New Jersey and raised in Miami. His photographs and sculptures synthesize hip-hop's visually baroque aesthetic with art-historical references ranging from Renaissance paintings to early modern furniture. He's had solo exhibitions at the Whitney Museum of American Art at Altria, the Berkeley Art Museum, and the Museum of Contemporary Art, Miami.

Raised in the Detroit-area, **Jackie Salloum** is a Palestinian/Syrian American artist and filmmaker, and she explores the language of pop culture to pressing political issues such as the Palestinian struggle and the representation of Arab identity. Her feature documentary, *Slingshot Hip-Hop*, covers the emerging hip-hop scene in Palestine.

LYDIA: Collectively, the individual histories of the four artists on this panel reflect the emergence and development of hip-hop culture. Nadine moved to New York with her Jamaican immigrant family as a young girl in the '70s. Sanford and Luis came up in Los Angeles and Miami, respectively, where rap music developed distinct regional flavors in the '80s and early '90s. More recently, we have witnessed the internationalization of hip-hop culture, which is exemplified by Jackie's documentary on the hip-hop scene in Palestine.

Though these artists were raised in different parts of the U.S., they share certain generational experiences. They were all born in the late '60s or early '70s, came of age during the post–civil rights era, and were in grade school during the old-school era. They attended art school in the '90s—which was kicked off in high form with the 1990 exhibition *The Decade Show: Frameworks of Identity in the 1980s*, an unprecedented collaboration between three forward-looking New York City art museums at the time—The Museum of Contemporary Hispanic Art, The New Museum of Contemporary Art, and

The Studio Museum in Harlem. This was a very lively survey of the multicultural '80s, and it really put pressure on more established institutions to open up and to step up to the challenge of presenting art in an increasingly diverse cultural context.

The multicultural discourse and the theoretical debates of the '80s were, in fact, beginning to make their mark on some more established institutions. The Dia Center for the Arts organized a very innovative series in the late '80s and early '90s called Discussions in Contemporary Culture with such progressive projects as *Democracy: A Project by Group Material* in 1990, *If You Lived Here: The City in Art, Theory, and Social Activism—A Project by Martha Rosler* in 1991, and *Black Popular Culture: A Project by Michelle Wallace* in 1992.

Also the Whitney Biennial of 1993 was probably the most diverse biennial in that institution's history. Certainly, it was the biennial that changed the way people looked at and thought about contemporary art. Not only were the artists who participated in the exhibition of diverse backgrounds but the issues dealt with in the exhibition were very pressing. An example of a work in the show was Pepón Osorio's *The Scene of the Crime* (1993), which is now in The Bronx Museum's collection. Osorio created a Puerto Rican living room decorated from floor to ceiling with kitschy furnishings and objects, and in the middle of it all lies a mannequin covered with a sheet. At first it might seem like a stereotypical scene that you might see in a movie. And in fact the installation was arranged like a movie set, with lights, cameras, and other equipment set up around the room. Another controversial work from that biennial was Daniel Martinez's museum buttons made specifically for the show that read, "I can't ever imagine wanting to be white."

These and other works were excoriated in the press as "victim art," and I think it really changed the discourse among visual artists. Museums started to retrench because of this external criticism, and artists were also concerned about being labeled as a Black artist, as a woman artist, as an artist who deals with AIDS, etc. So these subjects became taboo, and it's this context that our panelists began working in, graduating from art schools and starting their careers. So we turn to the artists to see where the legacies of the '80s and '90s have taken us.

NADINE: I came here to the Bronx in '77. At that time a lot of Jamaicans were emigrating to the North Bronx. I was the good English Jamaican student in Catholic school. I was always a good student but at the same time inherently a part of hip-hop because those were my neighbors. Seeing Heavy D at local

Nadine Robinson. Rock Box #1, 2005—six rhinestones, plastic, speaker, amplifier, digital music, 18 x 18 x 7 inches. Courtesy of the artist and Caren Golden Fine Art, New York City.

parties and him trying to date you, or going to Mount Saint Michael Academy where Sean Combs went to school. You see them develop into these icons, and so this is how I view the possibilities out there.

I studied art in the early '90s and was moved by the '93 Biennial as well but thought it was too didactic and too academic. I wanted to do work that didn't say "I'm a Black woman," but still be proud of where I was coming from. At the time, I was in the Bronx watching my cousins make sound systems. I saw the same sets being built in Jamaica and also in Brooklyn. I'm around this growing up, I'm studying fine art, and I want to make art that includes this part of my world.

I was taking the #2 train from the Bronx all the way to MOMA (The Museum of Modern Art) and looking at the art in that place and seeing there were really no Black faces. I didn't really see Black art until the early '90s. I was in my late twenties and now making art, and I was going to be heard. Hip-hop was about grabbing the mic—so I grabbed the mic and made these paintings I call "Boom Paintings" or sculptural installations and let my voice be heard.

My sound system, *Tower Hollers* (2001), showed at MOMA, and it definitely drew everybody's attention. It's big and obnoxious! It's the largest sound system I've done to date—made up of 455 twelve-by-twelve-inch speakers that are attached to twelve record players with custom pressed records. It's kind of a huge musical instrument around forty feet long and twenty feet high. It's wired like a Christmas tree and plays the same song, but eventually the motors sort of lag behind each other so it has a little reverb effect, like an echo, a wailing wall.

I began *Tower Hollers* on a residency program in the World Trade Center, and it combines not only my interest in the formal aspects of the sound system but also the issue of class. I am working class and feel acutely aware of it in the museum or the art world. At the same time, it correlates to my idea of Jamaican sound systems that are called "Houses of Joy." These huge master sound sets in Jamaica were massive speakers that would draw everyone from around. You'd to run to where you hear the sound, and it's a freak sound, and you would know this particular dub sound.

SANFORD: I grew up in Los Angeles, and for me, my earliest impressions of rap, I should say, because I don't think we were calling it "hip-hop" yet, would probably be '79 or '80. My oldest sister, she was going to school on the East Coast, and she would always come back home with all these mix tapes from whatever the DJs were playing back east—from that moment on I was hooked. I started b-boying really early. Graffiti is how I started getting into the kind of artwork I do now. Also I think from an early age, I looked at hip-hop as not just the music itself but the latest installment in a long tradition of African American vernacular culture. Going to the barber shop, listening to the guys talk—that was the same thing as rap—listening to Gil Scott-Heron, Last Poets, people capping on each other or playing the dozens. These were all things that had that same sort of competitive yet playful braggadocio you find in hip-hop. Around 1987 or '88, when Public Enemy started to be played, I really got into the idea of the message behind hip-hop and the use of it as a political force.

At that time, I was doing what is now considered "Black Romantic" painting. I was making oil paintings of historic Black figures—Harriet Tubman, Malcolm X, and so on—and I realized when I did those paintings people were asking, "Who was that?" So that was a way for me to communicate with and educate my friends, and this is exactly what the music of Public Enemy was doing for me at that time. Later on I moved to Japan and got very influenced by Buddhism, and the way that internationally hip-hop was being co-opted—not necessarily co-opted but borrowed, added on to, and modified by various cultures so that theoretically I believe I can go anyplace in the world and find b-boys and b-girls.

Some of my work deals with the syncretism of many different cultures, but often I make connections between modern art and historical works. At a certain point, I wanted to get away from making images with really direct references to people per se, to myself and to things that looked a lot like me. So I guess I started to sublimate those ideas in the use of pattern, in this case, in the use of the mandala. A mandala is basically a circular diagram that works as a portal from one universe to another. I started making these dance floors that look like Buddhist mandalas. I made a sort of pantheon of dancing b-boy Hindu gods and, in this case, a Shiva figure with several arms doing a head spin.

I made a dance floor, sixteen feet by sixteen feet, and it was shown here at The Bronx Museum in the *One Planet under a Groove* show. But before it made it to the museum, it was at the Battle of the Boroughs b-boying competition and was the official dance floor for the contest. Whenever this floor travels, it picks up the scuff marks each time people perform on it. Everywhere it goes—Munich, San Francisco, Minneapolis, Paris—at every opening, local b-boys come and dance on the floor. So it's starting to become a time capsule for all these movements—I guess an artifact of this urban ritual.

I was in Budapest to do a project for three months with Hungarian b-boys. No one believed that they were there. So I got to Budapest, and the second afternoon I walked around and saw a few skateboarders. I followed the skateboarders and asked the skateboarders where the dancers were, and of course they were like, "Oh, go to the tunnel at 4:30. That's where they battle." Boom—I found breakdancers.

I worked with five of these dancers: two were breakdancers, and three were modern dancers that fused *Capoeira* with Hungarian dance, breakdancing, and modern techniques. And they danced within the mandala, but around

Sanford Biggers. Creation/Dissipation, 2002. Video stills from performance; 13 minutes. Courtesy of Sanford Biggers and Trafo Artspace.

five minutes into the performance they start to freestyle and battle. They completely destroy the mandala, which is basically a universe, so they destroy the universe. And I sweep the whole thing back and start to draw another one. And then they start all over again.

Around the end of 2003, I made a ceremonial Buddhist bell, and this is used as a household altar to give homage to dead ancestors. But to fabricate this bell I took hip-hop jewelry from Harlem and from Tokyo and worked with a few different shops in Tokyo to melt down all the silver and the gold from that bling-bling jewelry to make this bell. So what is inscribed on the bell in Japanese is "Hip-hop *ni sasagu*," which means "In fond memory of hip-hop."

I took the bell to a Zen temple outside of Tokyo and worked with the head monk of that temple and fifteen other people to create a huge bell orchestra. We were all playing bells of different sizes for ten or fifteen minutes. The idea of this was to actually say good-bye to hip-hop because a lot of people have talked about the original spirit behind hip-hop being dead.

LUIS: I was born in New Jersey to Cuban parents, spent a few years in Washington Heights, and then moved and basically grew up in Miami. Miami created a strain of hip-hop known as booty bass, which started in the mid-to-late '80s. It had a lot of connection to New York electro, and it was made famous nationally by 2 Live Crew. What always attracted me to booty bass was that unlike the hip-hop coming out of New York, it wasn't so much about the narrative of the story. It was more about the beat, the sound, the volume, and out of that—as when Nadine was working with the Jamaican sound systems—I was attracted to the stereo car culture, which was creating loud sound systems in cars. That's how I got into that whole culture and participated in it all throughout high school. It wasn't until Public Enemy, as with Sanford, when Chuck D started to say things to me beyond what I was experiencing through the very basic booty bass.

My work ranges from all mediums to film and sculpture and photo. One of the things I started to do with my work is not so much try to mimic or make hip-hop but in a way reference, not illustrate, it but make something new that connects to hip-hop and other things in the world.

I did a series of images of fictional cheerleaders that were all non-American cheerleaders—Asian, Hispanic, Black, Indian girls—dressed up as cheerleaders but decorated in all this hip-hop jewelry, and their poses were based on references from Renaissance and baroque paintings, referencing these European

Luis Gispert. Turntables, 2003. Cibachrome, 50 x 60 inches. Courtesy of the artist and Zach Feuer Gallery, New York City.

Luis Gispert. Grave, 2005. C-print, 50 x 80 inches. Courtesy of the artist and Zach Feuer Gallery, New York City.

historical allegorical paintings. I then went back to Miami and started photographing members of my family. Basically, I created fictional tableaux using members of my family, dressing them up in these fantasies. I started working at this time with the icon of the boombox or ghetto blaster—I personally collect vintage '70s and '80s boomboxes. They started to appear in the photographs as surrogates for myself. But also I started to be interested in the boombox, the radio connected to these portable sound systems. They were a lot like the automobiles I drove in high school, which had these portable sound systems, and I think the ghetto blaster and the car system was why hip-hop started to spread outside of urban areas to the suburbs and other parts of the city. So I started then to play with the radio, using it as a kind of reference to modernist building blocks and other images.

More recently, I've been working on a film for the last couple of years. It's kind of a plotless film about these tribes, these groupings of people again around the boombox, becoming the fetishized object. This commodity kind of becomes this currency—there's a certain magic realist or surrealist element in the project. Again, electronic equipment and stereos are fetishized, and people obsess over them and collect them.

JACKIE: I started addressing hip-hop in my work really recently—about three years ago. My work usually surrounds issues of Arab and Muslim stereotypes and deals particularly with the Palestinian-Israeli conflict. I often work in the medium of collage, repackaging toys, gum-ball machines, and video. About three years ago, the Israelis invaded the West Bank and were attacking towns. It was a really tough time for me, and I wanted to create something that expressed my anger. I wanted people to see another perspective because obviously the media wasn't doing it.

So I was listening to public radio station WBAI, and there was an Israeli artist, Udi Aloni, on, and he was talking about the conflict, about Palestinian youth, and a hip-hop group called Dam (which means "immortal" in Arabic and "blood" in Hebrew) out of the town Lid. They made a song called "Meen Erhabe," which means "Who's the Terrorist?" I had no idea that this was going on. I heard the song and was so excited—I couldn't believe what I was hearing. In three minutes, they encapsulated so much. So I wanted to do something with that song, and at that time the invasion was going on.

I was a student at NYU. We had open studios over there, and I wanted to create something to put in people's faces. So I took the song, translated it, and

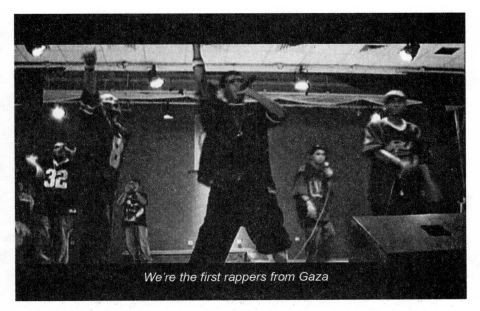

We're the first rappers from Gaza

Jackie Salloum. *Slingshot Hip-Hop,* 2006. Still from movie. Courtesy of Jackie Salloum.

used the images that people don't see here in the media. I used documentary films, grabbed whatever I could, and put it together. After seeing how that went, it really inspired me to continue to work in this way. So I went to Palestine and Israel that summer and went to meet the MCs and started filming. That was three years ago. I've been filming off and on since then, and I just came back a couple days ago.

LYDIA: All of you address hip-hop culture but also more broadly popular culture, and I think in some ways this isn't an easy fit in an art context, but your work resonates with a wider audience. So I'm wondering who you consider your audience to be and what sort of reception do you get from different segments of your audience?

JACKIE: When I decided that I was going to do work dealing with these issues, I didn't know how to approach it. It was really difficult. It's such an intractable issue, and when I've gone to different discussions around it, you get into really heated debates. I found when you put overtly political messages within things people are familiar with and comfortable with, it becomes more accessible. So

I started to use toys, gum-ball machines, music, that sort of thing, and I found that people accepted it much more easily.

For me, my audience is everybody. I'd like my work to reach everybody, but probably the most important audience for me would be the youth. I'm always hoping my work will reach the educational system, which it has amazingly. Teachers have requested to show my videos. I've been doing talks at universities, bringing my work out there.

SANFORD: One thing that's interesting about pop culture and, I think one of the reasons hip-hop has lasted as long as it has, is because at this point pop is referential of itself. Pop culture references itself all the time, and it's accepted. As an artist I go between different media because different things hit different people. There are different contexts for each piece. When I do a project for the Bronx Community College or the Zen temple, it's a different group than what would come into a contemporary art museum or gallery. So in that respect I try to open it up. It's not really a new idea, but traditionally most cultures that created what we call artworks really looked at a holistic experience. It wasn't just looking at painting, but it was partly a musical experience, a griotic, or a poetic or a word-based experience. Maybe food, maybe dance—all combined together for a larger cultural phenomenon called art. I like to take that approach for what I do as well.

NADINE: For me, my audience basically is everyone who can hear it. That's why I turn it up loud, so it can go outside the museum. Usually it drowns out other works, but the whole idea is to get outside the museum and draw people in, to lure them into the dance, the dance hall, or the gym, the yard, or the basement.

LYDIA: So maybe the second part of that question is really about the art museum's ability to accept popular culture and hip-hop. How is your work received in the art context, and do you find there is often an oppositional relationship between your work and the institution?

NADINE: Not really. I think we're going into a neo-Pop phase, post-Warholian, so in most of the works out there I see a bit of youth. I think the powers-that-be are going through some type of crisis. They're afraid of mortality or death. So it's hard for the artist to talk about serious messages like Jackie is doing. Because most of the time we're ignoring those bigger issues and working in

mediums that are comfortable to the audience, but the messages are being masked in all this shiny and intricate detail. I don't want to say one type of art is better than the other, but I think the problem with art that's based too much in popular culture is that it gets too dense, and then the simplicity of what needs to be said gets lost.

LUIS: In terms of museums, there's still a learning curve with art that's being produced by a generation of artists influenced by hip-hop. To date, it's been maybe a couple of shows—the first one being the one Lydia and Franklin Sirmans put together. You can see the trends out there among the powers-that-be, the people writing about and controlling what gets seen in museums. For example, the 2004 Whitney Biennial—it's fairly obvious what subcultures are being championed at the moment, subcultures that were very important to certain curators in their teenage years such as heavy metal, death metal, goth, rock and roll—that whole suburban, white subculture is being championed in art right now.

SANFORD: I do think that programmatically speaking a lot of museums and institutions, or a few at least, are a little more welcoming to the idea of this more youth culture–based work. Because it brings that demographic into the museum, and a lot of museums do not attract that kind of crowd. There are museums of course that have their market that's gonna come regardless, so they don't have to open their doors to different ideas, but some are more willing to do that. One thing I think that is very commendable is that the Bronx has been able to do that and really recognize the importance of being a museum in the Bronx—the birthplace of hip-hop—and continuously programming in that direction. The Studio Museum in Harlem also does that, and artists that have been showing in those museums lately have been getting a lot of recognition.

JACKIE: Because I work in different mediums, what I've experienced is that actually the pieces that use hip-hop, like "Meen Erhabe" (2004), have penetrated all different types of institutions. Starting out, it was galleries, and then it went to film festivals. Activists were using it for talks. It's amazing and I've had discussions with people that after they see the video they come up to me and say, "This was so effective," because they never hear the voices of the youth coming from that area—and because hip-hop is so familiar and people see it as honest, coming from the heart. They don't see it as

propaganda, and so that's why I've chosen to continue with it and make a documentary on it.

LYDIA: I'd like to give the audience the chance to ask some questions.

Q: My question is for Sanford. You made a reference to the original spirit of hip-hop, so I wonder if you could elaborate on that.

SANFORD: I don't want to get all misty-eyed and romantic about it, but for me the original idea was that it was a rebel culture, and in that respect it was very much like rock, bebop, jazz, which went against the grain at the time. In addition to that, growing up in Los Angeles and getting into it very early, it was always posed as an alternative to gang violence. Instead of fighting, people were battling and deciding it on the floor, deciding it on the wall, deciding it on the mic, or deciding it on the tables.

So it was a cultural movement. It wasn't just the music itself. It was everything that surrounded it. It really felt like we were on the verge of something. And though I'm from the West Coast, things really started to change when N.W.A. came out—pivotal group obviously—but the way the industry changed. It was no longer about making a movement and teaching and educating but more about shock, and from shock came sales, and from sales it went to commodity-based music. Now I think it sort of fits in the same formulaic pattern as soul music in the late '70s, with cookie-cutter songs. If you listen to what Sway and Tech used to do back in the day—because that is when you get to the raw stuff—that's what I meant by original spirit. In that piece where it says, "In fond memory of hip-hop," for me that's my way of commenting on, you know, how Common had "I Used to Love H.E.R." and all these people had these songs about the death of hip-hop. So that was my entry into that long tradition about "the death of hip-hop."

Q: Your work has been received by traditional art institutions, reviewers, critics. On the flip side, how has your work been received by the more traditional hip-hop purists, those committed to the original "four elements." You guys aren't necessarily quite fitting in any of those boxes.

NADINE: Well, I'm not hard in the hip-hop world. The hardest I've gotten is a request for one of my pieces to be in a music video, the background of a music video. Then you sound elitist—because this is a fine-art experience.

It's hard to negotiate and tell someone you can't put that in the video. But at the same time, when you look at music videos, what do you see mostly in the background? Something that looks like my piece *Big Baby Blue* (2001) probably—speakers, gold and shiny, girls dancing half naked, or something. Eventually, I can see myself working on this end to celebrate it, but right now I'm sort of in between and ambivalent. I don't spend so much time thinking about where I fit; I just do what I am compelled to do. I would always be doing this whether I had studied art or not. I wouldn't say that I'm concerned about whether I fit into the hip-hop world or what my friends and family think about my work or what the art world thinks. Basically, I put it out there for everyone to enjoy or to contemplate or to think about it.

LUIS: I agree with Nadine. I had a similar experience. I went to art school, and I don't think about where it ends up, but it ends up in the art context where it's received and accepted, I guess, and circulated and hasn't really crossed over to hip-hop. The biggest compliment I had was at the opening of the *One Planet under a Groove* show, where Fab 5 Freddy liked one of my sculptures. But I do fantasize or imagine what that audience outside the museum or gallery would think about the piece, so when I make something I always keep that in mind.

SANFORD: For me, there are a ton of things going through my head when I make work. I like to make references to the way music is made, and there's always the shout-out in hip-hop songs where they shout-out other MCs or shout-out something historical. I like to take that approach and do it visually. If I shout-out to Marcel Duchamp or Carl Andre or shout-out to Outkast or to poplockers—putting little things in the work that you know people who are from the institution or the academy might find a little something and people who are from the hip-hop community might find something. Ultimately, the goal is for them to cross-breed or cross-pollinate with each other. Whether that really happens, I don't know, and I can't really control that. I make work with that in mind because work is in some ways conceptual self-portraiture, so those are the worlds in which I live.

Lydia Yee is senior curator at The Bronx Museum of the Arts, where she has worked since 1992 and organized numerous exhibitions, including *Collection Remixed* (2005), *Commodification of Buddhism* (2003), *One Planet under a*

Groove: Hip Hop and Contemporary Art (2001, with Franklin Sirmans) and *Urban Mythologies: The Bronx Represented since the 1960s* (1999, with Betti-Sue Hertz). She also curated "Music/Video," a video program presented in *Vidéo Topiques* (2002) at the Musée d'Art Moderne et Contemporain in Strasbourg, France. She is currently working on *Street Art, Street Life* (2008), an exhibition that explores the relationship between visual artists and the street.

The City in Public versus Private

Through a Scanner Darkly

Paul D. Miller, a.k.a. DJ Spooky

PRELUDE

The following essay is a remix of a project that I did with the Tate Modern Museum in London, May 2006. Walter Ruttmann's 1927 film, *Opus: Berlin—Symphony of a Great City,* was projected throughout the museum as a large-scale intervention. The idea was to use the museum as a projection canvas.

BEGIN

We live in the era of the world city. So much of what we see is about what we project out into the world. Your eyes have a perceptual architecture. They break light waves and particles into some kind of coherent meaning that the mind then organizes, and makes into metaphors, thoughts, and, of course, images.

As an artist, a lot of what I do is about getting people to look outside the frames of reference that so many of us have been conditioned to accept. I live in NYC, and you can pretty much expect that most people have a reference point that the city provides: subways, poster placards, the sides of buses, and, lately, their cell phone networks that send info on various developments—news, videos, art, you name it, it's being broadcast. You walk down the street in NYC, and you see, in one form or another, a world tapestry made from almost every media outlet available to modern humanity. But the point here is

that, put simply, many of the same experiences could be had in almost any major metropolis on the planet. NYC, for me, is the template for a lot of issues in the twenty-first century: we live in a culture where immigration has been the mainstay in American life since its inception, yet somehow we tend to forget how linked we are to the rest of the world. What is the soundtrack of this conflicted self-image the United States has presented to a generation grown up on material like Wu-Tang and Flash Animation? What's the image track for an America equally at home with the art of Jean-Michel Basquiat as it is with Jackson Pollock?

The basic issue is this: we're all not quite sure. We don't necessarily have the tools to interpret how digital media have changed the our perceptions and this music we call hip-hop. I like to think that we have to understand where we've been to get a clearer picture of where we're going.

SAMPLE 1

Can it be a surprise that a society that has steadily dismantled or diminished the most basic access to health care, relief for the poor and the aged, and decent education; a society that has allowed the gap between its richest and poorest citizens to grow to unprecedented size; a society that has paid obeisance to the ideology of globalization to the point of giving away both its jobs and its debt to foreign nations, and which has just allowed one of its poorer cities to quietly drown, should choose to opt out of the debate about the debate that sampling has brought home to roost? The insight is simple yet prompts an odd revulsion: we are linked—the one and the many, the many and the one—in ways that digital media are finally making plain.

SAMPLE 2

One of my favorite poets, Saul Williams, has written in his recent book *The Dead Emcee Scrolls*:

> Your Intellect is disfiguring your soul.
> Your being's not whole. Check your flagpole:
> stars and stripes. Your astrology's imprisoned
> by your concept of white. What's your
> plan for spiritual health? Calling reality unreal.
> Your line of thought is tangled . . .

Paul D. Miller, a.k.a. DJ Spooky, performing "Rebirth of a Nation."
© Museum of Contemporary Art, Chicago. Photographer: Michael Raz-Russo. Used by permission of the artist.

I like to see this stanza as a meditation on the paradoxes of the way we live now. The world has been colonized, most would say for the worst, by the American dream: what this essay explores is the relationship between the urban experience of a history of film and multimedia from a couple of angles.

.

SAMPLE 3

People tend to forget that one of America's premiere poets, Biggie Smalls, and another, Walt Whitman, were both from Brooklyn. I like to create these kinds of juxtapositions, because too many people like to pull them apart. I'm a DJ, so indulge me . . .

In his 1855 opus *Leaves of Grass* Whitman wrote a line that Biggie could have easily said in the section titled "Songs of Myself": "So what if I contradict myself? I am large, I contain multitudes." It's a simple statement on the surface, but when we expand the concept to another stanza Whitman wrote in the same book, we're presented with a different vision of the city he called home. The minipoem was called "Mannahatta," and it went like this:

Mannahatta

I WAS asking for something specific and perfect for my city,
Whereupon lo! upsprang the aboriginal name.

Now I see what there is in a name, a word, liquid, sane, unruly,
 musical, self-sufficient,
I see that the word of my city is that word from of old,
Because I see that word nested in nests of water-bays, superb,
Rich, hemmed thick all around with sail ships and steam ships, an
 island sixteen miles long, solid-founded,
Numberless crowded streets, high growths of iron, slender, strong,
 light, splendidly uprising toward clear skies,
Tides swift and ample, well-loved by me, towards sundown,
The flowing sea-currents, the little islands, larger adjoining
 islands, the heights, the villas,
The countless masts, the white shore-steamers, the lighters, the
 ferry-boats, the black sea-steamers well-modelled,
The down-town streets, the jobbers' houses of business, the
 houses of business of the ship-merchants and money brokers,
 the river-streets,
Immigrants arriving, fifteen or twenty thousand in a week,
The carts hauling goods, the manly race of drivers of horses, the
 brown-faced sailors,
The summer air, the bright sun shining, and the sailing clouds
 aloft,
The winter snows, the sleigh-bells, the broken ice in the river,
 passing along up or down with the flood-tide or ebb-tide,
The mechanics of the city, the masters, well-formed, beautiful-
 faced, looking you straight in the eyes,
Trottoirs thronged, vehicles, Broadway, the women, the shops and
 shows,
A million people—manners free and superb—open voices—
 hospitality—the most courageous and friendly young men,
City of hurried and sparkling waters! city of spires and masts!
City nested in bays! my city!

———————

In 1925 one of America's premiere painters, Charles Sheeler, collaborated with an experimental filmmaker, Paul Strand, to bring that poem to life. The film was meant to be a visualization of Whitman's poem interpreted through the architecture of the Manhattan skyline, and was called by the same name: *Mannahatta*. It was one of the first avant-garde films to explore the city as subject. Sheeler and Strand's vision of New York was a cinema poem that was meant to portray the hecticness of an urban landscape drenched in the throes of an accelerated culture. From top to bottom, their film was linked to the trends of the day: Dada, surrealism, you name it—NYC was reflected in the edits and cuts of the ebb and flow of a portrait that left almost anyone who saw it with their breath taken away. As a collaboration between a painter and a filmmaker, we can only expect that many issues that we use to describe perception—foreground, background, clarity, density—all found their way into the way the film was edited.

So how do you translate a poem into film? That's the question. I guess I'm never really direct with this kind of thing, so I'll jump-cut straight into the next step: it's all about the language we use to name things: that's where Whitman gets jiggy. Like he said in his poem: "Now I see what there is in a name, a word, liquid, sane, unruly, musical, self-sufficient, / I see that the word of my city is that word from of old."

Back in the late 1960s and early 1970s the situation was different, but you could see where it was going. Trains were being "bombed" daily because that was the way kids felt they could bypass the authorities and get their message out. The ideal of being "all city" was the driving force for so many artists. In films like *Graffiti Rock* to *Wild Style* and *Style Wars*, you can see the same dialectic at work. There was a deep tension between public space and private expression. During the period of the late 1970s NYC spent more than one hundred million dollars to combat the idea of private expression in public spaces, and from the result, a new art form was born. The city didn't invest in training artists or developing young minds; it went to war with kids to keep public spaces blank. Today, you can see who won the war: advertising adopted the same strategies as the kids, and no modern bus or train would be complete without a bumper-to-bumper slew of ads.

What more can be done to saturate the landscape with a howling emptiness of our dreams? What more can be done to actually give people some meaning, some kind of connectedness to the way we actually live? The world is made of meanings—values that are shared, values that connect us to one another in a way that digital media are making clear. In a world where every

move you make online leaves a trace, whether it's the collaborative filtering process of last.fm, or the way people post almost every moment of their lives on Web sites like youtube.com and myspace.com, the end result is the same: you have a profile of someone's values, tastes, and the way they express almost all aspects of their outward identity. Graffiti was the underground response to the same issue: how do you as a young person create a situation where you can express yourself through the media around you?

To me, the whole debate of ownership—intellectual property, digital rights management, the whole scenario—all needs to be updated. Think of the situation as a kind of ecology: who owns the air? Who owns your DNA? Who owns your memory? I think that we're so caught up with the issue of ownership that we've forgotten some of the fundamental issues that make up the fabric of a culture. If you look back in time, other cultures dealt with intellectual property from the vantage point of a world where digital media didn't exist, and people pretty much had to make copies of the material—whatever it was, books, scrolls, whatever—by hand. For us, the digital copy is a color on a painter's palette—it's something to be used, abused, and flipped. Where *Mannahatta* synthesized several schools of early film—the realism of the Louis Lumière with the hyperbolic magic of Georges Méliès—another portrait of the city would emerge that added the dimension of film as a musical composition: Walter Ruttmann's 1927 *Opus: Berlin—Symphony of a Great City*.

SAMPLE 4

I draw a link between hip-hop cinema, poetry, and editing techniques because the whole idea these days is to apply DJ technique to cinema. So, another sample, and we jump-cut to:

Why should we watch a film like *Opus: Berlin—Symphony of a Great City*, almost eighty years after it was made? I like to think of it as a historical document made of fragments, a touchstone for the multimedia world we inhabit today. Basically, it's an insight into the patterns of life and living in a major metropolis—Berlin in the late '20s—but it's also a testimony of how urban life ebbs and flows in the patterns held together by cinema and editing techniques. And like Paul Strand and Charles Sheeler's *Mannahatta*, it was a snapshot of life in a dense urban landscape.

Walter Ruttmann made history with his 1927 masterwork *Opus: Berlin— Symphony of a Great City* by creating a film that looked at the city from almost every angle the camera could conceive. I tend to think that in our era of omnipresent media—of surveillance, video podcasts, and online streaming

media—we've finally caught up to his vision. *Symphony of a Great City* is one of my favorite examples of urban "realism"—it looks at the city of Berlin at the height of the Weimar Republic, a golden era on the edge of a deep, dark time, and asks: is this the way we live now? Maybe there's a parallel between the Weimar Republic and the United States under an administration many have felt has pulled us to the brink of a collapse of the democratic ideals that the country was founded on—in the name of security, of course.

When I remixed and rescored Ruttmann's film, I was inspired as much by the original film as by current developments—from the ubiquitous placement of cameras that are always online, showing us cities around the world, to the way people document their personal creativity through digital media's inheritance from the worlds of cinema and theatre. Antonin Artaud famously wrote that the theatre would be a kind of "double" of the world, a place where reality has been subsumed by the projections of itself. Ruttmann made that reality. Ruttmann originally studied architecture and painting, and even worked as a graphic designer; you see that in the way he searches for form as he juxtaposes the scenes from the everyday world in a collage that is meant to be a portrait of a city from dawn to midnight. At heart, *Berlin* is a film that feels like a twenty-four-hour vision of a metropolis uneasy with its first portrait.

Fritz Lang, whose film *Metropolis* set the tone for our vision of the future— sleek, gleaming skyscrapers; Americanized urban landscapes where everything and everyone work efficiently—is the counterpoint for this song of a city. Ruttmann's film came out in 1927 as well, and it created a different vision of a present-tense metropolis. *Symphony* rides a different rhythm than *Metropolis*—one is "fact," the other "fiction." But they both presented conflicting visions of the present and the future of German cinema, and anticipated later experimental films like Godfrey Reggio's *Koyaanisqatsi* or Orson Welles's *F for Fake*. The blur between what's presented and what's collaged is what makes the film so appealing.

Ruttmann's film career began in the early 1920s with the production of his hand-colored first abstract short films, *Opus I* (1921) and *Opus II* (1923). Both films anticipate the idea of cinematic collage and how we can think of the urban landscape as a dense, highly contested realm of public and private visions of what it means to live in a city. My remix looked at these issues from the viewpoint of a contemporary digital media landscape where software has blurred the distinctions among art, life, and the everyday realm of living in a media-saturated landscape. Where Ruttmann made his film as a response to cinema, digital media guide the same impulse today. Most major cities have

cameras of famous intersections that are permanently online, and of course Google maps update the same kind of vision—but on a global scale. Ruttmann's films were experiments with new forms of film expression. The remix I presented paid homage to how DJ culture—urban music—evolved as the soundtrack to a new way of looking at the city. Today, as I write, there's an image of Kingston on the top left-hand corner of my laptop—it's an image from Jamaica's *Daily Gleaner*—a camera on the top of the newspaper's building documents the daily life of Kingston, and every once in a while, just for kicks, I update the page to see what people are doing out in the street. It's just a flourish, but it's also one of those things that reminds me of the world we live in today. Links are what make this act possible—it's a meditation on a simple fact of daily.

The dialogue between film and music for Ruttmann—and first and foremost *Symphony of a Great City*—was a synthesis. It was essentially a "visual" orchestral work in five movements celebrating the Berlin of 1927: the people, the place, the everyday details of life on the streets. Ruttmann re-creates documentary as, in his own words, "a melody of pictures."

Symphony of a Great City starts with an uneasy tension between context and content: the film's framework is governed by time: it portrays the life of the metropolis from morning until midnight. The camera, for Ruttmann, is a kind of notepad. He wanted to make a landscape of poetry derived from the way the camera broke the landscape's continuity into a thousand shards of memory. The film progresses, evolves, and transcends time; dawn to dusk in *Symphony* we're presented with an eternal present, where time passes as a camera's clockwork mechanism. The sequence:

Morning: A sparse population of workers haunts the streets' morning-lit storefront facades as the camera's motion creates an uneasy tension between work and rest. Motion builds until the film crescendos with the rise of the working class and fragments into many other people's daily movements in the rapidly filling public spaces. The camera untangles the action of a dense landscape of movement and continuous multiple scenarios, its lens falling on the centers of morning life, on stations, factories, road junctions. And like an accompanying musical suite, you are given characters like musical motifs: they are faint impressions of a song of a city long gone. The camera presents slices of life like a DJ's cut-and-paste sample mix: it cross-sections from the private lives of big-city people—houses waking up, apartments coming to life, all flow across the screen. Noon arrives, evening arrives, and again and again the objective fits to situations flowing with life. The camera penetrates all aspects of the city—its jump cuts take you from poor to rich to the in between, from

human to machine and back again, from the luminous grandeur of the city scene to the sewers beneath, and always movement, movement in every way that can be found in the eye of the machine capturing it all. You see all areas, all districts, all social classes: you see the dynamism of a city in perpetual motion. Night falls, and the camera dissects sections of the dark existence of Berlin—you are presented with stark flashes of light over the darkest portions of a city as a projection surface. The film goes on until the night covers this incomparably seething life as the camera lens fades to black.

Rewind, fast-forward: repeat. Could this be hip-hop? The question and the answer, reader, are left up to you to decide. So how do you translate a poem into film? Like Sun Ra said so long ago: it's a message from "otherspace." I just want to provide some clues to help people navigate the terrain.

Paul D. Miller is a writer, artist, and musician probably best known under the moniker of his "constructed persona" as "DJ Spooky That Subliminal Kid." He has remixed and recorded with artists ranging from Metallica to Steve Reich to Killah Priest. His first book, *Rhythm Science,* came out of MIT Press in 2005, and his work has been exhibited at museums throughout the world. He has performed in a wide variety of contexts, including the Tate Modern, the Guggenheim Museum, and the Herod Atticus Theater at the Acropolis in Greece. He lives and works in NYC. His Web site is http://www.djspooky.com.

PART THREE

THE REAL: IDENTITY IN FLUX

The Real

Identity in Flux

Following the first-person confessionalism of the Baby Boomer/Civil Rights generation and the leveling tendencies of postmodernism and multiculturalism, empowered by technology, and determined never to accept voicelessness again, hip-hop takes the need to represent itself as paramount. Questions of identity are central to hip-hop arts. Some of these questions are intellectual (what is the "hip-hop" in hip-hop visual arts, hip-hop poetry, hip-hop dance?), and others are intensely personal (is there space for women or Queers or non-Blacks in hip-hop?).

When it comes to voice, hip-hop encounters a contradiction. Days of silent suffering are a recent memory, and so it is no surprise that loud, even aggrandizing discourse is valued. But when all voices are raised, claims surface that inevitably force a renegotiation of a community of trust and respect. This process isn't easy at all. Very visceral emotions surround the debate over the terms of inclusion, summed in the oft-repeated question: what constitutes "the real"?

In his examination of the aesthetics of hip-hop music criticism, "It Was Written," writer Oliver Wang tracks the formation of the hip-hop subject. From the mid-eighties, an image of the hip-hopper takes shape, first as ethnographic study, then as the object of Black aspiration and post–civil rights nationalist ambition. When the hip-hop generation steps in to represent itself, most notably in the magazine *The Source*, the hip-hopper becomes passionate, vibrant, slang-slinging, and, of course, authenticity obsessed. Wang's piece discusses versions of the hip-hopper as imagined by various editorial charges and follows the line through to the present moment, when the displacement of formal journalism into the democratic chaos of blogging threatens to dissolve the category of the "hip-hop writer," and, by extension, the hip-hopper, altogether.

For Kevin Coval, a white Jewish poet inspired by hip-hop, his embrace of the culture still necessitates a lacerating examination. "L-vis is a pioneer, or Legacy: The VH1 Special" slips from fascination to appropriation to exploitation to displacement. Coval warns that white fascination with hip-hop could lead to the erasure of the Blacks who create it, and a reinscription of the power differences that make whites' consumption possible.

Writer Dave Tompkins attempts something unusual with the pioneering, highly influential hip-hop journalist and entrepreneur Dave "Funkenklein" Klein's early columns from *The Bomb*, a fondly remembered Bay Area zine of the early '90s. He resurrects the late disabled white writer's singular voice and creates a megamix of his greatest lines, sentences packed with insider knowledge, half-thoughts, subliminal disses, and multiple hypertextual references. The result is fittingly visionary, uproarious, and generous, just as Funkenklein was, and as hip-hop is.

In "Black Talk and Hot Sex: Why 'Street Lit' Is Literature," a piece that began as a rant on her blog, Naked Cartwheels, Danyel Smith, famed *Vibe* editor turned acclaimed novelist turned famed *Vibe* editor again, considers the art of so-called street literature or hip-hop literature, the vastly popular pulp-fiction wing of African American literature. (See also Adam Mansbach's essay, "On Lit Hop.") Recognizing in the reaction to "street lit" the same criticisms that greeted West Coast "gangsta rap," Smith laments the narrow aesthetic standards that draw lines between what are acceptable forms of storytelling and what are not. Smith's spirited, expansive defense of "street lit" raises key questions once again: What is real? What is progressive?

These are questions that Juba Kalamka and Tim'm West, cofounders of the formative Homohop crew Deep Dickollective, also take up with fire and clarity. Homophobia within hip-hop is no secret, even if—see also re: sexism—hip-hop sometimes unfairly bears the burden of correction that critics refuse to extend to other spaces of popular culture. Queer hip-hoppers stare down an untenable position: both reactionaries and progressives seem to believe that hip-hop and Queerness are incompatible. Kalamka and West challenge that notion directly and discuss how recognizing the Other in hip-hop forces a rethinking of the subject. For them, being hip-hop is as natural as being Black.

Poet and author Joel Tan expresses much more ambivalence about hip-hop. His memoir, "Homothugdragsterism," recalls the early '90s Los Angeles colored Queer scene of "homeboys and vatos" from the point of view of a self-proclaimed "impostor" who sees its rise as "a survivalist return, a move back into the closet as a response to AIDS, racism, and homophobia." He then

interrogates the Filipino American spoken-word scene, whose easy embrace of his persona he questions. He concludes that hip-hop's hypermasculinity forces Queers into a performance of an identity that is inherently self-hating, and its inherent Blackness draws young non-Black people of color into, at best, awkward and, at worst, harmful moments of appropriation. A hip-hop utopia is an opportunity for disillusionment.

Not so for Robert Karimi, whose experimental, autobiographical prose poem "how I found my inner dj" dissects how hip-hop generationers can construct identity from bits and pieces of found culture, trivial pursuits, random education, and willed legacies in lives of constant motion. Karimi, the son of immigrants whose descriptions of his mixed-race heritage and polycultural context can set the mind reeling, calls the result "sampled consciousness." His piece speaks to the power of hip-hop to travel widely, absorb all, and enact identity formation wherever it lands.

Hip-hop's gender trouble has been well documented, and if the recent burst of feminist writing, discoursing, and organizing is any indication, many breakthroughs are on the way. Two of the most insightful thinkers on the topic, Joan Morgan and Mark Anthony Neal, sit down here for an extensive and critical conversation about what it means for women and men to be hip-hop feminists. Their discussion is provocative not only for the powerful analysis they bring to subjects like the development of a public hip-hop feminist intelligentsia, the meaning of the Mike Tyson rape trial and Duke lacrosse rape case, and the complicity of both men and women in hip-hop patriarchy but also for how they model building an alternative hip-hop-centric world in their personal friendship and the work that they choose to do. Questions of identity sometimes paradoxically become paralyzing. Neal and Morgan remind us that identity is not a law, it's not an answer, it's a process.

15

Trapped in between the Lines

The Aesthetics of Hip-Hop Journalism

Oliver Wang

Back in the mid-1990s, I remember reading a letter to the editor that appeared in *The Source,* heckling the magazine's staff as people who became hip-hop journalists because they had failed as rappers. It was a new twist on an old adage: "Those who can, do; those who can't, teach" (or in this case, write). There have been hip-hop writers who tried too hard to ape rap-lyric flow and wordplay, but the craft of writing, critiquing, and reporting on hip-hop was never meant to be a consolation prize for dim mic skills. What began as a way to document the emergence of hip-hop from a local street culture to a global musical phenomenon quickly developed a sense of style that was all its own, standing alongside hip-hop, sometimes a little too closely, but with its own sense of identity and vision.

The earliest writers covering hip-hop music did so with an ethnographer's distance—close to the action, but without a presumption of membership. Especially in the *Village Voice,* whose various articles and essays constitute a protocollection of "hip-hop journalism" long before the term ever came into use,[1] early exposés on graffiti, breakdancing, and DJ culture written by the likes of Steven Hager and Sally Banes sought to document the emergent street culture with a mix of downtown-meets-uptown curiosity and subcultural anthropology.

Despite the initial excitement over documenting hip-hop's visual and physical styles, ultimately, rap music captured the most critical attention. It

helped that the music itself was mercurial and dynamic, not to mention textual. Hip-hop's mesh of styles and meanings encouraged writers to both unpack its sonic collisions and decipher its myriad messages. Graffiti dipped back underground, and b-boying felt more like a fad, but the increasing success of rap records meant that the music would attract the vast bulk of writers' attentions.

Early criticism from the likes of the *Voice*'s Robert Christgau held hip-hop music at arm's length, discussing it on sonic terms but rarely attempting a sociological read. However, Christgau was instrumental in recruiting a cadre of young African American writers to the *Voice* in the early 1980s, most notably Greg Tate, Nelson George, and Carol Cooper, followed later by other writers such as Lisa Jones, Lisa Kennedy, Harry Allen, Joan Morgan, and others. This cohort—call them the cultural critics—became hip-hop's first intelligentsia.

What they shared in common was an engagement with hip-hop as an entry point into larger discussions of society, culture, and identity. Writers used the music as a catalyst to address subjectivities around race, class, gender, sexuality, and other issues. They may, for example, have used a rap song, album, or artist as a way to open up a larger discussion on late-century Blackness, male-female relations, class aspirations, or the shortcomings of modern politics.

Importantly, these writers connected hip-hop to a wider continuum of American cultural history (African American and otherwise), rather than centering it as the alpha and omega of youth life. In other words, hip-hop was important and enthralling, but they didn't treat the music as a unifying or all-encompassing cultural logic. The cultural critics celebrated hip-hop's importance and dominance, but they maintained a critical distance, willing to call into question controversial or detrimental aspects—as in questions of misogyny, materialism, and nihilism—of the culture when necessary.

Even though they were among the earliest writers on hip-hop, their craft was ambitious and sophisticated. As writers trying to tackle an emergent culture, they had to draw on outside frames of reference, building a polyglot language that reflected pop music criticism, critical race and gender theory, and personal experience. However, they also had the benefit of being on the forefront of hip-hop's mercurial changes in style at the time and were some of the first to frame the transitions from old school to new school to the rise of gangsta rap and beyond.

Within publication circles, cultural critics had the most exposure by the early to mid-1990s. The *Voice* continued to nurture a new generation of writers, including Touré and Karen Good. *Vibe*, launched in 1993, recruited many of their early freelancers from the ranks of former *Voice* writers; *The Source*'s

James Bernard regularly mused on race, masculinity, and class for his "Doin' the Knowledge" column. But the major rap magazines began publishing less and less "big-picture" cultural criticism (except, of course, after the deaths of Tupac and Biggie), and it fell to the alternative press to offer a home for cultural critics, including at newspapers such as the *L.A. Weekly* (Ernest Hardy) and the *New York Press* (Armond White). More established writers turned toward books as a new outlet, including Tate (*Flyboy in the Buttermilk*), George (*Hip Hop America*), Morgan (*When Chickenheads Come Home to Roost*), Bakari Kitwana (*The Hip-Hop Generation*), and others.

One of the key factors that helped marginalize cultural criticism—at least within the larger arena of writing on hip-hop—was the maturing of hip-hop itself. Once the music and culture had a long-enough internal history, writers began to write more insularly. References no longer had to bounce off people, ideas, and events outside of hip-hop; a writer could simply nod to someone or something within hip-hop, and readers understood. This was largely the model that the first significant "hip-hop publication" founded itself upon. Enter *The Source*.

EARLY 1990s: BIBLE THUMPERS

The cultural critics of the 1980s were often likely to be writers who turned to rap music as a way to direct their intellectual energies. However, among people who had grown up with the music since the 1980s, there were hundreds, if not eventually thousands, who went the other direction: they were fans who became writers. The publication that first tapped into this base was *The Source*, founded in 1988.

In many ways, the people who founded the magazine—Dave Mays, Jon Shecter, James Bernard—were not that different from either the writers they hired or the readership they cultivated. For its first few years, *The Source* was essentially written by, for, and about hip-hop fanatics. By this, I don't simply mean their passion for the music and culture, but also that their worldview was largely built on hip-hop as the prime filter through which politics, economics, gender relations, fashion, film, sports, and other ideas had to first pass through. If the cultural critics of the 1980s saw hip-hop as part of a larger sociocultural web, the writer/editor/reader—the distance between the three wasn't far—at *The Source* was far more likely to treat hip-hop as an inclusive, insular bastard logic that needed no father to its style or values.

As people who saw hip-hop as the most powerful cultural force for their generation, they also believed they had a responsibility to explain and express

this newly forming reality to everyone else. The early writers at *The Source* were activists and advocates. Best said, they were proselytizers. They treated hip-hop as a gospel, ready to spread the good word to an eager flock of fans. That desire had led them into writing in the first place.

In the early to mid-1990s, an astute reader could easily spot the writer/fan since their style of prose came directly off the music's rhythms or slang or both. To be sure, this rarely resulted in very good writing—it came off as a contrivance at best, pandering boilerplate at worst—but it certainly reflected a mind-set that these writers/fans weren't just out to represent hip-hop; they aspired to *be* hip-hop. (Insert your Fifth Element jokes here.) *The Source* expressed this attitude in their revolving taglines: "The Voice of the Rap Music Industry" and "The Magazine of Hip-Hop Music, Culture and Politics," and, most telling, "The Bible of Hip-Hop," a tag that spoke volumes to the magazine's eventual messianic complex.

In fact, *The Source* took its role as gatekeeper so seriously that it preoccupied itself with stories about the potential "dangers" to hip-hop, devoting long feature stories—even cover stories—to the rise of gangsta rap, the crossover between hip-hop and pop, and the miniwave of white rappers that followed Vanilla Ice and 3rd Bass's success. The magazine held each of these up as threats to hip-hop's purity—writers/fans were very big on purity—though in their defense, at that time, hip-hop had yet to vanquish American popular culture as it would by decade's end. They saw hip-hop as an underdog culture.

Lest I paint too harsh a picture of these writers as overly earnest, self-serious types, interested only in puritan, parochial notions of what "real hip-hop" constituted, this same generation of writers/fans was also at the forefront of promoting a hip-hop politics to a newly emerging generation of youth. They saw in hip-hop the potential to bring people together—not just nationally but internationally as well—and in their writing, they constantly emphasized the potential hip-hop had for social justice and global community building. This wasn't just the case at *The Source*, but also among the many hip-hop magazines that got their start in the early to mid-1990s, such as *Rap Pages* and *URB* and regional publications like Seattle's *Flavor*, San Francisco's *The Bomb*, and others. This first generation of writers/fans also had to contend with a lack of resources or precedents to draw from in order to master a hip-hop specific lexicon and set of reference points. There was no Strunk and White's *Elements of Style* for the boom-bap set, and in many cases their editors were just as inexperienced and untrained as they were.

Interestingly enough, during a conversation I had with a former senior editor at *The Source*, he intimated that the 1994 fallout between publisher Dave

Mays and most of the original "Mind Squad" editorial core—which lead to the Mind Squad resigning, all at once—actually helped "save the magazine" since, in his words, "it got rid of all the fans" and allowed the magazine to begin pursuing more professional editors and writers. Although *The Source* would be hampered by ethical questions regarding Mays's relationship with rapper Benzino, the magazine improved its general quality of writing during the National Magazine Award–winning tenure of editor Selwyn Seyfu Hinds. The magazine was now less idealistic in some ways, but more polished and professional in others. The changes were part of a larger wave of development within the rap-magazine community, and one main catalyst behind those changes was *The Source*'s chief rival for most of the '90s: *Vibe*.

MID- TO LATE 1990s: FEEL THE VIBE

By the early 1990s, it was clear that hip-hop had become one of the most enthralling and compelling forces in American popular culture, but no one could be certain what its long-term prospects would be. Under attack by conservative watch groups, snubbed by media outlets (including Black radio), and loved by youth but scorned by the older generation, hip-hop had an uphill battle to fight. As suggested before, this is perhaps one reason magazines like *The Source* thought it was their mission to defend and advocate for hip-hop music and culture.

However, the 1990s saw many of the initial fears of hip-hop being co-opted or selling out as largely unfounded. By the decade's end, hip-hop didn't cross over to the pop world; instead, the pop world came charged, gift basket in hand, to court hip-hop. That remarkable transition had a massive transformative effect on hip-hop. A few years prior, rappers were plotting how to bumrush the stage. By the end of the '90s they were strutting down catwalks. No other publication synchronized with this transformation better than *Vibe*.

Vibe came into the world almost fully formed. It helped that Quincy Jones was spearheading its creation—with Time-Warner underwriting the budget. But money aside, the magazine had a tighter vision. In fact, *Vibe* was an amalgam of sorts: it combined the larger cultural view espoused by the erudite writers at the *Village Voice* with the passion for hip-hop's power that so many writers at *The Source* expressed. But there was something more.

Its early visual style was elegant and minimalist, far more resembling an art or photography magazine than any comparable rap publication. Its editorial staff was a who's who of the most accomplished writers of the "80s plus newly emerging talents: Lisa Jones, Joan Morgan, Greg Tate, Rob Kenner, Kevin

Powell, and Danyel Smith. *Vibe* centered its coverage on hip-hop, but it also had more expansive tastes. Hip-hop sat alongside R&B, dance hall, and jazz. *Vibe* positioned itself not just against *The Source* but everyone from *Essence* to *Vanity Fair* to *Rolling Stone*.

Vibe celebrated the new Black stars—for now they were working not only in music but also in film and television—as the defining, larger-than-life icons of their generation, representatives of late-century Blackness. If the early '90s cohort of rap magazines saw hip-hop as the hottest urban style since never, *Vibe* saw possibilities that stretched beyond the street—its ideal lay somewhere at the imagined intersection between Linden Boulevard and Madison Avenue: high-brow but grounded, hood-smart but college-educated, Black and most definitely beautiful.

Vibe made celebrity interviews their main hook, pushing for candid profiles and Q&As that simultaneously tried to bring the star closer to the reader yet simultaneously elevated their status as VIPs. Jeff Chang described *Vibe*, especially under Danyel Smith's editorial reign during the mid- to late '90s, as a "mythmaking machine," and this was most obvious in the ways that *Vibe's* ambitions coincided with two of hip-hop's most popular stars in the '90s: Tupac and Biggie. In them, *Vibe* found crossover artists who matched their own vision of making hip-hop the biggest thing in urban America and beyond. Tupac fit this bill perfectly, possessing a complex, emotional personality and looks that were cinematically charismatic.

Vibe was hardly the only magazine to capitalize on 'Pac and Biggie's crossover rise. Nor were they alone in fueling the two men's East versus West rivalry. However, *Vibe* seemed uniquely equipped to chronicle the transition of the two rappers—and, by extension, hip-hop—from regional heroes to international stars. The magazine had embraced the high-life world of urban couture years before rappers themselves incorporated designer labels and top-shelf liquors in their rhymes. In short, they aestheticized the bodies, faces, and fashions of its icons and positioned hip-hop as the new standard in an urbane style.

The deaths of Tupac and Biggie, shocking as they were, did little to stem either *Vibe's* direction or hip-hop's ascension. It's a chicken-or-egg argument as to whether *Vibe* was simply following trends or predicting and influencing them, but, certainly, no other magazine seemed so well suited to hip-hop's burgeoning material success and values. They mastered the art of the "rags to riches" narrative—the kind that opened in pissy project hallways but ended with rappers splitting blunts in the backs of limos—and artists seemed more than happy to promote those mythologies in their music.

In all fairness, *Vibe* had company. If anything, their success compelled other rap magazines to copy their style.[2] However, when Raquel Cepeda writes that, at the beginning of the 2000s, "disenfranchised journalists feel that reporting . . . has regressed into a redundant, and well, prosaic brand of crude individualism," it's easy to point at *Vibe* as the most obvious embodiment of that trend. In either case, by the early 2000s, celebrity journalism was the norm over at *The Source* and *XXL*, the upstart magazine founded in 1998 that would soon displace *The Source* as the definitive national hip-hop rag.

Lest I come off too cynical about the waxy fruits of this era, the mid- to late '90s weren't all caught up in bling journalism. Smaller magazines like *Stress*, *URB*, and *One Nut Network* provided balance to the superstar focus of the bigger nationals, keeping an eye on more underground, independent artists (back when that meant something). However, by far, the most interesting magazine to emerge was *ego trip*, a creation of veteran writers Sacha Jenkins, Elliot Wilson, and Jefferson Mao (later Gabriel Alvarez and designer Brent Rollins completed the quintet). As irreverent as *Vibe* was self-serious, *ego trip* cultivated a loyal cult audience based on a personality-driven publication that was bracingly funny and insightfully candid.

The fact that most of their core editors were on staff at other magazines, like *Vibe* and *The Source*, was a brilliant irony. The editors used their experience—not to mention paychecks—from the bigger magazines and produced a publication without making the same compromises or commercially pragmatic decisions when it came to who to write about and how to write about them. *Ego trip*, in a sense, represented the completion of a cycle. They took hip-hop writing back to the purist impulse *The Source* exhibited in its early years but without the self-important, "we are hip-hop" complex. Instead, they opted to embody what they saw as hip-hop spirit—rebellious, irreverent, and fiercely self-dependent; do or die, D.I.Y.

Those qualities helped explain why *ego trip* was a favorite outlet for rap writers trying to get away from the staid styles at the bigger glossies. However, those qualities also explain why the magazine could never have crossed over to a mainstream audience (or advertisers) the same way *Vibe* and *The Source* did. *Ego trip* saw itself as a magazine of the people but never wanted to cater to populist tastes. In the end, the team closed shop after only thirteen issues—not for lack of viability, but because the magazine, in their minds, had accomplished what they set out to do, and it was time to move on. I'd suggest that, symbolically, *ego trip*'s decision could be read as a sign that hip-hop writing had run its course and had nowhere left to go except repeat itself. Maybe *ego*

trip saw the writing on the wall and decided it was better to choose their own end rather than wait for time and irrelevancy to do it for them.

2000s: THE REVOLUTION WILL NOT BE TELEVISED, BUT MAY BE BLOGGED ABOUT

At the turn of the millennium, hip-hop's faces changed, the sounds flipped, but in the print world, the writing remained remarkably stagnant. Far from the pugnacious, underdog position that hip-hop occupied in the 1980s, by the turn of the millennium, the music and culture became the dominant center of youth culture in America—if not the world. The aspirations that *The Source* and *Vibe* had for their respective conceptions of hip-hop—the voice of a generation, the epitome of modern Blackness—both came to pass. There were new artists to champion, but it seemed as if hip-hop writing ran out of new stories to tell.

The most dramatic change wasn't necessarily in the styles of writing but, rather, in who could call themselves writers. For all its chaos, the print world still operated within a basic organizational structure that new writers had to navigate if they wanted to move up. Then the Internet came along, and the blogging revolution took hold in the early 2000s, and suddenly anyone with Web access and an opinion could basically self-publish.

Though print writers held more prestige over their online counterparts, this was more out of tradition than impact. The best-read blogs, such as Jay Smooth's news and commentary site, Hiphopmusic.com, and Byron Crawford's infamously vitriolic Byroncrawford.com, were able to attract a readership through word of mouth that easily rivaled the circulation rates of smaller print publications. It's no wonder so many aspiring writers started with blogs and then tried to transition into print—low risk, potentially high reward.

Magazines like *The Source* espoused the ideal of incorporating the voice of the streets, but blogging cut the distance between "the streets" and the writing world. Blogging was a more democratic medium, but improved access didn't necessarily translate into different, let alone better, writing. It was passionate and opinionated, but often times amateurish and unfocused too.

There was also a question of attitude. The lack of accountability made it far easier for online writers to be mean, vicious, or just snarky at whatever artists they choose. Although there was much cheerleading going on, never had so many self-professed fans generated so much negativity against hip-hop artists. Whatever covenant print publications created with the industry

to implicitly support and advocate for artists didn't exist online. Brave new world, indeed.

Stylistically, though, what's interesting is that much of the acerbic, biting style that online writing took on resembled the writing in *ego trip* or, to be more contemporary, the monthly editorials written by *XXL*'s editor in chief, Elliot Wilson, a cofounder of *ego trip*. In a strange way, if *ego trip* had symbolically closed one cycle in hip-hop writing, it helped influence the beginning of a new one with a witty and clever writing style that was also cynical and, at times, mocking. In 2006, *XXL* commissioned the creation of several blogs that became a prominent feature on the magazine's Web site. One of the blogs belonged to Wilson himself, another full circle turned.

The long-term consequences of blogging—at the time of this writing—are too early to tell. Blogging may have expanded the number of potential writers exponentially, but it's unclear what effect this may have on the craft of hip-hop writing. In fact, over the past few years, there's been a decline in the number of people identifying as "hip-hop writers." This isn't out of lack of solidarity; rather, it's a reflection of the maturation of the profession. For the early '90s cohort of writers, scribing on hip-hop was a full-time obsession and dedication, but as they've become older—and as a newer generation begins to emerge—both see the label of "hip-hop writer" as limiting and pigeonholing.[3]

At the same time, there has been the ascension of hip-hop-savvy critics and journalists into the upper echelon of mainstream print publications. Though they may not self-identify as "hip-hop writers," critics like Jon Caramanica and Kelefa Sanneh at the *New York Times* or Sasha Frere-Jones at the *New Yorker* have become highly influential and respected writers who often write about contemporary hip-hop. Rather than treat their subjects as curiosity pieces (read: fetish objects), as was the tradition for far too long in the mainstream American press, these writers treat hip-hop as nothing less than what it is: the most important and popular American music genre of the young twenty-first century.

The aesthetics of their writing isn't anything radically new—in many ways, it nods back to the traditions of thoughtful and insightful criticism that *Voice* writers in the 1980s pioneered. The difference is that their placement in nationally respected publications hasn't just legitimated their craft to mainstream audiences; they are also serving as role models for up-and-coming writers trying to find their own voices and paths.

Perhaps this is a sign that hip-hop writing has finally come of age. "Hip-hop writers" don't need to wear the label as a badge of honor anymore but,

rather, are empowered to write on hip-hop without having to unduly defend their choice of focus. I don't actually think we're quite there yet, but after twenty-plus years of hip-hop writing, the craft—and its craftsmen and -women—have at least earned the right to try.

Oliver Wang is an assistant professor of sociology at Long Beach State. Since 1994, he has written nationally on music, culture, race, and America. His reviews and articles have appeared on NPR and in *Vibe, Wax Poetics*, the *Oakland Tribune, San Francisco Bay Guardian, XXL, L.A. Weekly*, and others. In 2003, he edited and coauthored *Classic Material: The Hip-Hop Album Guide*, and he currently runs the renowned MP3 blog Soul-Sides.com, as well as the pop and politics blog Poplicks.com. He lives with his wife and daughter in Los Angeles.

NOTES

1. Hip-hop journalism here also includes criticism. From experience, most journalists and critics tend to self-describe themselves as "writers," and I also use "hip-hop writing" throughout this piece to denote "hip-hop journalists/critics," but this should not be confused with, for example, fiction writers who work in a hip-hop idiom.

2. Meanwhile, it also needs to be said that *Vibe* had to make compromises of its own. It began with oversized, art-magazine dimensions but eventually shrunk to the standard size in order to improve newsstand circulation. And its ambitious, intellectual content from their early years all but fell by the wayside during their turn toward celebrity coverage.

3. Unfortunately, I think this is partially reflective of the ways in which hip-hop writing is still subordinate to rock criticism within mainstream publications. It has never been an issue for self-identified rock critics to write about hip-hop, but ask any hip-hop critic who has tried to pitch a story or review on a rock or country artist (especially if the artist is white), and many of them will express frustration over the double standard that keeps them barred from leaving their genre niche while rock critics seem to roam across the musical landscape with no barriers.

16

L-vis Is a Pioneer; or, Legacy

The VH1 Special

Kevin Coval

white folks feel safe
vacationing in black neighborhoods
for a night,
disney bohemian
jazz clubs,
cuz L-vis
tapped his foot in time,
clarinet case in hand,
hoping the band leader
would let him practice
blues he heard on Maxwell St.

white folks feel safe
traveling Mississippi
Delta cross roads
cuz L-vis
did anthropology,
patched spots of sweat
off his brow w/ a white handkerchief
and told Lead Belly,
sing in this hear microphone boy,
documenting what the world's sufferers sound like

white folks feel safe
@ rolling stones sold-out stadiums,
middle age leather jacket wearing stockmen
watch w/ hard-on L-vis prance
in silk scarves, big lips
on bulbous microphones
eighty dollars and *right on*
keith richards solos over
the din buzz of budweiser

white folks feel safe
at underground bass parties.
a Puerto Rican co-worker, slipped
mentioned it in passing,
and L-vis goes a couple of times
slapping backs at the bravery
he's bared. he belongs,
manifest destiny. L-vis thinks
i can do that, 4-bar internal
rhyme schemes, shakespeare's
been on that shit for centuries

white folks feel safe
at hip-hop concerts
cuz there are no more
black kids in raider jackets
and timberlands, stalking
bathroom ciphers, they are
in the basement, again
banished to the segregated
cities and suburbs, plotting
new shit in pidgin, we'll hear
in 50 years, as goldie dread locks
recycle cypress hill spliffs
front row and center
as L-vis screams *ho-o!!!*

white folks feel safe
at spoken word cafes

cuz race poems aren't
about me, i'm here
honestly it's not
solid writing
perhaps not
a poem
even,
maybe
a monologue,
though white folks
feel safe reading
journal entries
in public.
L-vis is
moving to the city
which makes white folks
feel safe, dining
in cafes his loft
looks over. young men
held that corner like atlas
until police round up
all those folks and people
who don't look
like L-vis

Kevin Coval is the author of *Slingshots (a Hip-Hop Poetica)*. His writing has appeared in *The Spoken Word Revolution* (Source Books), the *Chicago Tribune*, *Crab Orchard Review*, and *Make Magazine*. He has appeared four times on HBO's *Def Poetry Jam* and can be heard regularly on Chicago Public Radio. Founder of the Chicago Teen Poetry Festival "Louder Than a Bomb," Coval is the artistic director of Young Chicago Authors and curator of the Chicago Hip-Hop Theater Festival.

17

Burn Rubber on Plastic Bubbles

"Gangsta Limpin'" and the Art of Dave Funkenklein

Retreaded by Dave Tompkins

In 1993, a delegation of 18 Samoan rappers went to Disneyland. They averaged 300 pounds a pop and called themselves Boo-Yaa Tribe. Admission was on the house. At "Pirates of the Caribbean," Boo-Yaa crammed themselves into one boat and broke the standing record for maritime tonnage in an animatronic buccaneer fantasy. Even more astonishing was that Disney staff had the cannon balls to kick them out ("Please do not agitate the skeletons"). Apparently, Disney didn't share Boo-Yaa's enthusiasm for testing principles of volume and displacement. It's a small-ass world after all.

I found this rap barnacle when reading "Gangsta Limpin'," a column written by the late, great hip-hop writer, promoter, and impresario Dave "Funkenklein" Klein, who, as it turned out, had arranged Boo-Yaa's day on the plank. Klein headed a Disney-owned rap label, Hollywood BASIC Recordings, and was interested in adding Boo-Yaa to a roster that included Maxwell Melvins and a group serving life sentences in a New Jersey prison, Zimbabwe Legit, DJ Shadow, and two guys from Queens who rapped about cytoplasmic disintegration. Disney perceived this as counterintuitive to its singing dwarfs and dancing brooms, as if a night on Bald Mountain with Chernabog wasn't hardcore.

Special thanks to Dave Paul and Georges Sulmers.

That Mr. Klein ran this label with a malignant tumor in his spine and still had the energy to do things like catch Rodney O on a Friday night in Tijuana was more extraordinary than any duckster franchise.

The first and only time I spoke with Dave, the New Music Seminar was approaching, and advance mailings for Organized Konfusion (the two guys from Queens) weren't ready. The album was called *Stress: The Extinction Agenda*, and Dave said he'd hand them out in person if necessary. I asked what else was going on, and he said something about a tenth brain surgery, and what's up with that Afrika Bambaataa "Death Mix" I'd just reviewed? It was spring.

I knew him only in print, through "Gangsta Limpin'" columns written for *The Source* and then later with *The Bomb*, once he moved out to Los Angeles to start up Hollywood BASIC. *The Bomb* was a San Francisco Xerox operation run by Dave Paul, who incidentally had the same Pumpkin beat on his answering machine for thirteen years and who, as it were, solicited ads and contributors with the hook: "Photos of your grandma buck-naked break dancing." Through "Gangsta Limpin'" I learned that Coolio used to be a fireman, that Bozo the Clown's manager was named "Morty," and that JVC Force dug Detective Stan "Wojo" Wojciehowicz. And yes, Funkenklein was the white guy in the wheelchair at Latin Quarter when all old-school hell broke loose after Melle Mel challenged Chuck D to a battle.

"'Gangsta Limpin' was a tremendous influence on my shoddy attempt at an entertaining column," says Reggie Dennis, former *Source* editor who worked with Funkenklein. "More than anyone else, I think Dave helped set the bar for irreverence in hip hop journalism."

(Said bar was shot to hell one issue when Funkenklein called out *The Source* for putting TLC on the cover. "Dave's comment was a showstopper," says Dennis. "He said, 'Fuck a TLC cover.' It was war. Jon Shecter called David Paul to complain and called *The Bomb* 'a stapled-together piece of shit!'")

Before moving to L.A., Funkenklein ran the offices at Red Alert Productions and worked at Def Jam, often taking artists overseas and "making it possible for them to eat McDonald's in foreign lands." DJ Shadow, another BASIC signee, who dedicated his first album to Funkenklein, says, "Funk's most enduring legacy was his vision of hip-hop as a global phenomenon, often bringing English, Japanese and South African rap groups to play at the New Music Seminar in New York."

"He kept up a schedule that would leave me woozy," adds Dennis. "He was always going to a video shoot or a studio or a prison or an airport."

You could read about Funkenklein's jet setting in "Gangsta Limpin'," whether downworming tequila on a transatlantic flight with Ultramagnetic

or hanging out at Sea World with Erick Sermon. The average column included L.A. riot commentary, medical reports, inbred music-biz jokes, concerns for *Robocop 3*, and a review of a never-to-be-released 45 King tape. Or he'd just offer to swap glossies of Ice T's wife in exchange for a Wattstax video.

Despite being pressed for mortality, Funkenklein wrote about his condition with calm, witty detachment, as if neurological decay were just another weird/normal thing in L.A."Maybe he knew that his time was short," says Dennis. "He couldn't waste so much as a single day."

You feel this urgency in *The Extinction Agenda*, released in 1994, less than a year before Funkenklein died in September 1995. Pharoah Monch raps like he knows where his cells are at all times, tracking them across what oncologists call the "transmembrane domain" only to step outside himself and morph into a bullet in search of an innocent bystander. "Stray Bullet" is the second-to-last track on *Extinction Agenda*—before "Maintain."

How must this have sounded to a man running his wheelchair down an office hallway paved with bubble wrap, simulating a drive-by just to shake up the day—as if he wouldn't have lasers blasting away at his iliac that same afternoon, as if his biggest concern were the bubble wrap's contents—because limited-edition, advance-promo contents go a long way?

It must've sounded pretty damn good.

I REST DEFENSE ON MY LIGAMENTS: GANGSTA LIMPIN'S GREATEST HITS FROM *THE BOMB*[1]

Did interview with Havelock Nelson about Organized Konfusion for Billboard while I had mega-tubes stuck in me. Post-op spent most of my time watchin CHIPS re-runs and the freakshows on Sally-Jessie-Donahue while my mush brain roommate kept fartin and flickin the f*ckin channels. Industry people call you on the phone like this, "Yo, you just had brain surgery, man, but about those per diems you owe me." A coupla Lifers called cause Maxwell got thrown in solitary for some reason. I don't know. Don't send flowers. Send me Olympic Ninja Turtle Action Figures. Thanks.
Called The Beatnuts' 800 hotline to tell JuJu he should scratch up "ju ju baby" from Shalamar's "Make That Move" but the number didn't work, nuts!

The LAPD has two hookers and a pimp handcuffed on their knees on my corner . . . and on a Tuesday. There's another good one in JVC Force's

"Smooth and Mellow": "Barney Miller is my show / I trip on Wojo." I liked Bonz' review of Das Efx in *Spin*. He was talkin' about knocking somebody with a cue ball in a sock on a subway while listening to the album. Heard Atlantic signed these guys for 400,000. This ain't 1988. More respect to the little wooden family. Professor X and Paradise, architect of the X-Clan, dropped by the Disney lot for lunch. The yuppie directors love those nose rings. Saw Rick James at Tower-Hollywood. I think he was buying a Hammer cassette. Got in my Jeep, turned on the radio and Dusty 1230 was rockin "You and I." Drove all the way home before that jam was over. Wild Pitch has a good but overlooked album from Hard Knocks. Heard from a guy named Dorik Perman who calls himself the "Godfather of the Disabled." Ice Cream trucks are rockin their bells in my neighborhood at 11 pm (??) Yo Dave, what exactly is that on The Bomb logo?

The Disney lot had never seen something like the Organized Konfusion LA BBQ. Monch and Poetry, the Funkytown Pros, Everlast and members of Freestyle Fellowship did just that. The Quest release (damn is that all you do, go to release parties?) at Flavor played host to (and what, exactly, does "played host to" mean? I don't know, I read it somewhere) Nefertiti and Rosie Perez from "In Living Color" and Cypress Hill who stickered up the men's room. Once again when in LA, stay away from The Forum. Knuckleheads just stole some of the Lakers' cars and jacked one of their coaches. Saw Eazy E cruizin by Hollywood High in his 300Z, talking on his cellular phone. He looked at me like who is that bald MF honkin at me? They got this new dinosaur named Bruce on top of Ripley's Believe It Or Not on Hollywood. Barney sucks.

Took a big crew of the Boo-Yaa Tribe (18 or so) to Disneyland. Security, who were nervous, made Rosco Murder put on a Mickey Mouse t shirt before he came in. At lunch, I heard two waitresses talking, "Do you wanna ask em if they want desert? No, you ask em!" Outside by the Seven Dwarves building, Godfather hijacked a messenger bike and rode it around with a big smile on his face. Richard Dreyfuss walked by and the Boo-Yaas said "Hey we know that guy." We took a flick. Dreyfuss had no choice.

What classic rhyme invented the word "stere-ere-ooh?"

I was in my office eating ding dongs with an angel blade. So who says gangsta rap doesn't have a positive message: "rollin down the street smokin' indo sippin' on gin and juice." Gangsta Limp's 5 Top Caning Wishes 1.) Dionne Warwick 2.) MTV awards host in a red dress 3.) Al Gore/BC 4.) Doug Llewellyn 5.) John Tesh.

The remote waterfall ain't no joke. The on-stage Onyx commotion looked staged. Best line from Mrs. Doubtfire after she beans Pierce Broznin with a lime in the back of his head: "Ooh looks like a walk-by fruiting." The "wrestle ya" guy from the Kentucky Fried Chicken commercials was in the house last Tuesday. Did you know Coolio used to be a fireman? What's Ted "Gofer" Grandy doing as Iowa congressman? If you win the gubernatorial race does that make you a goober? Did you see Eddie The Dog from Frazier bouncing to Atomic Dog for Cheetos? And Skatemaster Tate at Woodstock? Great title: Biological Didn't Bother. Haiti, we're coming, no we're not, yes we are. So Bill, are we or not, or should I ask Jimmy? A new product Hermorroid is designed for female hemorrhoids. Doom-dee, Doom Dee, Sonic Boom DOOM DEE DOOM: residents of LA heard a loud boom the other day which turned out to be the space shuttle landing in the nearby desert. Grand Puba sounds like he got punched in the stomach after eating a bowl of goulash. Prince Charles was kickin' it in South Central on his recent trip to the US. There was a lady and her fetus in the LA freeway Carpool Lane claiming two passengers? If you're in need of a smooth but stationary 65 Lincoln with suicide doors for a video call FUNK.

Rap convention peev: guys who look like Lonnie from Gap Band shaking your hand in the bathroom.

Does anybody really think they're fooling people by putting "suite" in front of their apartment number? Bought an air freshener tree for my Jeep the other day. On the package it says "partially remove wrapper"—believe em! Almost suffered a Pine Fresh OD. Some guy's been going around Miami saying he's Schoolly D. Did you hear Marky Mark's intro at the AMA? "From the hip hop

Grand Puba description appears courtesy of Dan the Automator, circa 1996.

era. . . . " FYI, LA residents must register their assault weapons by March 30. I just like this guy's name: JT the Bigga Figga. Tonya Harding's ex-husband's name is Galooli. Godfather James Brown recently visited Mike Tyson in Indianapolis State Prison. Vanilla Ice is Rollin Em Up (his dreds?). Mac Mall's got some boomin bass "Sic Wit Tis." Fuck a TLC cover.

If you're ever real bored in the office and have access to a wheelchair, get some of that bubble pack and lay it across a quiet hallway. Back up near the end of the hallway and burn rubber over the plastic bubbles. It sounds kinda like a drive-by. Corporate heads'll be poppin' all out of doorways. That candy snot is getting popular. I got a call from a guy shoppin' a one-legged MC who does flips. He now sends his prose out on the back of Mica Paris glossies. Tim II saw the original Bozo the Clown in the lobby talking on the phone with his manager, Morty. Marge Simpson is an undercover B-girl. Out on Hollywood Blvd was a family of clowns—mom, dad and two baby clowns in strollers. Did ya know it's the sixty-fourth anniversary of the Twinkie?

Deepest condolences go out to 19 year old rap talent Charizma who was recently shot and killed.

MFs are looting sofa stores here. My apartment was full of Koreatown smoke. And the national guard was packin M–16s at the grocery store during curfew. All my swap meets are burnt down. Republican loser Buchanan blamed the riots on rap music. Well, as long as that non-word "wilding" doesn't show up again. Before that, another 6.2 quake shook the shit out of my apartment. Scuse me which aisle is the spray-on snow? Mike D and MCA came by the Disney commissary for a Son of Flubber burger and mozzarella sticks. Wanna be rap censors: Isn't saying something like Ice T's let'sgetbuttnakedandfuck just sort of an extension of old-time Hollywood Mae West's "whydon'tyoucomeupandseemesometime?" Positive K gets with Beavis & Butthead in "Come To Butthead" where they bumrush Run-DMC's tour bus. Biz has "Why is everybody pickin boogers on me?" The E gave me a 70s Coke machine for Christmas. Just-Ice mugged the Coke machine outside the studios used by Cold Chillin.' Fresh Gordon's hooking everyone up with free long distance. Color Me Badd goes to jail in their new

video. Ice Cube produced the video. I think the world is coming to an end. Ya momma is so dumb she climbed a tree to become branch manager. FREE FLAVOR FLAV.

"I got the modification to alterate"—What the hell did that mean?

Best of '92: Best store to loot in the next riot: Circuit City. Weakest mascot at the college bowl games: the Syracuse Orange. Most Lasers in Spine (6): Me.

Here's the word of the week: "brandishing." As in youths were brandishing a 9mm pistol. Can you say brandishing? I'm wondering if the doc who did Mike Jackson's nose saved the rest in a jar or something. Pork Butt Roast on sale at Ralph's for 99 cents a pound. It was ironic to see Tipper Gore shaking her rump at the MTV inaugural ball. Someone shoulda censored that ass out the door. A shooting at an LA nursing home last night is thought to be gang related. LA has officially been declared the "Bank Robbery Capital of The World." They should put that as the slogan on license plates. Now LA has gangbangers in the joint grooming dogs. By now you've heard about the Jack In The Box deaths due to feces bacteria (??) in hamburger meat. My dad was at McDonald's and a pigeon flew through the door and landed in the French fry vat. I know I said it before and pissed a couple people off but I'm starting to hate Reggae almost more than Techno.

Somebody asked me where I live the other day, I told 'em, and they said, "Oh my boyfriend's friend was executed gangland-style over there." Also bought a neon palm tree on the corner in Hollywood.

What is that horrifying love ballad LL did for Keith Sweat?
The neighborhood around LA Coliseum makes Compton look like the suburbs. They just tried to run the LA marathon through there and someone got shot. I had a vision in my mind of runners and baseheads side by side. And watch out for the latest controversial movie from Gangsta Limp films, follow up to "Attack

of the White Boys with Goti's" (editor's note: goatees), called "Invasion of the Cannaboids." Tom Silverman paged Mr. Bobdobalina on the intercom.

Think they shoulda convicted all the lawyers in the Rodney King trial. Boo-Yaa Tribe is in the new Janet Jackson video. Neneh Cherry moved to Brooklyn and got mugged. You've heard all the politicians' plans for '93, but the Funken-plan has two main steps: 1.) Teachers and cops get a raise which 2.) is deducted from the unreasonable amounts being paid to our slimy brethren in the movie and music business. Saw John Travolta in the hall the other day. I also saw what that asshole from SPY wrote about me. He's wrong. He's not square—he's wack. The Captain says the PM yawn kid got beat down at a CB4 party in LA by his girlfriend with a chair. Did I see Beastie associate Rickster in the audience on Donahue, or am I on some of that new improved sh*t? I'm starting an alliance of labels that would never put out some shit that goes, "Oochie coochie la la la."

RIP to Subroc of KMD.

And I second what B. Wade said about gettin what you can outta every day. You're healthy and alive and I know. Me and The E spent the weekend downin' banana splits at the Hardrock in Vegas. I housed the silverware. I have an idea for a new radio station: "All day, all night, all drum solos." I read that LL's "Pink Cookies in a Plastic Bag Being Crushed By Buildings" is about a dream he had. So here's my title: "Guys In Orange Suits and Helicopters Crashin In New Jersey." Deuce finally got a real Daisy Dukes video featuring The Raiderettes. Here's a new unit of measure to replace sq. footage: How many Boo-Yaa's fit in your new office? The next Ultra single will be on Wild Pitch. What's up with San Francisco, Harvey? All I wanna do is a zoom zoom zoom and a boom boom; that shit is deep. Let me see if I can get something straight. There's Sylk, Smooth, and Silk Smooth, Smoov, Schmoovy Schmoov, and wasn't there a Silky Smooth? Steve Martin walked by my office this week. How bout everybody lay off the "Funky Worm" sample for a couple of weeks? Duran Duran, ABBA and Meatloaf still suck. Kill my landlord—I'd rather jack my mortgage rep. I just picked up the BASIC line. Some guy goes, "May I

speak to, uh" then I think he died or something. Remember Slick Rick's fly green socks? Volume 10's "Pistolgrip Pump" on red vinyl. Damn I just saw Fat Joe chainsaw somebody on Video Juke Box. Luke's got a new song called Cowards In Compton. He calls out Dre and spits on the camera. What's up to Potna Deuce and tha 1 Rob G outta Vallejo, CA on Rated Z Records.

What is reassance?

Be careful where you point that bustduster. Lyrical geniuses OK in the office as I type. Erick Sermon is signing in the shower. Worms have been comin' out of the faucets connected to the Hollywood reservoir. Hi-C's drinkin' a 40 underwater in his 'Got It Like That' video. Nestle Crunch has a rap candy bar. Shaft eats at Burger King.

Question: who kicked this classic line 2 years ago?
 "Uh, uh-uh"

I'm not quite dead yet. 45 King thought I was. Anyway here's the partially pain killer–free report I promised following more brain surgery. They gave me morphine. (Who said I wear Bermuda shorts when I'm maxin' in hell?) I was happy. (Who could keep the average dancer hyper than a heart attack?) For about 6 hours. (Ice T should backmask something like "Benny Medina drives a Hyundai") Thought it was more than a coincidence that the Pope was also having surgery within 24 hours of mine. (Eric B is managing Kool G Rap.) Doc said my condition was "life threatening." (Father MC was doing a show at the Quality Inn on the NJ side of the Holland Tunnel.) UCLA cafeteria specializes in oatmeal and mashed potatoes. (Fruitkwan has a single called "Let Me Squeeze Your Bagpipes.") Wardrobe consists of some fly snowflake pajamas with a tie string. (Finally met Tweety Bird Loc.) Had a dream about two helicopters crashin' on Long Island. (What the f*ck . . .) Somethin about a guy with an orange hat. (. . . is on the cover of Divine Styler's album?).

I think I'm gonna have to leave Robocop 3 alone.

Gotta maintain.

Dave Tompkins has been writing for the lack of a better way of putting himself through a window. His book, *I Have No Vocoder and I Must Scream*, is being published by the Broken Wrist Project. It's about spread spectrum communications, war, "Pack Jam," and hearing things.

NOTES

1. Funkenklein's earliest work can be found in his Dance Music Report columns called "Stupid Deff."

Black Talk and Hot Sex

Why "Street Lit" Is Literature

Danyel Smith

I read a lot. I read for pleasure, for work, and for school.

I don't read enough of so-called "street lit." What I do read of it, I like about twenty percent.

Graduate school notwithstanding, I don't read enough so-called "Black literary fiction." What I do read of it, I like about twenty percent.

But then, I don't read enough of *any*thing. Time is prized, and when I'm not reading for school or work, I want to give myself over only to novels that slap me, irk me, move me, and leave me open. Pretty much in that order.

I'm the Black author of two novels with literary aspirations. It remains my goal to create the kind of fiction I like to read. It remains my goal—at this point, unmet—to have a huge amount of readers.

I crave the connection street-lit authors have with their readership. I crave their sales. I crave the thing in their souls that makes them, in many cases, not give a fuck about grammar. Most of these authors, I'm sure, are as bidialectal as me, but choose not to check and cross-check every sentence they write for the kind of grammatical perfection that rings like a glass bell at one of John Cheever's gin-soaked soirees.

Like the best old-school rappers, street-lit authors announce their presence with what many writers of Black literary fiction perceive to be dead-wrongness. Even the most average street-lit author rocks the pen like an old-fashioned "dope MC." It doesn't matter that the book is sometimes monotonous, or

larded with cliché, or slim on plot and character development—any number of Black literary novels could be accused of the same crimes. Street-lit authors—Nikki Turner, Zane, Shannon Holmes, and Marcus Spears among the most successful—write from the authoritative stance of authentic authenticity. Swagger-jacking the spirit of hip-hop from its earliest Bronx, Harlem, and Compton days, street-lit novels appeal because they seem thoroughly Black and free and loud and "real." Street-lit authors *put it all out there*—the stuff many African Americans spend their lives trying to get past, move away from, or talk about only among themselves.

By "the stuff," I mean the actual or psychological proximity to crime, drugs, and drug dealers; the family and/or friends in the prison system; the boldly less-than-conventional sex; the Ebonics and the profanity. *I like big BUTTS!* Remember how Sir Mix-A-Lot shocked with that song? Put Black women's *asses* on the proverbial Front Street as plump sex symbols for all to admire, publicly eroticize, and be disturbed by. *My anaconda don't want none / Unless you got buns / Hon!* Now, that's street lit, in content and style. And it's hard, no—? To be Nancy Wilson or Me'Shell NdegeOcello or Ben Harper or Jean Grae or Austin Willacy when Melle Mel and MC Lyte and Eazy E and Salt-N-Pepa and Grandmaster Caz are taking up all the oxygen in the room. So of course this thing between street-lit authors and Black literary authors turned into a fight.

At the turn of the last century, the J. California Coopers and John Edgar Widemans were tucked safely in the African American sections (a much debated practice heavy with the scent of *Plessy v. Ferguson*) of chain bookstores, and placed prominently in the windows of Black-owned mom-and-pop bookstores. Back then, the kind of books that would come to be known as street lit were almost always self-published and sold from card tables on the sidewalks in metropolitan ghettos. These street-lit novels, with their busty, trigger-happy covers, were profane, poorly spoken, and sexual—so they were seated squarely at the back of the bus. When by popular demand street lit moved from the fields into the house, things got ugly.

In "legitimate" public spheres like politics, Hollywood, corporate America, and publishing—leaving aside the exception of the past twenty years in the "urban" music business—the truism that there's only room for so many Black faces has held. So, the chatter began: Black-lit writers versus street-lit writers. Who's "better"? Who's more "real"? Who is most true to the spirit and needs of African America? Who's "progressive"? Who, in the words we hear so often, "is more positive for the Black community"? Who's least embarrassing?

Black-lit authors, living out the last of their middling advances, and feeling an intensifying disconnect with readers and potential readers, wondered

increasingly aloud at the fate of Black readers, Black publishing, Black families, Black children, Black bookstores, and Black literacy. Black-lit authors were shamed by their own lack of sales, and were horrified by the astronomical sales and prominent placement of books with the "ghetto" and (nasty!) sexual talk in books like *Gettin' Buck Wild: Sex Chronicles II*, *A Hustler's Wife*, and *Cream*.

When scorned, street-lit authors hollered, "Foul!" They hollered, "You hatin'!" Ridiculous. Writers of Black literary fiction and street lit should not beef. The wisest thing would be for us to collaborate actually and spiritually. There's much for us to learn from the other. And as always, there's strength in numbers.

But the grumblings came to a fevered pitch in summer '05, when two important books—*From Pieces to Weight: Once upon a Time in Queens* by the "gangsta" rapper 50 Cent and "hip-hop" journalist/blogger kris ex, and *Confessions of a Video Vixen* by "video ho" Karrine Steffans—made the *New York Times* nonfiction best-seller list. At this confluence of events, e-mail blasts from Black-lit authors came fast and furious. THIS MUST BE STOPPED! Lists were distributed via e-mail box of "great," "brilliant" books by Black-lit authors. CLICK HERE TO BUY! HOW CAN WE LET THIS HAPPEN? Why are we smart ones being relegated to field-hand status?

The response from street-lit authors was quick, but mostly muted and kind of cool. I imagined writers of street lit at tony Le Toiny in St. Bart's, creating stories packed tight with Glock 357s, perky breasts, big dicks, sweaty three-ways, and giant sacks of heroin. I imagined street-lit authors, typing THE END, and then moving money around in their 401(k)s.

Until the beginning of 2006, the fight between street-lit authors and Black-literary authors was hot, but still, in terms of publicity, unaired dirty laundry. It was January of that year when on the op-ed page of the *New York Times*, author and editor Nick Chiles wrote of his dismay upon walking into an "African American Literature" section of a Georgia Borders: "On shelf after shelf, in bookcase after bookcase, all that I could see was lurid book jackets displaying all forms of brown flesh, usually half-naked and in some erotic pose, often accompanied by guns and other symbols of criminal life. I felt as if I was walking into a pornography shop, except in this case the smut is being produced by and for my people, and it is called 'literature.'" Chiles's piece was provocatively headlined, "Their Eyes Were Watching Smut." It was, for a few days, one of the NYTimes.com's most e-mailed articles.

It was on: "babygirl" from Thumper's Chatroom in the African American Literary Book Club (aalbc.com) discussion board concurred: "Worse case sce-

nario, it will remain as a legacy of who we are as a people and a community for our future Black youth. Our kids already know far too little about their history and culture and too many have come to believe such lifestyles, as these books glamorize them. . . . Imagine the impression this will leave with their children and their children's children?"

"snakegirl" replied at the same board: "I don't see Jackie Collins and Harold Robbins stopping Joan Didion or Dave Eggers from being taken seriously and selling books and getting notoriety. . . . [F]or every one Alice Munro . . . there's about 20 Danielle Steeles."

This exchange was one of thousands. And—at least it seemed so, anecdotally—it was the writers of Black literary fiction who were more vehement and self-righteous. But behind the self-righteousness was something old and cold: Black-lit authors weren't as angry at the authors of urban lit as they seemed. They were and are distressed that the stories street-lit authors tell are so much the same as our "Black" stories were seventy years ago.

Regardless of the marches and assassinations and rallies and hard work and college educations and celebrated careers and boycotts and laws passed and laws rescinded, being Black in the United States since the Harlem Renaissance has not changed as much as we would we have it in our collective dream. This *sameness*, the ever constant themes and styles in African American literature, is depressing and hurtful. Take a walk through the Black American canon, and there's the realism/naturalism, the tragic heroes controlled by conditions and biology, the characters rendered without moral judgment, as pure and breathtakingly simple products of their milieu and heredity. There's the trauma of being behind the eight ball, the invisibility, the self-discovery, the (Black) power, the rising up from the bottom, the never being "just" a person but always being "Black" first—*this* is what makes a lot of Black people (and so many Black-lit authors) feel shame. It's *not* the phenomenon of street lit itself. The *cri de coeur* of both Black-lit authors and street-lit authors is WE ARE MORE THAN THAT. The novels just do it differently. That's all.

Writers of Black lit like to write *away* from those old themes, to present Black characters in what we consider their larger humanity. We strive to emphasize, as best we can, how Blacks are "just like everyone else," while trying, probably too hard, to convey how our characters' very Blackness is what lends them universality. We read the American and the European canon, and we want our novels and stories to be considered as "universal" and as "real." It's a wonderful thing, when you try to go deeper and deeper into a character's psyche and motivations, when you try to locate what, if anything, lies outside of his or her "Blackness," and then find that it all comes back to the bizarre and

wonderful and terrible parts of being Black, and the humanity ends up shining in this character, whether she or he finds redemption or unapologetically murders and sells drugs to people for a living.

Street-lit authors tell their stories boldly, without nuance, and with pride, over and over again. It's as if street-lit authors are saying, as rappers did in the beginning of hip-hop, "We are here. This is how it is. Make of us what you will. We're not tripping off you, or the way you think we ought to be. We can curse and be sexual and violent, and whatever we want to be. As a matter of fact: Fuck you—*and* pay me." You almost have to be in the hip-hop generation to feel the tingle in your toes when you pick up a street-lit book. The novels are as embarrassing to some Black people as hip-hop used to be (and sometimes still is). But you know what Nelly says, in his 2000 hit "Country Grammar": *Hot shit! My grammar be's / Ebonics.*

And Ebonics is ours. "It's the language. There's an authenticity in the voice," said longtime literary agent Manny Barron in a 2004 *Publisher's Weekly* piece about the surging sales of street lit. He went on to say that the "inconsistent grammar" and "nonexistent punctuation" of many self-published street-lit books, which can make mainstream editors "cringe," contribute to the immediacy that make them so engaging.

My grammar *doesn't* be Ebonics—except when I'm around my friends and family. But street lit says, *Here who I is, on the street where it's the main language understood. Here's who you is when you go inside and close the door of your lovely house.* Street lit is fun, it's sexy, and at its best it makes me think.

Of course, it's not the only thing I want to read.

According to Amazon.com, the books Nick Chiles references in his "Their Eyes Were Reading Smut" are filled with phrases like *dat bitch, dat nigga, dis shit, dat shit, wuz gonna, like dat, wit dat, fuck wit, dis time,* and *'bout dat.* A recent excellent book of Black literary fiction, Olympia Vernon's *Eden,* is filled with phrases like *crawling hair, missing wisdoms, man with the keys, red gas,* and *hog pen*—all the kinda lovely language that calls up incredible images and makes me curious. But there's a big difference, no? BIG.

Makes me wonder if I'm in touch with what the folks (and by The Folks, I mean Black People) find compelling at this moment in time. Look: first, Folks were mad (back in the day) because Black people had no voice, and then, when the surly, violent, damn-near pornographic Ebonic cacophony rises, Folks want to pick and choose who gets heard. I find it interesting that the

headline of Chiles's op-ed summons up Zora Neale Hurston's 1937 *Their Eyes Were Watching God*. Especially as Hurston, in her short heyday, very often struggled with the bourgeois response to her fiction.

USC professor Carla Kaplan, author of both *Zora Neale Hurston: A Life in Letters* and *The Erotics of Talk: Women's Writing and Feminist Paradigms,* says that when Hurston was writing, Black critics wanted her to stop talking about Black sexuality—especially Black female sexuality, "Most of her peers [were] saying that what she openly discusses are taboo subject matters that can't be treated safely in a white racist society." In other words, *Stop talking that nasty shit in that nasty way. Straighten up and fly right in front of white folks and so as not to embarrass Black folks who are writing in a style, and about subject matter, that, while it may be very true to the author's Black literary soul, is much easier for a "mixed" audience to digest.*

In a paper called "The Harlem Renaissance: The Development of a New African-American Consciousness," Angela Wiley discusses a split in what she calls that era's "third phase," an era that sought the advancement of African American civil rights through the creation of an artistic and literary movement. Whites had told Blacks to "quit complaining about not having recognition and start showing what they could do." So, Wiley says, "[Some] Black writers, afraid to fight and allured by money and publicity, agreed and decided to show what they deserved, and let the reward come to them."

But there was another reaction, too. Wiley adds:

> Among some of the poets and writers, there was simmering ingratitude and, finally, even open revolt against the high-toned artistic standards of the NAACP's and Urban League's distinguished directors. Writers such as Hurston, Langston Hughes and Wallace Thurmon openly expressed their feelings and their identities without fear or shame. No longer looking for approval from whites, they only considered whether their works pleased African-Americans. The Black writers were reacting against the stereotypes of African-Americans and were attempting to maintain an art that was unique while also maintaining their self- and racial-identities.

See? I told you our stories have not changed. I'm old enough to remember how the above argument was handed down to performers of not just "gangsta" rap but all rap. I was against the argument then, and I'm against this kind of unless-you-can-act-proper-don't-come-outside dictum as it's handed to authors of street lit now. The combination of Ebonics and hardcore Black

sexuality tends to make well-meaning, well-writing individuals upset and embarrassed. But I want—and I think we should all demand—ALL OF IT. Black literary fiction, street lit, Black fantasy and science fiction, great biographies and memoirs. I want Black pop fiction, Black erotic fiction, Black graphic novels. I want some good Black crossword puzzle books. I want the whole universe of Blackness, and I want the whole universe. You see what I mean. We can all be in the goddamn bookstore. The best of us can live in the imaginations and hearts of our readers forever.

———————

This is not the essay where I argue against our capitalist society. This is the essay where I big-up African American authors and self-made publishing executives for negotiating their way through a capitalist maze that has historically resisted their efforts. Yes! Okay. Yes: like "gangsta rap," a lot of street lit *is* "pushed out" by the "big companies." Big companies are big because they sell what makes money. And, like gangsta rap, street lit had to claw its way to significance through years of hardcore hustling, a.k.a. self-publishing (not that publishing with a big house isn't a hardcore, different kind of hustle itself). So maybe it's the hip-hop in me, but I respect the D.I.Y.

Do you know this story? In 2001, a woman named Vickie Stringer self-published her first novel, *Let That Be the Reason*. In '02, she started, with a partner, Triple Crown Publications in Columbus, Ohio. Stringer had begun writing while serving a prison term and, once released, has been so successful at picking books and authors that many Borders employees call her firm "the Knopf of African American books." Stringer eventually plucked Shannon Holmes from Atria and signed him for a five-book deal. That's like . . . Nelly leaving Universal Music Group for . . . Tony Draper's Suave House. Insane! Amazing. And, as far as I'm concerned, positive for the fucking community.

Clearly, there were and are readers *not* being served by the likes of fine writers like Tananarive Due, Pearl Cleage, Bebe Moore Campbell, John Edgar Wideman, Paul Beatty, Victor LaValle, and Shay Youngblood. Books like Olympia Vernon's *Eden*, Randall Kenen's *A Visitation of Spirits*, and Martha Southgate's *Third Girl from the Left* are praised in small, mostly inconsequential ways by the mainstream and in African American book-club chat rooms like AALBC. But between these authors and the Black audiences who buy books by the basketful at Borders, and from street vendors throughout Black enclaves like Harlem and East St. Louis and Oakland, there is disengagement.

Black-lit authors have to deal with some questions. Here are the ones I'm asking myself.

Who am I writing for anyway? Am I writing for the masses of African Americans? Or am I trying to explain The Folks to the mainstream/white readership? Am I trying to do both and not succeeding at either? Am I writing for the percentage of African Americans who are well educated/own their own businesses/have good incomes? If so, can I be mad at how my books sell (they do all right, I'm proud, and my publisher's not mad, but I'm *sure* not Teri Woods or Terry McMillan)? Is my "essential truth" not that many other people's essential truth? Is there disdain, cloaked or otherwise, for Black characters in my books? And, most important: am I writing from my most authentic self? "Authentic" doesn't mean "ghetto"; it means "of undisputed origin; genuine." Am I writing confidently and beautifully and truly from that place? It's a question that must be asked and answered every time my fingers start clicking away at the keyboard.

But if we're talking about what I wish for (and aren't we?), here's my list: I wish books of all kinds written by writers of color were viewed as valid and important and as brilliant as books written by white authors of the same caliber. I wish publishers and bookstores stopped with the segregation in terms of "Black books." I wish more Black readers and writers supported the few African American/Urban/Global literary journals and literary book reviews that exist (and I wish some of the more old-fashioned African American–themed book reviews would, um, kick it up a notch). I wish so-called mainstream literary journals and book reviews hired more reviewers of color and also reviewed (by reviewers of various colors) more work by writers of color. I wish more people of color worked at "mainstream" magazines of any kind, period. I wish public schools were better, so Black and brown kids wanted to read (and write) more, and with enthusiasm. I wish white people read more books by Black authors. I wish Black people read more books by Chinese authors and Cuban authors and Pakistani authors (Black people obviously read *plenty* of books by white authors; it's what, literally, we're schooled on). I wish Black authors who consider themselves and who are considered by others to be "literary" supported Black authors who are deemed "pop" or "street" or "urban" or some other adjective that usually is mentioned with the word *just* in front of it. These authors have a voice, even when it doesn't appeal, even when it seems unfair that The Big Companies are forcing it on us and not pushing the work we do. Literary work is important and necessary. It aspires. It envelops. It can be like poetry. It can coexist with street lit. Shoot, it already does.

I say squash the beef. I say squash it and go further: Black literary fiction and street lit should embrace in a rowdy, passionate, illicit love affair—very Romeo and Juliet minus the whole star-crossed thing. The two genres should hole up for a long weekend of wet, buck-naked lovemaking, and then part as the rare kind of lovers who remain acquaintances, but respect the other's skill and heat. In a perfect world, the two genres, each gangsta in its own way, would get together often for fun and pleasure, and, truly, for some respite from those who would try to erase them.

Who knows? From such a hot hookup (imagine the gymnastic lust, the hair pulling, the scratching, kissing, and conversations), there might evolve love. Such things have been known to happen. If readers were lucky, there'd be many, many children—each freaky and bold and wonderful in his or her own blessedly ensured way.

And what about my favorite, *Their Eyes Were Watching God*? Yes, Hurston is deep, is beyond beautiful, and she created what has come, over many years, to be known as a masterpiece of literature. But check the technique—I leave you with an excerpt.

The men noticed her firm buttocks like she had grape fruits in her hip pockets; the great rope of black hair swinging to her waist and unraveling in the wind like a plume; then her pugnacious breasts trying to bore holes in her shirt . . .

"Maybe us don't know into things lak you do, but we all know how she went 'way from here and us sho seen her come back. 'Tain't no use in your tryin' to cloak no ole woman lak Janie Starks, Pheoby, friend or no friend."

"At dat she ain't so ole as some of y'all cat's talking."

"She's way past forty to my knowledge, Pheoby."

"No more'n forty at de outside."

"She's way too old for a boy like Tea Cake."

"Tea Cake ain't been no boy for some time. He's round thirty his ownself."

"Don't keer what it was, she could stop and say a few words with us. She act like we done done something to her," Pearl Stone complained. "She de one been doin' wrong."

Take dat.

Danyel Smith is editor in chief of *Vibe* and *Vibe Vixen*. A former editor at large for Time, Inc., and a former editor in chief of *Vibe* (it was so nice, she had to do it twice), Danyel has written for *Elle*, *Time*, *Essence*, the *New Yorker*,

Rolling Stone, Condé Nast Media Group, the *San Francisco Bay Guardian*, and the *New York Times.* She's the author of the *San Francisco Chronicle* best-selling novel *More Like Wrestling,* and she wrote the introduction for the *New York Times* best-seller *Tupac Shakur.* Her second novel, *Bliss,* was published in 2005. Danyel lives in New York City with her husband, Elliott Wilson.

19

It's All One

A Conversation between
Juba Kalamka and Tim'm West

Hip-hop history, Juba Kalamka and Tim'm West argue, is incomplete until the presence of Queerness within it is acknowledged. In 1999, Kalamka and West cofounded Deep Dickollective, an out-and-in-your-face crew loaded with skill, wit, and clarity that soon became the most celebrated crew in the Homohop movement. Kalamka and West's work has now expanded into theatre and academia. Some trace the beginnings of the Homohop movement to the mid-'90s, with the arrival of Bay Area rap crews like Rainbow Flava, a predecessor to Deep Dickollective. But Kalamka and West argue that such a timeline barely begins to account for the presence of gays, lesbians, and bisexuals in the culture from the beginning. Such a view could potentially reshape popular assumptions about the hip-hop aesthetic.

Chicago-born and -raised Juba Kalamka is a rapper, producer, curator, and speaker. He started up Sugartruck Recordings to establish a alternative distribution network for out rappers. Arkansas native Tim'm West is a poet, journalist, scholar, educator, coach, and rapper. He released an acclaimed poetic memoir, *Red Dirt Revival,* in 2002. After four albums and countless spin-off projects, Deep Dickollective remains one of the most influential Homohop crews. They sat down at their keyboards for this wide-ranging, revealing conversation on sexuality, homophobia, aesthetics, race, and hip-hop.

JEFF: Let's go ahead and start where everyone else—rappers, journalists, academics, older-generation folks, peers—seems to start. There is a contention

198

made by both sides—progressive and reactionary: being hip-hop is incompatible with being Queer. In fact, that doesn't look like a beginning, but an ending. How do you confront this contention in your art and life?

JUBA: I would have to say that contention springs from a very typical romanticism and nostalgia and lack of memory that's a component of most pop-cultural pop discourse, especially around music. Hip-Hop as recorded rap music is now, if you're counting back to, say, Fatback's "King Tim III (Personality Jock)," about three decades old. That's long enough for it to have not only spun its own mythologies but to have marketed that nostalgia as well, the truth be damned. I mean, where does it begin and end? Do we keep it really real and admit that the MC-out-front-as-talking-head format was a commercial concession to sell records? Do we take it back to the days when the DJ was the main focus of party culture? Where do any of us belong as MCs then?

TIM'M: Good questions, Juba. But the MC "out-fronting" (pun intended) and perhaps eclipsing other elements of hip-hop that you experienced in Chicago and me in bumfuck Arkansas is precisely what allows hip-hop to be embodied as only "the man with the mic." Neither of us are young catz in the game (you having emcee'd since the mid- to late '80s and me as early as '89–'90). Hip-hop culture back then was a much more balanced portrayal of the deejay and emcee and dancers even. Part of the problem is that we "gay" MCs who have been emceein' since before our "coming out" get conflated with a "Homohop" movement that is too often presented as some new genre on the fringes of what's next (shall we call it "post-hip-hop"?).

While we too are men on the mic, it is taken for granted that this man with a mic is straight, urban, masculine, and any other number of adjectives that fall in the lazy categorical imperatives associated with the MC. But why are we even just looking at the dudes holding phallic symbols at their mouths? Do you think that sexuality was as much a question of the DJs, graf artists, and b-boys in early hip-hop when the truth is that the art of mixing was first initiated by "club/disco" music deejays, Queer graf artists like Basquiat or Keith Haring largely influenced visual culture, and much of breaking shared roots in forms of movement like "lofting" and even "vogue"? Have there been any articles about "Who Is the Gay DJ?" or "DL B-boys in Brooklyn"? Naw. So the mythology you speak about, Juba, is rooted in the reluctance to explore the ways that diverse sexualities have historically been a part of hip-hop culture. To that end, it's a bit frustrating when responding to questions about hip-hop being incompatible with Queerness.

How about hip-hop being riddled with delusion? How about the retelling of a hip-hop history that does not depict gay as necessarily Other to hip-hop but inextricably bound to it? What about citing the curious absence of Queers in such a homosocial context?

JUBA: Purity mythologies—that is, the idea that hip-hop is a *straight* industry—are nothing new, and though they make a few people feel good for a little while, they're an ultimately ahistorical, anti-intellectual, and myopic way of having conversations around cultural production in general. Hip-hop culture has schizophrenic conflicts around the need for validation versus a vampiric consumer culture. This problem was bound to be complicated by Queerness. This tension isn't specific to hip-hop, but its manifestation is interesting in a modern sense. I mean, as Tim'm has already suggested, many of the records, the graffiti art, the clothing, the language—all of it—were either influenced by or came out of the late 1970s overlaps of punk/new wave/garage/disco in New York City. All of those scenes had their Queer elements, as well as openly Queer and specifically male foundational personalities, like Basquiat and Man Parrish.

If you want to get even deeper—what kind of conversation about authenticity and maleness/masculinity, and by extension the absence of women and Queers, would we have if we talked about the Sugarhill Gang being the brainchild of soul singer and label owner Sylvia Robinson? How do we talk about the place of said maleness when the same woman is responsible for bringing Grandmaster Flash and The Furious Five to international attention? Or what about Blondie and lead singer Deborah Harry's contribution to hip-hop's mainstreaming with the single "Rapture"? Or Talking Heads bassist Tina Weymouth and her Tom Tom Club's "Genius of Love" being the basis for The Furious Five's "It's Nasty"? Who "belongs" in hip-hop then? Who's "real"? Are straight Black men who sample records by white women "real" b-boys? The line is clearly arbitrary and glaringly ahistorical.

TIM'M: So, for me, the conversation is not just about the reclamation of hip-hop by Queers, as is seen in the budding gay hip-hop and Homohop movements in the U.S., but a reexamination of how we've imagined hip-hop in ways that have de-emphasized and discounted Queer presence. Similar counterhistories are being explored with the military and professional sports, but I think that hip-hop, like these others I've mentioned, is the last stubborn bastion of self-congratulating homophobia.

JUBA: It wasn't until commercial viability became an issue for the record in-
dustry at large did the need for a categoric and hard-line heterosexualization
and hypermasculine posturing come front and center. Hip-hop's racial con-
textualization has been similar to that of early rock 'n roll—the sale of scary,
titillating, and ultimately Otherizing fantasy images of nonwhite people that
fit into that same old boxes of "frightening yet sexy." So, no, maybe a "gay"
identity wouldn't fit as a component of a "hip-hop" identity if you under-
stand "gay" as code for "weak" or "feminized" and therefore undesirable to a
media machine selling a particular kind of Scary Negro Drag, or someone
who's performing it and unable or unwilling to interrogate their positionality.

At the same time, there's the issue of "gay" or "Queer" being yet another
identity marker that had already been co-opted by white middle-class institu-
tions by the time hip-hop was beginning to receive mainstream attention. An
authentic b-boy (read: Black) would have had a difficult time integrating a
gay or bisexual identity into his pose, as "gay" was something he would know
he was racially, economically, and socially excluded from.

TIM'M: But even this undermines a rich legacy of gays and lesbians in Black
communities that had little to no interaction with white gay culture. Cultur-
ally speaking, Black gays have always preferred to abide alongside their Black
communities rather than "ghettoize" their sexualities into geographic "safe
spaces." This isn't a criticism, just an observation.

JUBA: I agree. There is the assumption by Black straights and white gays that
Black Queers were somehow automatically interested in participating in
white gay culture—which also assumes an uncomplicated relationship to be-
ing "out" in the way that most people understand that. That is extremely
problematic and, as you have said, lazy thinking.

Growing up in Chicago and attending high school in the early and mid-
1980s there was no real distinction between straight and gay in the house mu-
sic scene, though it was overwhelmingly Black and Latino. My high school
reflected this dynamic as well as that of white gay kids never really expressing
any interest in what we were doing.

Everybody I hung out with loved house because it was a local product that
was getting international shine. B-boys were a part of this scene as well, and,
with the random exception, there was a peaceful coexistence. Believe it or
not, the first antagonism in this regard was in the *reverse*. Hip-hop repre-
sented an aggressive encroachment on these cultural spaces that had been

carved out by Black gay DJs who had already experienced antagonism from white rock radio and consumers and created this new underground dance music scene that contained many of the same sonic elements from disco that hip-hop was cribbing.

The b-boy pose of the early to mid-1980s was problematic in one way because it was so hard to pull off, myself included. You couldn't dance. You had to be "hard" or street. And if you were a goofy, middle-class nerd like myself, it didn't work. I admired and invested in hip-hop performativity from a distance until Public Enemy and the Ultramagnetic MCs came around. Now I could be a weirdo or a Black nationalist because I had a context for both. That became complicated later as well, but I mention all of it to say it's always been complicated, much more than people are willing to admit.

TIM'M: To complicate matters further, we might consider the assumptions made about gays of color and social space. Places with strong Black gay and lesbian demographics are generally strong Black neighborhoods in general, whether we're talking about Bedford-Stuyvesant, Crenshaw, Hyde Park, Lake Merritt, or the Shaw in D.C. These are also spaces where hip-hop culture is mediated, proliferated, and "consumed," especially by youth and young adults. So the Queers in these spaces are getting the beatz and ciphers just like everyone else. I think that if "gay" equals "white" to you, then gays in hip-hop seems like some sort of contradiction. I think that if gay is the dreadlocked b-boy with headphones and a scratch pad for his rhymes on the train, a swagger not unlike the other b-boys in Brooklyn or Chi-town, then it doesn't seem like a contradiction at all. You'd see it as inevitable that homos would not just be consumers of hip-hop culture, but innovators as well.

The real question of homophobia should be placed on a market machine which has assumed that the larger popular culture doesn't and wouldn't have an interest in gay folk rapping, or that gay rap would necessarily be about "gay" topics, rather than general life experiences that a broad range of people can relate to. When has the larger culture ever been given a chance to see if they'd like homo rap? And frankly, many gay artists have been doing the damn thing anyway for so long that we find the small bread crumbs of some labels taking an "interest" in gay artistry to be a bit insulting.

Deep Dickollective has been touring since 1999. We're not asking for mainstream permission to be emcees. If anything, we are challenging the blatant homophobia, often through tokenization, of a hip-hop industry that would still prefer to pretend that boys in ciphers aren't sometimes exchanging digits after for sex sessions—I mean, editing each other's rhymes . . . yeah, that.

JUBA: Don't get me wrong. I'm not using the notion that critics have largely ignored nonwhite gay aesthetics inside of hip-hop culture as an excuse for the homophobia I or others have experienced within the African American community. I just think it's a much more complicated conversation than Black people—especially Black men, critics, artists, and consumers alike—want to have because it would require an examination of the way patriarchy functions intracommunally. Open conversations about homophobia as an extension of sexism and misogyny would put a lot of stuff on the table that gets dismissed in the name of silencing and the erasure of inappropriate faggotry.

TIM'M: You said "inappropriate faggotry." Let's not get it twisted. Hip-hop heteros rely heavily on the inappropriate faggot in order to even exist. In a really twisted sort of way, they rely on the verbal bashing of fags in order to substantiate their manhood. Which backpacking love, peace, and justice MCs have ever been regarded as "hard"? None. In fact, many of them are so often suspected of being "fags" that they go to sometimes great and awkward lengths to say: "Hey, I'm for peace and love but fuck a faggot." It's really funny, actually. Sadly, hard edge and masculinity almost always means you hate fags. We can imagine Eminem doing a song on stage with Elton John, but that'll be the day when Dre kicks it with Little Richard, "good lawdy."

I think there's also an assumption that people who seem to fag-bash in their lyrics are necessarily homophobic in the ways people normally think about homophobia. It's one thing to say you "don't like faggots" or "that's so gay," but, in reality, you love your lesbian mother or look out for your baby brother or cousin who you know ain't never had a girlfriend. It's another thing altogether to be raising megabucks to stop gay people from getting married or finance the Republican candidate for president. Sometimes I think I prefer the homophobic remarks I can strategically counter over the subtle, polite, smiling-in-my-face white (or Black) Christians who want to relinquish my most basic human rights. Generally, I just don't think there's ever been a thorough assessment of Black people's perspectives on Black people in their community who are gay or lesbian, unless produced by the Christian Right as a political scare tactic. Nobody's interviewing my mama or straight brothers. They aren't talking to the first (straight) emcees I ever rhymed with or people I collaborate with still who don't care 'cause they see talent. This may sound a bit odd, but I've been in a lot of Black settings where people know that I like boys, and ain't a damn person tripped.

We hear about any and every instance where homophobia is present, but what if we talked as much about the settings where people aren't? Gay and

straight alliances in hip-hop are simply not "good" news, so many journalists ignore any signs that hip-hop or people of color might actually be more okay with gays than is assumed. I'm just hoping for a more complex analysis of the situation. But I'm not holding the breath or the beatbox to wait for it to happen. We've got more records to break.

JUBA: Thanks for touching on something I hadn't addressed directly—power, specifically the institutional power or the ability to create and effect public policy around one's prejudices, global, white-supremacist, patriarchal capitalism—something that Black people do not possess. People do indeed get it twisted. Hip-hop didn't draft the Defense of Marriage Act, or create "Don't Ask, Don't Tell," or murder young folks like Sakia Gunn, Matthew Shepard, Gwen Araujo, Brandon Teena, and Rashawn Brazell. What happened to those young people was *allowed* to happen, and encouraged. I too get tired of the onus and responsibility for interrogating and eradicating homophobia being laid at the feet of poor and/or nonwhite people.

The hypocrisy on both Black and white media outlets is so glaring as to be comical. Even the majority of white LGBT media outlets are steeped in and driven by middle-class economic and cultural privilege. They maintain and invest in these conversations about hip-hop—seen as a poor, urban, nonwhite youth culture—as the *apex*, if not the genesis, of all pop-cultural homophobic notions. We get the attendant ridiculously satirical or frightened and aghast puff pieces about b-boys and b-girls pushing against-all-odds at some huge wall of nigga antagonism.

Then a movie like *Brokeback Mountain* becomes successful, and all of a sudden you see articles outlining the long history of Hollywood's homophobia and how these invariably white actors can't get jobs after playing fag on film. Huh?! What happened? Where did the b-boys disappear to—or is this our fault as well? Did Run-DMC secretly concoct some scheme to keep Harry Hamlin and Michael Ontkean from getting feature-film leads after they did *Making Love* in 1982? Where we at?

We're exactly where you say, Tim'm—invisible, trotted out when needed to create some furor or sell some magazines or cable shows. Poor and nonwhite folk (and yes, this includes Eminem's authenticated wiggerisms) become these abject, mythological characters. This is the genesis of my reference to the frightening, "inappropriate" faggot—by which I mean the real, the living, the breathing, fucking, fighting, loving, shit-talking faggot (and by extension the even more frightening, emasculating bulldagga/dyke) as opposed to the

ersatz, apolitical, defenseless "Men on Film" incarnation of the "sissy bitch-nigga" (wow, there goes that misogyny again).

I mean, really, could you watch Marlon Riggs's *Tongues Untied* and come away with a notion that queeny Black gay men were *afraid* of straight people, or somehow necessarily co-opted and conscripted by a whitewashed notion of "gay" culture? How does a straight Black man look at himself after reading Essex Hemphill's interrogations of his brothers' sexism toward Black women or deconstructions of how the white gaze had complicated his notions of what his desires *should be*? How do white and nonwhite men deal when confronted with Pat Parker's dialogues on female masculinity and butch identity?

Heteronormative culture, white and nonwhite, doesn't want to deal with the issues they discuss. It's all too scary. So they start making up these mythologies, these ghosts to go, "Ooooh, boogedy boogedy!" The conversation around Queerness in hip-hop has bubbled under for a long time, but has burst into the mainstream recently because of the way the Internet has allowed us to create community internationally and keep the conversation going, whereas before we were often left wondering where each other was, and hoping someone would pop up and identify themselves here or there. Now our presence, and the conversations around what we represent, past and present, cannot be dismissed as some aberration or wrinkle in time.

JEFF: Is form part of the problem here? Are there potential openings in other hip-hop genres—performance arts, dance, visual arts, film, theatre—to transform the discourse that aren't available within rap?

JUBA: Yes, they are indeed more viable. Though they struggle with homophobia in similar ways, dance, the visual arts, film, and theatre as general categories all have spaces in which nonwhite Queers have existed openly—thrived even—long before there was a "hip-hop" culture as we know and understand it. There was no way to keep Queer discourse from seeping into the hip-hop versions of those expressions.

So what happens is, whether intentionally or not, the MC becomes the arbiter of the culture, because vocal/verbal performativity by a Black masculinized body was the only place that could be inhabited with little or no questioning of whether there was any truth to the stories it was presenting. The MC is an extension of the preacher, the pimp, the Black Panther in

leather jacket, and the "strong Black warrior" mythologies that have defined so much of Black heterosexual male American cultural memory.

TIM'M: The growth of hip-hop in other genres can be misinterpreted if it is seen as growing out of frustration with hip-hop. I don't think that I'm any more frustrated with hip-hop than many of my straight comrades. What you're beginning to see are MCs, DJs, graf artists, and b-boys getting older. The viability of our presence in hip-hop has to take different shape as we mature. DJs start producing, graf artists start digital design work or go back to art school, b-boys start teaching hip-hop dance or doing choreography. Akin to the shift from some mainstream rappers to acting or entrepreneurship, many indie MCs are looking at starting labels or publishing companies to support the extension of their voices through younger generations inspired by their work. I may become better known through the hundreds of students I've taught and rhymed with at high school cafeterias than through my own interventions. Along those lines, I was not necessarily a poet before I was an emcee, but I do know that I'll probably be doing readings at bookstores and colleges long after I've retired the mic and the crotch grabbing. Hell, I'm getting "married" and expect to have kids in a few years. Juba is a father of two children. Our shifts are not always reflective of ideological discontentment with hip-hop, but sometimes the realization that it's a culture now, not just a genre of music (or, in fact, many subgenres) that happens to have exploded beyond anyone's projections. The kind of grip that some want to have on hip-hop comes off as a bit prudish and selfish. Hip-hop will continue *becoming*. I just hope that its becoming takes into account my presence and the presence of others who are gay, les, bi.

JEFF: How do you answer people who argue that even Homohop is a step backwards, that it's giving back ground in the popular culture, especially as it relates to notions of masculinity, and that it's part of a double-edged post-AIDS world that mainstreams reactionary notions of Queerness while erasing and marginalizing more radical positions?

JUBA: People who say that haven't studied or consumed the work of Homohop artists or the culture that they have created. They clearly don't understand the ways in which Homohop is informed by music-based cultural/political movements that have preceded it. In addition, anyone who would think so is being really assumptive with regard to the desires and motivations of the artists that comprise this community. It smacks of a really deep

denial of the nature of homophobia in our culture and how people relate to media and cultural phenomena as a result.

My ideas around male performativity in the Homohop community have been strongly influenced by the myriad of complicated dialogues around maleness and masculinity that are being presented there and by a myriad of other artists and activists from other communities past and present. Sugartruck Recordings doesn't exist without Marlon Riggs's Signifying Works, or Queer women's concerns like Olivia Records or Ani DiFranco's Righteous Babe Records. There is no Deep Dickollective without PomoAfroHomos or Sweet Honey in the Rock. Our notions of what comprises "man," "male," "gay," "Queer," and "masculine" are of course affected by race, class, geography, and the level at which said artists are able and willing to critique the way consumer culture has affected hip-hop, the ability and time to critique being a privilege itself.

The manner in which straight and gay mainstream media react and respond to Homohop artists is indicative of the subculture's radicalism and continuing relevance. For example, many of the artists in this scene, even those whose prime directive is "mainstream" acceptance and commercial viability, are, in my opinion, still far too complicated in their aesthetics, presentation, and politics (overt and implicit) to be acceptable grist for the mainstream media mill. Even the most "commercial" ones address gender, sexuality, race, and HIV/AIDS in such open and unapologetic terms as to be way too uncomfortable for consumption by a white mainstream audience, gay or straight.

I do believe "mainstreaming" of an out Queer hip-hop artist will happen at some point. I'm pretty sure it will be one who in the tradition of the major label industry is manufactured, programmed, and tailor-made for easy consumption. That won't be the fault of present-day Homohop artists. The mainstream has always mined the underground for cultural expression and identity—blues, jazz, rock and roll, punk, disco. It happens over and over again.

Maybe Berry Gordy's motivation in creating Motown Records and selling scrubbed-up Detroit project kids to suburbia in the 1960s wasn't completely altruistic. There are some people who might argue that he caved in to the whims of the record industry of the time and the ways felt safe consuming and presenting "Black experience." On the other hand, you could argue that if he hadn't, we may have never heard Stevie Wonder's *Songs in the Key of Life* or any of Marvin Gaye's 1970s output or any of the current independent and underground artists influenced by them. The same goes for specifically Queer

cultural output. Binary relationships like "mainstream versus underground" are ultimately self-defeating because, as Tim'm said earlier, they tend to dismiss the existence of lateral spaces of creative output and the conversations that happen within those spaces.

TIM'M: Let's be clear. Hip-hop needed "Homohop," or else it wouldn't have happened. The origins of the term are rooted in me and Juba poking fun at how seriously people were taking this gay rap shit back in 1999. So the codification and invention of the term as an actual category should be attributed to a hip-hop culture in desperate need of its "next shit." Deep Dickollective and others were called to the mic because of various challenges about our curious absence. When you have *Brokeback Mountain, Will and Grace, The L Word,* and a token gay on practically every reality TV show, there's a recognition, if not always an affirmation, that the absence of the Queer is unrealistic. In a generation of people still demanding, elusive as it may be, that we keep it real for real, there are thousands of hip-hop fans, many or most of them straight, who dig "Homohop." Would I love to see the term expire? Sure. Would I like to get paid every time it's used? Sure, that too. But the point is Juba and I could have mentioned "fruit gangstas," and some journalist at an interview would have taken it and run. Like I said in the doc *Pick up the Mic:* "It's all one hip-hop." Where it goes, my legacy will follow: revolutions, discontents, and all.

20

Homothugdragsterism

Joël Barraquiel Tan

"I wish I were Black. I want to feel what they feel."
**—Jean Genet confides in William Burroughs during the
1968 Democratic Convention in Chicago.**

Drink a beer, sit in his chair
Hands in his pants fiddlin' with his dick hairs
He's a rudeboy, a raggamuff
Ready to bag another brother that he ranks not ruff enough
'Cause if it ain't ruff it ain't right
—from "Ruffneck," MC Lyte, 1993

In the late eighties and early nineties, tired of the white West Hollywood scene of fluorescent Lycra and you-don't-belong-here glares from bronzed club doormen, I retreated into a parallel colored universe of Queer homeboys and vatos. Bald, tattooed, Dickies- and A-shirt-wearing, gold-toothed, goatee-sporting, prison-muscled, macho-swaggering, beeper-paging, Death Row Records–looking Blacks, Chicanos, Filipinos, Samoans, Tongans, and Salvadoreños, with a healthy sprinkling of white boys who, under the club lights, looked as brown as any of us. We danced and cruised the Catch, Arena, Circus, Horizons, Caper Room, Annex, the Study, the Griffith Park parking lot, 3626 tea dances, Score Sundays, low back-alley bars, and glamour clubs outside and under the radar of the blond-streaked, gym-buffed, and orange-tanned white Los Angeles.

During this period, the colored Queer scene was moving out of a largely house-dominated scene into hip-hop. The "house generation" was comprised of older, mostly Black gay men, and they centralized the sissy. With roots in

postdisco and Black gospel, house queens wore their sexuality front and center. These were siddity, sincty, clutch-carrying church queens. The kind of "gurls" that sassed and vogued across gender's fluid and slippery continuum. They were also a generation almost completely decimated by poverty, racism, homophobia, and AIDS. The freedom and joy that was house culture gradually disappeared as the number of AIDS-related deaths climbed. As the house sissies died off, a new generation of Homothugs emerged.[1]

Flowing rayon shirts and sweater sets gave way to thuggy Timbalands and Kani. Frankie Knuckles lost his queenly crown to Dre and Puffy. Brown and Black gay men thrilled to the macho posturing and related to the outlaw nature of gangsta rap, despite its homophobic lyrics waging a war against *punks, faggots, and Queers*. This shift was a survivalist return, a move back into the closet as a response to AIDS, racism, and homophobia. This younger hip-hop generation wore their masculinity like armor. The tougher (looking) you were, the more boys you could pull. While the white boys wiggled around to techno, the Colored Queer boys I ran with rocked it to hip-hop. Hip-hop.

But I was a poser. An impostor.

The irony of Homothuggism and its built-in homophobia wasn't lost on me. But I loved the beats, loved the way my brownness was embraced and celebrated, and the ways hip-hop provided the context and language to document my colored Queer reality, a reality that remained generally invisible to mainstream (gay and straight) society. The passion and immediacy of spoken word, with its roots deep in hip-hop, also greatly influenced my earlier poetry that was written more for "stage" than "page." Besides, I knew that if I was EVER going to get some tail, I'd better start dressing and frontin' the part of Homeboy.

But deep down inside I knew better.

I grew up in a working-class family in the San Fernando Valley. Although we had started off in low-cost housing, I would hardly call it inner-city living. My mom used food stamps and cooked with government cheese, but in no way was I a ghetto child. Everyone I grew up with in my working-class community aspired to be anything but ghetto. There was no romance of ghetto life there. I was not a tough, macho-loco kind of guy. I was a poet. An emotional, hypersensitive, working-the-entire-spectrum-of-gender kind of poet. How gay was that?

The first time someone called me a Homothug, I took it as an insult. Turned out I was being hit on. It was summer 1994, during Oldies Tuesday and dollar beer at the Sugar Shack in El Monte, a tiny bar that attracted aging Chicana lesbians, older vatas that looked and acted like men with their heavily

made-up *hainas* in tow. The Shack was old school, nothing but '50s Elvis records with a smattering of Bloodstone, Smokey Robinson, Shirelles, and other golden-oldies selections in the jukebox.

As I walked into the Shack, an attractive, tough-looking Chicano about my age threw a hard, menacing look my way. He was wearing a bright-white A-shirt that contrasted with the light honey brown of his muscular arms. We locked eyes, he lifted his chin up quickly, gesturing *wassup*. I replicated his signal, threw my chin up, then walked to the bar, his eyes burning a hole in the back of my freshly shaved head.

"Tssst. Tsst. Ey!" I heard behind me. I turned around and there he was, inches away from my face, mad-dogging me, and then he asked, "Where you from, eh?"

Before I could answer, he continued, "'Cause you looking fucking crazy, eh. All *Homothug* and shit."

Then, just when I was getting ready to respond with an equally heavy insult, he cracked a smile so big and lovely it felt like sunshine and sea waves breaking inside my chest. I mustered a lame, "Uh, thanks."

My "fucking crazy Homothug and shit" look that he was referring to was a pressed plaid-flannel Pendleton shirt, tightly creased khaki Dickies, and shell-top Adidas. My friends and I took our fashion cues from the local swap meet to fit in. Since I had started dressing thuggier, I noticed that I got cruised more.

He introduced himself as Spooky, but I pressed him to give me his real name because I didn't have it in me to call a grown man "Spooky." Vladimir, a.k.a. Spooky, was born to a Cuban mother and a Russian father but identified as Chicano, and was raised in the middle-class suburbs of West Covina. Apparently, I reminded him of an unrequited high school crush, a Filipino football player named Bingo. Vladimir loved birds and Marvel Comics. He went to a community college and hoped to transfer to UC one day to become an ornithologist. And as Vlad relaxed, his affected vatospeak and Spooky Homothug persona faded, and the more attractive he became.

I walked away from that night with a neck full of hickies, Vlad's beeper number, and a troubled sense of what it meant to be a Gay Man of Color in Los Angeles. What did it mean to don the ghetto armor of rap artists like Cypress Hill, Boo Yaa Tribe, and Dr. Dre? That the term *Homothug* had become a badge of masculinity, a measure of desirability that parroted stereotypes of working-class, inner-city, Black and Latino heterosexual men?

Three weeks after our initial meeting, Vladimir and I decided we'd date each other exclusively. We were giddy from the newness and excitement of

our budding romance. Vlad was particularly fond of dressing and "perfecting" my thuggy look that was meant to complement his. I didn't take my thug makeover too seriously, but Vlad got a sexual charge out of it. So seriously did he take his thug persona that once after making love, I caught him in the bathroom throwing hand signs and practicing prison Polaroid poses at his own reflection.

Vlad thrilled to public displays of affection whenever we were out at the bars and Homothug events. But outside of our Queer colored world, Vlad was "hands off," acting as if we were "just" homeboys. Nothing more. This bothered me and I told him so, but ultimately I also understood his anxieties. Vlad also didn't care for my queeny friends, the ones who referred to each other (and me) as "girl."

"Tell your fuckin' faggot friends you're not a girl already. Why do they keep calling you that?" Vlad and I were parked outside of a big backyard party in Bell. Queer cholos and homeboys in twos and groups were heading toward the entrance, where a giant Samoan dude named Teeny collected a five-dollar cover charge. Tupac's latest single, "California Love," was booming.

"Well, I'm not a girl. Right, Vladimir?"

"The thought of you as a girl just makes me sick. It's just so unnatural."

"What is?"

"Acting queeny. Why can't they just act natural?"

"Natural?"

"Yeah, like a regular guy."

"A regular like you, Vlad?"

"Well, yeah."

"But Vlad, you're not a 'regular' guy. At least not by society's standards. No one was born butch. That's learned behavior. "

"You mean to tell me that the way you are is just an act?"

"Hmmmm . . . maybe?"

I remember going to the party. I don't remember what kind of time we had. But soon after, Vladimir stopped returning my calls.

September 1996. It was a hundred degrees in San Francisco. Torture. Especially because no one had air-conditioning. Wouldn't need it, usually.

I was scheduled to read, and I hadn't gotten any sleep the night before, partying hard with Jorge Cortiñas and Ricardo Bracho, two promising Latino Queer playwrights whom I referred to as the Heathers. The night started off at some party where we dropped this and that, and I had passed out while Ri-

cardo was making some point about Coco Fusco. When I came to, we headed to The Universe. Not that any of us liked the mostly white, gay-boy, techno-circuit club, but there was no sleeping that night. And now, we were laying on Jorge's ratty futon in the middle of his living room.

"I could just no-show," I said.

Ricardo and Jorge both laughed. Jorge reminded me that my Filipino fans would kill me. Besides, Jessica Hagedorn was part of the lineup. And if partying interfered with my art, then it would also signal that I'd fallen from "recreational use" to "drug problem." So we went. Splurged on a cab and arrived to find that the small club venue had spilleth over. Hot, sweaty Filipinos everywhere, and a DJ was ripping it up. This was a young scene, straight, beautiful, and definitely all about hip-hop. Unlike other Asians, Filipinos came out in numbers for hip-hop.

And this mostly het community of Filipinos really dug me. Queer, talk-about-sex-all-the-time me. But why? Promoters regularly booked me for reading after reading where I performed spoken word about courting and fucking another Filipino man, striptease and cultural identity, and Griffith Park cruising Latino and Black Homothugs.

"Manila heat, yo! YO! YO! Manila heat, people!" Rafael, the evening's spirited host yelled and the crowd hollered.

Afropinos. That's what I called these young nationalist Filipino American hip-hop heads who wore their thick black hair in cornrows and Afro-puffs, dressed ghetto fabulous, and spoke fluent Ebonics. I think they thought I was one of them. After all, my big, brown tattoedness was its own statement about masculinity. Unlike other Queer men who were smaller and acted more effeminate, I didn't carry the fear of being fag-bashed or verbally harassed. My size and stature screamed, "Basher, beware, this big motherfucker will exact some scary fucking justice on your ignorant ass."

My community loved me. And it felt good. I thought maybe these young Filipino Americans were like the French hets who venerated Proust, Genet, Baudelaire, Gide. Not only were these beautiful nationalist straight boys not (visibly) freaked out or fearful that I would automatically make moves on them simply because they were male, but they respected me. Some called me revolutionary. Others kiddingly referred to me as "Godfather." I was labeled "O.G." A number of them confessed that they'd never before met a gay man like me.

All of this made me think of Genet when he visited the Panthers. Former Panther chief of staff David Hilliard recounted stories of Genet's tour of the United States promoting popular support for the Black Panthers. Mr. Hilliard

spoke highly of the radical French writer and referred to Genet as an impor-
tant "revolutionary." Genet was as supportive of Panther politics as he was
lustful of the young muscled bucks of the revolution.

I often wondered why other Queer Filipino poets/writers weren't booked
to headline these gigs. When I raised this issue to two of my favorite event
promoters, they politely considered my suggestion but ultimately expressed
reservations. Those other Queer Filipino poets weren't, "you know, down.
Like they not hip-hop." Neither was I, I told them. They looked at each other
and laughed. One of them said, "Yeah, whatevers. . . . "

And when it was my turn, I went up to the mic. The crowd was clapping
wildly, and the DJ played a hypnotic beat, repetitive, pulsing. Sweat and po-
made coursed down my face. Then I did my thing. Ripped into my comedic
sexual piece, "Flip Man," and when I got to the part where I threw out cock-
fighting as both metaphor and a literal act, the crowd went wild. Voices woo-
hoo-ing and "I know that's right," and I remember feeling really momentarily
confused about where I was, what I was doing—was I performing, or was the
audience? As I finished my set, I glanced to my right and looked over at Jessica
Hagedorn. Wondered if they thought she was hip-hop too.

Me and my better better sisterfriend Tyrome—we call her Tyesha—were out
trawling the Long Beach bars. It was a mellow Sunday afternoon, and Tyesha,
newly single, was sharing the tawdry details of her latest manhunt safari in the
wilds of the L.B.C. Six foot three, proud bottom, sweet pretty face, and built
like Laila Ali on male hormones, Tyesha is a veritable Homothug, down-low
brother, probation-officer-having-no-good-triflin'-ass magnet.

Settled nicely in my partnered domestic life, I lived vicariously through
Tyesha's sexual adventures. Tyesha had recently met a number of Black and
Latino men who identified as heterosexual but were all too happy to do the
horizontal polka. It was a classic fantasy. The brutish ghetto oversexed man of
color who could give any pussy, man's or woman's, a black eye. Nothing origi-
nal. It's even its own genre of porn. If you don't believe me, Google "Ho-
mothug" and see what you get.

Just as I was about to ask Tyesha whether or not her latest encounter had all
of his teeth, a boy-man stepped out into the patio and leaned seductively into
a table beside us. Tyesha stopped midsentence to take in the sight of the
travel-sized, pale-skinned Latino, attractive with prominent Indian features,
and with a wink she motioned him over. He swaggered over, and I noticed
that his shirt read, "I DON'T Do Girls."

"Yo, yo, yo, wassup, baby. Wassa-goin' onnn? My name Q-Dogg. And you?" The travel-sized Casanova stopped inches away from Tyesha, who turned to me and licked her lips, signaling that she was planning on making a midnight snack out of this chicken wing of a man. Our little visitor was obviously posturing as the dominant with his pimp-daddy strut, and I couldn't help flashing what he might look like atop Mount Tyesha. Something like a Cabbage Patch doll mounting a supermodel. I shook off the disturbing image, turned my gaze away, not wanting to engage in what already felt like a whole lot of messy brewing.

"So," Tyesha purred, fingering the short man's belt loop, "you've been here a while?"

"Me? Nigga please—"

Cartoon sounds of brakes screeching and auto glass and metal crunching echoed inside my head, and I braced for Tyesha's response. Nigga please? Raised in a proper Alabama middle-class Caribbean and African American family, Tyesha wasn't one to take kindly to any conjugation or variation of *nigger* or *nigga,* especially from non-Blacks.

"Nigga who?" The initial warmth in Tyesha's voice now ice cold. "Say that again, little one?" Tyesha stood up, her coquettish girly-boy aura aside, and towered over the tiny man.

Little Bit squeaked, "It's cooool, boo, it's cool, it's all good, it's cool, alright? And my name's Q-Dogg."

"Nah, Silly Dogg, it's not cool in the slightest." Tyesha tugged at the edge of Little Bit's baggy jeans. She spun him around, making it abundantly clear that he *nigga pleased* the wrong Black queen. The poor little thing struggled pitifully against Tyesha's frightening grip. Tyesha shoved him off with a light kick to his behind. "Get on outta here with that nigga shit."

"Dang!" Little Bit yelled behind him as he retreated into the bar. Tyesha turned to me, and we both shook our heads. Two more martinis later, and we walked back into the bar. Little Bit had found a new audience for his ghetto antics. Nelly's "E.I" was booming out of the jukebox, and Little Bit was lip-synching along, wildly miming gang hand signals alternated with embarrassing bootie whomps with his no-behind-having self. Surrounding Little Bit was a group of Black men, not Homothugs but some old-fashioned siddity church queen types. They were chanting "Go, Q-Dogg. Go, Q-Dogg. It's your birthday." The joke was on Little Bit, who was completely clueless.

———

I once got into a shitload of trouble for publicly denouncing hip-hop. And I was kidding. Mostly. It was during a panel for a UCLA Samahang "Hands On!" Queer Flip student conference, and I had developed a Queer FlipArts Manifesto. The controversy centered around items 9 and 10.

9. I try to fight the Pinoy urge to align my writing sensibilities with hip-hop. It's tired and played out. I have tried to cancel my subscription to *Vibe*, but they keep sending it to me. I try to listen to '70s and '80s punk now when I write. This is my proactive response to the hip-hop Pied Piper. Turn away from the turntables and resist, resist, resist.

10. It is of the utmost importance that I, whenever tempted to express myself passionately and in a manner that reflects today styles, go to the mirror and repeat this mantra: "I am not African American. Their struggle is not ours. I shall not imagine or affect unreasonable representations of Black people and abuse Ebonics as an armor of cool . . ." and so on and so forth. Now, repeat after me.

I admit, hip-hop was boring me. I was turning to other aesthetics for inspiration. I started to look to the '70s and '80s punk and new wave. I had made a conscious effort to move away from spoken word and began developing poetry for the page. I also began experimenting with poetic forms, favoring the repetitive/cyclical: pantoum, sestinas, villanelles, linked haikus, renga.

By now, hip-hop and Homothuggism had already mainstreamed into Queer culture. There were publications, circuit parties, and openly Queer hip-hop artists of every genre. It was less fun. Less dangerous. Hip-hop suddenly started to feel like a choke collar, and one that took itself way too seriously. As if it was the only way to be brown and American.

I had also grown weary of Afropinos, Queer and straight alike. It didn't bother me that Filipino Americans were affecting and talking Black. What vexed me was the ways this adopted Blackness went unquestioned, and the defensiveness and the hostility I faced anytime I challenged these young bloods to look at themselves critically.

When I delivered the manifesto, some audience members laughed. Got that I was kidding. Mostly. That I was stirring it up to initiate much needed discourse about the complex ways hip-hop, North American Blackness, post-colonial flip identity, and Queerness informed our artistic and cultural expressions. But some walked out. And later I learned that word had gotten around that I had "betrayed" hip-hop, that I'd alienated my community, that I

had wrongly dissed hip-hop heads, and that I was championing whitey. That I'd gotten too big for my britches and that somehow I'd compromised or questioned Asians' and Filipinos' rightful place in hip-hop.

But belonging to something means being able to criticize it. Anything beyond that is dogma.

I went with Tyesha to Chico's in Montebello, where it's known to be "Thug Night every night." Sure enough, there were Homothugs everywhere. Black and brown, varying ages, pressed khakis and drooping jeans, drinking Alizé and Cuba Libres, smoking Newports, and affecting ghetto fabulous. Wall-to-wall men on the dance floor, and strippers that looked like they were recruited from the HBO prison series *OZ* wiggling on a podium, flashing for cash, and rubbing their groins into the eager faces of dollar wavers. The beats were mesmerizing. But I had never heard any of the music the DJ was giving. Hip-hop had passed me by.

I remembered a time when hip-hop was one night a week at this or that obscure club in the hood. I remembered when this whole Homothug scene was underground. Before all the Web sites, the fashion name brands, when we brown faggots were just happy to have something for ourselves, something other than the scraps of White Gaylandia. Suddenly, I felt old.

Once, I had hoped for this, thinking that this Homothug life would be enough. But I was left feeling like these brown men might be selling themselves short. I wondered how many of these beautiful brown men were like Vladimir who loved birds and called himself Spooky to get laid. I wondered how many of these tough-looking hoodies had an affinity for orchids or sonnets. How many of them aspired to be something beyond their Dickies, Pumas, and Homothugging? And what was it about hip-hop culture that compelled Queer men to perform masculinity and non-Blacks to perform cartoonish Blackness?

A light-skinned Black man in a tank top and a beanie was eyeing me. I went outside to get some air, and he followed.

"Hey," he called. Under brighter lights, he appeared older, about my age. He had kind eyes and an easy smile.

"Hi."

"My name's Brian. You having a good time?" I wanted to tell him that, actually, I wasn't having a good time. That I felt way too old to be at this bar and needed something else. I wanted to ask him what he thought about this whole scene and Homothugging. I wanted to engage him in a serious discussion

about the scene happening around us, but I didn't. This handsome stranger simply asked if I was having a good time.

"Good time? I'm ready to go home."

Joël Barraquiel Tan (born 1968) received his B.A. in ethnic studies at U.C.–Berkeley and his M.F.A. in creative writing at Antioch University. Joël is the author of a poetry collection, *Monster,* and the editor of Cleis Press's *Best Gay Asian Erotica Series.* His essays, short fiction, and poetry appear in various publications, including *Fresh Men: New Gay Men's Fiction* (Carrol & Graf), *Pinoy Poetics* (Meritage), *Asian American Sexualities* (Routledge), and more. His poem "manila zoo" recently won the grand prize for Spoon River Review's 2004 editor's contest. Joël, born a Manileño, grew up as an Angeleno, and now lives in the Bay Area.

NOTE

1. It is important to note that Homothugs existed in the form of "banjee boys" during the house period. Banjee boys were the butch/male counterpart to the house queen. Representations of this male/female "queerly heterosexual" dynamic is represented in '90s Black Gay literature and visual arts, particularly James Early Hardy's *B-Boy Blues Series* and Belasco's erotic cartoons.

21

how I found my inner DJ

robert karimi

Listen:

Beep. Beep. Beep.

Why, it's a laboratory, and that gentle-looking guy, can he be behind all this?[1]

Everything living strives for wholeness. If we deeply felt love for each other—not verbally but really—then all this division would come to an end. The one primary word is the combination *I-Thou*. The other primary word is the combination *I-It;* wherein, without a change in the primary word, one of the words *He* and *She* can replace *It*.

Because a lot of people out here say, "I love my car" or "I love my chain" or or "I'm-I'm just in love with that girl over there," so for all the people out there that fall in love with material items, we gonna bump the beat a lil' something like this.[2]

1. Forget the MLA. Each footnote provides the cultural reference or literary reference I sampled to create certain paragraphs. The first sample comes from San José's own DJ Peanut Butter Wolf from "Styles, Beats, Flows," one of the only DJs that used to sport a Morrissey haircut.
2. Sampled from Carl Jung, Krishnamurti, Martin Buber. KRS-ONE.

This is a sample of how I became unstuck in time like Billy Pilgrim[3] by sampling.

Listen:
robert karimi has come unstuck in time.

———————

poet steps up to the mic:

i am
from the Bay Area
before it was the Yay Area
before Tupac was sainted
before MC Hammer embarrassed our teenage egos and went 2 legit
and my hip-hop heart went a-a-b-b a-a-b-b to Too Short's beat.

listen to the memory of what i hear:
djs change records as if i pressed scan on my radio:
song to song to song,
no static in btwn.
only minor scratches, juggles. here. there:
the hands on these records: african american, latino, pilipino, anglo.
not: what set you claim?

what country?
ireland? holland? philippines, guam, taiwan, british? guyana? france?
el salvador?
who cares . . . sissy!
12 o'clock noon
(before or after june—the equinox of my existence
in elementary, junior and high school):
Michael Erickson, Cameron Paul mix
on the radio station named after the sun and the soul,
that is my daily bread
leading me away from the temptation
of gang initiation circles
(how do you say gang in farsi, dad?).

———————

3. Billy Pilgrim from Kurt Vonnegut's *Slaughterhouse Five*.

Hoda-hafez, robert-joon, say hoda . . .
Yabba yabba yabba doo!
White lines, going through my mind
GOOOOOL!
Boy the way Glenn Miller played, songs that made the hit parade,
guys like us we had it made, those were the days . . . [4]

my inner dj reflects my partial history:
 (pilipino garage djs
 spin stevie b, trinere with krs and o yes l'trimm
 i am not the only one who never has eaten pancit
 at the birthday party (where is your colecovision?).
 we all are the first ones born here in the bay.
 someone steals a copy of eddie murphy's new tape
 we sneak into the VCR cause he's hellaaaa funny)

which mixes with my fractured present day:
 (poet, teacher
 embraces the sound of over 29 languages,
 young eyes want to hear
 my i's history.)

to create the constant flux i call my reality
because
the Bay,
everywhere
i have been
flows in her hands.
she is my inner dj
taking me across continents
and reminding me of home
with the slide of the mixer: from infinity to zero and infinity again
i dance, nod
my head to her beat: yes, i am.
 infinity to zero to infinity ad infinitum . . .

4. This is a journey into sound: someone teaching me how to say good-bye in Farsi, Fred
Flintstone, Melle Mel and the Furious Five, Andres Canto (Univision soccer announcer), and
Archie and Edith Bunker.

222 · TOTAL CHAOS

This is the story of how I found my inner DJ. How hip-hop provided me the vocabulary to bridge the thoughts of philosophy, math, identity with community, self, and culture.[5] How I realized the concept of sampled consciousness in contrast to the authentic-culture police that beat me down with "Are you down?" 41 times *y mas*.

Once upon a time in the '80s, when Ronald Reagan perpetrated lies and bad trickle-down trickery, I was going through puberty.

My world: DJ mixes, GM layoffs, an air-traffic-controller strike, Dungeons and Dragons, Apple computers, and being in a cotillion and *quinceñera* before I was 18. My dad made my Persian food. My mom got mad when I played my first 2 Live Crew record.

"You want some what?!" she screamed and banned Luke and company from a Fremont, California apartment.

I first heard N.W.A. after a dinner party at an Indonesian family's house in the Bay Area suburb of Union City. The relatives were singing Atlantic Starr and Kenny Rogers on a Karaoke machine. In the back bedroom behind closed doors, we—Vietnamese, Indonesian, Iranian-Guatemalan, Taiwanese, Chinese *y mas*—nodded our heads, singing: "Dopeman, dopeman!"

Sampled consciousness. It's an old idea with one of hip-hop's gifts, the sample,[6] serving as a point of departure. Every generation engages in this quest to establish self (and culture) in order to find one's relation to the universe and the universe's relation to one.[7]

Throughout the history of art, literature, and philosophy, people destroyed the old to create the new. Hip-hop came along with the sample, a tool that refuses either-or statements. Hip-hop did not reject the past; it said, "It is part of us."[8]

5. Warning: I am an O.G. computer programmer who created poems in BASIC and Pascal. The language of math, beats, and rhymes has been in my heart and directly influences this piece you are reading. (I sometimes mix up For-Next loops with sound loops.) Apologies to all the non–math heads in the house.

Yeh, some folks inherit star spangled eyes,
ooh, they send you down to war, Lord,
And when you ask them, how much should we give,
oh, they only answer, more, more, more, yeh,

It ain't me, it ain't me,
I ain't no military son,
It ain't me, it ain't me,
I ain't no fortunate one[9]

Sampled consciousness:[10] n. a state of self (being) created by the act of sampling different experiences: education, stories, interactions, and observations. The individual takes these experiences, knowingly or unknowingly, and makes them part of their worldview, the way they create/interact. The consciousness is continually in flux, alternating, adding, subtracting, choosing. Self (being) is negotiated. We sample, blend, fade in and fade out the various experiences, remixing the self in service to its goal: zeroness.

It starts at zero and ends with zero.

6. There are many definitions of the word *sample*. For this piece, it is very important to distinguish between *sample, sampled,* and *sampling*. I consider there are three definitions of *to sample:* 1) to use or incorporate an audio segment of an original recording in a new recording, 2) to change from analog to digital, and 3) to select a proper subset of elements from the full population so that the subset can be used to make inference to the population as a whole. The word *sampled* implies the consciousness has engaged in the act of sampling for its creation, and the word *sampling* means the act of doing definitions 1 and 2. *Sampling consciousness* implies that you are taking other living things' consciousness, and *sample consciousness* just makes no sense.

7. Krishnamurti: "Under no circumstances, accept what the speaker says at any time. There is no authority, neither you nor the speaker have authority; both of us are investigating, observing, looking, learning."

8. And thus many a hip hop producer, rapper, etc., has been sued by many a singer, band, and/or record company.

9. Taking it back to the old school: Hayward, California's own John Fogerty's "Fortunate Son."

10. The consciousness part comes from Paolo Friere, who defines *conscientization* as that "of developing consciousness but consciousness that is understood to have the power to transform reality." This is why sampled consciousness is an act that says we have the power to transform reality.

224 . TOTAL CHAOS

Zero: As a child (especially as a teenager), I struggled with self. My identity. My friends. My goals. It started from me. The I.

As a Catholic school student, I was taught that the struggle is to find our vocation and discover our gift to aid in this search.[11]

I saw my father pray to Allah in his bedroom because there were no mosques in the Bay, his prayer book underneath his pillow. My mother went to church every Sunday even though we were excommunicated after my parents' divorce.

My father and mother told me that before I was born that they made an agreement: neither one would push their version of God, Muslim or Catholic, on me. I should find her/him/*duende* on my own. A-men (I mean A-lady).

1979: I was hit with Jonestown[12] and Bokononism.[13] I stopped believing in anything. I thought all religions were scams for money and power.

My religious crisis was interrupted by the identity politics in the music and the books I encountered. I began to read Baldwin, Acuña, Nietzsche, Castañeda, Angela and Mike Davis, Gomez-Peña. None of these philosophers really reflected my total reality.

It's a Black, brown, yellow, red, Queer thang, you wouldn't understand.

11. The catch: according to the Catholics, our vocation is already predetermined, so I guess the quest is to just find out if God and I are on the same page. I think he ripped my page out a long time ago.

12. Jonestown was the site where followers of Jim Jones and his Peoples' Temple (located in San Francisco) committed mass suicide in 1978. They used cyanide-laced Kool-Aid. To scare us, older kids sometimes threatened to pour killer Kool-Aid on us. I was afraid of Kool-Aid for years.

13. Bokononism is the religion created by Bokonon, the central character of Vonnegut's *Cat's Cradle*. Bokononists "believe that humanity is organized into teams, teams that do God's Will without ever discovering what they are doing." Akin to the whole Catholic vocation idea.

African.
Very African. Come and step in brothers temple see what's
happenin
you'll taste the bass flow, coming from a zero,
tell me what a sissy know.
funkin lesson is a new flow[14]

————————

Hip-hop was walking hand in hand with Multiculturalism, and the first one said its name loudly because it was backed by marketing and money. The MCs were announcing "I AM" loud and proud. The DJs were providing the rhythm to this declaration of the Self. This was the "Let" of hip-hop.

Let there be MCs. And it was good.
Let there be DJs. And it was good.
Let there be nerdy dudes in sweats who have a hard time asking women to dance but are flexible and can pop, spin, and lock. And it was good.

I am
I am!
I AM!

Were we all expressing our joy of Popeye or Descartes? I wasn't sure.

————————

I grabbed the mic and started to sing my song
My young homeboy heard me rap
And said he had way more freaks than that
I'm your idol, the highest title, numero uno
I'm not a Puerto Rican, but I'm speakin so that you know[15]

————————

A mirror of sorts, DJ Peanut Butter Wolf:

As a young kid growing up in San José, Chris Manak soon realized he needed an escape from the realities of suburban life in the Silicon Valley. The age of

————————

14. Brother J in X-Clan's "Grand Verbalizer What Time Is It?"
15. "Freaky Tales" by Too Short, "I Got It Made" by Special Ed.

nine was his coming of age. This was the year he discovered sports (Pittsburgh Pirates), video games (Pac Man), girls (Anita Balderama), and hip-hop ("Rappers Delight"). Alongside partner Sweet Steve, young Chris fashioned primitive mix-tapes (using the pause button) and ran amok at the local roller rink.[16]

It's a Bay Area thing, you wouldn't understand.

Where do the cultural fusions of my life fit in the essentialism of cultural construction? Nowhere.

JUDITH BUTLER: "Identity is performatively constituted by the very "expressions" that are said to be its results."[17]

It is a battle of I am with another I am. Or I know what you are, but what am I?[18] I know what you are, but what am I? Or I know what I am, but what are you?

Then something happened.

I saw John Castro's *Diary of a Gangsta Sucka*.

REMIX!

Buber in the house!

I read *I and Thou*, a book by Jewish German philosopher Martin Buber, written in the '20s. Buber wrote:

> The primary word I-Thou can be spoken only with the whole being. Concentration and fusion into the whole being can never take place through my agency, nor can it take place without me. I become through my relation to the Thou; as I become I, I say Thou.
>
> All real living is meeting.[19]

16. The LP version of DJ Peanut Butter Wolf's story: http://www.stonesthrow.com/pbwolf/index.html.

17. Giving credit where it is due: Judith Butler's *Female Trouble*; p. 25 to be exact.

18. Paul Rubens in *Pee Wee's Playhouse* (1986).

Buber's philosophy centered around his attempt to find out how we can talk to God. Buber came up with "I-Thou" as the primary relation, one of the words man uses to relate with his universe, the relation with the spirit.[20]

Thou was a name of a beloved, and this is how Buber felt we should see God and other living things, as our beloved ones. The relation is our expression to our beloved spirit inside us. Thus, I-Thou is the mutability, connection, relation with nature, humans, and spirit at once.

Divided and together. I and I. From analog to digital and back again.

———————

With sampled consciousness, the individual seeks I-Thou or her zeroness in the universe.

The selection of experiences, memories, and the entire scope of a person's being come into play in the creation of the self. We do not just pick one record at a time. Our inner DJs are like a multiarmed being,[21] our records are infinitely grooved, and the sounds of our lives captured and mixed, remixed like the strings of energy physicists now believe are the basic building blocks of life.

Our struggle: to meet the Thou although we are constantly being pulled by the I-It relation.

———————

The I-It relation is where the individual passively allows itself to be experienced. Buber explains: "In so far as man rests satisfied with the things that he experiences and uses, he lives in the past, and his moment has no present content. He has nothing but objects."[22] In I-It, spiritual ideas are just the accumulation of stuff like crosses, verses of sacred texts, etc. Culture in the I-It world is just objects of the past that provide the boundaries for what is "authentic" culture.

———————

19. When I say Buber, you say I and Thou (Maurice Friedman's remix). This is a cut from page 11.
20. In German, the relationship is "Ach und Du," and since we do not dissimilate between *yous* in English, and we do not have a personal *you* (as in the Spanish *tú*) and a formal *you* (as in the Spanish *Usted [Ud.]*), the translators used *Thou*.
21. Shiva perhaps or any multiarmed (G)od will do. Draw your own inner DJ. Go ahead.
22. Buber! *I and Thou*, page 12.

poet steps up to the mic:

He says
he's got so much soul
it's coming out his asshole.

kinte cloth draperies,
joseph's multi-colored coat
woven by Guatemalan Indians
tells the world
he wears his politics.

Poet Federico García Lorca's term best describes the force we should tap into to alternate from I-It to I-Thou, *duende:*

The "mysterious power that all may feel and no philosophy can explain."

The *duende,* then, is a power and not a construct, is a struggle and not a concept. . . . That is to say, it is not a question of aptitude, but of a true and viable style—of blood, in other words; of what is oldest in culture: of creation made act.[23]

I-Thou is realization of this power, of the "creation made act." When we consider other living things, see their connectivity, their relation to us, we realize this power, a holiness inside ourselves and other things. God, the spirit, the power of the universe is not far away. You have the Thou in you.

I-thou
I-thou
I-THOU.

A baseball player may call this the Zone, a psychologist interconnectedness, a philosopher Tao, or another person may call it their a-ha! moment. A-ha! *Duende!*

23. Source: http://www.musicpsyche.org/Lorca-Duende.htm from *Lorca's Duende: Theory and Divertissement.*

Duende becomes visible in the zero-point.

The zero-point is that point in a painting where all lines converge. "The zero-point in the center of the painting contains an infinity of space."[24] This is graphical representation of our path. The zero-point is our zeroness: it, too, contains an infinity of space inside it, and all the identities and definitions we can imagine are inside there as well. It gives us perspective.

The zero-point, the point of vanishing, now becomes the place where we can be the no thing and everything. It is like the black hole, the place where we are sliced into many pieces and, with our inner DJs, put ourselves back together again.

We are living convergences in relation with all the living things around us. We are part of a process of continuity. We remix and remix so that we are in relation with the ethereal and physical parts of our existence. This is sampled consciousness.

Sifr. The number zero. Arabic root for "cipher." Hip-hop's home for raw verse mixed with raw beatboxes. Zero is a dot in Farsi. Three dots in English mean infinity. And so it goes.

All this hit me when I watched San José filmmaker/activist John Castro's film *Diary of a Gangsta Sucka,* a faux documentary satirizing the Suburban Gangsta, specifically the privileged Pilipino who tries too hard to be hard. "Junior," the protagonist, becomes a gangsta after watching *Boyz N the Hood,* and says "Later" to his family. Junior's idea of gangsta-ness is about wearing the right clothes, getting into the right fights, an I-It conception of manhood and hip-hop.

Castro meets Butler: "Da boyz" go to a costume party. When asked about their outfits, they say: "We're here as Snoop Doggy Dogg and tha Dogg Pound."

24. The notorious Charles Seife from his *Zero: The Biography of a Dangerous Idea,* p. 86.

Philosopher/performer/Renaissance man Shawn Taylor and I discuss this essay. He says, "The cultural event that tied us all was *Star Wars*, not hip-hop." We argue. Shawn: "How many times did you see it?" Me: "Five."

Panj. The number five in Farsi. Written as an upside-down heart. The only number I can write in Farsi. Symbol of my estrangement from half of myself, and the quest to learn more. The number that represents five brothers from Gary, Indiana. And now my favorite group, Jurassic 5. Both are J Panj to me.

—5—

Why are we called the hip-hop generation?

Why aren't we the Jedi generation? Watching Jonzi D, Danny Hoch, and Sarah Jones in Jedi Theater? Looking for a Jedi platform to counter against conservative lies and liberal waffling? Why do we follow Russell Simmons and P. Diddy toward empowerment and not Yoda?

"There is no try. Do or do not."[25]

This is a battle for abstraction. The spirit, God, the ethereal are not easily defined. If constants are attached to variables, then the world is made more concrete, more manageable. We stay I-It. Frozen in the objective world, people are MADE more manageable, controlled easier.

Sampled consciousness allows us to understand that we—our self, our culture—are a moment in time, our worlds are both abstract and literal at the same time, and the creation of the self is constantly flowing and stopping.

We don't throw away the past—we transform it. Past, present, future converge inside us.

25. Yoda in *The Empire Strikes Back*, with all respect to Frank Oz.

The groove of the self goes on and on and on, then stops. Then on and on and on. Stops, scratches. Juggles. Stops. On and on and on . . .

––––––––––

Like John Castro in *Diary of a Gangsta Sucka* or DJ Peanut Butter Wolf on the turntables, the role of the artist is to create art informed by the I-Thou that challenges us out of I-it-ness. Artists are the bridge between the physical and ethereal, and they can negotiate both these worlds. Artists need to be the ones that show that alternation, choice, creation, *duende* is inside all of us.

––––––––––

Art is the prism of the self. To define art as "hip-hop art" or "people of color art" or "trailer park theatre" limits the spectrum of light the prism emits.

If we want to make money off of this art, then it is a necessity that we dabble in the I-It world. If we just live in the ethereal world of art, we do not eat, but we can't stay stuck.

Our interaction with art, with hip-hop in the moment, is our attempt to say I-Thou. Hip-hop is dead. The vehicle to connect with the living.

––––––––––

Culture and self are created through the performance of daily life. We rehearse with our inner DJs. We wish to be like the artist and hold the ethereal and physical inside us; it is our birthright. It is the zero tattooed to our souls. We be us.

––––––––––

The poet steps back from the mic, curtain closes, and cut to the Muppets in the balcony:

WALDORF: That was wonderful.
STATLER: BRAVO!
WALDORF: I loved that. It was great!
STATLER: That was great.
WALDORF: Well, it was OK.
STATLER: Well, it was all right.
WALDORF: It was awful.
STATLER: It was terrible.

WALDORF: Get 'em away.
STATLER: BOO!
WALDORF AND STATLER: BOO! BOO! BOOO!!![26]

robert karimi is an interdisciplinary artist/activist who has been featured on HBO's *Def Poetry Jam*, and at Artspace, Galeria de la Raza, Yerba Buena Arts Center, La Peña Cultural Center, and the Smithsonian Institution. He was a member of the 1999 National Poetry Slam Championship Team and has been published in *Callaloo* and *Latino Literature Today*. He has created curricula for poetry and performance in middle and high schools. He directed the Towner Award–winning play *blindfolded*, a youth performative exploration of the connection between the Iranian hostage crisis and 9/11. He was recently awarded a Fellowship for New Genres in Performance by the Illinois Arts Council.

26. "Mahna Mahna," *The Muppet Show*.

22

A Brand-New Feminism

A Conversation between
Joan Morgan and Mark Anthony Neal

Joan Morgan and Mark Anthony Neal aren't just two of the leading, pioneering hip-hop feminists; they're close homies from shorty days in the Boogie-Down Bronx, reconnected by their high-profile work as hip-hop heads and public intellectuals. Joan is an award-winning journalist and writer, whose book *When Chickenheads Come Home to Roost* has become an indispensable book in the emerging canon of hip-hop intellectualism, and a founding text of hip-hop feminism. Mark is Associate Professor of Black Popular Culture at Duke University, and one of the most consistent, prolific, and influential thinkers of the hip-hop generation. His *New Black Man* (Routledge, 2006) is an important, audacious entry into the rapidly expanding discourse around gender, sexuality, race, and hip-hop. In short, you don't want to mess with this crew.

During the spring of 2006, they hit the road for a series of discussions on hip-hop and feminism. The context for these discussions was provided by the landmark Feminism and Hip-Hop Conference organized in April 2005 by Cathy Cohen at the University of Chicago's Center for the Study of Race, Politics, and Culture. There, hundreds of participants gathered to speak, many for the first time, about these issues. The conference converged with an explosion of scholarship in the field—important new books by Cheryl Keyes, Imani Perry, and Gwendolyn Pough had just been released, joined within the following year by works by Neal, Charise Cheney, and Kyra Gaunt—and features

Thanks to Anna Alves for the transcription.

234 · TOTAL CHAOS

passionate debates about the nature and future of both feminism and hip-hop. Here, in this piece assembled from talks they gave at the University of Tennessee and the University of Illinois, Mark and Joan engage many of the topics that came out of those discussions.

JOAN: Mark and I grew up in the Bronx in the '70s. I lived on the first floor; he grew up on the third. Mark was one of my first friends ever. I also grew up with two brothers. So I grew up with a real safe understanding of sharing space with men. I really didn't come to understand how important that was or that we were being groomed for something much larger.

We were hip-hop kids prior to hip-hop ever being played on the radio. Then we kind of went our separate ways. We were those good post–civil rights kids who made it out of the hood, went on to good colleges, blah blah blah. It's not like I planned to have a career writing about feminism and hip-hop, but I've been blessed enough to do precisely that. So imagine my surprise to find out my old South Bronx buddy was doing the same thing and kicking down the same doors in the academy at the same time I was doing it in journalism.

Feminism is very often looked at as women's work. It's the work of a society that intends to evolve into a better place. It's work that men and women have to do together, and sometimes it feels like very isolating work. So if you can imagine the gratitude of hearing a male voice that you know has your back and also knowing that he's your people, well, that's a wonderful thing.

MARK: We're also the product of strong mommies, mothers who really willed us into the world to be successful, to have certain kinds of dreams. I remember—this is the moment when hip-hop as an intellectual activity really clicked for me—I was reading the *Village Voice*. It was June 1990, maybe July. Got off the train, I'm walking home, and there's this piece on Ice Cube. The author is Joan Morgan. It was like, "Oh my god. I know her. I grew up with her. Damn, I want to be *like* her!" I didn't know what I wanted to be, but after reading Joan's work and Greg Tate, I knew I wanted to be a writer. Then there were folks like Cornel West and bell hooks and Michael Eric Dyson who emerged. What this meant for us was that this was a world in which we had the power to write about who we were and our culture.

Hip-hop is thirty years old, and at thirty years old, if hip-hop was a person, he'd probably be married, and have a few kids, and be pursuing a professional career, dealing with the challenges of paying for a mortgage and child care and car notes. This conversation about gender and hip-hop right now is

about hip-hop growing up. What does hip-hop look like when it becomes grown folks' business? Part of that business is challenging that misogyny and sexism and homophobia that exist in our communities and in our society. Part of that business is: what is the real challenge of raising children in this society and embracing hip-hop at the same time? How do we continue to help hip-hop grow up and change the world the way that we envisioned hip-hop changing the world years ago?

JOAN: I should start with a confession. My relationship with hip-hop, in terms of journalism, specifically, has always been a bit reluctant. The piece that Mark was talking about, it was on Ice Cube's first album, *Amerikkka's Most Wanted*, but really I wrote the review about the conflict of accepting the assignment. The first two pieces I was asked to do were very comfortable—I was asked to review Queen Latifah, and then I did a profile on Monie Love. That's the chick stuff. I really didn't want to accept the Ice Cube assignment in the first place, but I was thrown a challenge. My editor, Joe Levy, told me: 'You're from the South Bronx. If not you, then who?'

And I kind of thought about all the ways I had seen hip-hop covered by many white male journalists who had gone to Harvard and Yale but who were doing the vast majority of hip-hop coverage at the time. And they were just getting it wrong on so many counts. It really made me step up and claim something that was complicated, that I had issues with, that didn't always allow me to stand very clearly on one side of the moral fence or another. But at the end of the day it was my story to tell, and my greatest wish was to document it so that people like you would have it. It has really turned into far more than I ever expected.

It is not easy to love and to grow up in a music that has so many aspects that are relentlessly sexist and misogynist. And even more difficult for me is that it really exposes the way that women are complicit in exacerbating that misogyny and sexism.

So I got to a point where I said I can't do another panel talking about how sexist the lyrics are of this rapper, or how sexist the director is in terms of the images that come across in the video, and not talk about the hundred chicks in the video. Why is there no system of accountability for women to each other? Nobody puts a gun to anybody's head and says, "Let's be in a rap video." Nobody is really making tons of money being in a music video. Melissa Ford is not rich. Karrine Steffans became rich because she got a million-dollar deal doing a tell-all. It's not because she did music videos. As women, there was this code in feminism that said, you took the stance of a

victim, and the male was the oppressor, and you never acknowledged your own complicity.

There's sexist hip-hop I really like. I came to hip-hop writing about aesthetics. Beats are merciless in their ability to move and give you amnesia about what you're moving to. So I felt like I had to bring all that honesty to the table when I wrote about hip-hop. It has never been an easy place to stand. The beauty about hip-hop journalism as a form of social criticism is that we understand we don't write from an easy place.

MARK: There are a generation of Black folks whom I call "soul babies"—folks from the post–civil rights generation who learned about the movement in the E185 section of any library in the country. We need to mark what we're doing generationally; we need to bring an energy that distinguishes what we are doing as an intellectual project from what other folks have been doing. And I remember when I opened up *When Chickenheads Come Home to Roost,* and I'm reading a great Joan Morgan line: "I want a feminism that fucks with the grays." I'm like, yes. This is what we're talking about.

We're not beholden to old notions that we need to conserve Blackness and not deal with the contradictions and the stereotypes that come with Black imagery. We need to accept that there's something cutting edge about a show like *In Living Color* or early Spike Lee films that don't make us comfortable, that don't make us feel good about ourselves, weren't necessarily positive images, but conveyed our humanity in complex ways. It's important that a conversation about feminism and gender would be right in the mix of creating a new space. Part of what *Chickenheads* was doing, and what Lisa Jones and Dream Hampton were doing, was creating a whole 'nother space for there to be feminist voices. And what I think was critical was that there were men who were willing to listen to what these women were saying. You had a generation of women that said, "I love hip-hop, but I want to deal with the contradictions. I'm committed to this, but I'm also going to hold it accountable." So for me, it was about: how do I as a Black man define a feminist consciousness?

Kevin Powell invited me down to BET to talk about Black masculinity. On the screen it read: "Mark Anthony Neal, Male Feminist." Which I was cool with, at least intellectually. I took seriously the scholarship of Audre Lorde, bell hooks, Patricia Hill Collins, Angela Davis. What I wasn't expecting was the people who called me the next day. My parents. My boys. "What the hell is a Black feminist?" At that moment, it got real to me. I realized if I do this

weak-ass, I'ma get punked, on the real. What does it mean to be a heterosexual man who claims a space that's profeminist and antisexist?

I took a great amount of leadership from someone like Kevin Powell, who wrote a piece in *Essence* talking about being a recovering misogynist, talking about "The Sexist In Me," this idea that he was going to challenge the power that came with being a man. To make that public statement was critical. Or to read Greg Tate when he wrote an obituary of Miles Davis, and acknowledges he was the embodiment of Black genius and American genius on the twentieth century, but his gender politics were wack. What I found there were examples of men who were able to put their male privilege on the line.

It's a conflicted space. You don't want to come off as the Black male feminist on a horse in a white hat, where the critique is to protect the women from the dirty things that hip-hop is doing to them. What about the women in another context who see this as a space to express their sexuality? We don't have any language in American society and Black culture in particular that allows us to have informed discussions about female sexuality. We deny it and we demonize it.

I *like* women. When Mos Def in "Ms. Fatbooty" is like "Ass so fat you can see it from the front." Damn, that's an ass! That's an ass I kinda wanna see. That's an ass I appreciate. So I'm trying to figure out how do we talk about feminism in this case, or being a Black man who is profeminist who at the same time can acknowledge heterosexist desire. And that's real. There's a fine line between objectification of Black female sexuality and appreciation of it. So what do you do with "Baby Got Back"? Is Sir Mix-A-Lot objectifying Black women's asses, or is he having a real conversation about the inherent beauty of Black women's bodies in a society that has always derided Black women's bodies as strange and unusual and ugly? Thank hip-hop for allowing us to have this conversation out in the open, hopefully in productive and progressive ways.

JOAN: Hip-hop made me a better feminist because it didn't allow me to rest. It challenged me to go into very uncomfortable places without being able to have a moral pedestal to stand and insulate myself from, in terms of difficult questions. But it also, I think, liberated feminism from the old guard and allowed my generation to define feminism on our own terms. Because if there hadn't been this music—which the older generation was so absolutely unwilling to engage, especially engage any of the greys in it—we would never have been allowed to construct—and really struggle through constructing—this

feminism that allowed our voices and our youth and our culture to be injected into the canon.

I read a critique of Patricia Hill Collins of something I did, probably *Chickenheads*. She said my writing about "the erotic" was a misreading, and she went on and on about Audre Lorde's interpretation of the term. I don't worship at the temple of Audre Lorde. I use *erotic* the way I want to use *erotic*. Who says that if you're a feminist and you use the word *erotic* that it can only mean what Audre Lorde wanted it to mean in her brilliant work, in which she was allowed to express herself for exactly who she was at that time?

Hip-hop, to me, has always been the voice of people who have not had a voice. So it was natural to claim the right to have my voice even if that was not what my feminist predecessors wanted me to say. Hip-hop pays reverence to and acknowledges its influences, but it does not necessarily conform to what those influences want it to be. That was a really critical point for me in terms of I guess what is now "hip-hop feminism." It's funny to create things to try to figure out what to call your book, and then movements are born! It was very difficult to liberate my voice from the tradition that had given me so much language to dissect this music and culture. That was a strange place to be.

Another strange place to be was, OK, I gotta say this: those same feminists were really open to my male counterparts. We didn't get that kind of welcoming at all. There was an absolutism in feminism that alienated a lot of younger people. We just didn't feel like feminism was talking about us. How can you deal with feminism and not want to deal with hip-hop? I don't just mean deal with the sexism and misogyny. I mean, Dre's *Chronic*—I don't know one woman who was not on the floor shaking their ass to that shit. How can we not have these complicated conversations? And there were some critics who felt I didn't slam males enough, that I had produced a "male-friendly" feminism. It's a strange place to inhabit. Hip-hop doesn't ask for permission to speak. You just let the shit fall where it may; people get upset.

MARK: Too often the folks who are critical of hip-hop, who talk about hip-hop's misogyny and sexism and violence, are not folks who would listen to it. For me, I just had to accept that's the contradiction I have to deal with. That I always have to think about hip-hop in ways complex enough, that I can appreciate as a critic what's happening in the aesthetic while being real about the politics that are inherent in it. There is a way to love the music but hold the music accountable. That's what folks taught us about Miles Davis. It doesn't have to be an either-or, it can be a both-and.

Too often we isolate hip-hop from the worst of American society. Hip-hop becomes this site from which all of society's sexism, misogyny, and homophobia are emanating. Hip-hop isn't doing something to Black women that American society isn't already doing to Black women. That's why to put the pressure on the rappers to rethink their gender politics and not to put the pressure on the society to do the same thing is unfair. We need to do both.

JOAN: If you took an unofficial poll of songs that most women find offensive, I think that Mos Def's song "Ms. Fatbooty" would never ever come up. The thing that gets masked in all that is there's so much conversation about how sexist music videos are, but there's no conversation about an alternative vision. What's an alternative vision? I don't want music videos to be void of sex. I think sex is good. People should have it! But there's no development of language for a positive erotic for Black women. There's no place to be sensual.

There has been a historic misrepresentation of Black female sexuality that occurred after slavery—which was about the supposed lasciviousness that Black women possessed. Our lasciviousness was responsible for everything from the lynch movement to the nonexistent state of the Black family. It's all because we have this overt sexuality. The response of many Black women has been to develop this mask of sexual conservatism, of wanting to not deal with sex at all. That's just *not* going to work for me, in terms of who I am as a woman, how I need to express myself, how I need to express my sexuality.

So my problem with music videos has never been that they are sexual; it's the ways they are sexual. It's the message that's put forth that says the women that are in them are being sexual but only to service the sexual desires of men. How about being really revolutionary and putting in a space where mutual sexual desires are being served, that a language occurs about what is sexually pleasurable and what is not? I'm saying that there is so much space. Hip-hop has put cameras in the hands of more Black men than any other medium. And if our videos are any indication of what we're doing in the bedroom, that would be just a really sorry, adolescent view of sexuality between Black men and Black women. What I am saying is that the beauty of hip-hop is that we can push this conversation further. I don't want a hip-hop where there's no female sexuality! I don't want a world where there's no Black female sexuality. But I'm amazed at how tongue-tied we are. There's a little fidgeting even going on in this room when we start talking about this stuff.

MARK: Male scholars who engage in very strong feminist politics desexualize themselves to do that work. As Joan is saying, that's not healthy. What we're

trying to create is healthy sexualities. In most women's minds, the last thing they want is a male feminist. When you're young, you want a roughneck. Once you're called a hip-hop feminist, you get Queered in all kinds of ways.

It's about this notion of desire. Hip-hop has created a space—for bad or worse—where Black women can actually see that they are desired for what they look like in a society that has always tossed Black women aside for this ideal of white beauty. For many young Black girls, this is the space where I can be desired, where the gaze is on me, and I can feel pretty and beautiful. How many other spaces are there in society for Black women to have that desire directed toward them?

JOAN: And being validated in some way for many people is better than not being validated at all. But I will say these images are not only affecting women of color. I do think this issue of hip-hop and representation has been seen as a Black women's issue, even though Black girls are hardly the only ones watching music videos. I was out in a club in New York a week ago, and there was a bunch of nineteen- or twenty-year-old models, mostly white, and they were all dancing the stripper dance. That was mind-blowing to me. I knew this was from people watching too many damn music videos!

We can talk about feminism and creating space for women to sit next to men in the classroom and in the boardroom, but when we start to enter the space of the erotic and relationships, the power shifts dramatically to men, because we haven't come up with the language to make that a more equal playing field. It's not about a feminism that is desiring access to white male privilege. Until we break it down at that heart, coalition building is going to remain very difficult between white feminists and feminists of color.

I covered the Mike Tyson rape trial. It was a very eye-opening experience for me, because I think when you are talking about sexual assault, particularly in the Black community, that it raises the real notion of not only the silence of Black women but also the disposability of Black women when confronted with a sexual assault, really by Black men, but particularly by Black men perceived to be empowered in the community, perceived to be celebrities, perceived to be a valuable contribution. It is always an equation of whose story is more valuable here—who is more valuable to "the cause"—and overwhelmingly, the answer to that is that the male story is more valuable.

I chose to speak less about the trial than how it was impacting the community not just in Indianapolis, but the larger conversations that were going on in the community as a whole. The National Black Baptist Convention held a prayer rally for Mike Tyson, the focus of which was really to demonize Desiree

Washington. And I'm not using that language lightly. She was called a Jezebel. She was called a harlot. There were prayers for her soul. They had other women come up and testify about how women led men into sin all the time and that we were there to rally for Mike Tyson's soul.

But women in general were Mike Tyson's strongest supporters. They were the ones that were outside the courtroom every day—Black and white—with the "Free Mike" signs, and I really needed to understand the psychology behind this. I think what happens to women in general—particularly Black women—is that no one seems to want to admit how vulnerable we are to sexual assault. So the mentality becomes, "This is something you can avoid if you're not stupid." And so the very violent and virulent response tends to be to criminalize the victim and blame whatever has happened to her—if you can acknowledge it at all—on her own stupidity. And I think probably one of the most insidious things that sexual assault does is not just that it violates the victim, but really how it violates relationships between women themselves.

Because acknowledging that vulnerability and acknowledging a sisterhood that says, "I understand your pain and fight for your right to express your story and stand with you in getting justice," means that you have to admit that you are vulnerable to this type of assault too. And that if you're a Black woman, that you also have to admit that not only are you vulnerable to it, but you are vulnerable to it by men that look like you, and that if you bring it up, nine out of ten times, you are going to be disposed for the male figure. And it's very painful.

MARK: There are historic discourses in this country that suggest that Black women *can't* be raped. So that when you look at examples of sexual violence against Black women during the antebellum period, when they went to court, they weren't cases about what happened to these Black women and their bodies; they were cases about trespassing against whoever owned her. Like trespassing against their property. And in some ways, when you look at the conversations about sexual violence within the Black community, when they cross the color line, the conversation between Black men and white men seems to be about who continues to have ownership over Black women's bodies. That's the only way that you can explain this silence that occurs when sexual violence occurs within the Black communities.

So even when I look at what's happening now, in Durham, and Duke University, and North Carolina Central University, the only reason why we are having a national discussion about this case is because it's a high-profile case about white male privilege and the spectacle of sex across the color line. Had

the accuser been still a Black woman and the accused been a Black man, we wouldn't have any conversation about that. That would've just been another Black-on-Black rape in the Black community, just like thousands that occur during the course of a year. Of course, there are five hundred thousand reported rapes in the United States every year. There are obviously much more that never get reported.

Had this been a case of Black men sexually assaulting a white woman, yes, there would still be a spectacle because Black men would be in jail. And just because we have to deal with the reality of white supremacy and racism as it affects the lives of Black men, that doesn't mean we still don't hold Black men accountable for sexual violence against women. So while it's important and has been historically and tactically important to close ranks now around certain Black male figures, we also need to hold them accountable for their behavior. If you're R. Kelly, I don't care what your genius is, and I don't care how they dealt with Jerry Lee Lewis—the first retort is "Well, Jerry Lee Lewis got away with it," and they name all these white men that got away with having sex with twelve and thirteen year olds; the case of Woody Allen is always brought up. That's all fine and well, but that's *their* issue. Within our community, we need to hold folks accountable.

JOAN: This is a little-known fact that a lot of people don't know about the Tyson trial: Tyson's entire defense strategy—I mean you probably shouldn't get tax lawyers to defend a rape trial if you want to win—by his extremely well-paid white defense team was to prove that he was sexually so big that there would be bruises that would be likened to nonconsensual sex because he's the big Black ape of a man. That he wasn't intelligent. That he wasn't capable of discerning "no." That basically he was a brute, and they likened it to what he did in the ring. That all this is so public, that any woman knows this, and must be willing to know what was going to happen. So all of the people who want to talk to me about how it was racism that put Mike Tyson away, I'm like, "Yeah, it was the racism of his defense team."

Because what Desiree Washington's lawyer had to do—Garrison—was then put Mike on the stand and prove that he was extremely intelligent. He engaged him in a conversation that had him talk in-depth about boxing, in-depth about his life, in-depth about strategy, about his ability to make moral decisions about other things between right and wrong. And I still don't think Mike Tyson knew or understood that he raped Desiree Washington. I have said over and over again that he did, but I still don't believe that he *knew* it be-

cause he really didn't—I don't think he understood that a woman has the right to say "no."

MARK: There's a troubling scene in Aishah Shahidah Simmons's film *No* where she interviews her mother, who's a scholar of Islamic studies in a university in Florida and was a SNCC organizer, and she recalls when she was raped by another Black male SNCC organizer and went to the leadership where she was, and the leadership's response essentially was, "Well, why didn't you give him some? If you would have gave him some, then there wouldn't be any tension and we could get the real work done." And that was the implication. That's exactly what you're talking about, where we've bought into this kind of notion that Black men have been so damaged by white supremacy and racism—and that may be the case—but we don't check Black men for the varied nefarious things that they do in our communities because we want their Black masculinity to be unfettered. "So then give him some so he can feel like a man and go out there and do the real work, where he can be a man."

I teach courses every semester, 8:30 in the morning. I get a high concentration of athletes in my classes, because they like for them to get up and be in classes together, then go work out together, go get breakfast together. So for the last three semesters, I've had a steady contingent of ten to fifteen Black male football players in my class. And it's been interesting processing a lot of this stuff with them. I teach courses in popular culture. If I do a course on hip-hop, we spend two weeks talking about domestic violence. And part of the rationale for that is there are myriad cases of rappers who were domestic abusers, most notably the late Notorious B.I.G. and the late Big Pun.

I could do the progressive thing and, say, teach a course in women's studies, and I'd have a room full of, probably, white women. This is a chance for me to have these conversations with Black men in the room. What's been very striking to me is where they are in terms of processing sexuality and gender. So these same young men, very comfortably, even though Mike Tyson was incarcerated for three years and was convicted of rape, believe that Mike Tyson was innocent. And I just can't work through their process, because if folks don't believe that Mike Tyson was guilty, then nobody we ever accuse is guilty. If we can't believe Desiree Washington, we can't believe any of these women, if that's the case.

But the same contingent of young men expresses the belief that a man *can't* rape his wife. And that became a very interesting conversation, right, about how do you as a man get to the point where you can listen to the women in

your lives and be able to understand their bodies? And those conversations never come up, and men never think to ask those kinds of questions. So part of what I think we need to do is be serious about being open to have discussions with young Black men.

JOAN: I think that women also have to get very serious about the modes of power that we *do* have and the spaces that we *do* control. I always say *feminism* is a noun, but it's really a verb, like you gotta *do* something, you know what I mean?

PART FOUR

WORLDWIDE: HIP-HOP ARTS BEYOND BORDERS

Worldwide

Hip-Hop Arts beyond Borders

If Afrika Bambaataa was the first ambassador of hip-hop and Universal Zulu Nation the first global hip-hop institution, the culture's worldwide spread has nonetheless been conditioned also by American economic and political hegemony. In other countries, even partisans often complain that the culture can be wielded as a neoimperialist tool. But it has also given voice to local identities and resistances around the world. As Bambaataa foresaw, hip-hop's concerns with identity and pride of place travel very well.

Hip-hop reflects omnivorous tastes and multilingual signifying, so the polycultural trafficking is far from one-way. Hip-hop music, for example, not only figures in bhangra, dance-hall, reggaetón, hip-life, and dozens of other hybrid styles but has also been transformed by those sounds. The speed at which these shifts occur has accelerated. Similar effects are happening in hip-hop theatre, fine arts, poetry, and many other genres. In an era defined by both top-down globalization and networked localisms, hip-hop arts are both an advanced result and a near-instantaneous reaction.

Hip-hop thus reflects a root-down attachment to place, even as it leaves behind the materiality of geography. In Palestinian American poet Suheir Hammad's heartfelt hood-repping "Brooklyn," pride of place and hip-hop itself seem to merge. By contrast, Staceyann Chin, her fellow cast member in *Def Poetry Slam on Broadway*, finds herself in a self-imposed exile in Brooklyn because of her Jamaican birth land's homophobia, yet still drawn home by the voice of Bob Marley. His art and her own create the necessary in-between space she needs to survive.

Hip-hoppers in Cuba represent a new generation of community-minded artists. Filmmaker Eli Jacobs-Fauntauzzi salutes their spirit of *inventos*, pulling something out of nothing, a sense of self-determination that animates local hip-hop scenes around the world. Jacobs-Fauntauzzi notes that hip-hop

simply reflects the values of the society in which it takes root, and for the United States, it's "get rich or die trying." Yet hip-hop's relationship to its audiences is also complicated, and never is it wholly revolutionary or wholly reactionary.

In "Cape Flats Alchemy: Hip-Hop Arts in South Africa," Capetonians Shaheen Ariefdien and Nazli Abrahams discuss the rise of hip-hop as a force of resistance for Coloureds and Blacks under the apartheid regime. Hip-hop arts provided a generational space to develop new politics and aesthetics, giving voice to a loyal oppositionality to the postapartheid Black neoliberal government. Such stories are not often heard in the noise of metropole, but they suggest possibilities for hip-hop arts that may otherwise have been difficult to imagine. In the South African context, for example, installation art meant to evoke a prison takes on new layers of meaning.

Locating the global in hip-hop also means rethinking the culture's history. If much of hip-hop scholarship emphasizes its African American roots, author, journalist, and filmmaker Raquel Cepeda's compelling essay, "AfroBlue: Incanting Yoruba Gods in Hip-Hop's Isms," resituates hip-hop music, dance, visual arts, fashion, and philosophy in the context of Afro-diasporic Yoruba traditions transplanted in the New World. Hip-hop retains, she argues, a "collective memory." Extending the historical frame helps explain why hip-hop has taken root so easily in so many places. Movements like, say, Rio de Janeiro's funk carioca, a seeming mutation of Latin freestyle and '80s bass music, or São Paulo's *pichaçao* movement, an eye-popping, wholly unique variation of graffiti, make perfect sense.

Cristina Verán's roundtable discussion, "Native Tongues: The Global Indigenous Hip-Hop Movement," introduces the idea of hip-hop as a global native culture. Her guests—Darryl "DLT" Thompson, Litefoot, Grant Leigh Saunders, Mohammed Yunus Rafiq, and JAAS—represent indigenous peoples from New Zealand, Australia, North America, Africa, and South America. They discuss generational change, the development of indigenous rap movements, and the links between indigenous rituals and hip-hop culture. Afrika Bambaataa's ideal of a "Planet Rock" thus attaches itself to the oldest world traditions, and hip-hop begins to look like an ancient futurism.

23

brooklyn

Suheir Hammad

sometimes we pose you loud like
a cheap trophy posturing look at me
from the planet of illest mcs and brickest cheese

sometimes quietly we know the streets
is watching our actions recorded
we secret you from those who patrol
our thoughts and study our styles

we leave you in
order to see your beauty from a distance
back home in instants we drop baggage
and settle into our selves

your children travel far and wherever
we are we hear bk represent always
the boldest

we say if you can make it here
you got nothing to fear

see every borough fashions fly shit
but they come to your streets to make it legit

you have as many stories as streets

as each of us shaped by
your concrete and green

you became the safe jerusalem
for us not chosen
yet did not shelter yusef
hawkins's running form from hate

if we tell the truth here
we got nothing to fear

you molded heroes
and sent them out on record tours

brooklyn, i could write you
love letters forever on every corner
on the backs of handball players
with the exhaust of your buildings
for your exhausted masses i could
write you forever for the absences
and abundances of the childhoods
you gifted us

listen to the way you gallop from my mouth
make folks smile just to hear me talk
because they trace my cadence
back to you

we always return
like love and heartbreak are one coin two sides
you are your daughters' currency in foreign cities
we always come home
and you always make room,
like expandable apartments
filled with immigrants and their labors

you always make room
for our sins and our saviors

you always make room for prodigal daughters
who sometimes talk out loud to our selves
just to hear your stories come out our mouths

Suheir Hammad is a poet and activist. She appeared in *Def Poetry Jam* on Broadway. Her column for *Stress Magazine*, "Psalm 26:7," was one of the longest-running woman-written columns in a national music magazine. She is the author of *Born Palestinian, Born Black, Drops of This Story*, and *Zaatar Diva*, in which this poem originally appeared.

24

Falling for Bob Marley

Staceyann Chin

It is autumn again. I am at *the* bar in Brooklyn. 275 Grand. This is the place, the café, where I write, where I eat, where I brood. It is raining. It has been cold all week. I have traded sandals for sneakers, sarong for sweatshirt. Winter is almost here.

If I were heterosexual, I would still be in Kingston, eating jerk fish from Island Grill and drinking a cold Red Stripe Light. But I am an out lesbian, so reality pounds icy on the windows of *my* New York City. Mixed green salad, chamomile tea, salmon and cream cheese on everything-bagel. I am in political exile. Self-imposed. Necessary. Difficult.

Bob Marley is crooning "War."

> Until the philosophy which hold one race
> superior and another inferior
> is finally and permanently discredited and abandoned
> Everywhere is war . . .
>
> until there are no longer first class
> and second class citizens of any nation
>
> until the basic human rights are equally
> guaranteed to all . . . everywhere is war . . .

In light of where we are in Jamaica with the homosexual question, it is ironic that I can still find solace in the familiarity of reggae music. But Bob's words have always meant more to me than anything Beenie Man or Elephant

Man or Bounty Killer could ever say in the attempt to render me a second-class citizen in the country of my birth. Some die-hard Rastafarians may argue that these words were never intended to voice the sentiments of any lesbian in exile. But something in them speaks of tolerance and freedom. I have always interpreted the Marley message as one that spurns the power structures that keep any body under the heel of any form of oppression. So the irony is less than nuanced when there are accounts of freedom fighters avoiding reggae concerts and boycotting organizations that make room for the expression of violent intentions toward individuals who identify as and/or make room for the discourse around the rights and safety of homosexuals. I like to think of Bob turning in his tomb over the grave mishandling of his legacy of liberation.

Naive or no, this is my take on the Bob Marley Blues.

Navigation of the Jamaican culture is as brutal as the New York weather. On one visit home, the bougainvillea is in flagrant bloom. The next, everything is dry and ungiving under the ravage of the constant heat. My own relationship with Jamaica is as turbulent, as unpredictable. One performance there can yield a standing ovation. Another, my very own miniriot, complete with the warring factions of the audience praising or denouncing me while I scream poems about revolution from the stage.

Jamaica has always been that for me: brutal and misleading, carnal and alive. I am at a loss as to how to achieve consistency. Eight years ago, I left Jamaica because it was dangerous to be an out lesbian there. But when I got here, I realized that in the Greater USA, it is almost as, and in some ways more, dangerous to be Black. Add all that to being a writer, and a voice who openly disagrees with most of the tradition of American foreign and domestic policies, and what appears is an entity in constant quarrel with itself.

I write poetry to survive the dance of being home and not home, of being freer but not free. I spend all the parts of my life making room for the discourse around being gay and Asian, Black and immigrant, woman and writer, U.S. resident and Jamaican citizen. I argue with the cab driver. I instigate discussion with arbitrary faces in the elevator. I engage the police officers in my neighborhood in Crown Heights. I date women who are concerned with more than their own pleasures.

Every day brings its challenge. Today it is the tragedy of autumn. Tomorrow, it may be Scott, or Brett, or Todd, who imagines Jamaicans, naked, native, and inarticulate. He will in his lack of knowledge and exposure ask where I learned to speak English so *good*. Most days, I will look right through him, ignore his flawed syntax, and pretend whatever I am eating is really fried fish

and festival from Hellshire. Assuming my silence could not be deliberate, he will ask again.

If I find, in that moment, that I need the sound of "War," more than I am able to offer him explanations, I will slowly turn up the volume on my iPod, and watch his specter disappear under the ragged breath of my very own Bob Marley *Talkin' de universal Blues*.

Staceyann Chin has been an out poet and political agitator for as long as she has been a writer. From the first angry rants delivered at the Nuyorican Poets Café to one-woman shows off-Broadway to cowriting and performing in the Tony Award–winning *Russell Simmons's Def Poetry Jam on Broadway*, Chin writes, speaks, and breathes in hopes of a world without poverty, prejudice, or injustice. Her poems have been featured in magazines, newspapers, anthologies, and her chapbooks, *Wildcat Woman*, *Stories Surrounding My Coming*, and *Catalogue the Insanity*. The film *Staceyann Chin* premiered in Denmark in 2001. Staceyann is currently working on a memoir to be published by Scribner. The poet/performer/activist/entertainer is desperately trying to create some room to travel to see her sister and to breathe.

25

Inventos Hip-Hop

An Interview with Eli Jacobs-Fauntauzzi

Jeff Chang

Eli Jacobs-Fauntauzzi works at the convergence of global cultures and is one of a number of emerging filmmakers—including Brian B+ Cross, Jeff Zimbalist, Vee Bravo, Raquel Cepeda, Tom Feiling, Lisandro Perez-Rey, and Michael Wanguhu—interested in exploring hip-hop's potential to bridge place, culture, and feeling. Naturally polycultural and liberated by low-cost digital technology, these artists often see their work as an extension of their activism. Some were non-American-born natives who have been participating in hip-hop since its international spread in the early '80s. Some have found their voices through the growing networks of antineoliberalist formations such as the World Social Forums. Others, like Jacobs-Fauntauzzi, organize and participate in informal cultural exchanges, where hip-hop serves as a bridge.

Jacobs-Fauntauzzi was born on Maui and raised in northern California, where he was inspired by the Bay Area's progressive political legacy and renowned indie hip-hop scene. In 2000, he began filming *Inventos Hip-Hop Cubano* on trips to Cuba, interviewing key players in the Havana hip-hop scene, and weaving them into intimate portraits of Cuban community and family life. In 2004, *Inventos* and Perez-Rey's brilliant *La Fabri_K* portrayed millennial Cuba as a haven of radical hip-hop. Both captured the ways hip-hop had woven itself deeply into Cuban culture. North American audiences often came away finding hip-hop feeling a little less familiar, but no less inspiring. Jacobs-Fauntauzzi has continued to explore hip-hop culture's

transformations in local scenes in South Africa, Egypt, Israel, Colombia, Mexico, and Puerto Rico, including for 2006's *Homegrown: Hip-Life in Ghana.*

JEFF: Why are you interested so much in scenes that are not occurring in the U.S.?

ELI: I feel we have so much to learn from other people in other situations. Americans are really in some sense close-minded. Especially if you look at our hip-hop scene, we don't really listen to too much music outside of our own. But if you go to another country, they're bumping stuff from all over the world. So I think we have a lot to learn from other countries. And also they have a lot to learn from themselves. It's great to capture something and then show it to them. It validates them in some sense and they're like, "Wow, we really have a movement out here." It's a way to see yourself outside of yourself for a moment, and that's a great experience.

JEFF: Talk about how you started filming *Inventos.*

ELI: My brother, Kahlil Jacobs-Fauntauzzi, started a cultural exchange project in 1994. I was touring the Caribbean in 2000 and he was going to Cuba, and so I met him over there. It wasn't like I was going to Cuba to do a documentary. It was me taking the camera and going around. I'm a hip-hop head, and those are the folks who I hang with, everywhere I go in the world. So I linked up with them, and it was just everyday life. That's why you get to see their moms; you get to see them walking through the hood. And *inventos* literally means "making something out of nothing." I didn't have a film crew. I didn't have the money behind me. It's just what I saw them doing—making do with what they had. And that was the same struggle I went through.

California underground hip-hop had a huge influence on me, and if it wasn't for that I couldn't have done Inventos. Because the way I did *Inventos* was how Mystic Journeymen did their CDs, how they blew up the underground. I used Too Short and Master P's method. I took my film and started to sell it out of my backpack. They showed that you can do it. You don't need anybody else to do it for you. You don't have to beg a major corporation to sign you or distribute your product for your work to get around the world and make an impact. *Inventos* is that underground movement, you can do it by any means necessary. Without the resources that one would normally have, any obstacle you face, there's another way to do it, and you can still get it done.

After *Inventos* was made, different Cuban groups came together to make an album. The groups in this photo are **EPG&B, Anonimo Consejo, Los Paisanos,** and **Explosión Suprema**; together they were called **El Cartel**. Taken at Producer **Pablo Herrera's** house/studio, 2003. Photo by **Peter Graham** for *Inventos*.

Ghanaian hip-hop crew **Vision in Progress (VIP)** filming a video in Accra, Ghana, 2003. Director **Eli Jacobs-Fauntauzzi** is on the camera. Photo by **Laurence Latimer** for *HomeGrown*.

JEFF: Tell me what you did with the Sankofa Tour.

ELI: That was one of my dreams. You know I feel like all these documentaries are being made, but what happens to that community that they're documenting? Last summer, we were able to bring Inventos home. I got Sankofa from Ghana, and it means "returning to its roots so it can move forward." We brought Inventos home so that it can move forward as well. We brought the first Pioneer CDJs out there, a digital eight-track, microphones, and two laptops, and we made sure everyone in the movie had DVDs and all the promotional material. We shook each person's hand, gave them a hug, and told them, "Thank you for being part of this project. Thank you for believing in it." It felt like a great closure to that chapter.

JEFF: Some North Americans say that hip-hop around the world is where we were at fifteen to twenty years ago. Is that a little presumptuous? What do you see occurring?

ELI: When people say that hip-hop overseas is like what we had fifteen years ago, I think what they're really saying is it looks like it did before the commercialization of hip-hop—when people were doing it because they had the heart and desire to do it. People were into hip-hop to express themselves. They were not doing it on the basis that they would be compensated for it. In that way, it's a legitimate thing to say, because there are a lot of us who grew up with hip-hop who miss that.

But in another sense, it is arrogant to think that what they're doing is being made for us. They're doing their own thing. They're not doing what they do for us. They have their own methods, their own culture, their own way of expression, and that goes to the second part of the question. What they have is their own, it's unique, and I love that about it.

JEFF: You've been doing the Ghana documentary for eight years. How has hip-hop changed there? That seems like a lifetime in hip-hop.

ELI: In Ghana, they call it "hip-life" because they take highlife, a more traditional music, and they mix it with hip-hop. Academics call it transculturalization. They've taken inspiration from their culture and our culture and said this is something new that we're bringing into the world.

Whenever I look at hip-hop abroad, it takes a while for it to really come into itself. I think at first it almost starts out as an imitation. Because they just

Vision in Progress at an AIDS-awareness show in Accra, Ghana, 1998. Photo by **Kahlil Jacobs-Fauntauzzi** for *Inventos*.

Audience at Ghanaian AIDS-awareness show at sunset, 1998. Photo by **Kahlil Jacobs-Fauntauzzi** for *Inventos*.

love hip-hop, and they just feel it so much that they either remake songs, or they use the same beats. At the early stages of hip-hop everywhere they don't have money for production of beats. But then as an economy starts to grow around it, then it could start paying for itself. So over eight years, it's really come into itself. It's becoming distinct, and it's so beautiful to see it grow. Hip-life is an industry now in Ghana. You have the two sides of the spectrum—you have the hard-hitting hip-hop beats with the MCs rapping in their own dialect over it, and you have the more highlife, guitar-based beats with English over it. You have both sides of the spectrum, but most of the time it's somewhere in between.

Some things work when they travel across cultural or land barriers, and some things don't work. I love what my man Panji said. He was talking about the things that don't work for hip-hop in Ghana. He was talking about the attitude of "fuck the authority," because hip-hop in the U.S. has always been about "fuck the government," "fuck the police." But when you take that into Ghanaian culture, it doesn't work. Because who is the authority in Ghana? Your grandparents, your parents, the chief. Some things translate, and some things shouldn't translate.

JEFF: What about people who say hip-hop is promoting materialism, American cultural imperialism, or hegemony?

ELI: When you look at 50 Cent and his album is called *Get Rich or Die Trying*, that's exactly what America's philosophy is. It's extreme capitalism, and he represents that the best. It's not a coincidence that his music is pushed all over the world to represent what America is about: Sex. Capitalism. Money. Drugs. Violence.

JEFF: So does hip-hop have a negative force around the world as well?

ELI: Yes, and I think that we're not aware of it. And that's a scary thing. It's like what you're doing is affecting people worldwide, and you need to know that. But at the same time, people also don't realize the power that hip-hop has and the positive aspects that have traveled and been given to youth around the world. It's really complex. We need to start looking at the full picture and not just say that hip-hop is revolutionary and then look at just the people using it for change. And you can't just say that hip-hop is bad and is being used as a neocolonial tool. We need to start breaking it down and say this isn't working and this is working, so we can move forward.

Hip-hop is not isolated. Hip-hop has a purpose. That's why everywhere you go in the world, hip-hop is different, because the society calls for something different. So the way our hip-hop has so much aggression, so much violence, is so capitalist is because our society is that. But when you look at Cuba, those elements aren't really there. The society isn't like that. What is society talking about? Look at the movie, and you'll see. They're talking about politics, global politics, they're talking about culture, because that's what the society calls for.

JEFF: What has been your intention in making these movies?

ELI: Everybody has a story, and everybody has a voice. When I first started filming in high school way back, it was about me going to a lot of protests and just showing what the news wasn't showing in a thirty-second clip. So friends would just come over and watch the footage and talk about it. And it was almost like an organizing strategy: there's a story, there's a message to be heard, and I'm capturing that and then bringing it to another audience that I feel needs to hear the story and so communication can begin.

26

Cape Flats Alchemy

Hip-Hop Arts in South Africa

Shaheen Ariefdien and Nazli Abrahams

We are two hip-hop heads from Cape Town, the birthplace of hip-hop in South Africa; one is from a performance background, a producer for and a former member of a crew, Prophets of da City (POC), and the other with a background in education.

We think of hip-hop in relation to the notion of alchemy. We don't mean this only in the old-school mystical chemistry way. We see hip-hop as the resilience of the human spirit, that process of transforming yourself and your environment, kinda like Common's observation that under the FUBU is a guru untapped. Imagine the oppressive conditions caused by the barbarism of Ronald Reagan's neoliberal economic strategies. The youth of South and West Bronx had little resources, were systematically marginalized and alienated, but filled with an audacity and inner capacity to want to rock the planet. No musical equipment? Well, then beatbox! We've heard many heads equate hip-hop with producing something out of nothing. We disagree. Hip-hop is about seeing the *something* in what we are often told is nothing.

This is the powerful idea that attracted many a youth in Cape Town, South Africa, to what we heard, felt, and saw as hip-hop. Our experimental forays led us to develop youth programs that try to advance hip-hop as an educational tool, that marries hip-hop aesthetics with critical pedagogy. Although this piece draws attention to historical contexts as they relate to hip-hop in Cape Town, we present here our story and views, and do not claim that it is representative of all hip-hop in South Africa or Cape Town.

We are not the first ones to work the idea of critical pedagogy and hip-hop, but what informs our approach is the acknowledgment that all things in the universe are connected. We want to see the beauty and interconnectedness in all things while still being mindful of the inequalities, challenges, boundaries, and contradictions of our daily lives. Though much of what we do builds on the foundations of knowledge of self and kicking truth, we are much less concerned with conveying truisms or "true" knowledge. Asking questions is more important because it is about embracing a journey that faces up to "conventional wisdom." We live in a country where for hundreds of years "conventional wisdom" is what kept us shackled, to the point where we became our own jailers. But facing up is about not only freedom of expression but also the expression of freedom. For us hip-hop grassrootsifies or makes street the magical role of the act of creation in the face of oppression.

Although the history of hip-hop in Cape Town can be traced back to the early 1980s, the cultural exchange between the Black United States, the West Indies, and Black South Africa was widespread since the 1800s. Black South African artists were influenced by minstrelsy to swing to bebop and beyond. The affinity for these cultural expressions was partly in response to British imperialism, but our elders did not do a straight cut-and-paste. Instead, we reworked the expression to speak to our own contexts. Africa, in turn, has acted as a spiritual and mythological reserve to many activists, artists, and the average cat in the African diaspora. Southern African musical styles have influenced Black American expressions. These cultural conversations went back and forth like the intro to Run-DMC's "Peter Piper." Take, for instance, the Bambata rebellion that influenced Afrika Bambaataa to start the Zulu Nation, an idea itself partly influenced by Garveyism.

RACE, HOW LOW CAN YOU GO?

Too much spirit was founded, they needed to break that
Blacks to the townships, coloureds to the Cape Flats

Hip-hop first took off in predominantly *coloured* working-class neighborhoods in Cape Town. Interestingly, *coloureds* were the first group to be impressed by Black American music and have been instrumental in the dispersal of Black American music into the interior of the country. *Coloureds* can best be described as a heterogeneous, complex, and Creolized group of people. The slave trade in South Africa brought together slaves from places

like Indonesia, Malaysia, Mozambique, Angola, and other places, and formed a sense of community based on a shared oppression. British colonial and later apartheid divide-and-rule laws, along with the struggle for resources, gave impetus to what is now known as *coloured* identity. In South Africa, *coloured* did not just mean not Black and not white, but superior to Black and inferior to white. *Coloureds* also endured forced removals, exploitation, and discrimination.

Youth of colour identified with hip-hop's passion, its anger, its creativity, its style, its music, and its similar use of language. When we first saw music videos featuring the Rock Steady Crew and the New York City Breakers, they looked so much like us we immediately identified with them. It went beyond that. During the early 1980s, lyrics painted vivid images of an America that certainly was not synonymous with Disneyland or Hollywood. Rather, it smacked of images closer to the South African experience of Soweto and the Cape Flats. Young people who grew up in the South Bronx at that time had to endure racism, police brutality, high levels of unemployment, gangsterism, the influx of drugs, and a multitude of other socioeconomic problems. We could relate completely.

We are '70s babies. We grew up in a time when the skill, attitude, and style of Bruce Lee and all the badly overdubbed kung fu flicks of that time were about the underdog reigning supreme. Bob Marley and Pelé very much inspired how we approached the things we did. We also grew up in a time when the apartheid government banned many South African Black bands' music, so we were very much exposed to a lot of bad British pop and Black American music.

In Cape Town, b-boying and b-girling, emceeing, beatboxing and aerosol art developed before deejaying and music production because you needed more money to be able to get your hands on equipment. Even then, it wasn't Technics 1200s, but a wooden set of Lencos with a coin to balance the stylus. Because of the economic sanctions and political pressures from outside of the country, music and information were very difficult to come by. They usually came from pen pals, family or friends in exile, or those who emigrated. There was the occasional imported record or magazine, and some local record stores stocked British imports of U.S. hip-hop albums. Cassette copying became the primary means for circulating music.

We grew up listening to both U.S. and British hip-hop. For many of us, DJ Pogo, MC Mello, and Hijack from the U.K. were as important as Public Enemy, N.W.A., and 2 Live Crew. We did not privilege any coast or region, although we recognized the differences in styles of production, writing, and

delivery. As we deconstructed album covers, scratch techniques, production styles, rhyme structures, and content, it was clear that the notion that hip-hop was only about raw gut-feeling mixed with passion was a misconception. Lesson learned: mad intellectual rigor is needed to craft some ill shit.

FROM SLAVE SHIPS TO TOWNSHIPS

When corporal punishment, general shame, private anguish
And major pain left tenants of the Cape Flats to languish

Hip-hop was also about our politicization in the 1980s. With a state of emergency imposed by the South African government, the political situation was volatile, and there were boycotts and riots in most parts of the country. For many heads this was a period conducive to the expression of anger channeled through aerosol art, breakdancing, or writing raps to express everything against the system. The anger and the expression were not just about chanting down the apartheid enemy but also a means to connect with other young people who felt similarly.

We remember the long and often boring awareness programs we attended at school when speaker after speaker would regurgitate the same information. A few hip-hop heads at school decided to create "musical" breaks between speeches that still somehow managed to reflect the speaker's general sentiment. This often involved students clapping their hands to a beat and the heads reciting rap verses either about the importance of a specific date or event. Other heads at other schools were doing exactly the same thing at that time.

Although heads were involved in various student-awareness campaigns and some political marches, we were unable to make serious links with the more traditional mass movements because elders saw hip-hop as a musically inferior, counterrevolutionary tool of U.S. cultural imperialism. So no substantial links were forged. This is ironic because these same people had nothing but praise for local South African jazz musicians who sounded like their U.S. counterparts. Hymns like "We Shall Overcome" that hailed from the United States were part of many a protest repertoire. In effect, we were silenced and marginalized.

The Black nationalist period that dominated hip-hop in the United States had a profound effect on many *coloured* heads to the point that many of us rejected *coloured* identity by constructing alternative Black identities. Although Biko's Black Consciousness had been influential since the 1970s, this was the

first time that working-class kids embraced it to this degree. As crazy as it sounds, many of us found a new respect for Africa through hip-hop. For a lot of first-generation hip-hop heads, hip-hop was African traditions with Japanese technology, processed by kidnapped Africans on stolen land. We defied the cultural cut-and-paste assumptions many parents and political activists had about hip-hop. In spite of these accusations, we still managed to pull together the important but short-lived organization African Hip-Hop Movement,[1] a moment that attempted the formation of a hip-hop antiapartheid social movement.

For many, the courtship with U.S. hip-hop is very much love-hate. On the love side we have respect and acknowledgment for the part U.S. hip-hop played in our work. On the flip side we bear the brunt of much of U.S. hip-hop's links to structures that are largely responsible for the devastating conditions in Third World countries. Some of us feel that U.S. artists like the *idea* of Africa but do not really respect the people of Africa and often display a similar kind of patronising attitude that U.S. establishment is known for.

Certain crews refuse to rhyme in English or with American accents. Instead, they choose to flaunt what is perceived as a uniquely Cape Town or South African sound. Hip-hop took the language of the "less thans" and embraced it, paraded it, and made it sexy to the point that there is an open pride about what constituted "our" style. *Gamtaal*, a dialect consisting of a mixture of Afrikaans, English, Xhosa, and Arabic, spoken mostly in Cape Town, and *spaza* rhymes, a mixture of Xhosa, Afrikaans, and very little English, are used to express local reworkings of hip-hop, and the rhymes often critiqued U.S. hip-hop. Even some local emcees who rhyme with an American accent get dissed in some quarters.

Back in the day, Prophets of da City attempted to fuse the funkiness and raw energy of U.S. hip-hop with African-based instrumental and vocal samples. We sampled marimbas, mbiras, and West African chants and programmed it hip-hop stylee. This was not just about us stating our geographical/cultural uniqueness or presenting an oonga-boonga-fication of hip-hop. It was a plea not to follow mainstream formulaic productions and a critique of some U.S. emcees who allowed corporates to define hip-hop. We felt that these emcees disregarded the legacy of those who laid the foundations before them.

FROM NEO TO NEON IN THE NEO SOUTH AFRICA

But just like in the 15th century I'm sensing we still get sold on the seven C's
Captivity in Colonies, "Civilized" by Common thieves
Church, Coke and Capitalism equal many more than tenures
Ten years of Demockery

It's the "postapartheid" era, and the air is supposed to smell a little sweeter. The first democratically held elections in 1994 symbolized a victory against apartheid. Euphoric excitement was accompanied by high expectations of a better life for all.

Postapartheid South Africa was all abuzz with "transformation talk," but more than a decade later, wages have dropped by 21 percent, and poor areas have seen water costs increase by 55 percent and electricity by almost 400 percent. The most sensitive government responsibilities—such as water, housing, health, and electricity—are becoming privatized.

For many, the struggle continues. . . .

The in-your-face markers of racial divides became blurry. We were all warmly embraced by the sun-kissed, open-to-all beaches, and the gastronomic heaven of the pearly-gated McDonald's promise of better and cheaper food for all. But in the new millennium, apartheid's legacy and the introduction of neoliberalism continued to govern the lives of young people. Around the same time that the new South Africa was born, media conglomerates in the United States co-opted aspects of hip-hop and turned it into a multibillion-dollar industry. Intergenerational differences, both aesthetic and ideological, became one of the key obstacles to rebuilding a hip-hop movement relevant for a postapartheid era.

These trends informed the approach we took in designing and developing youth programs using our hip-hop-as-alchemy idea. We see hip-hop as the resilience of the human spirit, that process of transforming yourself and your environment. Our challenge is to use hip-hop as a means to provide young people with a meaningful platform for expression. Our challenge is also about young people being comfortable and loud about their confronting "conventional wisdom" and critically questioning accepted norms in a changing South Africa. The way we use hip-hop and what we see as hip-hop's function are still rooted in pursuing freedom in a postapartheid

context. Being critical of the new South Africa means that, in all probability, you stand the chance of being labelled an "Afro-pessimist" or falling prey to a kind of colonial talk. But we see hip-hop as not being burdened or constrained by this line of thinking.

This has been our modus operandi from the time we started working with young people in the mid-'90s in our various hip-hop-related programs. In 2003 some of the youth decided to create a hip-hop art exhibition where their lyrics would be displayed in non-grab-a-mic-and-kick-it manner. For example, one young person decided to build a wooden structure that looked like a prison cell—with the lyrics pasted in lines on the inside of the structure. The back of the wooden cell was open and covered with a piece of white canvas painted with a distorted Black figure. For him, it was about making his struggle present in the present. This was the very first time that this kind of display was attempted in South Africa, and we were unaware that this might have existed elsewhere. And it didn't matter. What made this unique was not so much that it was a first for us, but that the materials used were all traditionally considered "rubble" or "garbage." The young people scouted garbage heaps, abandoned factory yards, and sidewalks to get their materials and used them in a way that literally spoke to the lyrics that informed the art pieces. The kind of material also spoke to what we espoused, and that is about making something out of what we are often told is nothing and about transformation—alchemy, if you will.

We debated and argued about the ways in which the performance aspect could be even further extended. We started experimenting with choreographed performance, determined to learn how to effectively use space. Big spaces, small spaces, make-believe spaces and make-do spaces, contested spaces. We started with breathing exercises that influenced the flow of the rhyme. We then went on to movement and worked on dramatic entrance, voice projection, delivery, and the expression of thought without sound. It was hard work conveying meaning through body language, and the combination of rhyme, performance, dramatic personae, and theatrical theorizing was, in essence, a display of our commitment to building on the foundations laid down by some of hip-hop's most gifted craftspeople.

Here's an example of what youth participant Marlon Burgess came up with—a critique of the post-'94 South African education system under neoliberalism:

This Revolution's got us going around in circles like the second
 hand–Education system
Where to manufacture consent is how they planned the fractured
 content they're inserting
Inverting the facts insisting on hurting the cats that don't listen
 and diss them
Our children are ridden of the rhythm to crit' them.
We thought our liberation was from racism but oppression in this
 place isn't only face driven.
So the play play in Grade A was a great way. For sewing behaviour
Patterns that when
 kids are forced into class,
 where the principle is
To skrew with their heads
 and between the periods they plant seed in our pupils
 so all we can look forward to, is going into labour.
Then babies are baptised in brainwash begging for social conditioning
 from an over the counter culture

We embrace the transgressive nature of hip-hop, and so we look to push and jar conventional boundaries of what is acceptable or accepted. When we talk about knowledges of self, we refer not only to the "person" and focus on aspects of Black consciousness but also to an ideal that is less bound, and we look at the intersecting of the self, political, educational, spiritual, philosophical, environmental, and "cultural." All of this speaks to a kind of "oneness of being." We are of the opinion that art does not only mirror reality but that it shapes reality. Even beyond that, art is about embodying reality with all of its contradictions, its complexities, and its sensitivities. It is about critiquing the way things are done; it's about an ideal but also about us challenging ourselves. Art cannot be divorced from the rest of our lives; it's part of everything we do, be it about the spirit, the political, the philosophical, the cultural.

The cornerstone of what informs our work is based on alchemy. Hip-hop's power is in the art's expressions of freedom, hope, and audacity. Hip-hop is about using the little we have to push boundaries beyond what is visible to the naked eye.

Shaheen Ariefdien is a former member of the pioneering South African hip-hop group *Prophets of da City*. He is involved in a number of youth education projects using hip-hop as a tool for social justice and has facilitated several youth programs in South Africa and abroad. He is currently completing his M.A. in social anthropology at York University in Toronto, Canada, with his research area focusing on hip-hop and pedagogy.

Nazli Abrahams is currently completing her M.A. in education at the University of Cape Town and is a member of an on-campus worker-support committee. She has taught in several different countries and has had a longtime interest in curriculum design and program development. Nazli codesigned and cofacilitated a number of youth programs fusing hip-hop, academia, and media and is particularly interested in hip-hop pedagogy and the use of hip-hop as a tool for social justice.

NOTE

1. For more information on the African Hip-Hop Movement, visit http://www.mio.co.za/article.php?cat=&id=559.

27

AfroBlue

Incanting Yoruba Gods in Hip-Hop's Isms

Raquel Cepeda

Art historian Robert Farris Thompson once concluded that "popular music of the world is informed by a flash of the spirit." There is a collective memory in rock, jazz, salsa, highlife, juju, mambo, and other kinds of music with roots in improvisation and ingenuity that extends well beyond their soundscapes. The principles of song and dance inherently present in these aesthetics were founded by a source initially acquainted to this relatively New World by way of slavery. If we were to adhere to Farris Thompson's definition of the principles of *flash*—the dominance of a percussive performance style, a penchant for multiple meter, overlapping call and response in singing, inner pulse control, suspended accentuation patterning, songs and dances of social illusion—we might make the argument for hip-hop's initiation into the coolness of this spirit. Rap, and hip-hop culture as a whole, is linked to this spirit, not only through its innovation in artistic expression but also due to the manner in which its syncretic relationship with West African religion and philosophy planted an ancestral frequency into this chilled-out generation of heads.

Black Africa's most populous areas in the western regions of Nigeria and the eastern Benin Republic somehow survived to beget a tradition that has borne many spirits under one God in the New World via the transatlantic slave trade. Known in its Latino form as *La Regla Lùkùmí, Santeria,* and *La Regla de Ocha;* in Brazil as *Candomblé;* in Trinidad as *Shàngó* (Baptist); and through the more popular African American nationalist term *Yoruba,* the tradition has many names. And although they differ slightly from place to place,

these indigenous religions, including the Haitian V*oudon,* or Voodoo, are all branches from the same proverbial tree in that they are vicissitudes of slavery.

Throughout hip-hop's still embryonic life, Yoruba religious philosophy and aesthetics have consistently informed graffiti art, fashion, rap music, and breakdancing. Hip-hop now again witnesses the "changing same," to sample Amiri Baraka, a curiosity with the intoxicating aesthetic that has inspired popular music for generations: Yoruba iconography and music. "I think that [it works] because it's so clear, so down to earth," says Farris Thompson, "and powerful because the symbols are so flexible that they will expand into any high-tech thing you want."

In the very first generation of commercial hip-hop music, Our Father Afrika Bambaataa experimented with allusions of Yoruba philosophy when teaming up with a group called Shango for the LP *Shango Funk Theology.* On the cover, an Ice Man, an abstracted orisha Obàtálá, hovers over earth and emits, from his hands, a deep freeze, chilling out the planet. Afrika himself postures above in the shape of a double-headed ax, an *oshe,* emanating fire, synchronizing himself with the thunder god, Chango. "His fingers are arranged in the funk sign with two fingers up and the rest all curled down," points out Farris Thompson. "The fingers are witty because they are also the two meteorites that [in folklore] were hurled for moral vengeance by Lord Shàngó." The use of a futuristic robot looking down on the left side of these divinities, and a mortal on the right, symbolizes the special relationship that coexists between man and the supernatural.

Popular examples of African retention in our collective memory lie in the Brazilian martial art called *Capoeira,* in the Afro-Cuban street dancing by the *rumberos callejeros,* and the acrobatic mambo dancers in New York City circa 1950s, all forms that could arguably have sired what we know today as breakdancing. The West African griot and the Cuban *sonero* are progenitors of the MC, who share a (pre)disposition of improvising witty rhymes echoing generations past each time she summons the ancestral spirit known in its boundless nom de plume as "freestyling." Hip-hop fashion statements and hairstyles like cornrows are as bold as the African royalty and the gods and spirits in whom they are descended, our huge gold medallions and opulent taste in jewelry markers of our allegiance to this holy trinity. This flash even exists in our vernacular. The idea of being "chill," "cool," and "fresh" embraces the fundamental Yoruba philosophy of cultivating *ìwà pèlé,* or good character, by keeping our heads *cool* under circumstances that challenge our character.

Cuban immigrants and Afro-Cuban musicians first introduced this religion, however subliminally, to America in the 1940s. By the late 1950s, Mongo

Santamaria's "Afro-Blue" had become just one of the many Latin jazz mainstays. According to historians John Mason and Henry John Drewal in *Beads, Body and Soul: Art and Light in the Yorùbá Universe*, the first known African Americans to be initiated in Cuba dated back to August 1959—three months after the recorded release of "Afro-Blue." Although the exact number of Yoruba patrons living in the United States is unknown, the late professor Dr. Mary Curry estimated the head count as being anywhere from 250,000 to one million in her book, *Making the Gods in New York: The Yoruba Religion in the African-American Community.* Today across the United States, there are whites, Blacks, Mexicans, Dominicans, Puerto Ricans, Panamanians, West and East Indians, Jews, African Americans, *all* kinds of people who have been "called" into this spiritual connector to God.

Santamaria's "Afro-Blue" conceptualized its melodies from an *oriki*, or praise song, dedicated to the orisha of creativity and coolness, Obàtálá. It was adopted by American artists like John Coltrane and Dizzy Gillespie, Abbey Lincoln, Cal Tjader, and many others. The *bata* drums, or "talking drums," sacred to patrons of the tradition, have belted out enchanted messages from Cuba's shores before Fidel Castro reigned and the ensuing U.S.-imposed embargo dubbed the "Special Period" halted the cultural exchange program between musicians who previously were awakened to the flash of spirit memory.

Cadres of hip-hop's finest continue to innovate the traditions and superior musical and visual aesthetics rooted in Yoruba and Congo religious philosophy. Just listen to the revolutionary sounds of the Cuban hip-hop group Los Orishas, who fused Afro-Cuban music with the universality of rap beats and rhymes, or the praise lyrics for the river rain goddess of beauty known as Ochún by Queen Pen and Hurricane G.—the latter being an initiated priestess of this divinity—in their rhymes, reawakening the atmospheric connection to their transmissible rite. The sampling and experimentation of Yoruba praise songs are seamless with rap because at the most basic level the principal ideal of the dominance of a percussive performance style, polyrhythms, and the call-and-response model fits into the musical paradigms of *orikis* and rap.

In 1999, Common traveled to Cuba to perform at the yearly hip-hop festival in the neighborhood of Alamar in Havana. There he performed in front of an enormous acrylic painting called *El Mensajero*, dedicated to the divinity Elegba's abstracted, looming figure. It was a striking contrast: Elegba's abstracted, looming figure offset by Common in a Cuban-style *guayabera* outfit, hat, holding a *cohiba*, and his Cuban counterparts wearing boots, baggy jeans, and oversize T-shirts by PNB. By the end of the trip, Common had been

deeply moved by the culture and music, particularly the *orikis*, sung in a Creolization of the Yoruba language that came to be known as *Lùkùmí*.

Common's experience, and his desire to test himself musically with more of a melodic base, coupled with singer Vinia Mojica's *àshe*, or spiritual command, resulted in the befitting introduction to his millennial release, *Like Water for Chocolate*. Mojica—an initiated priestess of the orisha Yemayá, the archetypal mother to the world and source of all life who can also be heard singing the intro on Common's *Electric Circus*—combined two incantations dedicated to Elegba, translated here from the featured *Lùkùmí*:

> Talk a little time
> Talk a little
> He wanders around separating
> Make way He's separating
> The Owner of Vital Force
> He shoots, kicks, He pierces
> He ties the knot
> He darts out
> But He does not speak
> He wanders around separating
> Make way, He's wandering, separating
> The Owner of Vital Force

Elegba, one of the most important divinities to survive slavery, is the messenger of our prayers to Olodumaré, the Supreme Being and Creator. The owner of the crossroads, the trickster who can clear and cause chaos in a whim, is the inaugural divinity to be invoked in a Yoruba religious context.

"Common was having a lot of blockage during the creation of [*Electric Circus*]," remembers Mojica, "so I immediately thought about Ogún." The blacksmith divinity who cuts down obstacles with his iron implements, while mimicking warlike dances similar to those incorporated into breakdancing, becomes a perfect inspiration for hip-hop. The intro to *Electric Circus*, titled "Ferris Wheel," features Mojica belting out praise names for Ogún, as he gets ready for battle and the spiritual cleansing of his host, ridding him of indecision and negative energy. Author Ivor Miller was astonished to find that The Last Poets libated their album *Chastisement* with a chant for Ogún. In his book *Aerosol Kingdom*, he wrote: "The significance of Ogún to New York City, the trains, and the continuity of African-derived culture can hardly be over-

stated. . . . The Last Poets were leading the way not only for future rappers, but for a reconnection to West African spirituality via the Caribbean."

Over the years, Yoruba philosophy and aesthetics have roused the aerosol art of DOZE Green, EZO, TOXIC TDS, and other artists who, like their ancestors of African American and Caribbean descent, Ivor Miller wrote, "related to trains as symbols and metaphors . . . [and] worshipped gods of iron." The Ogún connection exists between graffiti artists and the iron implements empowering their lives, these faceless youngsters with names becoming as legendary as the force that dominated their spirits. "As in all art, including graffiti, the connection between Yoruba art and philosophy is that they are both in the business of explaining man's place in the universe and his connection to a creator," affirms EZO, who began bombing in the late 1970s. "Spirituality is an important part of Latino culture, and the Latino influence on graffiti is incalculable, so references to faith topics were inevitable."

In one of DOZE Green's paper pieces, "Untitled (1999)," a b-boy blurs the lines between mortality and divinity, sporting a halo while receiving a libation from a Supreme Being. On the lower-right-hand side, there is a figure representing Elegba that features both Yoruba and Catholic symbols associated with this divinity, including an enormous penis (embodying fertility and infinite potential), the number three, and a devil-like horn representing the dark forces associated with this trickster by zealous missionaries. In the center of the acrylic canvas painting *Ghetto Resilient* (1998), DOZE features a more traditional image of Elegba—the form of a small cement head with cowrie shell eyes and mouth, protector of all that is Caribbean. The word *Chango* is also featured on the painting. Hip-hop-influenced visual artists find that Yoruba art and philosophy, and the children of Ogún, with nerves of steel, are propagated from the same source.

Yoruba philosophy and art are rooted in individuality and style, which can be a seductive quality for artists. Imbued with the mystery of adventure, of the unknown, the paths toward expression become infinite. It is common to find a hip-hop head-rocking a huge gold pendant of the Catholic saint Lazarus—depicted as a sore-riddled man on crutches accompanied by two dogs—synchronized with the divinity of sickness, Bàbàlú Ayé. Even fashion runways and lifestyle magazines have used models sporting colorful bead necklaces that are oftentimes specially "prepared" *collares* or *ilékes*, representing the protection of the Yoruba divinities, as well as linking the wearer to his or her godparent. The origins and history of this beaded set of spiritual armor are reflected in the colors and patterns used to make them.

At the outset of 2001, neosoul singer D'Angelo, a rapper literally possessed with a resonant voice, released the follow-up to his 1995 debut, *Brown Sugar*, ironically christened *Voodoo*. Fundamentally, the title did not reflect the concept of its namesake. Its Yoruba aesthetic was featured on the pages of the album's accompanying CD booklet. D'Angelo skates over the fine line between inspiration and religious insensitivity by sporting an *ìdé*, an intricately beaded sacred bracelet worn by initiated priests in the orisha community that identifies their divinities, in this case Shàngó. Rather than depicting a voodoo ceremony, a staged *tambor*—or a religious fete—was given by a group of priests in Havana on the one-day photo shoot.

In all fairness, D'Angelo's goal was not malicious. He did not intend to further inflate the stereotypes associated with African religion. He wanted to create an atmosphere that showed a continuum between blues music—commonly referred to as the "devil's music"—and what has, to him, an extension of the soul he aimed to capture on this excellent collection. A few weeks before the album was released, D'Angelo, whose father and grandfather are preacher men, commented on Baraka's "changing same," noting that "the thing that came to mind was basically church [because] when we in church we catch the holy ghost and start speaking in tongue. And that's real similar to me."

Roots drummer Ahmir "?uestlove" Thompson, who coproduced both Common's aforementioned albums and D'Angelo's *Voodoo*, says, "I feel that a more spiritual base is coming around to combat the materialism that is slowly plaguing hip hop. I wouldn't say 'religion' per se. But I definitely feel a spiritual based feeling coming around." This explains the rise of hip-hop's pop-culture shamans.

But D'Angelo's case proves this newfound visibility to be a double-edged sword in the case of Yoruba, Congo, and Voodoo religions, which remain insular by nature. Many of the reports about the religions have been riddled with misinformation and taken out of context, in both mainstream and urban media outlets. Hollywood movies—too numerous to name—that exaggerate stereotypes of all that is African, recasting indigenous religions as negative or Satanic, keep many of the religions' patrons "underground," so to speak.

Cypress Hill rapper B-Real is a *babalawo,* or "father of secrets," in the Ifá system of the Yoruba religion. He says, "Like *Los Orishas* did in the Spanish-speaking countries on their records, eventually somebody will put it out for the English-speaking people to understand." But after eight albums, Cypress Hill has not purposely infused any religious elements into their music or visu-

als. Ironically, though, their use of skulls and cemeteries, B-Real says, "is linked to where I've fallen into with Ifá."

He believes that the complexity of the religion's secrets are better left to those who "are supposed to be exposed [to them] and those who need it." He adds, "I think people [have to] be careful with the lines they cross" when using Yoruba iconography unless "you're using it to bless your project and give light to the culture."

There are no right answers for what road to travel because of the spiritual conduit that is working, informing each individual that it chooses to possess with the flash of the spirit, or with ancestral intuition. The connection is atmospheric. The culture is concentric with time, and "while how we code it may change," said a Congo priest to Farris Thompson, "what is coded *never* changes."

Raquel Cepeda edited *And It Don't Stop: The Best American Hip-Hop Journalism of the Last 25 Years*, which won a 2005 PEN Award, and is featured in *Da Capo's Best Music Writing, 2006*. Cepeda has written for many publications and television and has edited as well. She's currently in production on her first film, a VH1 "rock doc" titled *Bling, a Planet Rock*, a documentary about hip-hop, diamonds, and the eleven-year uncivil war in Sierra Leone, West Africa. She lives for her daughter, Djali.

Native Tongues

Hip-Hop's Global Indigenous Movement

A Roundtable Curated by Cristina Verán, with Darryl "DLT" Thompson, Litefoot, Grant Leigh Saunders, Mohammed Yunus Rafiq, and JAAS

New York City has long called out to a whole host of displaced "tribes," infusing the local culture with new ideas, social norms, and cultural practices. Once upon a rhyme, Bronx originals Soulsonic Force moved nations with the Zulu funk of *Planet Rock,* and Harlem's native sons Spoonie Gee & The Treacherous Three heralded *The New Rap Language.* Into this polyglot gumbo of aesthetics in performance, presentation, and expression today, Indigenous youth around the world are rocking the planet anew, fusing hip-hop's expressive elements of MCing, DJing, b-boying, and aerosol graffiti art with their own traditions of oratory, music, drumming, dance, and the visual arts. Make way for the new rap language(s) of this generation's most potent and expansive youth "tribe."

Rap lends itself as a motivational force and context in the promulgation of indigenous languages and group identity, for peoples as diverse as the Maluku of Indonesia to the Sami of Norway. Culturally significant sources too—think whale calls, as employed by Greenlandic Inuit DJs from the tundra-fied streets of Nuuk—provide rich soundscapes to remix infinitely. In Mexico City, meanwhile, hip-hop-style graffiti art (re)connects urban mestizo (the mixed-race, nontraditional-Indian mainstream) kids with their artistic patrimony and iconography from grand Aztec and Teotihuacán mural traditions. Even Diné (Navajo) b-boys on the rez have related the corporeal movements

and rhythms of breaking and uprocking with their own styles of more traditional powwow dancing since the early 1980s.

Here are five Indigenous hip-hop artists and thinkers, from the United States, Chile, Australia, Tanzania, and New Zealand, representing both the pioneers and the latest vanguard of an urban Native aesthetic movement. Their work parallels the global rise of Indigenous Peoples' political and social activism and organizing, a ripe, fertile ground in which the seeds of hip-hop are thriving, strengthening its voice and spreading native pride to the beat of a proverbial new drum.

THE PANELISTS

Darryl "DLT" Thompson is a pioneering DJ, b-boy, MC, and graffiti artist in Aotearoa/New Zealand and a founding member of Upper Hutt Posse. His staunch Maori-conscious vision and contributions *to* hip-hop culture in the Pacific set the bar high for Indigenous artists around the world. Of the Ngati Kahungunu tribe, he resides in the city of Auckland, where he continues to represent for the cause as a music producer, visual artist, and arts educator, as well as a hip-hop radio host.

Litefoot is the premier Native American rap artist promoting music-with-a-message, representing hip-hop and the Cherokee Nation of Oklahoma. As an actor, he starred in the feature film *The Indian in the Cupboard* and has appeared in numerous big- and small-screen productions. Also an entrepreneur, he founded Red Vinyl Records as a home base for top hip-hop artists throughout Indian Country and today helms Native Style Entertainment and Clothing while visiting hundreds of reservations each year with his Reach the Rez tour.

Grant Leigh Saunders has been a devoted b-boy and MC since 1983, first catching the groove as a junior high student near Taree Township, New South Wales. He is Koori, from the Biripi tribal group; a Katang-language-speaking Aboriginal people of Australia. His documentary, *B.L.A.C.K.: An Aboriginal Song of Hip-Hop*, explores the history and impact of hip-hop among Indigenous Australians, as does the master's thesis he completed at Macquarie University: "D Hip-Hop Bakehouse: Indigenous Mob Hip-Hop & the Silenced Revolutionaries."

Mohammed Yunus Rafiq is a core member of Tanzania's Maasai Hip-Hop collective and the internationally renowned group X-Plastaz, promoting Indigenous pride that confronts neocolonial Black African mainstream societies

and governments that have taken the place of the Great White Hunters of the past. A poet and music producer of Segeju origin (he is also of Punjabi/Kashmiri descent), he also cofounded Aang Serian, which provides culturally relevant educational opportunities for community development in the city of Arusha, as well as the Faza Neli Community Recording Studios, supporting the efforts of local hip-hop artists.

JAAS is a hip-hop artist in Santiago, Chile, proudly invoking her Mapuche roots in a country whose mainstream has long marginalized its Indigenous Peoples and their vibrant heritage. She raps in both Spanish and Mapudungun (the Mapuche language), with songs and videos that educate and serve as a call to young Mapuche to awaken and actively engage in the struggle to assert and maintain their land and cultural rights in Chile.

CRISTINA: I'd like to get a sense of what, in some of your communities, was the initial appeal of hip-hop? What kind of response did it receive?

DLT: Well, first of all, hip-hop offered a lot of reaffirmations for young Maori. Back in the early '80s, Afrika Bambaataa was talking "tribalism," and his whole Zulu Nation hip-hop thing turned all us Maori kids on to a *new* kind of tribe. It was like, hey, even scalawags like us could work together and build a new kind of village. That's what our early hip-hop crews became for us. Rap, specifically, was like this media created by other "have-nots," like us, and we could see that the averages of truths it spoke were higher than all that white, Western brainwash media out there.

LITEFOOT: Who I am as a human being in my culture, in my traditions as a Cherokee? That comes first, before anything else that I do, and through hip-hop I found another way of representing that to the fullest, every single day. When I first started doing shows for different tribes, someone there might get up to do a jingle dance. Another person might do a country music song, while someone else would play a traditional flute. Then I would go and do an hour or rap. In the beginning, the traditional drummers and singers would just look at me like, "Come on, man. This is a powwow." A lot of the elders complained, too, but I worked very hard to dispel some of the negative stereotypes about hip-hop that were held by many tribal leaders.

GRANT: In Australia, during the late '70s and early '80s, there was literally nothing on TV or radio representing Black *Australian* [that is, Aboriginal]

aesthetics. Hip-hop, with its brown faces and voices, came and really filled a void, this lack of visibility and representation we felt in the media. It was very empowering, even politicizing, to see, and it gave us a framework in which to express pride in our Blackness—not as African Americans, of course, but as Aboriginal Australians and, in my case, as Koori. Early on, tracks like "The Message" really spoke to us, talking about the scenario of abject poverty in the States. It sounded a lot like what my extended family was living through, on the Aboriginal mission reserve outside Taree. At that time in particular, it was really all about identity politics for Aboriginal people.

YUNUS: When hip-hop arrived in Tanzania, it was like the sons and daughters of the land being welcomed back home, introduced back to the families, clans, and tribes. At the same time, it came to us like a needed rain when the earth is dry, bringing a new voice, new ideas. Its rain fell and transformed the land; those who resist the changing cosmic waters now face being swept away in its powerful torrents. If our cultures are going to survive, though, young people have to take it from this generation to the next—and hip-hop is making this possible. We can be tribal, and at the same time, we can also be global! It's opened more communication channels for us than if we only spoke through the traditional forms, because almost everyone listens to hip-hop. It's like a forest, this wild territory where we can go out and scream and scream, to talk about our dreams, vent our frustrations, and express who we are.

JAAS: I actually live in the community of San Joaquin, in metropolitan Santiago, and so my hip-hop awakening happened here—not in a Mapuche village. My mother's family comes from the pueblo of Los Angeles in the south of Chile, and my Mapuche roots are especially strong from this side. I'd always been encouraged to connect with our people there, and also to seek out those like us who are urbanized. Back in '95 or so, during this especially big hip-hop boom in Chile, I became very curious and would seek it out, going to all the places that hip-hop people would hang. Very quickly, I found myself moving in these circles of people who'd already been living hip-hop for years: the real b-boys, graffiti writers deep into the movement. With my own eyes, I saw how big this thing was . . . wow. I connected with it so much.

Around the same time, I also went to spend time in Temuco, in southern Chile, where I found myself as inspired to connect more to my Mapuche roots as I was connecting to hip-hop. I was curious about how the two worlds could possibly come together.

CRISTINA: What, if any, are some examples of your own Indigenous cultural practices that might themselves, perhaps, be evocative of hip-hop in some way, in terms of energy or form?

YUNUS: As with many East African oral performances, such as the Maasai *os-ongolios* and the *kuimbana* among the Swahili, the style of dialogue or talk in hip-hop is a similar convention. Our storytelling is done through an oral tradition, so songs—like raps—are like our books, used as media to criticize, to advocate, to relax, to entertain.

DLT: Maori youth are raised on *kapa haka*, a kind of performance battle which can also be like clowning, at times. In form, it's about moving your body; you gesture with your facial features, with your tongue protruding, making certain hand gestures and stomping your feet, all kinds of body language to make yourself, in a sense, bigger than you are. It says, "We are these proud people," while warning, "Fuck with me and I'll tear your throat out!" It's so like b-boying, really, and so we relate to it because we're into the challenge.

The *wero*, too, is a Maori ceremonial challenge presented in the first initial meeting on the *marae*—which is like a church, a spiritual safe ground—between a local tribe and a visiting group. Entering the *marae* during a ceremony is like engaging in a Shakespearean drama, and you have to be conscious and cautionary of ulterior motives and political maneuvers under the surface. When the *wero* begins, there's a thirty- to forty-foot gap between the visitors and the people of that *marae*. The fastest warrior of the tribe comes out carrying his weapon, while addressing the guests with a token gesture—usually a leaf of a tree or a branch. He must grab their attention in this ritual, this *wero*. In b-boy language, you could say he has to rock a routine. In doing so, he's representing many different forces of nature, changing his form, in essence. He may become like a *pukeko* [bird], while another might instead become a lizard—and enact that for the whole routine, giving it his all. A representative of the visitors then steps forward to pick up the gift to indicate an acceptance of the greeting, and then backs up to the group, which is led onto the *marae atia*, a kind of sacred space where both sides can come together under *kawa*—the law of the particular *marae*.

And so, for Maori kids, hip-hop's dancing, rhyming, piecing . . . these elements became a new way to go out there and do the *wero* to society, to confront this larger adversary and stare it down.

GRANT: The whole "cipher" concept in hip-hop in particular is, for us, a contemporary context for our traditional storytelling circles, where we as Aboriginal people would sit around a campfire and exchange stories—more egalitarian than a straight-up battle. You'd talk about who you are and where you're from, and about important or interesting things that have happened to you. There was an implicit contract between listener and speaker. The listener would verify what was being said at various points in the telling, like, "Oh, yeah, that's true. That part's true." Or else, it'll be more like, "Nah, you don't know what you're talking about. Go back to your place."

CRISTINA: How have Indigenous cultural practices and aesthetics directly influenced, perhaps even fused with, the kind of hip-hop being produced from and for your communities?

JAAS: For some hip-hop tracks, you might hear the sounds of some Mapuche instruments, like this certain kind of trumpet and the *chicluca*, into it. Graffiti artists, too, represent the *kultrung* symbol in their pieces, which indicates the heart of the people, the *tambor* of the street.

The idea to make a video for my song "Newen," in Mapudungun and Spanish, came about during a recent trip back to Temuco, in the south. The Mapuche community there was very enthusiastic about this, and they helped me with the ideas and whatever they could. We filmed half of it there, in the community, and then we went to Santiago to do the second part. We wanted to show the differences—and the links, too—between the countryside and the city experience of Mapuche, to give people a better understanding of how and why I represent as not only a hip-hopper but as Mapuche *in* hip-hop, how it's all linked together.

GRANT: In Australia, some of us adapted our own indigenous dances' movements to hip-hop—like the "shake-a-leg," for example—reappropriating them in a b-boy context to make it more Koori flavored. Many tribes here, especially on the east coast, are known for the shake-a-leg, which involves a sort of stomping on the ground, shaking your knees in and out while moving toward an audience or toward another dancer. Till today, this move's incorporated in our styles of breaking.

Musically speaking, hip-hop artists are using clapsticks, the traditional rhythm instruments among tribal groups throughout New South Wales. The

didgeridoo has also been used to provide rhythm in Indigenous hip-hop music, because of its ability to emulate many different sounds through certain vocal and tongue acrobatics. A good didg performer can even reproduce the sounds of a turntablist scratching! The group Local Knowledge provides a segment in their live acts where there's a duel between rapper Abie on didg and the DJ on turntables. These sounds have also crept into tracks produced for other Aboriginal groups like MC Murris and the Barkendji Boys.

DLT: There's a quintessential Maori flavor, a Maori vibe to our hip-hop—especially in a battle-type situation. It's all in the attitude, this love of the hunt. Maori kids don't play all their cards; they'll always have something extra—mentally, spiritually, the whole nine.

In terms of my own art, one of my favorite pieces to this day is this huge 30-feet-high and 120-feet-long graffiti mural I did for the millennium with a gigantic Maui figure, representing our greatest ancestor: Tiki Tiki o Taranga Maui Potiki, who fished up this island we live on from the sea.

Our people were sailing all around the Pacific back when Europeans still thought the earth was flat. We're raised knowing our *whakapapa*, taking pride in our genealogies going all the way back to our ancestors who arrived here on those first *waka* (great canoes). My staunch old grandmother would tell us about Rongo Mai Wahine, who married Kahungunu—my tribe's name, Ngati Kahungunu, comes from him—and that his father was an *ariki* during the great migration from Hawaiki. From Ti Toku Waru, a great chief of Taranaki, to Rua Kenana and Te Kooti, these great ancestors represented this real, "word is bond" type of honor—they were hip-hop, eh! So by the time I discovered hip-hop, these people, these ancestors . . . they were right there with me. That's who I represent in my graffiti stuff especially, incorporating elements of *maoritanga*, my knowledge of my culture and ancestral heritage in the design and presentation.

LITEFOOT: Around Indian Country, it's kind of sporadic, in terms of the crossover influences one way or the other. Mostly, you can see it in the style, in the clothing, bringing hip-hop into a Native context. Like at the powwows today, when you look at everyone sitting around in the drum circles, singing their songs: most of them are not dressed in traditional regalia. They're wearing some Roc-A-Wear or FUBU or Ecko gear. Also, if you just look at the back of the CDs for a lot of powwow music, beginning back around '95 till today, you'd swear you were looking at a rap album from the titles of songs they use. It's just more evidence that hip-hop style affects not just Detroit or Miami, or Dallas; it's hitting the reservations, too.

YUNUS: With X-Plastaz, for example, Faza Nelly and G-San come from the Haya tribe, and so they brought the traditional Haya sound and songs into the kind of hip-hop that the group would do, mixing rhymes and warrior chants. Haya music incorporates a lot of drums and a special type of guitar called a *zeze,* while Maasai music comprised mostly chants with very little, if any, instrumentation, and is noted for its "throat singing" elements. Putting Ki-Maasai to a hip-hop beat was a very big challenge, though, which our brother Yamat Ole Meiboko—also known as Merege ["Male Sheep"]—had to work out. When we all first met, Merege didn't know Ki-Swahili. We knew, however, that bridging these music styles and languages would also bridge together peoples.

CRISTINA: What about the incorporation of Native languages into your music—how does that work, and what are some challenges to doing this, if any?

YUNUS: The problem for our crew was how to fuse the music of the Haya members with the very different music of the group's Maasai members into the hip-hop mix—*and* do it all in Ki-Swahili, the national language of Tanzania, so everyone can understand it.

JAAS: Those of us living in the cities don't have the luxury of being surrounded by our Mapuche family members with whom we can speak it every day. The schools don't teach it. First is Spanish and then English, even though Mapudungun is an original language from here, the language of our roots. So I decided to actually rap and record my songs in Mapudungun—even though I am still learning the language.

A friend told me about some Mapuche guy who'd heard about me and was coming to the city one day, wanting to meet me to talk about the music I was doing. I was excited and really looking forward to meeting him. When we got together, I told him what I was feeling, as far as wanting to be more connected with Mapuche and to represent this in the songs I was writing. So he offered to translate them into Mapudungun for me. I thought, "What a great idea." I want for all the little kids to see and hear this, to grow up experiencing Mapudungun in their everyday life—even in a rap song. Hopefully then, they'll be inspired to study it and want to speak it themselves.

LITEFOOT: Unfortunately, I don't speak my own Cherokee language, so that's a real struggle for me. I know that if I rhymed in Cherokee, that would really help to get the point across, to encourage others to learn or maintain their languages, too. I need a platform through which I can give the message to a lot

of people, though, and so I've got to do it in the tongue everyone who plays my CD will understand: English. There's five hundred–something tribes out there, you know, so if I was to do my songs in Cherokee, I can just imagine the flack I'd get from all the others, like, "You didn't mention MY tribe!" Or, "How come you didn't mention OUR rez? Why you hatin'?"

CRISTINA: Has any slang crossed over, meanwhile, from your native language into the local hip-hop speak?

JAAS: Some of the Mapuche words that have woven into our slang are like, *nielay cullín*—which means "there's no money." Another is *kichiu*, which means "bracero." *Curiche*, in Mapudungun, signifies Blackness, Black people.

YUNUS: In terms of our slang, rappers will say *wa kuchana*—"we're ripping rhymes." Another interesting word is *kufoka*, which means "boiling" or "shouting at." That's how they will describe what they do—not "I'm rapping," but "I'm ripping, I'm boiling."

DLT: *Hori* has become like an equivalent to the *n* word for Maori, though not with the same heavy history. It's often used in hip-hop scenarios to refer to a brother, but it originates as the Maori version of "George." It became like a slur at some point; as slang used by white men to refer to *every* Maori as "hori." I say being *hori* means being barefoot, not being afraid to let my feet touch the earth—and that, to me, is hip-hop.

GRANT: A lot of MCs use the saying "young, Black, and deadly," and that's actually common speak around Australia now. The word *gammon,* which originates up in the Northern Territory, is also used a lot. It means "joking" or "fake."

CRISTINA: In terms of giving a voice to your communities over all, please share some examples of how this is happening and what's at stake, in terms of issues that need addressing toward the mainstream society and within your own peoples.

DLT: I'll just say that hip-hop really pushed us off the fence, to confront the system and be like, "Here's what I think, and I don't care if they don't like it." We became the first Maori kids to stand up and say, "Fuck the queen. We're not gonna be on no colonial, Union Jack bullshit."

GRANT: Hip-hop has proven itself a powerful voice and a powerful motivator in the way it's been utilized by Aboriginal Australians. It has, I believe, strengthened the longevity of our Aboriginal cultures. We're conscious that when our elders pass on, their knowledge will, too—unless we make it accessible to the young people, as hip-hop hop does indeed do.

YUNUS: During the 1960s' Pan-African movement era, there was more traditional music promoted and played on Radio Tanzania. Now, the radio stations are privately owned, and most all they play is Western or American music. This makes it especially hard for local artists to penetrate that barrier, no matter how passionate we may be about our cultures. To get that exposure, to get airtime, we must "modernize it." Mixing it with hip-hop in some way has helped it to be more accepted. It's so ingrained in the Tanzanian mainstream that one has to dress and act like Westerners to be successful, to really make it, so there is very little emphasis on or recognition of indigenous cultural values.

In Tanzania, maybe 95 percent of us are farmers and pastoralists, yet there aren't any real social programs to help the youth deal with the pressures that exist to "modernize." They run away from our villages to the big towns and cities, putting themselves at high risk for contracting HIV and falling prey to drug abuse and crime. Hip-hop is helping to educate them about these dangers, and in fact there's a Chagga rap group from the Kilimanjaro area, called Motomkali, doing this very well. Their name means "blazing fire," a term that's also a metaphor for AIDS. Most of their songs are geared to educating people about HIV and what should be the response of society.

JAAS: In Chile, you see nothing Mapuche in the mainstream media. There is exactly one TV program in Mapuche, and from time to time something on community radio, but you won't see an "Aboriginal" face on TV normally. The newscaster will be some skinny blonde lady. And the news here in Santiago will say nothing about what's going on in the south in Mapuche lands, where the government wants to take over one of the mountains to mine gold and where people have been protesting, for example.

I saw that I could use my rap to provoke this sleeping society of ours to wake up, to see how much injustice, how much discrimination, exists here against Mapuche and anything that's indigenous. The hip-hop community was a lot more open to and interested in these themes, to this *causa*, more conscious and seeking of truths. They really get it, I think. I feel good knowing that maybe my ideas will spread and people will be more conscious about and recognize the Indigenous side of Chile.

CRISTINA: What are some stereotypes or misinformation about Indigenous peoples in your country's prevailing mainstream attitudes which hip-hop has been vocally challenging?

JAAS: Well, the big, ugly stereotype in Chile is that Mapuches are just a bunch of drunks, people that only want to drink and drink. I mean yes, there are certain cultural ceremonies where wine is consumed, but in terms of drunkenness . . . that's in every community, eh? No more or less among Mapuche.

YUNUS: In Tanzania, there are different degrees in the social order of the country. Maasai or Hazabe, for example, are seen as *washamba*, which has this connotation as being "primitive" compared with other tribal groups. When Maasai come to town, they face a lot of prejudice from the Westernized Tanzanians. A Maasai friend of ours came to a hotel in Arusha for a meeting, wearing his traditional garb. When the hotel manager saw him, though, he told our friend to leave immediately. When he refused and tried to explain that he was meeting a hotel guest, the hotel security grabbed him and slapped handcuffs on him. They threatened to take him to jail and extorted a bribe to let him go.

CRISTINA: Have your Indigenous communities, hip-hop or otherwise, ever been exploited, stereotyped, or otherwise kept at a distance by the mainstream hip-hoppers you come across? If so, how do you feel about this?

LITEFOOT: In the States, definitely. As long as rap stars like Outkast are gonna show all Indians as living in teepees in 2004, insulting our sacred songs like they did on the Grammys, the show might as well show Black folks living in the jungle and white people living in caves! Would I ever dress up like a racist caricature of a Black person, some kind of Kunta Kinte slave, Al Jolson painted in blackface, sticking a bone in my nose or something? Hell no! Because I have respect and knowledge of my own culture, I wouldn't disrespect someone else's sacred traditions. I realize that African Americans are mostly disconnected from the tribal cultures of their ancestors back in Africa, but that's no excuse to come along and insult mine—or to tell me I don't have the right to feel insulted.

At the same time, I've definitely had my share of Native elders saying about me, "Why's this young man trying to be Black?" That's really funny, because if I was singing rock instead of rapping, I know these tribal folks wouldn't question me, saying I was trying to be "white."

I first started appearing at the Gathering of Nations Powwow, the biggest gathering in Indian Country for the year, back in 1993, and it has given me a platform to reach so many Native people. There in New Mexico, right in the middle of it all, you've got the largest tribe in the country just two hours away, in the Navajo Nation, all of those Pueblos, too, and still more tribes beyond that.

GRANT: Back in the '80s hip-hop was dominated here by brown kids, Aboriginal and migrants like the Greeks, Italians, Turkish, and Lebanese, who've all gone through similar things, as far as racism or marginalization in Australian society.

Ever since Eminem came out, however, hip-hop has actually been considered a *white* thing in Australia, affirming White Power. There's been a big, ongoing debate about this whole "accent" thing, in terms of Australian identity and hip-hop. White hip-hoppers are the gatekeepers, calling all the shots as far as hip-hop on a national level is concerned. They maintain that you gotta have that true "ocker" accent, the whole "Ay, g'day, mate" kind of talk. Anyone here who doesn't talk or rhyme like that gets classed as "inauthentic."

These white Australian groups like Hilltop Hoods or Buttafingaz . . . what they talk about doesn't resonate with Aboriginal people; there's no connection there. We relate a lot more to Black American issues, so we align ourselves more with American styles.

CRISTINA: Are there any ways that hip-hop—maybe rap specifically—has influenced your communities in less positive, perhaps disturbing ways?

LITEFOOT: Look, I'll just put it out there that we have become in large part assimilated—to the good, the bad, and the ugly, as far as hip-hop in Indian Country.

DLT: Adverse effects that hip-hop may have had in Aotearoa come from the commercial side of things, really—like the growing obsession here with acquiring bling, this materialistic illusion/delusion stuff. Also, you shouldn't be surprised to find all these Maori kids following what American rappers show us by example on all their big hit records, in their movies, saying, "What up, my n#$*%s."

YUNUS: The thing that helps to "shield" us from what I understand to be some more negative kinds of rap music is that, for the most part, we don't

understand the English words that they're saying! We just feel the power, the anger in their voices, though, and we connect with that. In a sense, through hip-hop, the Maori story becomes my story, the Lakota story is my story, and even the Zulu Nation story is my story, as I question the order of things and continue to discover these universal strands that connect us all as indigenous peoples.

Cristina Verán is a journalist, historian, and consultant-lecturer who has extensively documented global cultural phenomena and sociopolitical movements. A United Nations correspondent, her work has been featured in *The Village Voice, Vibe, News from Indian Country*, as well as *World Chronicle*, the UN's news-roundtable television program. Issues and initiatives pertaining to Indigenous Peoples comprise a particular focus, often intersecting with her longtime interest in hip-hop—a movement she's personally connected with for over twenty-five years, having been a proud member of the genre-defining artist collectives TC5, Rock Steady Crew, and Zulu Nation.

NEXT ELEMENTS: HIP-HOP ARTS AND FUTURE AESTHETICS

Next Elements

Hip-Hop Arts and Future Aesthetics

In 2005, the Universal Zulu Nation threw a celebration for hip-hop's thirtieth birthday. There were plenty of signs of vitality in the hip-hop arts movement. But as writers like Greg Tate warned publicly about hip-hop's future, and some young people began talking about the emergence of a "post-hip-hop generation," the question of "What's next?"—one that had driven decades of innovation and ambition—took on a different tone.

So we return to the question present since the days of the Sugar Hill Gang's "Rapper's Delight." Is hip-hop dead? Or in yet another transition? This is the core tension at the heart of these essays.

Walidah Imarisha's untitled poem reads like a statement of purpose that might have been written in 1992, at the height of hip-hop's fist-raising idealism. But even now, after hip-hop's absorption into capitalism, she argues that it can still be "intoxicating/exhilarating/potentially devastating." Imarisha's cry is a generational one. The political reversals that occurred so quickly and thoroughly after the late '60s led to a hip-hop arts movement that appeared coarser and less rigorously politicized than the defiantly outsider Black Arts or multiculturalism movements that preceded it.

As a Baby Boomer, Roberta Uno's embrace of hip-hop came only after she understood hip-hop's inside/outside duality, in stark postsegregation contrast to the us-or-them lines that had been drawn through the '80s. Her piece, "Theatres Crossing the Divide: A Baby Boomer's Defense of Hip-Hop Aesthetics," not only neatly summarizes the context for hip-hop arts but also closes the gap between generations.

Hip-hop journalist Eric Arnold's roundtable of independent hip-hop filmmakers develops the issues raised by Imarisha and Uno and by others in this anthology. Groundbreaking artists Rachel Raimist, Kevin Epps, and Michael Wanguhu are at the vanguard of an explosion of filmmakers working in features,

shorts, and documentaries made possible by digital technology. Here they discuss images of women, African Americans, and Africans in mainstream film and hip-hop video; how their work counters those images with alternative, empowering visions; and how they maintain an independent aesthetic in an era when commercial visions appear to dominate.

B-boy and graffiti legend turned celebrated fine artist Jeffrey "DOZE" Green has a different response to hip-hop's commercialization. He has given it up. In this interview, DOZE discusses a distinguished career that has often defined the cutting edge of hip-hop arts in dance and visual arts, and why he no longer likes to describe his work as "hip-hop." Perhaps with DOZE, and artists like TWIST, Shepard Fairey, Phil Frost, and FUTURA, we are seeing the rise of post-hip-hop visual art, unimaginable without hip-hop, but somehow different in intention.

Painter, teacher, and conceptual artist Brett Cook-Dizney, who also began as a graffiti artist, talks about one of his favorite pieces of conceptual art, a block party he threw in Harlem in the summer of 2003 called *Revolution*. The daylong celebration was a chance to honor the roots of hip-hop and completely reimagine the block party as a site of an alternative future. But such events are also ephemeral. Revolutions, Cook-Dizney reminds us, are not forever.

Increasingly in hip-hop arts, energies have been directed toward the conservation or preservation of hip-hop, efforts meant to protect and maintain the culture. Such gestures are not new. Before hip-hop found its commercial footing during the mid-'80s and made the question (at least temporarily) moot, New York City cultural folklorists attempted to do the same thing. In this new context, conservation and preservation may be the signs of a maturing culture. Critics often take these moves to be conservative when, in fact, they can be a progressive response to a sense of a loss of control.

Poet, playwright, and activist Rha Goddess is interested in questions of sustainability—both individual and cultural. In "Scarcity and Exploitation: The Myth and Reality of the Struggling Hip-Hop Artist," she discusses hip-hop artists' "poverty consciousness," a dismal and disempowering point of view that draws from the romantic but self-victimizing idea of "the struggling artist, the culture's inherent competitiveness, and American individualism." Hip-hop and hip-hop artists, she argues, need to grow up and rethink how to build a livable, collective-minded arts movement. She asks the provocative question, "What would it look like if we *won*?"

It is a question that Danny Hoch, the actor, playwright, director, and founder of the Hip-Hop Theater Festival, grapples with in his piece, "Toward

a Hip-Hop Aesthetic: A Manifesto for the Hip-Hop Arts Movement." Hip-hop theatre is a space that self-consciously looks back to the original "four elements," involving as it does movement, sound, word, and visual art, so Hoch is positioned to outline the aesthetics of those elements and how they have developed and expanded into current practice. If Harry Allen starts off *Total Chaos* with a theory of hip-hop's Big Bang, Hoch closes this anthology by painting a broad-brush picture of the universe it has become. Along the way, he discusses questions of patronage, audience, ownership, and power. He concludes with an urgent call for a debate over hip-hop aesthetics. What's next? The question is on the table, and the discourse continues.

Untitled

Walidah Imarisha

came out sticky
with rage rebellion
riot-flames

our history the immediacy
of a break beat.

Afrika/ The Republic of New Afrika
The Deep South/ the South Bronx

our will to survive
playful and mischievous
kinky and freaky
raw and angry.
we could move mountains
and nations
and asses

You don't know us
You don't want to know us
"they ain't scared of rap music, they scared of us,"
right,
Boots?

a flicker in the corner of the national eye
a low rumbling no one noticed
until it became a roar.

Outsiders ryde or die-ers
Make our own rules
Hip hop crooning in a brown fedora
"I did it my way."

consumed by capitalism
belched back in our face
black rage
to suburban dreams
hip hop
to hip pop
counter culture
to amerikan culture
distorted
as that sista's ass
in the ludakris video

just the latest po/mo expression
of our post soul existence
we don't hold on too tight
anything can be taken from us
time bombs laid in society
concussion grenades
duct taped to mic stands
break with boldness
bomb like badasses
cpr on the unda unda ground
and understand
evolve or die, baby
bluesbecomesjazzbecomesrockbecomesfunkbecomessoul-
 becomeshiphopbecomes
a new rebellion subversion love shout
intoxicating
exhilarating
potentially devastating

we are innovation in motion
spontaneity on the tongue

Walidah Imarisha is a historian at heart, reporter by (w)right, and a rebel by reason. Walidah helped to found and served as the first editor of the political hip-hop publication *AWOL Magazine* and was one of the editors of the 9/11 anthology *Another World Is Possible*. The bad half of the poetry duo Good Sista/Bad Sista, Walidah is also the director of the post-Katrina documentary *Finding Common Ground in New Orleans*. She does antiprison organizing with the Human Rights Coalition, a group of prisoners' families and former prisoners.

30

Theatres Crossing the Divide

A Baby Boomer's Defense of Hip-Hop Aesthetics

Roberta Uno

Hip-hop is a worldwide multibillion-dollar industry and cultural phenomenon that evokes passionate responses. Many are turned off by its commercial promotion of materialism, misogyny, and violence. And, paradoxically, there are those who believe that it is a culture and art form that provides a space for artistic innovation, democratic participation, incisive social analysis—that it is an effective organizing tool for reaching youth and disenfranchised populations.

The scholar Augustin Lao Montes tells us that these two divergent experiences of hip-hop emanate from the way in which hip-hop has been globalized on two parallel yet permeable tracks: One track is the top-down globalization of the marketplace and global capital; it is insidious, omnipresent, and incredibly sophisticated. The majority of rap, for example, has been promoted as urban Black culture and ironically is sold in the suburbs to white consumers. The second parallel track is the ground-up, grassroots globalization of hip-hop, which has been embraced by communities across the lines of race, class, and ethnicity worldwide. This track reminds us of hip-hop's origins in the Bronx in the early '70s—where DJs such as Kool Herc, Afrika Bambaataa, and Grandmaster Flash created havens that celebrated unity. Hip-hop as an art form has given voice to individual expression and community narratives. The conscious roots of these aesthetics have been embraced by hip-hop-generation activists

A previous version of this essay appeared in *American Theatre* magazine, published by Theatre Communications Group.

such as the Prison Moratorium Project, the League of Young Voters, Third World Majority, the 21st Century Youth Leadership Project, and others who have evolved the civil rights–era agenda to address myriad issues—including educational reform, the prison industrial complex, labor practices, immigrant rights, the environment, and civic participation. British hip-hop theatre artist Jonzi D asserts, "Hip—hop isn't violent—America's aggression in the global marketplace is the real violence."

We all know that other true innovations in art have elicited similar polarized response and controversy: we need only look at the beginnings of modern dance, modern drama, or modern art. Perhaps the closest parallel would be to compare hip-hop to a previously unrecognized indigenous American art form. Jazz—once reviled and associated with crime, shady characters, and disreputable places—is now appreciated as America's classical music and preeminent contribution to world culture. Hip-hop, born on a continuum of African American culture, is now old enough to have a history and a legacy as its four interdisciplinary elements—MCing (or rapping), DJing (or turntablism), b-boy (or breakdancing), and graffiti—influence performance forms, media, visual art, literature, fashion, and language.

The popularization of the term *hip-hop theatre* was propelled from inside the culture by Brooklyn-based writer Eisa Davis in *The Source* magazine; it has come to describe the work of a generation of artists who find themselves defined in a new category of both prospective opportunity and limitation. These artists range from dance theatre choreographers Rennie Harris, who heads Puremovement of Philadelphia, and the New York City–based duo Rokafella and Kwikstep, founders of Full Circle Productions; to ensemble artists such as Universes and I Was Born with Two Tongues; to solo artists, including Danny Hoch, Sarah Jones, Will Power, Aya de Leon, Caridad de la Luz, Marc Bamuthi Joseph, Teo Castellano, and Mariposa; to playwrights like Ben Snyder, Kris Diaz, Eisa Davis, Candido Tirado, Chad Boseman, and Kamilah Forbes.

These artists range widely in their response to the term. Hoch and Forbes, for example, are at the center of defining and promoting the genre as the coartistic directors of NYC's Hip-Hop Theater Festival, which has produced highly successful satellite festivals in San Francisco and Washington, D.C. Forbes talks about her beginnings as an MC; it was her involvement with and love of language that led her to study Shakespeare at Oxford. But it was her longing for hip-hop's audience that compelled her to forge a new form, "hip-hop theatre." As an MC, actor, and playwright, she contends hip-hop demands heightened listening because of its compression of language and complex rhyme schemes—not unlike Shakespeare.

Other artists have benefited from, yet feel constrained by, the term. Mildred Ruiz, cofounder of Universes, bridles: "What we do is theater. We come from Hip-hop and poetry and our cultures, but what we do is theater." Still other artists who define themselves by hip-hop culture critique the cavalier use of the term. Choreographer Kwikstep champions what he calls "classic hip-hop theatre," asserting, "People don't know the history, so what you get is a bad carbon copy of a carbon copy."

Still other artists, raised in the hip-hop era, acknowledge its influence, but they are concerned that hip-hop's hegemony produces formulaic work, rather than encouraging an expansive definition. The worry is that producers, presenters, and those who are external to the hip-hop culture will recognize its presence only if marked by the most obvious characteristics of the four elements, narrowing innovations, subtleties, and original points of departure.

Rather than grapple with these complexities, the theatre, many hip-hop artists feel, has tended to relegate hip-hop to audience-development/"audience of tomorrow" slots, to second-stage outreach and education slots, or to token "minority"/"multicultural"/"diversity"/"artist of color"/"kill-two-birds-with-one-stone-if-it's-a-woman-too" programming slots. The concern is that *hip-hop theatre* will become the latest, and even more restrictive, buzz word for the multicultural box, pitting artists against each other despite their differences in aesthetics and narratives.

In the effort to build tomorrow's arts audiences, conventional practice has been to approach the next generation of audience through education and outreach programs. At best, these invaluable programs inculcate an enduring appreciation of the arts—yet this approach can also be viewed as a type of missionary activity. Implicit is an assumption that young people must be brought to a higher culture, which necessitates the teaching of audience etiquette and proper behavior. It is assumed that our efforts to "bring them to art" are a positive alternative to what they would do if left to their own devices, such as passively watch TV, hang out at the mall, or join a gang.

About seven years ago, while running the New WORLD Theater of Amherst, Massachusetts, I initiated a reverse outreach effort. Instead of bringing youth to my theatre, I decided to leave the familiar comfort of a dark theatre to see where young adults, particularly of color, are passionately committed as audiences and artists of their own volition. This led me to b-boy and DJ events, poetry slams, fraternity and basketball step performances, and open mikes—in short, places where I was the oldest person in the room. But once I got over the age disparity, what I encountered was artistic virtuosity, experimentation, and large, dedicated audiences defined as community.

Have you had a substantive conversation with someone under twenty, not your son or daughter or their friend, in the past month? I raise this question because linking with the next generation is not fostered in this society and often takes us outside of our comfort zone. Fear is an unstated barrier to engaging with teens and young adults, especially those of color. I've been to countless conversations about "the next generation," both in arts and social activist circles, without anyone under twenty, or even thirty, in the room. Very few think to include these young people in the conversation or, more important, go to where parallel conversations may be happening in their world. The next generation is valued, but not on their terms. In recent Broadway seasons, *Def Poetry Jam,* Sarah Jones's *Bridge and Tunnel,* and Full Circle's *Soular Power'd* gave ample proof that a new audience and etiquette, one that is passionate and participatory, could exist in mainstream venues. Our theatres, however, appear at a loss as to how to consider, contextualize, and support this work.

Even as it challenges definition within the theatre, hip-hop provides new examples of changing models of arts organizing, partnerships, and networks. In numerous arts discussions, I've heard the question raised of the viability of arts organizations, as we know them. At an intergenerational meeting of producers in 2004, Clyde Valentin, producer for the Hip-Hop Theater Festival, shocked all of us older folks in the room when he spoke up after listening to people waxing nostalgically about the National Endowment for the Arts. "NEA, NRA, it wasn't there for us," he quipped. "We did it anyway." While the strengthening of the NEA continues to be a primary goal in the arts community, we forget there is a post-NEA generation; members also of the postparadise AIDS generation, they are acclimated to living in perilous times and working outside conventional boundaries. They are media savvy and entrepreneurial, and while community is core to their work, their generational approach to network organizing often transcends their lack of resources and real estate.

Please understand: I am not a hip-hop head. Born in the mid-1950s, I am not of the hip-hop generation even if I stretch the timeline. My first intimate encounter with hip-hop was that of every other suburban soccer mom in America; it was through those little labels on those pre-DVD, pre-CD cassette tapes that warned "Parental Advisory." It's the late '80s. I'm standing in an aisle of a music store at the local mall, realizing that everything on my son's holiday shopping list bears that label. I'm trying to figure out if what I'm buying is the equivalent of buying him a carton of cigarettes and a six pack of beer. It's a horrible feeling.

Fast-forward from a kid's holiday shopping list to a sixteen-year-old teenager's extracurricular activities. My son and his best friend have taken the initiative to go to the University of Massachusetts radio station and request DJ licenses from the college's community affairs department. They get their FCC training and become the first high school students to host a radio show. They call it *S and S's 5 Boroughs,* which I think is funny, because my son was born and raised in bucolic New England. I don't think he can name all five boroughs, much less find them on a subway map. But it's all about the music, my son tells me. And the music is hip-hop.

One day he tells me he's going to a station meeting because he wants to change the station's policy. I say, "Hold on a minute. You just got your show—don't you think it's a little early to start challenging the rules?" He replies, "The station won't accept collect calls during my freestyle section." I tell him I agree with the station policy; his friends shouldn't be calling from pay phones, they should go home and call—collect calls are expensive. Then he explains that the collect calls are coming from strangers, inmates at a nearby prison within the broadcast area. His show creates a radio cipher that offers a means for young men—many of them just a few years older than him—to have their voices and stories transcend their incarceration.

It is this changing terrain—the universal power that goes into and comes out of hip-hop, its ability to build across communities and make a huge impact, individually and collectively—that gives us the opportunity to pay attention in the arts to evolving aesthetics. Consider the speed of travel. My grandmother came to this country on a slow boat crossing from Japan. Compare that to the experience of a new South Asian immigrant—one moment in Delhi, the next in London, and now in Jackson Heights, Queens, where bhangra blends freely with hip-hop beats.

How is a high degree of media literacy shaping aesthetics? We tend to ignore popular media or view it negatively—after all, it is depressing as a theatre director to know that one episode of any mundane reality TV show is seen by more people than the combined audiences of a lifetime career. Yet I'm always shocked by the ability of young people to understand and interpret challenging nonlinear theatre works, until I watch TV with them and see how they simultaneously watch several different channels and are able to tell you exactly what is going on. While this certainly is a comment on a lack of content, it also points to a type of technology-influenced, sampling consciousness that embraces juxtaposition and fragmentation. A permeable art form, hip-hop reflects and reinterprets the world around it; it incorporates legacies and the next thing on the horizon—and in a subversion of conventional appropri-

ation creates a space for democratic participation: note the presence of Filipino DJs, German graffiti writers, South African rappers, and so forth.

It should be mentioned that in addition to the four discipline elements of hip-hop, the fifth element is considered to be knowledge. Hip-hop artists state that critics lack a genre exposure; their deficit of language—their lack of knowledge of history and terminology—further marginalizes innovative new work. They may like what they see without knowing breaking from b-boying; popping from locking; or toprocking from uprocking—the point is that even when hip-hop forms are noticed, they are not understood or critiqued from within the discipline vocabulary. This type of technical knowledge is as important as historical, cultural, and self-knowledge. At the end of the day, it is this fifth element, glaringly absent from the marketplace, that may provide the space where art can flourish.

Roberta Uno was the founding artistic director of the New WORLD Theater and the Martin Luther King Jr./Cesar Chávez/Rosa Parks Visiting Professor at the University of Michigan at Ann Arbor. She is the editor of *The Color of Theater: Race, Culture, and Contemporary Performance* and *Unbroken Thread: An Anthology of Plays by Asian American Women*, among others. Her directing credits include Pearl Cleage's *Flyin' West* and *the bodies between us* by thuy lee, and her dramaturgy credits include Marc Bamuthi Joseph's *Word Becomes Flesh* and *Scourge*. Roberta is the Program Officer for Arts and Culture at the Ford Foundation in New York City.

31

Put Your Camera
Where My Eyes Can See

Hip-Hop Video, Film, and Documentary

A Roundtable Curated by Eric K. Arnold, with
Rachel Raimist, Kevin Epps, and Michael Wanguhu

Addressing the aesthetics of the visual medium in hip-hop should be easy, right? Yet in actuality, it's anything but. There's certainly no shortage of source material to examine, from mainstream rap videos to urban crime dramas to neoblaxploitation comedies to indie documentaries to video games, all of which have influenced our cultural perception of hip-hop in one way or another. However, that perception has been affected by the mainstream commodification of the genre and the involvement of major record labels and major Hollywood studios, whose economic agendas often have little, if anything, to do with the cultural ideals hip-hop was founded on.

At times, it's a stretch to incorporate the ideology of "keeping it real" into a mainstream aesthetic, the 50 Cent biopic *Get Rich or Die Trying*, and *Breakin' 2: Electric Boogaloo* symbolizing just two examples of culturally inauthentic results. In fact, it could be said that for all the visceral thrust, box-office validation, and occasional poignancy of *8 Mile*, *Boyz N the Hood*, *Hustle & Flow*, or even *Superfly* or *Scarface*, Hollywood has yet to make a completely culturally authentic hip-hop film. As hip-hop journalist and screenwriter Cheo Hodan Coker recently pointed out to me, there hasn't been a screen treatment based on Ice Cube's most powerful works, *Death Certificate* or *Amerikkka's Most Wanted*; instead, the onetime "nigga you love to hate" has been transformed into a comic foil (in the *Friday* movies), portrayed an implausible ac-

tion hero (in the *XXX* sequel), or played third banana to a thirty-foot-long fake snake and J-Lo's *culo* (in *Anaconda*).

Hollywood hasn't always been the most progressive when it comes to addressing gender, race, and class issues, but it *has* succeeded in creating a formulaic template that predictably exploits stereotypes of African American and urban-identified culture. Yet at the same time, a revolutionary movement has been happening under the mainstream radar, spurred on by both the trickle-down effect of technology and a desire to tell culturally relevant hip-hop stories from a personal perspective. Indie filmmakers have continually countered hip-hop clichés with works that either transcend stereotypical perceptions altogether, such as Rachel Raimist's *Nobody Knows My Name*, which examines the role of women in hip-hop, or Michael Wanguhu's *Hip Hop Colony*, which takes an in-depth look at new cultural frontiers in Kenya, or reveal a depth not immediately apparent on a surface level, like Kevin Epps's *Straight Outta Hunters Point*, which not only illuminated the place from which gangsta rap comes from but also showed how violent Black-on-Black crime and the cycle of drugs and incarceration are linked to socioeconomic issues and racism of both the environmental and the institutional variety.

Who better, then, to try to arrive at a working definition of the visual aesthetics of hip-hop, and how it relates to a larger worldview, than these cutting-edge documentarians who are creating their own representations of urban culture outside of an overly commercialized context? These visionaries have remained true to the spirit of innovation that, some believe, is still as important to hip-hop culture as the maxim "Cash rules everything around me."

THE PANELISTS

Born to a Puerto Rican mother and a Jewish father, and raised in upstate New York, **Rachel Raimist** began making videos at age fourteen. Since emerging as a powerful, insightful voice of hip-hop feminism with the award-winning documentary *Nobody Knows My Name* in 1999, she's also established herself as a progressive force in the fields of academe and literature, teaching courses at the University of Minnesota, appearing on numerous conferences and panels, and coediting the forthcoming anthology, *HomeGirls Make Some Noise! A Hip-Hop Feminist Studies Reader*. She describes herself as a "mother, filmmaker, hip-hop feminist, activist, scholar, emerging poet, and beginning blogger."

Michael Wanguhu's 2005 documentary *Hip Hop Colony*, which won numerous awards (including Best Feature Documentary at the 2005 H20 Festival and Best Urban Documentary at the 2005 Houston Black Film Festival, in

addition to being an Official Selection at festivals in Cape Town, London, Rio de Janeiro, and Amsterdam), elevated the Kenya native, currently a Bay Area resident, to the upper echelon of promising young African film directors. The film's often-revelatory depictions of indigenous African urban youth adopting hip-hop as their own cultural movement earned it favorable comparisons to *Wild Style* (Charlie Ahearn, 1982) while suggesting hip-hop globalism is no mere fad, but an evolutionary process.

Kevin Epps is often credited with launching the ghetto vérité movement—a raw, gritty, D.I.Y. approach to urban filmmaking one notch below guerrilla and two steps past visionary—with 2001's *Straight Outta Hunters Point*. Since then, he's taken the Hip-Hop Film Festival (which he cofounded) to various colleges and venues across the country; completed his second film, *Rap Dreams*; and is currently finishing up *Black Rock*, a look at the African American experience on Alcatraz. In addition to being a director, Kevin is an activist, community advocate, and outspoken commentator who has appeared at San Francisco's Commonwealth Club six times, quite possibly a record for any current or former Hunters Point resident.

ERIC: What are the defining aesthetic components of hip-hop film? What constitutes a hip-hop film, aesthetically?

RACHEL: That's actually a really difficult question. One of the main defining things about hip-hop is it's a huge cultural sphere. And I think there's certain qualities of stuff that have been extrapolated from hip-hop and mapped out to more commercial venues. When you see a commercial for a product or a fashion show that's in a film medium, they'll use a slanted camera angle, or real fast editing, or fake graffiti-style lettering that gets into the hip-hop kind of aesthetic or suggests an authentic street feel. So really, the hip-hop aesthetic encompasses anything from a no-budget, gritty, hip-hop concept-driven piece to a multimillion-dollar music video where everything's shiny and steady-cammed, but it features some artist or some hip-hop-inspired fashion.

What makes something hip-hop and makes something not hip-hop? When you map out the visuals or the aesthetic, there are things that visually are within hip-hop that come from artists and photographers long before hip-hop was called hip-hop. I think now there's a surface aesthetic, things like graffiti-style letters that gets equated with, "Oh yeah, that's hip-hop, that's urban." There's a really changing aesthetic too. I was talking to someone about videos from the early '90s with the low-angle, in-the-street, everybody rapping into the camera, kind of beat-down-style, everybody stomps the camera

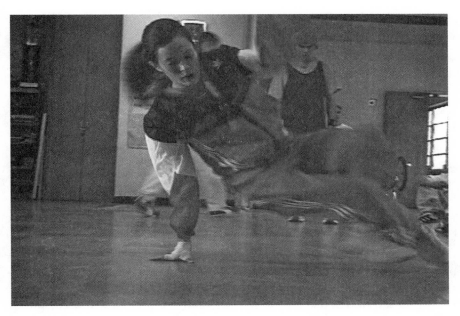

Asia One in Rachel Raimist's *Nobody Knows My Name*. Used by permission of the artist.

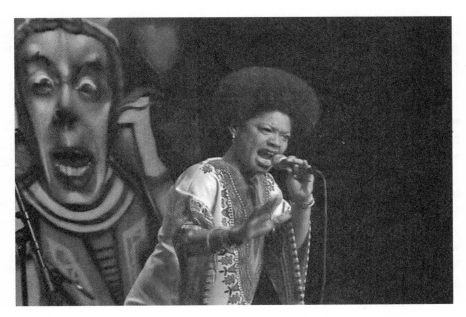

Medusa in Rachel Raimist's *Nobody Knows My Name*. Used by permission of the artist.

with their boots, and there's kind of a revisiting of that with all the Southern videos. Low-angle, with people on the porch, cars driving by. For me, it becomes this kind of nostalgic aesthetic. It used to be set in New York, but now it's set in Atlanta.

When I was young and aspiring, I wanted to direct videos. I thought, "Oh, it's an amazing genre with all this potential, this creative, visionary potential. Here's a short film, the budgets are not that big, you don't have to spend years of your life telling one story." Then, as I got closer, I realized videos are nothing more than a commercial for an album, for an artist, and for a particular sort of ideology.

ERIC: Unfortunately, that's true. Every now and then, you'll have a video like Quasimoto's *C'mon Feet* (Tomas Apodeca, 2001), which is really a short film—it's been entered in festivals completely outside of a hip-hop context—or Madvillain's *All Caps* (James Reitano, 2004) which has this really innovative comic-book treatment. Even back in the day, you can look at Herbie Hancock's *Rockit* (Godley & Creme, 1983), which was all stop-motion animation, depicting inanimate objects like furniture talking. Not only was it probably the first hip-hop video to get significant airtime, but it's one of the freshest things that's ever been played on MTV.

But as soon as you had *Yo! MTV Raps* and BET's *Rap City: Tha Bassment*, programs that that were driven almost exclusively by ratings and ad dollars, art kind of got pushed aside in favor of commerce. Every now and then, you'll see something that's highly conceptualized, like the whole witch-doctor theme in Busta Rhymes's *Put Your Hands Where My Eyes Can See* (Hype Williams, 1997) or the Beastie Boys' *Sabotage* (Spike Jonez, 1994) which pays homage to '60s spy movies and '70s Quinn Martin TV shows, or something that just grabs you viscerally, like the real stylized black-and-white shots of the rappers, jump-cutting to turf dancers shaking their dreads, jump-cutting to motorcycles doing wheelies in E–40's *Tell Me When to Go* (Bernard Gourley, 2006).

But it's hard to complain too much about the content of rap videos when you don't even see too many of them on MTV these days—they'd rather you watch something like *Pimp My Ride,* which has this whole street-culture/hip-hop aesthetic to it, but it's really about pushing mass consumerism on people as a form of escapism from socioeconomic reality.

RACHEL: I think if you look at the last twenty years of video, there's definitely been trends, dealing with ethnicity and race and class. You see the kind of

LL Cool J *Jingling Baby*–type (1989) ghetto girls in a lot of videos of that time. And then you have the *Rumpshaker* videos (1989), which are really setting up the Hype Williams era, where, really, he's sort of using women's bodies as kind of the transition between shots. Or a shot sequence where a girl is walking through a bar, and you only see her from behind. And pretty much after he did that, that became commonplace. And after Hype sort of really pushing the wide angle, he really started showing a lot of shots with no head. Nowadays, directors say that networks won't air videos of women with no heads, but I remember when R. Kelly and Keith Murray had, I think the video is called *Home Alone* (1998). I used to use film from that in some of my classes, and it was frame-by-frame of a girl cut off, right above her butt, walking into a shot.

ERIC: Limiting them to just a body or basically contextualizing women to where the only way they can possibly be viewed is as a sex object, right?

RACHEL: Exactly. You get to see a woman's face, you might be lucky and get to look into her eyes, but for the most part, you have the classic porn pose used in advertising, where her eyes are always warm and inviting, her lips are slightly parted, all the makeup to bring attention to her sexuality, that kind of a thing.

ERIC: If you go back, before the Hype Williams era, to the early days of MTV, before you even had any rap videos, and you look at the *Thriller* video . . .

RACHEL: . . . The woman had a character. You followed her, in the plot, in the shot, in what was happening. But those videos are kind of gone. Even videos that are on the R&B side of things, like I just saw that Ne-Yo video, with the parade of girls. The songs are about women, and you get shots of their faces, but it's always in this objectified pose, where they're the object of our gaze. There not really actively engaged within the sequence of the scene. I would say the artist owns the frame, and the women are just living, moving, breathing props.

ERIC: Let's talk about the relationship between gender and race in film. You have films out there like *White Chicks* (2004), *Undercover Brother* (2002), *Black & White* (1999). What's your perspective on how these movies address gender roles as they apply to race?

RACHEL: The desire is not to really tell any kind of new story, but just to rely on the stereotypes that we already have. The roles get definitely mapped with race and this ranking of skin tones. The lighter women, like the J-Lo kind of girl who counts as a brown girl because people know she's Puerto Rican, but she can pass as more European, those are the objects of affection. The larger, dark girls, the Queen Latifahs, are definitely the best friend or sidekick.

The thing about hip-hop, in a cultural sense, it's supposed to be about innovation. It's supposed to be about you're in a circle, one b-boy goes in, does a move, and it's like, "Wow, where did that come from?" The next b-boy can't do that same move. You have to go and take what he did and build on it. Flip it. Most of these Hollywood hip-hop-influenced films have done absolutely nothing to add to hip-hop. Instead, they just base themselves upon the kind of mainstream stereotypes about what hip-hop is.

So you then get these kinds of caricatures of women in hip-hop. Like *Boyz N the Hood*, for instance. If you look at the women characters in that film, you have the kind of archetypal or stereotypical characters for women. You have the mother who's trying to be a professional, but doesn't know how to raise her son. Then you have the crack-baby mama who can't take care of her babies. Then you have the baby-mama girlfriend—most of the time you saw her snapping her gum or her neck, just waiting for him to come home. Then you had the innocent, virginal girl next door, who will get out of the hood, who is worthy of marriage. You hope she has some kind of future beyond being somebody's baby mama or a mom who can't take care of her kids. You see those kind of characters in every movie, in *Jason's Lyric* and all those kind of movies, from the '90s on up.

ERIC: When you get into ideas of cultural authenticity in hip-hop and you start talking about the historical role of women, their participation has always seemed sort of more tomboyish, and a bit counter to this rigidly defined gender paradigm. If you look at the women graffiti writers and the b-girls, they were doing the same things the guys did, like Lady Pink in *Wild Style* (1982). She was the main character's object of affection, but she was also on a more equal footing, in that she participated in the creation of art. She wasn't just an observer; she was painting subways and walls.

RACHEL: As a graf girl, what are you gonna do? Wear a skirt and go jump off bridges and trains? You're hiding from the police at night in the dark, you gotta be in a hoodie. You gotta have kicks where you can run, if someone's chasing you. If you went out there with nails, you couldn't have can control.

As a b-girl, how are you gonna spin on your head, if you're wearing a skirt? People feminized the b-boy gear, with colors or the way you did your hair, those kinds of things, but the art form necessitated that.

ERIC: The point I was about to make is these are historical archetypes and they're culturally authentic, but we haven't really seen that in a major Hollywood film.

RACHEL: There's been attempts. In the '90s, Leslie Harris's *Just Another Girl on the I.R.T.* (1992), which looked at the Brooklyn girl, it was like her struggles with her man, she gets pregnant. . . . She directly addresses the camera, and you get the story through her point of view, and she's like a New York hip-hop girl. There were a couple other lower-budget indie films . . .

KEVIN: . . . *Anne B. Real?* (Lisa France, 2002)

RACHEL: The woman who made that film tried to get real women in the community who could rap. Also, the Darnell Martin movie about the Puerto Rican family with Lauren Velez, *I Like It Like That.* That was kind of more of a Latin hip-hop, Bronx story. She still goes through some sexual harassment or different things at the job, but here's a character that's not the thinnest girl with the biggest boobs. The studio was pushing it as the first major Hollywood film directed by a Black woman, but the same studio released *Pulp Fiction.* Where are you gonna put your money? Quentin Tarantino? Or this half-Black woman, whose film is about Puerto Rican families in the Bronx? So there have been attempts to tell the b-girl inspired (story), these stronger women-driven plots, but they don't get the money behind them, they don't get the promotion behind them. And when there's not major gross in process, it doesn't happen. Hollywood is just about making profits.

ERIC: Kevin, I wanted to ask you to comment on something that Rachel said earlier, which is, Hollywood hip-hop films have done nothing to add to hip-hop culture. Would you agree with that?

KEVIN: Me right now, and the movement we're on, it could be looked at as it's our responsibility, now that we're capable with the technology we have, to take back ownership of the culture by creating our own films. Telling our stories. In one way, it's totally all about money, and that's just the way the game is. But now that this technology and the movement have kind of emerged,

and given rise to another voice in so many ways, Hollywood is, like, falling! They gotta conform to the masses, because what we're doing is bigger than Hollywood. Hollywood's not bigger than the world.

Everybody has a spirit of independence, and everyone has something within them that will empower them to tell their stories. It's going back to the community. Despite what we see with the mainstream media, in reality, in actuality, it's a big facade. People are resorting to other sources for their sources of information in all aspects of media. And so, hip-hop is transforming itself.

It's like Chuck D said—just to throw him in, 'cause I'm kinda involved with what he's doing, podcasting—it's about empowerment. People getting content on their mobile phones. That's something that's happening right now that's about to be real big, with some of the other programs that's in place and how they're gonna bring it out. I'm looking at Chuck D, he's the heart of hip-hop. He had a lot of issues with the industry in terms of conforming. He was one of the brothers that didn't conform, and they did a lot of things to assassinate his character, and they really took him through a whole thing. But I look at some of the strides that a brother like that is making, taking it upon himself, and not, like, sell out. That keeps me going. And I'm like, you know what? The struggle continues; that's just the way it is. We're gonna take control of our land, because that's what hip-hop is, 'cause it is property. We gotta fight for it.

ERIC: Michael, would you also agree that Hollywood hip-hop films have a very limited range of expression?

MICHAEL: Yeah, I do. We don't have enough representation—like the unions, they don't really cater for us, and when I say that, I mean minorities and stuff, especially Africans, and African writers. That's my take. I would just add on to that that I just came back from Kenya, and some of the things we were discussing there was like foreigners who come into Kenya or Africa, they don't really care about the local talent too. Because of the same reason, we don't have people to stand for us or to stand for these people and to fight for them.

ERIC: In *Hip Hop Colony*, you feature a female MC very prominently.

MICHAEL: Nazizi. That's her name. That was 2003, and now, it's crazy. Actually, a lot of females are coming out right now. So it's changing in Kenya. The young people have already deleted all that stuff, but you can still see it in the older generation. If you look at guys that are in their twenties, and you look at

guys who are in their late thirties and early forties, there's a big difference. There's a lot of females who are holding it down right now in a lot of places in that whole industry in Kenya. That whole new music, like the hip-hop movement. As far as TV shows, things are really changing right now. They're getting a voice. It's a new platform for them, and they're really taking advantage of it now.

ERIC: So is hip-hop in Kenya changing the cultural dynamic there? Are we beginning to see progressive elements coming out of that?

MICHAEL: Yes, it's beginning to change. A lot. Me and my partner, we were joking around and we were saying that hip-hop is the new Pan-Africanism. It's crossing borders and doing all that stuff. The radio shows, the hosts and all of that, the majority of them are women. And they are breaking it down completely now. They are running things. With this new hip-hop thing, they can get away with so many things the older generation was not allowed to do.

ERIC: In terms of the aesthetics of hip-hop cultural expression in the visual medium, you can really draw a line right down the middle between mainstream, major studio productions, and independent D.I.Y.-type films, especially documentaries. You all have had success making documentaries, so what's your take on the role of documentary in terms of actually presenting this culture in a real way?

RACHEL: When you make a film about a subject matter that you care about, that you're invested in, that you're somehow aligned as an insider in your perspective, and have access and you don't need a translator to say, "Wait, what did she just say? What was that about, huh? I just missed that." Which often happens. So it's kind of like, what is driving the film? Is it a piece of passion, or made for profit? Is it something where you're trying to add something to the conversation about hip-hop in that place, with these players and this community? I think documentary has been real successful at doing that. There's a slew of filmmakers and distribution companies that have taken notice to that. Thousands of people have shown up all across the country to see these films, because people are hungry for alternative content. Something that feels more authentic, so they can say, "Oh, I feel that; that's my story."

MICHAEL: Filmmakers from Africa don't get access to some of these festivals out here, they're not known in Hollywood, and if they do a film, because

they're not in the system here in the States, they don't get as much exposure. So to go there and do a story from that perspective was, in a way, to bring that here. Taking advantage of what we'd seen here and understanding the industry, how it worked, so at least we knew how to expose our culture, so people can see it.

Also, telling the story from that perspective, I believe Rachel said, we have to tell our stories. Every time in Africa, everything that people see abroad about Africa, someone from Hollywood goes down and does that story. We had a big discussion in Kenya about *The Constant Gardener*. That was the last film that was done in Kenya, and I believe somebody actually won an Oscar for that film. The filmmakers, they're talking about Kenya, how beautiful it is, and how much they wanted to make the film there. We all know that's a front. If you watch it, it's like, it's so funny, it's so fake. They had to justify that, but in reality, they didn't even tell the Kenyan story. They just did what Hollywood does best. They didn't represent Kenya in its true form. Yes, there are the problems and all of that, but when they had a chance to show a metropolitan city that's inviting to investors, they did not do it. In the film, there's a scene where this character is going to work, he's riding his bike downtown to go to work, he lives in the slums. Let me tell you, Kenyans were excited they were going to see downtown Nairobi on a big screen. But they take the back routes to where this guy works; all you see is the doors swinging open to the classy, five-star hotel where this guy works, foreign elite people sipping on wine and stuff. That was sad. That was an opportunity to actually show a different side of Africa—you know, modernization. But unfortunately, they didn't do it. If we don't have people to represent that, then we'll just keep failing. So, documentaries are the quickest and easiest way to communicate with people. So by us doing a film, we go in and show people what's really happening there. To really get intimate with the subject, so the subject actually connects with the audience. When you're doing a film, it's all scripted and there are actors and stuff. But when you're doing a documentary, you reach people a certain way that another film cannot do. At the end of the day, you have to tell your story, and the best way to tell the story is to do a documentary.

RACHEL: With a documentary, we're still filmmakers, it's still constructed, you have to have a certain point of view, it's still a narrative that we create with footage that we've captured some way. It's still a reflection, but it reads to an audience as real and authentic, and makes an easy access for an audience into a subject matter, a kind of "Wow, this is what it's really like" kind of vision.

Nonini from Calif Records in Michael Wanguhu's *Hip-Hop Colony*. Used by permission of the artist.

Doobeez, a.k.a. **Abbas**, from the group K-South, in Michael Wanguhu's *Hip-Hop Colony*. Used by permission of the artist.

318 · TOTAL CHAOS

To kind of connect a point that Michael was making to our conversation about gender, I think that nation and culture are another facet of identity that gets mapped with all kinds of stereotypes. When I think about portrayals of Africa or Latin America, or any sort of quote-unquote cultural place, what we see in a video has become exoticized. I think of Snoop Dogg and Pharrell going to Brazil. So they take the look of the video girls, and you map it out to where they're exotic and Brazilian, but they're still props. Ludacris just had a video set in Africa, and again the women are just background props. Then you have the Outkast video where women are strutting, kind of exoticized, making you see what you think of when you see Africa. You see the women moving through the grass like giraffes, with animal prints. So I think with documentary, like Michael's film, or any of these films that are coming out from non-U.S. places, you get to see culture from people who are creating the culture—rappers, dancers, artists—from within.

ERIC: Then you have films that aren't documentaries but kind of play like pseudodocumentaries, in a sense. Like *The Harder They Come* (Perry Henzell, 1973) is a film like that, *Wild Style* is a film like that, *City of God* (Fernando Mereilles, 2002) is a film like that. *Tsotsi* (Gavin Hood, 2006) is another film like that, where they have a lot of people in the film from the actual culture, and that's why you have some of that same level of authenticity that you would normally only find in a documentary. Do you folks agree with that?

RACHEL: To a point. I think the way location is used. The points that Michael was making about how the way in which a city is revealed. Like in *City of God*, those elements add to the fact that some of the kids were street kids. I can think of bad examples of that, something like *Mi Vida Loca* (1993), where Allison Anders decides she's gonna make this *chola, Girls N Tha Hood* type of film, and the real *cholas* are sitting in the background of every shot to try to create that sense of real place.

ERIC: The other film I wanted to mention was *La Haine* (Matthieu Kassovitz, 1995), which is another film along those same lines. *La Haine* also has a great soundtrack of French rap—that was the first time I really realized the impact and scope of global hip-hop, when I saw the film and heard that soundtrack. Ten–twelve years after the fact, it became a situation of life imitating art, because you had all these riots in Paris over issues of race, class, and police brutality, which is what the film deals with.

KEVIN: That was a major film, the characters, it was a powerful drama. But it kind of represented some authenticity to me, from what I understand, talking to some of these brothers from France. They said, you know, it's a lot more unification over there as far as like a collective of people doing hip-hop. But as independent filmmakers, we still have a long way to go as far as getting in the game. People are still drawn to BET and stuff; the images are so powerful, it's hard to shake. We got a lot of work to do, because those brothers sold out and built a billion-dollar company. I'm like, wow, what do we do? The love of what we have has value, I'm sure of that. But that's not the driving passion behind what we do. I'm trying to think about, when you get to this crossroads, with so many people expecting you to take the money, how do you differentiate or decide what's right? It's different once you start making money off of what you create, know what I mean?

RACHEL: As a filmmaker, you have to stand on what you say your principles are. I mean, I was offered a pretty substantial DVD deal that people have been saying for years I was crazy to turn down. I got to the point where I'm negotiating something like the fifth or sixth version of this contract. And I went to sign with this company that's putting a tremendous amount into what they were calling their hip-hop/urban film division. And I have this small, low-budget, underproduced film where I was kind of anti the "hip-hop aesthetic." No graffiti letters, no flashy editing, just these characters telling their stories. And so the guy's like, "Yeah, I think it's really important that we have these kinds of stories." And then he kind of laughed and said, "But let's get real—your film isn't the moneymaker. I'm just signing this because I think it's important. But you know the money I'm paying you with is coming from my porno division." I put the pen down, I called him some not nice things, and I was like, "Fuck this. I'm out." I didn't take this deal because I've been a person who traveled around the country talking to other girls in hip-hop like me, and I've been like, "This is who I am; this is what I stand for," and it didn't feel right. I needed the money; my kids need to eat. Have I matched that money? Not in one lump sum, but I want to look at myself in the mirror and say this is who I am, and this is what I've stood for in hip-hop.

Eric K. Arnold began writing about hip-hop while an undergrad at UC–Santa Cruz, during the height of the Afrocentric age, after realizing there was a connection between the then new urban youth culture and what he was learning about in African history courses. After serving as

editorial director of the now defunct *4080 Magazine*, he went on to be a columnist for *The Source*, *Murder Dog*, *Africana.com*, and the *East Bay Express* and has written for many publications, including *Vibe*, the *San Francisco Bay Guardian*, and *XLR8R*. He has written extensively about hip-hop film and documentaries. Eric is currently working on his much anticipated first book, on the history of Bay-area hip-hop and other related urban phenomena.

32

Codes and the B-Boy's Stigmata

An Interview with DOZE

Jeff Chang

Jeffrey "DOZE" Green has been a hip-hop polymath. A second-generation b-boy who came up on the streets of the Upper West Side, he learned how to b-boy from family and friends in the North Bronx during the mid-'70s. By the time he reached his teens at the start of the '80s, the dance had gone out of style, and he and his friend Ken "Ken Swift" Gabbert were among the last b-boys left in New York City. They linked up with other Uptown kids with a strong nostalgia for the old Bronx style, and together they helped to revive interest in b-boying as part of the Rock Steady Crew.

At the same time, Green was attending the High School of Art and Design, where he fell in with a coterie of some of the most accomplished graffiti writers of the day. On the trains, he wrote DOZE and other names as a member of TC5. When hip-hop crossed over to international audiences in the early '80s through movies like *Wild Style* and *Style Wars*, he became an icon of the emerging art form—an uprocking, turntable-spinning aerosol artist captured in full b-boy stance, complete with a defiantly upturned chin and bottom lip.

At the beginning of the '90s, he began moving deeper into the fine arts, particularly painting. Graffiti writers, painters, and graphic designers now routinely cite DOZE as one of the most influential artists of the past two decades. He has created distinctive characters that combine ghostly presence—they are often eyeless, suggesting a third sight—with hard, armored, urban-ready exteriors. His most enduring paintings place these mysterious figures—often tropes for his deeper interests in myth, religion, economic and political globalization, grassroots resistance, the occult, Afrodiasporic traces,

and the unknowable—into floating color-fields of stylized signifiers (tags, names, numbers, markings, conspiracy theories). These works seem especially to reverse the process of creating a graf masterpiece, a poem, or a loop of music; they unravel and reveal the meanings contained, compressed, and sometimes obscured by hip-hop's method. Like hip-hop itself, the paintings demand commitment and participation from their viewers.

As one of the most compelling artists to emerge from the old school, DOZE embodies for many the progressive nature of the hip-hop movement's founding principles. But his views on the hip-hop arts movement and the aesthetics of hip-hop are often surprising.

JEFF: Is the term *hip-hop* thrown around too much with respect to art these days?

DOZE: Of course. It's the way to put a price tag on it. It's a way to commodify and make money off it. Stigmata. The b-boys' stigmata.

JEFF: Does it help you now in your career to have that historic attachment to hip-hop?

DOZE: I don't really care either way. Well, I do kinda care now because people don't tend to take you too seriously when you attach hip-hop to it. But, you know, hip-hop is nonexistent for me. It hasn't existed in its truest form for years.

I've done a lot of things in my life that I haven't really attached to other things. I used to skate—I even skated in '74—I was down in the original Zoo York, but I don't call myself a skater anymore 'cause I don't skate. I'm still a b-boy. I'll always be a b-boy, 'cause it's more of a spirit than a label or a clothing line. To me, being a b-boy means something different than being a hip-hop guy, you know?

JEFF: What's the difference to you?

DOZE: B-boy is more of an ethic, it's a code, it's a way you live your life. To be a true b-boy you would have had to have done at least two of the elements, and I've done like three of them. A b-boy is a full-pledge, full-circumference kind of thing. But I'm a painter. I've always been a painter first, you know. I like opera, but I'm not an opera singer.

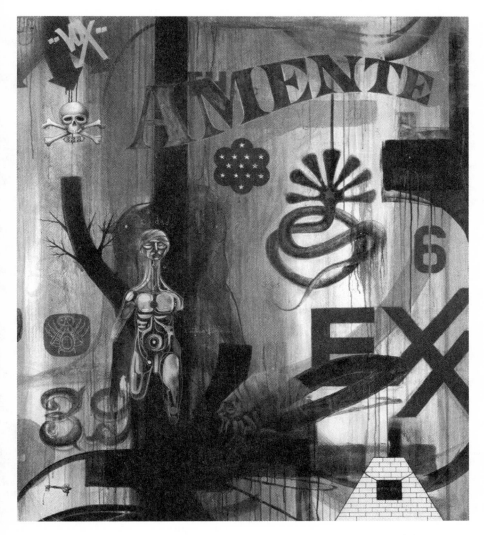

Amente. Mixed media on canvas, 2004. 65.5 x 57 inches. Used by permission of the artist.

I'm lucky enough to be a part of something that changed the face of music in the twentieth century, even culture, fashion, and attitude and speak and all those things. But I don't really like to dwell on something that I've done a long time ago. I'm forty years old. I'll still dance, I'll still rock when the music's right and I feel it in my bones, but it's like something that I don't practice every day. What I do practice on is expanding my knowledge of things around me in the world and symbols and symbolism and different genres of art.

Everything is not so black and white, and everything is not labeled all the time because things are in different shades of gray. And there's a spectrum of things that are nondefinable, the really obscure, the really undefinable. So I kinda meander right now in those shadows with these paintings.

JEFF: Is the problem for you that hip-hop has joined the mainstream, and the mainstream is what you've always been against?

DOZE: True hip-hop has nothing to do with the mainstream. Hip-hop is underground. Hip-hop is the voice of a people. And it was also there to make one feel good, better about oneself, but not to the extreme of being really narcissistic and not caring about other people. It was always about community. And that is definitely not a factor in what the world of hip-hop plays in today. There's no community. There's cliques and scenes, but nobody's really looking out for nobody.

That goes into the art world, too. Everyone's on their own. Everybody's wanting to be an art star. Somebody just wants to show themselves getting their dicks sucked by their girlfriends, or take really nasty photographs of people puking and shit. That's funny, ha-ha, you got a chuckle, but yo, the five-minute-chuckle artist is over. What kind of value and what does that really carry to the next century? It's not about funny all the time, and it's not about taking oneself too fucking serious either, but there's a middle ground of information, dissemination of information, and aesthetics and beauty and human experience.

JEFF: You've called your art "fusionism." Why?

DOZE: Fusionism is an excuse. It's a word. I don't even bring it up anymore, because it is what everybody's doing anyway right now. Everybody's fusing because it's just natural.

JEFF: Give me an example of what you've been trying to do in your work.

DOZE: As far as styles go, I paint anything from semi-realist state to the very abstract, to drawing from cubism or surrealism, dreams. Of course, there are always the graffiti letter forms and hip-hop influences and street-life stuff, and then I'll take classic themes and use them in a new form. I'll take the Titans, the biblical stories, and apply them to like, twenty-first-century b-boys. I'll take Mercury—Mercury will be like an MC, will represent the traveler and

the purveyor of information to humanity. The woman, the Muse, represented as Isis or Yemaya—she could be a b-girl with chunk jewelry. It's the same stories that have been with humanity for eons—stories of war, stories of the gods, of the creators, of Enoch, Moses, or Osiris or Set, even Yoruba, the Santos. They will be veiled again in b-boy form, because, after all, in time things always get veiled and changed around anyway. In the Yoruba tradition, all the Santos were veiled as saints in the Catholic tradition. Seeing that, knowing that, why not just take it to the next level?

We're in an age where symbols are everywhere around us, and we don't really understand where they came from; we just walk by them every day. They're on buildings and banks and trains and logos and gasoline stations, and they're really ancient symbols that people have just kinda monogrammed into new icons. People just do not [ask] where does this come from? What is the root of this? What does that happen to come from? There's so much out there that people don't see, that exists, and I like to bring it to light again.

JEFF: What do you think of some of the hip-hop genres that aren't yet as commercialized, say, hip-hop theatre?

DOZE: I like what it is right now. It's underground; no one's making a million dollars off it. It's from the heart, it's unadulterated street talk, it's not molested yet, and I don't see how it can be. You can't market that.

Struggle breeds creativity. That's why a lot of good work is coming out of South America, good work is coming out of Africa, good work is even coming out of the Middle East, 'cause there's a lot of struggle, and what struggle brings—protest and resistance—also brings creativity to the game. Cuba—that's some sick shit, there's some amazing music coming out. It's a reflection of what's going on in *their* world. We've got it good in America, so maybe that's why hip-hop is so fucked up, 'cause we got it so *good* now.

JEFF: I did not expect you to say you did not want your stuff to be called hip-hop art. Does that have to do with the fact that you're older now, and the label "hip-hop" might take you backward when you're trying to progress?

DOZE: Not really. Let me clear my throat! It's like, when you go through a portal, and the actual room that it exists in, and you walk through it to the next door, you look back, and you nod your head, you look forward, and you go onto the next door, and the next room, and the next room, and you walk. That's moving forward and not looking back or letting it become a crutch.

Yes, hip-hop is a part of my life. I become more full and more powerful going forward, not staying still and just reaping the benefits of something that I did twenty-five years ago. I know a lot of b-boys, they just sit around and do that all day. They still just b-boy, or they still just do walls, still just do trains, 'cause they're purists. But then what happens when you do that? You cut yourself off from so many things that are unseen, and that keeps you from creating and re-creating new thought because you're stuck in this hip-hop limbo. You don't want to be in that place; it gets boring. You die a thousand deaths.

JEFF: Is hip-hop itself inherently limiting?

DOZE: No! Not at all. What I'm saying is that I went through what my idea of hip-hop is, passed the torch to a number of kids that have lived their experiences through hip-hop, and in turn hopefully will pass the torch. See, that's how it keeps going; that's life. For me, my idea of hip-hop is a certain thing.

JEFF: What is your idea of it?

DOZE: It's always been communication to me, and it's always been a more benevolent society, a more helping, more community-based kinda thing, where everybody sticks together and looks out for each other and talks about new ideas and then puts them out there.

JEFF: How important is battling in the hip-hop aesthetic?

DOZE: That is very important, 'cause that keeps the youths on their toes and creates room for expression. Graffiti artists can say, "I burned you"—you know, "I outdid you." But that's up for interpretation because I've seen many battles. Take a classic one: SLICK and HEX. Some people like HEX's shit, some people like SLICK's shit, and it was just—you know, who burned who? That was the first debate. I think that comes to politics then.

Then you have crew politics—like, how many people like this crew more? Which one is more popular? People usually go with the crew that's more popular or has the most power. In that way, b-boy battling is like MC battling—words and movement, dance movement, that's always dictated by the crowd. When we battled Dynamic Rockers in their neighborhood, with all their peoples, their screams came out louder than our screams. The Lincoln Center—we won, 'cause, one, it was in Manhattan. The Bronx and everybody was down with Zulu. That's what I'm saying. It's up for interpretation, I guess.

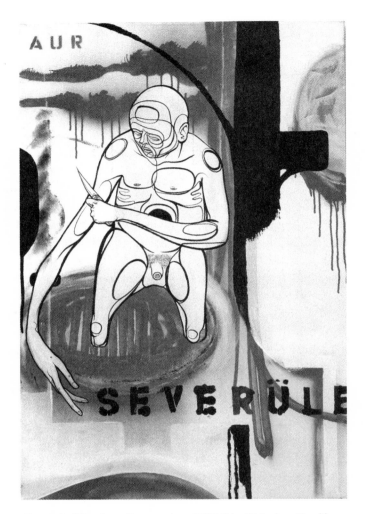

Severule. Mixed media on canvas, 2004. 24 x 30 inches. Used by permission of the artist.

JEFF: But the competition is important to driving the ideas forward, the art forward.

DOZE: When you get in the purest form of hip-hop is kids coming up and nobody's heard of any of them. And *then* they rip it, and people go, "Awwghh!" That's the purest thing about battling for me. But it still relates to community, it still relates to, like, yo, everybody's a part of it.

JEFF: What else defines hip-hip for you?

DOZE: I've been to parties where I've left my body, just been that elated by everything I see around me. But that was back in the day when people was just getting down, DJs were just scratching, kids were doing things on the walls, fine-ass girls dancing, and just, like, it was like everybody had their own little thing but it was all together. It was just like an eye orgy, an eye frenzy, of color and music, and I mean, there was this thing to take pride in. It wasn't like, yo, everybody's postin' up with a fucking Stoli or Cosmopolitan in the corner. It's like kids getting down on the ground, kids not even dressed that tight, kids are just there for the music and the art and not a fashion show.

JEFF: Is that a vibe or energy that can translate into other fields? In other words, can that feeling translate into someone saying I'm a "hip-hop actor," a "hip-hop designer," a "hip-hop senator"?

DOZE: If you wanna call yourself that, call yourself that. That's not me. I mean, either you're a b-boy or not. Simple thing. That's it. You used to say "Hip hop, you don't stop." It really was never called "hip-hop" until it went downtown and some fool heard "Hip hop you don't stop" and they said, oh, that's a name. That's where I stand on that. It's more of a feeling, not a label. Its essence is ethereal; it's ether.

JEFF: If it's ethereal, then it can cross over.

DOZE: Oh, it can cross over, when you carry that with you every day. If you carry it with you every day, if it's part of your life every day, sure. So you're a hip-hop designer. Sure, OK. But that kinda like limits you, don't you think? 'Cause then you're kinda stuck to a style.

When you're talking about hip-hop, when you want to get a broader sense of the word, you're talking about poor people. 'Cause most of the fashion comes from the street—and who's the street? Usually working-class people who create style in fashion. So would that be hip-hop, or would that be urban influence? It has to do with poor people; it has nothing to do with hip-hop. It has to do with a person who got creative and couldn't afford fucking Bally's and created his own designer label on his pants, or cut his shirt in a certain way, or her shirt in a certain way, or tied it up in little knots. Because she couldn't afford to buy a haute-couture top, she made her own. That's what hip-hop is in fashion: people creating what they like, *creating* the look. People used to paint on clothes, not go to the store and get

something painted. They do it themselves. It's not authentic when you buy it off a shelf. It's just not.

JEFF: How does one maintain a sense of being true to hip-hop?

DOZE: By being true to oneself.

JEFF: There are a lot of people that feel they are hip-hop because they practice the elements.

DOZE: But how many of those moves you're doing on the floor are yours? How many of those paintings and those letter forms you do are yours? Create something that's *yours*, and then we'll talk. People need to have a little more faith in themselves.

At the same time, I think it would be good to be introduced to hip-hop by a master, a past master, and imitate how they do it. You should have something to guide you through shit, and you should be able to take your dues, to pay your dues, 'cause that's another thing nobody does anymore. People jump into the game, and they just think they can do it, right off the bat. You should have a foundation.

JEFF: Is that something that's been taken from the culture?

DOZE: Well, yeah, because it's been commodified. You wear your uniform; you are *this* now. And that's what it boils down to. A b-boy could walk down the street, the police would only see him as an enemy. We all have uniforms. But when you don't cater to that, when you play to your own realm, you create your own genres, and your own identity, then people can't really put you there, can they?

It's not about "What's the new shit?" It's never been about the new shit. It's about what's shit and what's not shit. What is real and what is unreal, and when you cater to what's unreal you keep doing what's unreal over and over and over again.

JEFF: This is one of the interesting paradoxes: hip-hop has been about building out of destruction. You destroy again to re-create, which is the whole competition thing as well. You want to burn your competitors, as if you're burning a Bronx building down, and you're erecting a new one with your new

style. But how do you make that process a permanent one and not let it get frozen in time?

DOZE: That's what I'm saying. Every time you burn something down, you don't re-create the same building on the foundations of the old building, because it might be burnt and charred too far. The most stoic of trees can fall if their roots are not firmly planted. Sometimes trees burn, and then new life springs from their carcasses and they do in a different direction; and sometimes they adhere to the old tree and create a whole new tree comin' out the old trees. You understand?

There's room for change, and there's room for new interpretation; you don't have to worry about that. But you need to have that root. That foundation is always there, and hip-hop is like a tree, and it's got as many hybrids and low branches around it now. Even hip-hop is connected to a bigger tree called rock 'n roll; rock 'n roll is connected to a bigger tree called rhythm and blues, and that goes back to ragtime, and ragtime before that to Africa, and Africa before that to Kemet, Mu—you know, it's all the same tree.

JEFF: When we started this discussion you were talking about how you didn't want your art to be pegged as hip-hop. Yet you used the analogy of walking through rooms, moving forward. Are you saying that hip-hop is a generational thing that will pass?

DOZE: This is back to the question of what I see is hip-hop. You're asking me, do kids see hip-hop in a different way? Is it not hip-hop, or can it be construed as hip-hop? That's up for interpretation. What you think or what you believe is hip-hop, then so be it. But for me, my ideology of what hip-hop was is not here anymore and doesn't exist.

The next generation will do things on their own terms, and create new stories, taking ancient stories from times of old like biblical stories or mythic stories and adding a twist to it so that they may not die. They'll flourish with a twist, and they can be identifiable to the next generation.

33

Revolution

An Interview with Brett Cook-Dizney

Jeff Chang

During the early '80s global explosion, Brett Cook was a teenage graf writer in San Diego. He quickly developed a unique style that highlighted the characters over the letters. To him, the people he portrayed—including himself—were more interesting than the traditional name-and-fame game. He continued to play a crucial role in the development of West Coast graffiti when he moved to the Bay Area to attend the University of California at Berkeley. Under the tag DIZNEY, he painted important, topical murals that commented on apartheid and racism. His street art and public persona became so wrapped together that his tag became part of his name: Brett Cook-Dizney.

In 1992, he and a friend, Aaron Wade, began collaborating on huge anonymous paintings and then hanging them on the streets of San Francisco. Like the work of "guerrilla artist" Robbie Conal, they were edgy, explicitly political, sometimes polemical comments on current events, such as the Rodney King verdict. Unlike Conal, they left the paintings unsigned. Hung without permission, but treated with an astonishing amount of respect by residents and passers-by, the paintings became a sensation.

After moving to Harlem in the mid-'90s, Cook continued his work, now seeking to make the paintings more consciously a part of a community-building process. For Cook, the process is integral to the art. He wants it to be values-based—inclusive and educational—and he hopes to empower people through his paintings. To that end, he began hanging large portraits in

Harlem of locals he met. He would interview them, then render them, including bits of the conversation that they had just had. Like African photographers Malick Sidibe or Lolo Veleko, he wanted to decenter himself, reverse the process by which painting really became about the auteur, not the subject. These unsigned (thereby authorless), very public paintings—more than fifty were hung on 125th Street and some of the other most traveled byways of the community—also became sensations.

In 2003, Cook culminated his work in Harlem with a massive block party. He wanted to draw on the legacy of hip-hop's spontaneous summertime street celebrations. Here he talks about the project, and what it meant.

JEFF: Why did you call the block party project *Revolution*?

BRETT: I wanted to magnify the voices of people in my neighborhood, this place that I had lived at for eight years. I thought of doing these nonpermissioned pieces on my block that would be portraits of them, along with other works that I had done. And then it came to me that the way to really do this was to have it be a celebration.

Revolution was both something that I was aspiring to produce as well as something that I think was happening in the process of making the celebration. "Revolution" is a term that has so much baggage. Oftentimes, it has this connotation of violence. What I was trying to consider was change in the ideal sense, to try to be the best that we can be. Where we now so often times compromise or make concessions about the music that we hear, or the parties that we see, or the culture that we live in, this experience was not going to be any of that. It was going to be revolutionary in that it was aiming to manifest the ideals of creative expression and inclusion and collaboration.

JEFF: At the time, you were going through Harlem and painting people, asking if you could have permission to interview and paint them, and then just putting these portraits up on the street.

BRETT: In thinking about Western art, so frequently the model never has a voice. When we see some famous photograph of someone or a famous painting, so often it's through the filter of the artist that we hear about and see that person. And so for some time in my own artistic practice, I have had a facet that has been about magnifying the voice of the people that I am working with, in an effort to make the work less about me and more about that person and their values.

The flyer for *Revolution* advertised a connect-the-dots drawing of a drum, in keeping with the collaborative painting projects of the day. Used by permission of the artist.

Celebrate Harlem 127th Street A Collaborative Block Party

Brett Cook-Dizney: "Thinking the divine in us creates a revolution." Used by permission of the artist.

And that gesture has another profound significance when I think about it in a community like Harlem that is marginalized from resources. To be specific—in Harlem, there aren't a lot of images of people of color alive, happy, talking about things they care about. Occasionally, there will be pictures of them when they die. Someone will paint a mural of them or more frequently people have taken to putting images of people of color in advertising.

JEFF: Talk about the different elements that made up the block party.

BRETT: Since this gesture is a gift and vehicle for the community, I felt I should ask them what they want, what would be elements of something that would be fun for them. In other instances of social collaboration in Harlem, people actually determined the questions they wanted to answer themselves. So part of the creative process for me is witnessing these templates that give people the opportunity to have a voice. The idea of doing the connect-the-dots drawings was one way of investigating how do I take myself even further out of the actual creative process and make it more connected to an expression that is theirs.

We were going to have a screening room of short films that were going to be about hip-hop in Latin America or why the draft doesn't work. We were going to have free all-organic food or give away free school supplies. You were going to be able to make things out of clay or wood or crochet, or participate in different creative elements that are about working with people, all for free.

This was meant to be a new type of block party. It wouldn't be based in advertising. It's not based in alcohol. It's not based in a police presence. It's not even based within a religious institution, per se, but really community generated, with these ideas that are not competitive, totally inclusive, and about a collective creation of something that talks about arguably the most important place in America for African Americans. At the same time, not done in a way that ignores that this place is still very alive and vital in the present. I wanted to be conscious of crafting something that would inspire how we can celebrate the future. So it's really a past-present-future celebration.

It was not about a talent show or a half-court basketball game or these other things that are really so traditional from our society that I think are really, to be severe, divisive. Our celebrations so frequently model competition, they model hierarchy, they model elements that have been causes for suffering for so long. They're about separation, about marginalization, about some having, some not having. Yet even within this culture of hierarchy, the inclusive block-party idea was something that I contemplated for years.

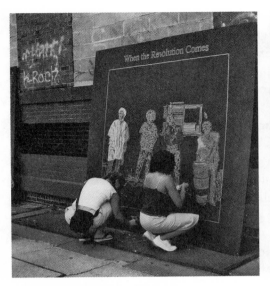

"There's this weird tension—you feel like you don't want to mess up, but you know that you can do your own interpretation. So sometimes I go over the bold lines, but sometimes I stay within. It just depends on how I feel." **—127th Street revolutionary participant**. Used by permission of the artist.

JEFF: I was thinking of stories I'd heard from pioneers in the Bronx about the block parties—and there being graffiti and people comparing their black-books, having b-boy competitions and stuff like that. There's a notion of "style wars" being at the heart of hip-hop. You didn't have those kinds of things. It wasn't about being competitive.

BRETT: For a long time, I was going to block parties and thinking: what are the elements that are really beautiful, what are the things that are great, what are the things that aren't so great? At the time, the most popular TV show was *Survivor*, which portrayed our culture as individualist, survivalist, hierarchi-cal, and all about winning for self. And oftentimes, the block parties them-selves would be this really secular kind of gesture where people would put up barricades at the end of the street to keep the cars out but also to demarcate it like, "This is *our* block's party." And in the worst cases, it would be *that* block's party. My effort was: this is gonna be for everyone! This is gonna be for people who have never been to Harlem before, for people who might have never been to the United States before, for people who know about art, for people who were going to my art gallery show the next day or people who worked at the mechanic shop across the street that I'd known for the whole time I'd lived there.

I'm certain there are things I could have done better. But I wanted to err on the side of inclusion and on the side of values that nurture joy and compas-sion and happiness without the expense of someone else. So when the Sprite truck came, I'm sure a lot of people were like— "The Sprite truck is coming, that's great!"—and I was like, "You gotta *go*! I don't really want you to be here." A lot of people would have really wanted to have the Sprite, but for me what I was trying to encourage was this notion of people really connecting to themselves. Let's not be distracted by social conventions or competitions or objects that catalyze our habit energy and limit the way we see our world. Conversely, have a revolution and see the world through new eyes, see what is possible in a new way.

It is so easy to get stuck in these habits of what hip-hop is supposed to be, what painting is supposed to be, what activism is supposed to be, and have that dictate what comes out. The revolution is about let's make a new thing. As a revolution it revolves, so, of course, it is considering what has come be-fore it, but it's changing to a new manifestation of the thing.

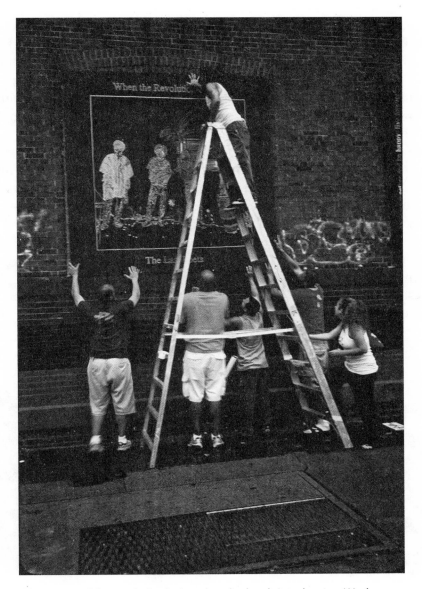

"The course of the revolution is three hundred and sixty degrees / Understand the cycle that never ends." **—The Last Poets.** Photo used by permission of the artist.

JEFF: Your graffiti name has been incorporated into your birth name. In graffiti, it was always about the name, putting your name forward, and the hegemony of the name—world domination of the name! It's an alias, and it's a sort of masking process that is commenting on what society does to the individual. But you've gone from getting started in graffiti and making yourself known to negating yourself, to putting up paintings that you don't sign, and forefronting the community. That seems like a revolution in itself.

BRETT: Well, yeah, now I'm just Brett Cook. Or just Brett. There are so many elements of this culture that nurture ego in us. And I think at some point it became my intention to not be driven or aspire to those things. So, yeah, you don't need to know who did this painting; you don't need to know whose block party this is. I want the world to be more generous. I want the world to be more inclusive. I want the world to be peaceful. I want the world to be humble. So then if that's what I want to see, that's what I need to be. And then it exists. And I think that was part of the profundity of the revolution of that day on 127th street for so many people.

JEFF: What has happened to the block since?

The Morning After: 127th Street in Harlem. Used by permission of the artist.

BRETT: It's a good question. I was actually evicted, so that's part of why I no longer live on that block. For me, the unexpected change reaffirmed this idea of trying to do the work not for some external goal or time, but really realizing impermanence, and touching deeply the present moment. Nothing is gonna stay forever. Hip-hop is not forever. Sometimes when I've experienced change in my life, it has felt never ending, traumatic, or difficult, but I aspire to think of challenges as opportunities for breakthroughs. It's even more liberating to realize that this revolution can happen anywhere, any neighborhood, any setting. People all over the world are, I think, thirsty to see new ways to celebrate community, thirsty for new ways to express themselves that are inclusive and really empowering.

34

Scarcity and Exploitation

*The Myth and Reality of the
Struggling Hip-Hop Artist*

Rha Goddess

Poverty consciousness is the fear of lack and the denial of self-worth. It is the distrusting of the abundance of life. It is a social and mental illness that can afflict those with a lot of money as well as those with none at all.

—Leonard Orr

There's a philosophical belief that poverty and lack of resources breed creativity. And if creativity is the life force of the artist, then the artist is nothing without a palatable sense of creativity that he or she can translate into art. Hip-hop began under the conditions of poverty and lack of resources, and we are the heirs to this poverty consciousness. This point of view about money, competition for survival, scarcity of resources, and exploitation runs through our culture. It affects the quality of the art we produce and the quality of lives we live.

Our poverty consciousness runs deep. When I say deep, I mean that people are not aware of how ingrained our beliefs about resources, accessibility, and viability are. Within hip-hop, these views run to the core of our culture and identity. For most of us, these beliefs operate in the subconscious, yet they completely frame our perception of self and our perception of others. More-over, they dictate our behavior, thereby creating our reality.

SO WITHIN . . .

Within our society, there is a romanticization of this idea of struggle, of being able to tell a rags-to-riches story, being able to LIVE a rags-to-riches story. It is an old mythology; it's the mythology of transformation—the ugly duckling becomes the beautiful swan, the moth becomes the butterfly. It's the mythology of triumph.

What makes the struggle attractive and "inspiring" is the opportunity to transcend it. But what happens when the struggle doesn't lead to triumph? What happens if your struggle just gets you more struggle?

Struggling and starving artists acquire a certain kind of credibility. They garner a sense of sympathy and nobility. If you're struggling, you haven't sold out. Somewhere in the midst of your work there must be some truism, some realism, some INTEGRITY.

Being struggling and starving somehow gives artists a perception of being on the ground with the masses, being in touch, being on the pulse, being original, being innovative, being pioneering, being courageous. The artist is seen as one who has shunned the allure of material gain in a world where material gain is everything. The artist becomes the rebel, and their personal struggle is now seen as political. The artist is then elevated to "folk hero." And this dilemma is way older than hip-hop. It goes way back—think, like, Jesus.

I know a very talented artist who has traveled the world a few times over, has written a number of books, been featured in countless magazines. He rubs elbows with some of the world's greatest celebrities and intellectuals, his house is nicer than mine, yet he just can't stop calling himself poor. Every other sentence out his mouth speaks to how oppressed he is, how limited he is, how powerless he is, and how he detests the Black middle class because they are "bougie." He makes these points while sipping the finest cognac money can buy, lounging on a butta leather couch in his living room.

Our addiction to the mythology of triumph tells us we must come from nothing, overcome something, struggle to achieve everything because that gives us credibility and validity as human beings. This idea of being seen as successful becomes easily distorted because not only is it connected to what you have acquired, but it is now also connected to how much shit you had to go through to acquire it—crucifixion brings extra props—and there is a real romanticism around that in hip-hop.

The problem is that when the spotlights go down, struggling isn't all it's cracked up to be. And when we are alone, most of us who do struggle also secretly wish not to. Yet we are reluctant to acknowledge what we really want for fear that it will not meet our "rebel ideals" and therefore isolate us from our loyal fans. The integrity of the artist has become synonymous with poverty. Artists who move to a place of not struggling or not wanting to struggle face a crisis of identity, or, worse, they get labeled as "commercial" or a sellout.

We have seen it a hundred times. A young brotha grows up in the hood, gets a record deal, and does really well. His friends don't change, so he's back in a community where his economic reality is dramatically different from the brothas he's rollin' with. It is important to him to still identify and be down, and because of this he makes certain choices about how he spends his money, where he spends his time, and the kind of records he makes.

"Representin" is a two-edged sword. One side is, "I gotta do shit to prove I'm the same old brother. Which gets me in trouble." Another is, "I got it like this, and now I gotta let everyone know who never thought I was gonna make it just how large I am." This means driving $100,000-a-day rentals, taking you and your twenty-five homeboys to the Bahamas, and anytime you're in the room everybody's sippin Cristal on you!

But one can only have as much money as he thinks he can have. So when brothas blow through millions and millions of dollars, it has a lot to do with what their psyche can hold about themselves. A poverty consciousness can cause a rapper to totally self-destruct because his psyche just can't hold it. Everybody knows that hip-hop's worst nightmare would be to wake up one morning with no street credibility. But what are we willing to endure to maintain it? Street credibility can get you killed. The list of dead rappers is a mile long.

There is a fundamental internal conflict embedded in the mythology and reality of the struggling artist. We truly appreciate the props that come with the perception of struggling, but we also need to pay our rent. We love what the drama brings to our work, but hate that we spend more energy worrying about the light bill than doing our work. Metaphorically, being hungry is cool, but literally being hungry is a whole other thing,

Yet because of our scarcity-based conditioning, many of us really believe that if we don't have drama in our lives, then we don't have anything REAL to write about. Without the struggle, our creativity is in jeopardy. And if the collective consciousness tells us that our dopest shit happens when we're shit-hungry and struggling, where is the incentive to be anything else?

The biggest dilemma we face on the road to triumph is that we have yet to figure out just how long one should struggle before one has earned the right to triumph. And once we have triumphed, who do we become then?

SO WITHOUT . . .

The mythology of the starving artist gets passed around and handed down like a spliff at a gangsta party, and at the end of the night, everybody is high on the same bullshit.

In hip-hop, the tell-tale sign of a poverty consciousness is that you don't do good business. You're a hot rapper, and a record label approaches you with a bad deal. Your thinking is, "Well, I didn't have shit anyway, so anything more that nothing is something. If a record label tells me I get five points out of a hundred, then five points is better than no points." As far as you're concerned, any biscuit is better than no biscuit. You're not even in a conversation about what your real value is.

You get offered a $20,000 advance to do an album, and you think, "I'm rich now! A bag of weed and a Cadillac ought to suffice. I don't need my record royalties. Besides, so-and-so is definitely looking out for my best interest." There is this consciousness that tells us, "This looks like my only shot. I'd better go for it, and just swallow the terms, whatever they are." Forget that there's even a concept called negotiable. You're not thinking about all of that. You're "the artist," and all that other stuff just doesn't concern you until you realize you've been screwed over. We know this has happened over and over again in Black music.

Then you hit the media circuit and tell your story, and everyone gets to nod their head and go, "See, I told you. Better to stay starving then be done over by some shady music exec."

These ideologies moving around within the collective consciousness have an incredible amount of power, because now the conviction does not just belong to one lone "drum beater"; it has been passed along to the masses, and they become "drum beaters" for the entire community, and pretty soon, these beliefs become embedded in the culture, individually, interpersonally, and institutionally. And the narrative takes shape: artists are the victims, organized money and institutions are the culprits, artists don't know how to do business, executives exploit the artist's ignorance, and on and on.

The idea of impoverished artist becomes naturalized. How many times have you heard someone say, "I'm an artist. I can't afford it"? If I'm an artist,

and I'm not on MTV and Hot 97 every five minutes, I assume that I'm supposed to be struggling. Why? Because all of the other artists I'm talking to are struggling too. And they assume that they're supposed to be struggling because that's what artists talk about all the time, the struggle.

Arts institutions will often follow their lead with mantras like, "Arts funding is down," "Opportunities are limited, and this fund is very competitive," "We are only funding this every other year," "Can't you do it for less?" "We need to add in three more shows, two more workshops, and a meet-and-greet while you're here too." These notions of scarcity breed unhealthy forms of competition, where artists hoard information and work in isolation, all in the hopes of maintaining an edge.

We as artists believe that in order to remain true we must continue to be in the struggle. That inevitably equates to being poor and, in some cases, making only a certain kind of art. But in the conversation of survival, this society looks upon art as a luxury, not a necessity, though we can point to many places where art has saved lives, including our own. Thus, if we choose to pursue our art in this society, there is an automatic belief that we will be poor because we are committed to having integrity or we will be poor because this society just does not value our art enough to pay us well or because there is just not enough money and recognition to go around. So many incredible artists resist their artistic urges, and society is deprived of their contributions. And those of us who choose to go for it become consumed with "making it."

Conversely, society does value entertainment, which is perceived as an ES-CAPE from the daily grind for survival, and this escape is considered to be a necessity. Common definitions of entertainment that float about include words like *fun, amusing, easy to digest, not requiring much thought.* Artists who take ourselves seriously may feel challenged by these definitions, and see them as dumbing down or diluting the depth and meaning of our work.

Moreover, when we "make it," we may also feel challenged. Even if our work has not changed, we somehow still feel like sellouts; we question whether people really understand the nature of our work. We now feel uneasy around our peers. We may feel like, "Why me and not these other people?" Or we may now feel beholden in ways we did not feel before and romanticize about the good old days when we didn't have anything, even if the good old days weren't that romantic if we told the truth about it.

Or we struggle, struggle, struggle and get something, and then everyone else has shit to say about it. People are talking about whether or not we deserve it. We suddenly feel compelled to defend whatever we got while at the

same time questioning whether the others are right. A separation happens between us and the community because we're "blowing up" now. People treat us differently, and we feel uneasy about it, unsafe about it, untrusting about it, like we need to watch our back because other artists are eating sour grapes.

There is another artist I know who is also very talented, and she is having a record year. She's received a couple of major grants, landed a book deal after a bidding war, is working on a new album, and has received the lead in a major performance work. Whenever I see her, she never stands still long enough to have a real conversation, she never makes eye contact, she is always moving away while she's talking, saying good-bye before she's even said hello. It's as if she is afraid that I will ask her for something because she has had all of this success.

If we look at that consciousness superimposed on hip-hop, what we see is that it creates extreme polarization. You have the purists saying, "The commercial hip-hoppers sold out," "They sold their soul," "They're ignorant," "They chose money," "They aren't MCs, they're rappers!" The commercial hip-hoppers look at the cultural purists and say, "Nigga, you can't pay your rent. You're talking all this righteous shit, and you can't pay your rent or your bills. So if I gotta go and do this over here with the man and look the other way or compromise, I'm gonna do that."

Poverty consciousness is part of a larger societal consciousness. It's the landscape that hip-hop grew up in. American culture is about scarcity. The reaction is mass consumption, which teaches us that, because "I am not enough, I need this to be powerful, I need this to look cool." All of this keeps us in a place of mental, spiritual, and emotional scarcity. What we ultimately want to experience cannot be obtained through the external. But we gonna chase it like crack fiends because at the end of the day we want to be somebody too.

AIN'T GONNA STRUGGLE NO MORE: LIFE AFTER THE MYTH

We have to challenge these ideologies. What it comes back to for me is this question: what is your authentic truth about your creativity?

What fosters your creativity? Maybe what fosters your creativity is being in the woods for two weeks, being able to write uninterrupted. For other people, maybe what fosters their creativity is being able to get a massage once a week, being able to lay on a beach in Jamaica for ten days. Or maybe what fosters your creativity is sitting by the washing machine and hearing your kids kick and bang on it.

What is true for you? What kind of work haven't we been able to make because we believe in the romantic idea of the struggling artist? If you get money, do you feel bad about yourself? Do you feel bad about the money you got because the kind of work you did is what's selling now as opposed to what you really felt compelled to create?

For some people, perhaps their truth is the struggle. I don't think poverty has to be the only condition for creativity. Each of us has the opportunity to ask ourselves: Do I need to have all the drama around my work to do my work? Is the drama my work?

People are not eating, that's very real shit, and they are assuming that's how it's supposed to be. Artists are starving because somewhere we have decided that is what is available to us. Until we do the internal work to believe and decide that something different is possible, we're starving. But the reality of it is so within, so without. The artist has, in some way, shape, or form, bought into the idea that this must be part of their journey, that this somehow contributes to the art, makes it better, or this is their destiny.

I think the hardest part to swallow is that none of this stuff is real. There is a reality we create, but the reality is still built from a mythology. Many of us have been taught that being hungry gives us an edge. Does the edge exist because you're poor, or does the edge exist because you're willing to challenge your reality in ways that others may not? Are they related? Is there an assumption that you have to be poor and struggling to challenge and question your reality? Does being poor automatically equate to being more true, and why?

I'm not saying don't recognize your own journey. I'm not saying don't recognize the historical context that you come from. But there's a fine line between recognizing and perpetuating. I don't think we understand those delineations. It's not about, "Everybody now needs to be like so-and-so." I think the opportunity is to get in touch with your own truth. You don't have to create from just one place; you can create from anywhere. You can stand anywhere. You can stand inside of poverty. You can also stand inside of wealth. And you can challenge both.

I suggest to you that the biggest challenge that we face is finding our most honest vision for success. Because we have huge machines that tell us every day all day what it's supposed to look like. But the idea of going within, being able to shut out the noise and get to a real place, is a different conversation.

Tremendous possibilities occur the minute you get authentic. When you are real, you give someone else the permission to be real too, and that immediately builds intimacy and trust and community.

Collectivity cannot happen without some semblance of honor. You ain't got to love everybody, but there needs to be some level of respect and acceptance and honor. To me, collective success looks like communities of individuals living authentic lives, operating inside a common vision.

Not long ago, I worked on a creative piece with a team of incredible artists. They are married and have a very clear vision of the kind of lives they want to live and the kind of work they'd like to make. These artists are deeply respected in the larger community, and are always creating opportunities for other artists. Their philosophy is: what helps you helps us. They have been directly responsible for nurturing the careers of dozens of artists, all while pioneering a new genre of theatre that I believe will be studied for years to come.

Their abundant attitude has created countless opportunities for their work, and they are currently touring the country in preparation for launching the New York premiere of their latest work at one of the nation's most prestigious theatres. The underground and aboveground love they have received has been all about the spirit of who they are, which is infused in their work and gives them the kind of edge that all of us can celebrate.

Some may argue that this country does not support its artists as well as other countries, like Japan or Canada. It is true that there are grants and other opportunities that are available in other countries that are not available here, but what we also know is that people pay $50,000 in this country for a painting. People pay $150 to go see *The Producers* on Broadway. What I do know is that both are true, and one is not more or less true than the other.

In hip-hop we talk about the categories of mainstream and underground. The underground cats got the raw real shit, and mainstream niggas got the soft ice-cream shit. They got the money, but we got the credibility. It's a powerful conversation.

Well, that's cut-and-dried, but then what happens when you begin to make that kind of money? Are you now mainstream? Are you now a sellout? Does it now mean your art is weaker? Less relevant? Are you doing that wack commercial shit? How many people would rather die than be seen as a wack mainstream artist? What does that set up as a context if your choices are to sell out and have a little money or to really keep your shit real and have nothing? If it's really true, what happened to Sarah Jones? If it's really true, then what happened to Carl Hancock Rux? What are we saying about those artists now? They got lucky? And if we say that, what are we creating for our own reality?

I want to advance the idea that we can have the best of both. I realize that idea is scary. If it's possible to have both, then that means I have to be responsible for my reality. I have to be responsible for what I'm creating. I don't

think we look enough at how much our speaking and our consciousness give us our reality.

We're at the cultural juncture. The real questions are: What would it look like if we won, if we didn't have to struggle anymore? What are we going to have to give up in order to hold that? If my whole game is based on being oppressed and I am no longer oppressed, who am I?

Rha Goddess is a performing artist and social/political activist. Her work has been internationally featured in compilations, anthologies, forums, and festivals. As founder and CEO of Divine Dime Entertainment, Ltd., she was one of the first women in hip-hop to independently market and commercially distribute her own music worldwide. In May 2000, *Essence Magazine* recognized Rha as one of "30 Women to Watch." In 2002, BAM's prestigious Next Wave festival chose her as one of six artists deemed to be influential in the next decade. Her activist work includes cofounding the Sista II Sista Freedom School for Young Women of Color and being the first international spokeswoman for the Universal Zulu Nation. She is currently the founder/vision keeper for The Next Wave of Women & Power/We Got Issues!

Toward a Hip-Hop Aesthetic

A Manifesto for the Hip-Hop Arts Movement

Danny Hoch

More than twenty years ago, in 1984, I was a graffiti writer, a breakdancer, and a rapper. I was pretty damn good, too; I was, however, not an artist in any of the above categories. I toyed with each discipline, didn't work too hard at the craft, and had no vision for a career as a hip-hop artist, because hip-hop was not viewed as "art." Instead, I went to school to study theatre and became an actor and playwright.

Now, after serving as artistic director of the NYC Hip-Hop Theater Festival for five years, I am asked by folks inside and outside the culture to discuss hip-hop's aesthetics. As great as these conversations are, the consistent challenge has been to define not what hip-hop means as culture, but what hip-hop means as art—in fact, to make the case that hip-hop *is* art.

Hip-hop art, when it is bad, is often embraced by the mainstream as the entirety of the talent and voice of the hip-hop generation. When it is good, outsiders and insiders alike misunderstand it for reasons of politics and fear. Bad hip-hop art is invariably inarticulate, unpolished, amateurish, juvenile. Good hip-hop art is highly articulate, coded, transcendent, revolutionary, communicative, empowering.

Unfortunately, hip-hop, bad or good, is almost always relegated to a marginalized gray area, a penalty box, if you will, where it is denied the status of

A previous version of this essay appeared in *American Theatre* magazine, published by Theatre Communications Group.

art; it is seen as radical political thought, a really bad manifestation of pop culture, or, with some luck, novelty entertainment.

But if hip-hop is to be discussed as art, then what are its aesthetics? And, just as important, what happens to hip-hop's aesthetics when they are mixed with the aesthetics of "recognized" art, or when hip-hop's venue changes from the street to the stage, from the subway car to the gallery, from the school yard to the screen?

TRADITIONS, CONDITIONS, PHENOMENA

Hip-hop's origins are multifaceted, politically conflicting, consistently debated, and highly complicated, because we are still living through many of the same conditions that caused its birth. Nevertheless, hip-hop's aesthetics lie foremost in the social context from which it sprung. The end of the civil rights movement in the late 1960s, the turmoil of the militarized political movements (Black Panthers, Brown Berets, Young Lords), urban blight and the advent of Reaganomics, the digital age, an exploding prison population, and epidemics of crack, guns, and AIDS—all of these forces converged to create a socioeconomic landscape unlike any other in history. That situation, combined with New York's inner-city demographics—southern Blacks living alongside Puerto Ricans, Dominicans, Jamaicans and a handful of working-poor whites, all of whom drew upon both inherited and appropriated cultures in the face of urban decay and accelerated technology—created a legacy of art forms and language that would wind up being inherited by all races, colors, and classes around the world.

Hip-hop issues from the following traditions, conditions, and phenomena:

- an African and Caribbean continuum of storytelling and art
- a polycultural community of both immigrants and migrants
- appropriation of European cultural traditions and Japanese technology
- a legacy of political and gang organizing
- the bumpy transition from post–civil rights and militarized nationalist organizing to the supply-side economics of the 1980s
- the devastating effects of Reaganomics on urban America
- the age of accelerated technology

The notion that hip-hop is solely an African American art form is erroneous, and this becomes clear when we really examine its aesthetics. It is certainly part of the African continuum, and if it were not for African

Americans there would be no hip-hop, but hip-hop would not exist if it were not for the polycultural social construct of New York City in the 1970s. Hip-hop art is so multilayered that it could never have been born solely from the African continent, or solely from a poor community in the United States without African diaspora traditions. Neither could it have been spawned solely from a polycultural community in Durban or Barcelona or from a rural Missouri community devastated by Reaganomics. It could only have been born of the fusion—and profusion—of all of these complex conditions and circumstances.

INHERITANCE, RECLAIMING, FUSION

Looking at the original four elements of hip-hop, we find its aesthetics:

Graffiti

Political graffiti existed for many years as an outlet, as did the tradition of scratching one's name into a tree or inscribing "I was here." But it was not until the blight of the 1960s that young people started to make a habit of writing their names in public places, not just to let everyone know that they were there but also to lay claim to public property in the face of poverty and powerlessness. Many poor youth in New York City high schools in the 1970s were encouraged to take classes like wood shop and printing, where a strict block style of writing was used, and one could even say "enforced." Early rebellious variations of this block style became the basis for hip-hop-generation graffiti lettering. Add the advent and proliferation of the spray-paint can and the widening gap between rich and poor, and you not only see a culture where poor youth are putting their codified names on public transit, schools, and property as if to say, "We own this—this is ours," but also a highly evolved language emerging from groups of young people (crews) who are battling for graffiti stakes and fame in certain neighborhoods and on train lines. City walls and the physical facades of trains define the style of painting, as do the limitations and properties of the spray can and the wide-tip marker, and the colors available from Krylon and Rustoleum. Graffiti artists encode their work not only against police and the rich but also for each other, to the point that some don't even paint their name, just their style. Crackdowns on graffiti across the country change the aesthetic again, and we see graffiti artists painting on canvas, and being celebrated in museums and galleries around the globe.

Graffiti Aesthetics: Enforced block letters, reclaiming of public space, codified ownership, train-as-canvas, 1970s–'80s art supplies (and colors), and criminalization of the form.

DJing

This element can be attributed to the dub and sound-system traditions from the island of Jamaica, dating back to the 1950s, but exported to New York en masse in the early 1970s, when selectors or record programmers would attempt to loop and ultimately reverb the instrumental segments of reggae records because they extended the playability and, most important, the danceability of a song. Jamaican immigrants brought this technique to New York, along with the tradition of huge outdoor speakers, which enabled DJs to play for more people and bring the club outside. However, the popular music of choice in NYC then was disco, and those were the records that were being looped. Add to this the advent of newer mixers and analog artificial beat machines, where you can create your own beats like a musician and still play the disco record. When the DJ sought to loop the break beat in the mid-'70s, by pulling the record backward by accident, that's when the famous scratch was discovered/invented, yet this by-product became part of the aesthetic, and people began to expect it in the art. The repeated breaks become the samples that also contribute to the aesthetic, and DJs ultimately become composers in their own right. The form is a codified art unto itself, reliant not solely on recording but also on battling in the skills of scratching, looping, bumping, and mixing live.

DJ Aesthetics: Jamaican sound system, disco, funk and soul, 1970s and '80s electronic musical technology as musical instruments, dancer appeasement, and codification of recorded sounds by sampling.

B-Boying

Commonly known as breakdancing, this is the reason the DJ was searching for the break beat in the first place, to get people to dance. The dance traditions of West Africa, Brazil, Puerto Rico, Cuba, and the Dominican Republic can be found in this dance, yet it is informed by the breaks of disco and funk music. Poor youth could not afford to go to the downtown discos, nor did most DJs own their own clubs, so illegal improvised outdoor parties took place, with electricity provided by the closest street lamp. Park jams called for

a different kind of dancing. The urge to get all cute and John Travolta was lessened if you were dancing outdoors on asphalt and concrete. Gangs were dying out by this time in New York, but the tension was still there, so fighting moves began to join the repertoire, as did martial arts choreography, thanks to the popularity of kung-fu films, which dominated movie houses in poor neighborhoods. If we're talking about aesthetics, let us not forget cardboard and linoleum. The 1970s saw an acceleration in manufacturing and a proliferation of cardboard packaging that had never been seen before. It was also a time when New York City apartment dwellers were replacing their linoleum floors of the '50s and '60s with carpet. The sanitation department was notorious for underserving poor neighborhoods and leaving heaps of trash in the street, along with copious amounts of cardboard and linoleum. The backspin, windmill, glide, and headspin would not have been invented were it not for young people reappropriating these two mundane items. They certainly didn't conceive them in a dance studio at Lincoln Center. They defied the ground by spinning on it, on their backs, on their heads, on garbage.

B-Boy Aesthetics: Bomba, Rumba, *Capoeira,* salsa, funk, soul, gang fighting (battling), stylized kung fu, asphalt or concrete dance space, sanitation, and cardboard and linoleum.

Rap

This tradition is clearly rooted in Afro-Cuban Rumba, Puerto Rican *Plena,* southern blues, and Jamaican toasting. You can see it in the battle, the griot, the storyteller, the call-and-response. We can also see a connection to the Black and Latino political poets of the 1970s, as well as another unexpected influence. In the 1970s when the NYC Board Education realized it was failing to adequately educate the city's poor Black and Latino youth, they implemented an unofficial curriculum of limericks in all English classes from first grade through high school. Instead of overhauling the entire system and reallocating resources, they figured if they could get the kids to rhyme, maybe they could read enough to fill out a job application. Well, Scottish limericks are pretty boring. But they sure are catchy. Problem was, "There once was a lad from Gylwynny, who sold his poor sheep for a penny . . ." ain't got nothing to do with what's happening in the South Bronx in 1974. So young people appropriated limericks and made them about their own experiences, everything from party rhymes to rhymes of self-worth and micro- and macro-sociopolitical analyses. They rapped these Rumba/toasting/*Plena*/blues

limericks over the instrumental disco beats that the DJs were playing in the clubs. This was happening for years before anyone ever thought to record it. In fact, the DJ was the original rapper, throwing in these Caribbeanized street "limericks" to get the crowd hyped up between songs. Later, the DJs brought in specialized hype men (rappers), who would just do the rapping. Soon, the rappers were the stars of the show instead of the DJ.

As the crack epidemic, the gun epidemic, and the prison epidemic swept through U.S. urban communities like a war—fifty thousand people were murdered with guns between 1985 and 1994, and the prison population grew exponentially, with forty new prisons built in New York State alone—the content of the lyrics changed. In the 1990s corporations realized that the gritty, graphic stories of misery, abuse, and pain coming from poor youth, combined with beats you could party to, were the recipe for riches, and they encouraged rap artists to glamorize and romanticize urban misery, even if it was not their experience. The culture wars of the '90s demonized rap—making it even more popular—and brought both a resurgence of the party ethic that made billions more as well as a resurgence of politically conscious and wildly articulate rap artists who sold, well, fewer records.

Rap Aesthetics: Toasting, *Plena,* Rumba, blues, bomba, *palo,* African American poetry, call-and-response, limericks, urban blight, party animation, corporate demand, exaggeration, and battle.

———————

To summarize, here is a list of many of the aesthetics from hip-hop's original four elements, in no particular order:

- codification of language (spoken and written), dress, gestures, and images
- call-and-response
- sociopolitical context and legacy (post–civil rights/ '70s nationalism/Reaganomics)
- metaphor and simile
- illusion (magic)
- polyculturalism (immigrant and migrant)
- battle, braggadocio (competition)
- lack of safety, barriers, boundaries (stage)
- African- and Caribbean-diaspora performing traditions
- lack of resources and access

- reappropriation by hip-hop creators of materials, technology, and pre-served culture
- Urban Blight
- Criminalization of poverty
- Criminalization of culture

One note: I believe that political context, lack of resources, and reappropri-ation belong together in a list of more traditional aesthetics, like metaphor, codification, and illusion. Not only do they provide an aesthetic context from which hip-hop has sprung, but they have also informed—and continue to in-form—our artistic practice, even when the form or genre varies.

WHAT'S NEXT

Hip-hop art is not a coincidental pop novelty. It involves craft, which varies, depending on the discipline. There are old and new traditions, which are rec-ognized by people inside and outside the culture. Other forms that have emerged and are recognized as elements of hip-hop art—beat boxing, lan-guage, fashion, self-knowledge—all draw upon the same set of aesthetics.

In the past ten years, a new wave of hip-hop arts has taken shape in dance, music, writing, visual art, and other forms. These new works follow hip-hop's aesthetics closely, yet they are not wholly comprised of the original four ele-ments. These works instead are products of a generation that grew up in hip-hop and is now branching out of the fundamentalist book of elements and rules.

Some works are created by traditional hip-hop artists who feel limited by the original four elements yet wish to continue the aesthetic; some are made by hip-hop kids who went to art school, others by art school kids who discov-ered hip-hop later in life. Some of the creators are old-school b-boys who have recognized that, as artists, they want to do more than perform in Las Ve-gas as an "attraction." Others are old-school graffiti artists whose gallery work has provided a vastly different context for their vision of what they can do with paint (or with other materials—such as metal sculpture, clothing, or computer software). Still others are rappers who feel the need to expand the possibilities of their storytelling beyond the sixteen bars they are allotted on a rap record.

For me, the most exciting place where this new hip-hop art is taking shape is in theatre. Hip-hop theatre provides the best paradigm for examining what the new hip-hop aesthetics are, what they aren't, and what they could be.

HIP-HOP IN THEATRE, THEATRE IN HIP-HOP

I remember several years ago running into Stretch Armstrong, a hip-hop music personality in New York. I gave him a flyer for the Hip-Hop Theater Festival, and he said, "Hip-Hop Theater Festival? What the fuck is this, some ill new marketing ploy that I've never heard of before?"

The Hip-Hop Theater Festival is, in fact, the only institution of its kind that curates, presents, produces, and develops a broad range of hip-hop and hip-hop-generation theatre. In five years we have presented more than seventy-five plays, and branched out to three other cities—Chicago, San Francisco, and Washington, D.C.

At the festival, we constantly ask ourselves: what constitutes hip-hop theatre? In determining what makes it into the festival and what doesn't, we came up with these criteria: hip-hop theatre must fit into the realm of theatrical performance, and it must be *by, about, and for* the hip-hop generation, participants in hip-hop culture, or both.

The clamor for more hip-hop theatre on the legitimate stage is not unlike the cry of theatre artists of color during and after the civil rights movement. But few hip-hop theatre pieces fit into a solely African American slot, or an Asian American or Latino one. This is because the face of the hip-hop generation is considerably more diverse. And this is a good thing, because hip-hop shouldn't fit into a tokenized "slot," and certainly not one that narrows its scope. It's a bad thing because theatres don't seem to have a category for this work, and therefore don't know what to do with it. That's okay—they'll catch on soon enough.

What It Looks Like

A quick rundown of a few works that have been presented at the Hip-Hop Theater Festival will give you a picture of how diverse and eclectic hip-hop theatre is.

Hip-Hop Theatre Junction's *Rhyme Deferred* is a play with two DJs onstage who are live-scoring modern hip-hop-based dance choreography (in other words, *not* breakdancing), yet the story is about two brothers who are MCs. Another piece, *Five Elements of Change*, from the Tortuga Project of Albuquerque, New Mexico, uses Aztec dance, *Capoeira*, breakdancing, and rap to tell the story of hip-hop's relationship to indigenous culture and sustainable farming. Nilaja Sun's piece, *Black and Blue,* is about a young woman at a hot New York City summer day-camp playing a musical role as Smurfette. The

protagonist of Ben Snyder's conventional play, *In Case You Forget*, is a graffiti artist, but the play is about much more than spray painting.

The Hip-Hop Theater Festival also presents dance theatre: *tOy/bOx* by Philadelphia's Olive Dance Theatre pares down b-boy movements to tell a story about a fantastical toy. Rennie Harris Puremovement's repertory embraces narratives told through b-boy and poplock-inspired dance. Jonzi D of London's *Lyrikal Fearta* and *Aeroplane Man* uses hip-hop text and choreography to weave stories about police brutality, British hip-hop culture, and the modern-day African diaspora. Benji Reid of Manchester performs what he calls "hip-hop mime" in his *Holiday* and *13 Mics*. Eisa Davis's plays, *Umkovu*, *Angela's Mixtape,* and *Six Minutes*, are three entirely different plays that delve deeply into language and issues that could come only from this generation and culture. *Umkovu* is a conventional play about people struggling with the conflation of violence and commerce within the hip-hop music industry. *Angela's Mixtape* is literally a hip-hop generation musical and theatrical mixtape of woven-together scenes and memories of the playwright's childhood growing up as Angela Davis's niece. And *Six Minutes* is a very unconventional, highly experimental play that teases with hip-hop language and allusions, yet focuses on the surreal relationship between two Ph.D.s caught in a sweaty, high-octane struggle of love, abuse, politics, class, and activism. My own work ranges from monologues dealing with hip-hop commercialization and the prison industrial complex in *Jails, Hospitals & Hip-Hop* to the explorations of polycultural hip-hop in *Some People* to a standard two-act play, *Till the Break of Dawn*, about a group of idealistic hip-hop-generation teachers and activists who go on a trip and learn how to live with some difficult contradictions.

All of these pieces either employ hip-hop's elements, comment on hip-hop culture itself, or address specific issues that affect the hip-hop generation. More important, they incorporate hip-hop's wide range of aesthetics, and not just the four original elements. The plays, while structured within a contemporary Western theatre model, rely on some, if not all, of the fourteen aesthetic elements I listed earlier.

It is a huge misconception to think that hip-hop theatre means doing a rap-music version of *A Midsummer Night's Dream*, or that hip-hop theatre must have any one of the hip-hop elements, for that matter. In 2002, for example, the festival received a curious complaint that Indio Melendez's piece, *Manchild Dilemma,* did not belong in hip-hop theatre, because he didn't rap or breakdance in it. His piece was about a Latino kid who joins the army to get away from his mother and inadvertently gets sent to Operation Desert Storm in 1991. The piece starts with a real video letter from his pregnant

girlfriend, asking when he's coming home, and the story unfolds into a series of solo scenes taking us from his home in the projects to the recruitment office and a drill sergeant who hunts him down to force him on the plane to Kuwait. All of the language, references, locales, contexts, and the story reflected dilemmas of the hip-hop generation; it didn't need any of the four elements of hip-hop to qualify as a "hip-hop-generation play." And it was a great piece of theatre. It belonged in our festival, just as it belongs on the main stage of every theatre in the country.

On the other hand, a play titled *Bomb-itty of Errors* was performed in New York City a few years ago and has since toured internationally. I found it painful to watch—not because it was poorly written, poorly acted, or poorly directed. It was actually a genius adaptation of *Comedy of Errors*, performed by greatly talented, former New York University theatre students. But as universal and timeless as Shakespeare is, performing his plays in rap does two very damaging things. First, it sends the message that the hip-hop generation has no important stories of its own, and that in order for hip-hop to qualify as theatre, it must attach itself to such certified texts as those of Shakespeare. Second, it devalues hip-hop as art by relegating rap to humorous accompaniment. The feeling that results is of watching a hip-hop minstrel show. Not only wasn't the play *about* the hip-hop generation, but the audience (and ticket prices) failed to reflect the generation as well. This was not a hip-hop theatre piece, but rather a Shakespeare adaptation that infused rap. Ouch.

The festival continues to receive hundreds upon hundreds of submissions of "performance poetry" or "spoken word." For some reason, people think that undirected, unchoreographed recited poetry equals hip-hop theatre, but this could not be further from the truth. A recited poem with some movement in it does not make a play. Nor is it "spoken word." It is simply a poem with movement. Sometimes it's a great poem with great movement that has been made into a play, like Marc Bamuthi Joseph's amazing piece, *Word Becomes Flesh*. But the notion of lumping spoken-word poetry into the category of hip-hop theatre distorts, dilutes, and diminishes not only hip-hop and theatre, but also poetry.

CONTRADICTIONS AND CHALLENGES

Hip-hop has become a catchall box for postmulticulturalist arts, a way for mainstream theatres to check off both the "young" and "of color" boxes at the same time. Artists of color whose works have nothing to do with hip-hop are often pigeonholed into the category of hip-hop. Meanwhile, hip-hop artists

are often pigeonholed into the ethnic or minority category. It is up to us to make sure that we are not pitted against each other, especially in a climate of decreasing arts funding and trend-based arts funding.

Few theatre directors know how to handle hip-hop aesthetics, many have no idea what they are, and rare is the dramaturge who knows what to make of a hip-hop text. At the same time, few hip-hop theatre artists know what dramaturgs do or understand how they can help. There are few theatres commissioning hip-hop theatre artists, and even fewer that are offering artistic development for this genre. As is usual in the arts, the amount of resources is not proportionate to the work being made, or the work screaming to be made, and the situation is even worse for the hip-hop arts movement.

Hip-hop was already swimming in dangerously contradictory waters when it sprang up as a grassroots art form in the ghettos of the biggest capitalist state in history. Now that hip-hop is maturing in the fields of art, activism, education, and business, what are the risks of hip-hop theatre itself becoming elitist and exclusive precisely because of having penetrated mainstream institutions? What happens to graffiti's aesthetics when the canvas is legal and the museum is commissioning you? What happens when the rapper whose main themes are selling crack and suffering and death makes it big and gets himself a 401(k)? Isn't that what hip-hop set out to do in the first place—take over mainstream institutions and redistribute power and ownership?

What about *cultural* power and ownership? If the Def Jam, No Limit, and Jay-Z empires are examples of this revolution in the for-profit world, then what will the revolution look like in the not-for-profit world? Will not-for-profit institutions co-opt hip-hop culture into their programming and hoard grant money without really giving up any power? Will hip-hop art at not-for-profit venues become highbrow and distant from its intended audience?

What happens to all that codification? What happens when we share (and sell) the language that *the man* wasn't supposed to understand? If the answer is that we create a new language, then where is it? What happens when hip-hop moves into the opera house and we still don't own the opera house? What if we *do* own it?

How do the aesthetics of hip-hop change when the cardboard and linoleum become a $20,000 marley floor? How do the aesthetics change when, instead of plugging into a street lamp, an artist is plugging into a million-dollar sound system in an acoustically tuned concert hall? How about when your audience is paying seventy-five dollars to see you on Broadway instead of for free in their own neighborhood? What will hip-hop theatre look like when, instead of hustling together something with one light

in a warehouse in their spare time, the artists are being paid union salaries, and the play enjoys real development money and a staff of designers and dramaturgs?

In 2050, when we of the hip-hop generation are in our seventies and eighties, will we be hovering around Lincoln Center with our wrinkled Ecko suits, buying thousand-dollar tickets to see renditions of Busta Rhymes and Benji Reid? Will we still be relevant? Will the thirty-somethings be complaining for *us* to get out and give them the keys so they can start their own movement? Or will hip-hop generations keep generating themselves, as poverty and injustice do?

I'm not sure of the answers to all these questions, but I know that hip-hop is not waiting until it turns seventy to find out. Hip-hop, for the most part, is not waiting to "get into" Lincoln Center, and hip-hop is not waiting for anything, because, unfortunately, the last and crucial part of this aesthetic is that hip-hop creates work through a fatalistic lens that has little to do with passing reckless youth. Most of the hip-hop artists who lived through the 1980s in America's cities never thought we would reach the age of twenty, let alone thirty. Many did not, and many who did so spent their time behind bars or under very difficult circumstances. Even if our lives or families were not directly affected by crack, guns, AIDS, Giuliani, Daley, or Riordan, the bleak expectation of premature death is greatly responsible for many hip-hop artists not seeing ourselves in a trajectory of artistic longevity. Not as individual artists, not as ensembles, not as institutions. Add mistrust, discrimination and marginalization, and you have a situation where many artists wouldn't even think of approaching an arts institution, let alone performing in one.

That said, there are quite a number of us who have survived the '80s and '90s, who have, albeit through sacrifice and struggle, moved the culture forward, and who now feel entitled to not only enter these historically exclusive institutions but run them and own them as well. Which poses another question: should hip-hop be concerned with developing autonomous institutions, as happened with the Black Arts Movement? Or should hip-hop take its rightful place in the mainstream venues that are theoretically "for the people"?

If the hip-hop generation now outnumbers the baby boomers and the blue-hair arts patrons, then aren't WE the people? I say we are, and that motherfuckers need to not only give us a slot in the season but also hand over the keys. At the same time, I wouldn't have founded the Hip-Hop Theater Festival if I thought someone was gonna give me a key. But one of the unique things about the HHTF is that although it is an institution, it hasn't sought its own separate venue. Its goal is to, as hip-hop did with limericks, turntables and

kung fu, reappropriate performance spaces and resources that our artists and our audiences are entitled to.

This leaves us in a contradictory place of negotiation. Part of hip-hop wants to be accepted, and part of it does not. Part of hip-hop wants to institutionalize, and part of it does not. Therein lies an age-old contradiction, one that predates hip-hop: that of wanting to change things within and outside of the system at the same time. This is not so much an aesthetic as it is a strategy. The hip-hop generation is working inside and outside "the system" in the arts, politics, business, education, and activism. These two poles point to an inner battle within hip-hop, a battle that has made it difficult to even attempt to define the aesthetics of hip-hop.

We often speak of two hip-hops. There is the corporate one that we are allowed to see on TV and hear on the radio, the one we're allowed to buy. Let's call the artists and movers and shakers who practice this kind of hip-hop the "blingers." Then there is the other hip-hop, practiced by the grassroots artists and activists, the ones hustling grant applications, standing in the rain at protests, using hip-hop for social change and community education and empowerment—you know, the "righteous."

These days, the righteous are mad at the blingers for being sellouts, for misrepresenting the culture, for exporting a one-dimensional image of itself. And the blingers are mad at the righteous because they feel hated on, and responsible for carrying the entire culture (and all oppressed people) forward on their shoulders. Thirty years have gone by, hip-hop is worldwide, but we're still fighting each other more than the people who are denying hip-hop access.

Even among the righteous there are those who criticize folks who have crossed the line to work with an institution, and those within institutions who criticize those who will not. This constant infighting in hip-hop goes beyond the inside/outside the system dialectic, and the capitalist/socialist, blinger/righteous dialectic. The reason for this is hip-hop's battle aesthetic.

Battling is a key component of hip-hop aesthetics. It signifies resistance, rebellion, mastery of skill, and competition. But if hip-hop artists continue to look at hip-hop simply as a "game," then we devalue our culture. And how do we make good art? Game is distraction, sport, and competition. If hip-hop is to have artistic longevity, it cannot remain in sport or pastime. If grassroots activists continue to disqualify, or refuse to acknowledge, the gangster rappers' bling, and if hip-hop-industry moguls ignore, or do not support, the work that grassroots hip-hop artists and activists are doing, then both sides have already lost the battle.

Hip-hop must transcend the battle, by reappropriating it. This is something that is so elementary to hip-hop, but we never thought about doing it with something WE created. Why? Because hip-hop has always looked outside itself for resources, rather than looking at our own creations as resources themselves. Record companies never think twice about appropriating what hip-hop creates. But when will we, inside the culture, reappropriate our own resources? It would be revolutionary—for real.

The two hip-hops must engage each other every day, and support each other equitably, in a reciprocal way. If hip-hop corporate moguls engage the grassroots only when it benefits their bottom line, and if the grassroots engage the moguls only when they fund a project, then we are not thinking long-term. At the same time, if we support corporate hip-hop that is socially unhealthy, then we defeat our purpose, and if we support grassroots artists who are not very good artists, then we are not challenging the aesthetic either.

If hip-hop arts are going to have a future, then we must critique one another's work, but not solely through the limited lens of Western aesthetics. Too often we read reviews by outsider critics who simply do not have the language, context, or understanding of hip-hop culture to seriously critique a piece of work, and the movement suffers because of this. We must critique one other, and we must be honest, everybody! If some shit is bad, we gotta tell them, "Yo—it's bad." And tell them why. And if it's good, we must support it, and let everyone know.

Can hip-hop continue to produce a steady flow of quality art, and not just one-dimensional pop culture? I believe that hip-hop is more universally relevant and democratically resonant in this day and age than opera, ballet, classical music, or traditional theatre. Only time will tell whether hip-hop becomes "classical" art in the next two hundred years. I believe it will, not simply because I like it, but during the past thirty years hip-hop has already influenced generations of artists and audiences around the globe, like good art always does.

Hip-hop *is* art. Whether it is revolutionary art or bling-ass-make-money-biaatch art, hip-hop art does not depend on how many records it sells, how much the gallery piece sold for, whose hip-hop theatre piece goes to Broadway and whose doesn't, how many rallies were held, or how many times the kid can spin on his head. Although the culture is marginalized and misunderstood, it is also moving on and maturing. There are rules, there is a foundation, and motherfuckers better know the ledge. At every opportunity we must loudly define hip-hop's aesthetics. It is critical that we do.

Why? I attended a panel where scores of hip-hop artists and activists were debating over what to do with folks like Russell Simmons, Puff Daddy, Master P, and other rap moguls, who were being accused of a litany of revolutionary crimes: sending negative messages to young people, making poor financial decisions, being inarticulate, embarrassing the Black community, and—worst of all—misrepresenting the hip-hop movement. Harry Belafonte, the artist and cultural activist, was in the audience, quietly listening to the raging debate. After three hours, he rose and said, "Y'all gotta define yourselves. Until you do, *they* will." Then he left. I'm with Harry.

Danny Hoch is an actor, playwright, and director whose plays *Pot Melting, Some People*, and *Jails, Hospitals, Hip-Hop* have toured the world and garnered numerous awards. A fellow at the New School's Vera List Center for Art and Politics, his writings on hip-hop, society, race, and class have appeared in the *Village Voice, New York Times, Harper's*, the *Nation*, and *American Theatre*, and his book *Jails, Hospitals, & Hip-Hop* is in its second printing by Villard Books/Random House. Mr. Hoch is the founder of the Hip-Hop Theater Festival and directed Will Power's *Flow* off-Broadway. Mr. Hoch's new play, *Till the Break of Dawn*, will soon premiere off-Broadway.

Acknowledgments

It must be said that *Total Chaos*—pun only partly intended this time—would not have been possible without the help of hundreds of people. The most important is Roberta Uno, whose vision is the reason this book exists. Thank-yous are also in order to San San Wong, Margaret Wilkerson, Alison Bernstein, Eddie Torres, Dave Mazzoli, Christine Balancé, Sophia Dhu-Stewart, Laurence Martinaud, Sylvia Sherman, Laura Ruiz, Juan Berumen, Paul Chen, and all of the incredible people who made the Future Aesthetics events happen from coast to coast. To the staffs of La Peña Cultural Center and Ford Foundation, thank you for providing a home for this work. Also, a hug and a pound to Lydia Yee and Ron Kavanaugh, and The Bronx Museum of the Arts for all of the love.

I owe a huge debt of gratitude and steaming plates of food to all the people who contributed to this anthology. Aside from your brilliance and light, you all are some of the most patient people I've ever known, even if all of you ain't the most punctual. It's all good—we did it!

To Tricia Rose, Joseph Patel, Hua Hsu, Todd "Soundmurderer" Osborn, Matt Black from Coldcut, Kristina Rizga, Clyde Valentin, James Kass, Hodari Davis, George Harris, Jorge Ignacio Cortiñas, Cathy Cohen, Sekou Sundiata, Kenyon Farrow, Tamara Nopper, Chris Kahunahana, Amanda Berger, ZEPHYR, Steve Colman, Universes, Toni Blackman, Stephen Cohen, my Tumi's fam, the Eastside Arts Alliance, the San Francisco Foundation, Alvin Starks, Anna Lefer, and the Open Society Institute; Ellis Finger and the Williams Center for the Arts; Claudine Brown and the Nathan Cummings Foundation; Ajay Nair and the University of Pennsylvania Asian American Studies Program; Randy Gener and *American Theatre* magazine; James Bewley, Terry Lily Hwang, and the Hammer Museum; Mike Wakeford, Victoria Malone, and the Center for Art Policy at Columbia College; and Dave Twombly and the entire Lavin Agency fam, thank you for your inspiration.

A big salute to Laura Stine, Annette Wenda, Jason Brantley, Chris Greenberg, Rick Pracher, and the hardworking Perseus staff. To my own totally chaotic crew, including the indefatigable Anna Alves, the intricate Dave Tompkins, and the incomparable Mike Stern, and especially the great women who make it all happen, the magnificent Victoria Sanders, the amazing Benee Knauer, the uncanny Sara Daniels, and, last but never-the-least, the glorious Ellen Garrison, a million metaphorical flowers, or whatever your favorite plant may be and its usage.

And to the Changs and the Pagaduans, especially Lourdes and the boys for being nice enough not to cut off my food rations during the finishing of this book, thank you from the bottom of my bent body and welling soul.

Index